D1253641

Jackson

Pollock

A BIOGRAPHY

Deborah Solomon

SIMON AND SCHUSTER NEW YORK

Copyright © 1987 by Deborah Solomon
All rights reserved
including the right of reproduction
in whole or in part in any form
Published by Simon and Schuster
A Division of Simon & Schuster, Inc.
Simon & Schuster Building
Rockefeller Center
1230 Avenue of the Americas
New York, New York 10020
SIMON AND SCHUSTER and colophon are registered trademarks of
Simon & Schuster, Inc.
Designed by Eve Kirch
Manufactured in the United States of America

10 9 8 7 6 5 4 3 2 1

Library of Congress Cataloging in Publication Data
Solomon, Deborah.
 Jackson Pollock : a biography.
 Includes index.
 1. Pollock, Jackson, 1912–1956. 2. Painters—
United States—Biography. 3. Abstract expressionism—
United States. 4. Painting, American. 5. Painting,
Modern—20th century—United States. I. Title.
ND237.P73S65 1987 759.13 [B] 87-4314
ISBN: 0-671-49593-3

ACKNOWLEDGMENTS

For helping me tell this story I am indebted to the following individuals: Mary Abbott-Clyde, Frances Avery, Will Barnet, Ethel Baziotes, Josephine Ben-Shmuel, Thomas P. Benton, Grace Borgenicht, Carol Braider, the late Fritz Bultman, Rudy Burckhardt, Peter Busa, Leo Castelli, Janet Chase-Hauck, Herman Cherry, Irene Crippen, Whitney Darrow, Jr., Fielding Dawson, Dorothy Dehner, Joseph Delaney, Paul Falkenberg, Herbert Ferber, Helen Frankenthaler, Constance Garner, Sidney Geist, Max Granick, Clement Greenberg, Florence and Peter Grippe, David Hare, Ben Heller, Joseph L. Henderson, Clair Heyer, Rebecca Hicks, Harry Holtzman, Axel Horn, Elizabeth Hubbard, Merle Hubbard, Vetta Huston, Sidney Janis, Paul Jenkins, Buffie Johnson, Mervin Jules, Reuben Kadish, Jacob Kainen, Jerome Kamrowski, Nathaniel Kaz, Ruth Kligman, Joyce Kootz, the late Lee Krasner, Ibram Lassaw, Berthe Laxineta, Violet de Laszlo, Harold Lehman, the late John Little, Josephine Little, Cile Lord, Jessie Benton Lyman, Arloie McCoy, Jason McCoy, Yvonne

5

Acknowledgments

McKinney, George Sid Miller, Sue Mitchell, Robert Motherwell, Hans Namuth, Annalee Newman, Ruth and Tino Nivola, Alfonso Ossorio, Frances and Wayne Overholtzer, Philip Pavia, Eleanor Piacenza, Alma and Jay Pollock, Charles Pollock, Elizabeth Pollock, Frank and Marie Pollock, Herbert L. Pratt, Milton Resnick, Dan Rice, Dorothea Rockburne, May Tabak Rosenberg, Patia Rosenberg, Lou Rosenthal, Berton Roueché, Irving Sandler, Nene Schardt, Rachel Scott, Dorothy Seiberling, Charles Seliger, Jane Smith, Eleanor Steffen, Ronald Stein, Ruth Stein, Hedda Sterne, Wally Strautin, the late James Johnson Sweeney, Allene Talmage, Araks Tolegian, the late Manuel Tolegian, Esteban and Harriet Vicente, Theodore Wahl, James H. Wall, Joan Ward, Enez Whipple, Roger Wilcox, Reginald Wilson, Maia Wojciechowska, Elisabeth Zogbaum, and the late Marta Vivas-Zogbaum.

I am grateful to Lee Krasner for granting me unrestricted access to Pollock's papers. Eugene Victor Thaw, the executor of the Pollock estate since Miss Krasner's death, has kindly given me permission to quote from those papers.

Most of Pollock's papers are located at the Archives of American Art in Washington, DC. I owe special thanks to the Archives staff, particularly Bill McNaught and Jemison Hammond, for their gracious assistance and patience.

Some of Pollock's letters remain in private hands. I am grateful to Arloie McCoy, Rebecca Hicks, and Charles Seliger for letting me examine their letters. Frank Pollock made available to me the letters of his mother, and Irene Crippen allowed me to consult some additional letters from Stella Pollock.

I am especially indebted to Stephen Campbell of the Thomas H. and Rita P. Benton Testamentary Trusts, United Missouri Bank, Kansas City, for granting me unrestricted access to and permission to quote from the Bentons' personal papers.

Many people aided me in my search for pertinent documents. My thanks to Ray Ferren of Guild Hall; Bonnie Clearwater of the Rothko Foundation; Sandy Hirsh of the Adolph Gottlieb Foundation; Marilyn Cohen of the Betty Parsons Foundation; Lawrence Campbell of the Art Students League; Altamae Markham of the Park County Library, in Cody, Wyoming; Ward Jack-

son of the Solomon R. Guggenheim Museum; Dorothy King of the East Hampton Free Library; and Stephen L. Schlesinger of the John Simon Guggenheim Memorial Foundation. Time-Life, Inc. provided me with transcripts of unpublished interviews with Jackson Pollock, Betty Parsons, and several others. Pat Carlton shared with me her research on Caroline Pratt, and Constance Schwartz shared her research on Lee Krasner. Clair Heyer led me through an overgrown church cemetery in Tingley, Iowa, in search of the gravestones of Pollock's ancestors.

I am grateful to the New York Public Library for use of the Frederick Lewis Allen Memorial Room and to the Dallas Public Library for use of the Frances Sanger Mossiker study room.

John Herman, my first editor, got me off on a strong start. Bob Bender provided superb editorial advice later on and improved my manuscript immeasurably. Kathy Robbins, my literary agent, has done as much as anyone to encourage me and has also provided essential editorial guidance. Her assistant, Loretta Fidel, has been most helpful. Many others have supported me over the past few years, but I am particularly grateful to Kent Sepkowitz, Karen Marder, Douglas Pollack, David Firestone, Lee Stern, Jesse Kornbluth, and James Atlas.

*To my parents
and my sisters Lisa and Cherise*

CONTENTS

My God! I'd rather go to Europe than to heaven!
 —American painter William Merritt Chase (1849–1916)
 when offered the chance to study abroad

Everyone is going or gone to Paris. With the old shit (that you can't paint in America). Have an idea they will all be back.
 —Jackson Pollock, 1946

1 Origins

1912-28

Jackson Pollock's mother, Stella May McClure, was born in May 1875 in a two-room log cabin in Tingley, Iowa, an isolated farming town in the southernmost part of the state. As the oldest child in a struggling pioneer family, Stella was saddled with responsibilities from her earliest years. She quit school after the sixth grade to help raise her six brothers and sisters, two of whom died in childhood. The family was poor but respectable, and it gave them an edge of distinction to earn their livelihood by a means other than farming. Stella's father, John McClure, was a mason and carpenter who laid most of the foundations in Tingley; and her mother, Cordelia, was known among the townspeople for her weaving. Stella, like her parents, was good with her hands. Besides sewing all the clothes for her family, by the time she was a teen she was sewing beautiful long dresses that she sold to the wealthier women in town. She loved fine, well-crafted things, and it made her proud to be descended on both sides from weavers. Once when she was asked to write a family history, the only

people she included were the craftsmen, as if no one else really mattered. "Great Grand Pa Boyd was born in Ireland was a linen weaver," she noted. "Great Grand Mother Speck weaver of woolens and carpets. My mother wove first piece of linen when she was sixteen."

Stella's grandparents were Irish weavers of Presbyterian stock who had emigrated around the time of the great potato famine and settled in Ohio in the 1840s. Her parents, John and Cordelia McClure, both of whom grew up in Iowa, had traveled to Tingley by covered wagon in the 1870s, when land was selling for ten dollars an acre and farmers were burning fields of bluestem grass to make room for corn. Tingley was off the track of pioneer cross-state travel, but rumors of a coming railroad drew enough settlers to fill up the farms. When the Humeston & Shenandoah Railroad Company ran a line through Tingley in 1882, the town prospered quickly. Within two years its population swelled from one hundred to four hundred and its Main Street was lined with sixteen businesses, including two lumberyards, three general stores, a hotel, a blacksmith shop, and a livery stable. The townspeople were mostly farmers who grew crops, raised cattle, and shipped their livestock by railroad to faraway cities that the farmers themselves rarely visited.

Stella grew up at a time when the railroads were changing the country. When she was seven years old the first locomotives had arrived in Tingley. She and her sisters Anna and Mary had spent many afternoons walking along the freshly laid tracks, picking wildflowers and watching the trains pull away. They listened to stories about young newlyweds who had gone west, and surely the McClure girls wondered when their turns would come. Mary McClure, four years younger than Stella, was the first of the sisters to leave, marrying a railroad conductor and moving to Denver. Anna McClure, two years younger than Stella and the first in the family to graduate from high school, never left at all; she died of tuberculosis when she was twenty-two. Stella was twenty-six when she finally left Tingley, but the circumstances of her departure were different from the ones she must have imagined as a girl. She was pregnant, and she was unmarried.

Stella McClure left Tingley to hide the secret of her illegitimate pregnancy from the local farmers and their wives; she was too proud to become the object of their gossip. Alone, she rode the train to Denver, where she moved in with her sister Mary and awaited the birth of her first child, who was born on Christmas Day. She named him Charles. She sent news of the birth home and two weeks later traveled halfway back to Tingley, to Alliance, Nebraska, where she was met by the father of the baby boy. The *Tingley Vindicator* reported early in 1903: "Word has been received by Tingley relatives of the marriage of Mr. Roy Pollock and Miss Stella McClure, which took place January 13 at Alliance, Nebraska. They are now living in Wyoming."

The newspaper announcement made no mention of Stella's infant boy, and the details of her marriage would remain a lifelong secret. She would never tell her children that she had left home pregnant and unwed, and she would never confess to having been married in Alliance in a service conducted by a Methodist minister she did not know. She told her children that LeRoy Pollock had courted her on moonlit sleigh rides through snow-covered fields. She said she had married him at the United Presbyterian Church in Tingley and the entire town had turned out for the happy event. The truth about her marriage, like all the disappointments in her life, Stella kept to herself.

LeRoy Pollock was a quiet, serious, and sensitive man, a year younger than his wife. His marriage to Stella McClure, however imperfect, at least offered him the illusion of escape from the cruel indignities of his childhood and the town in which he had spent it. LeRoy was born in Tingley, in the township of Eugene, in February 1876, the son of Alexander and Rebecca McCoy, poor, coarse, Scotch-Irish farmers who had married in Pennsylvania and raised two sons in Peculiar, Missouri, before LeRoy, their youngest child, was born. According to the 1880 agricultural census, LeRoy's father owned only "two horses, one milch cow, and ten swine." His farm machinery was valued at a scant $30, and his forty-acre farm was valued at $700, which placed the family's

total worth sixth from the lowest among the township's ninety-six farmers. When LeRoy was three years old his four-year-old sister Nina died of tuberculosis, and her death was followed two months later by that of his mother. LeRoy's father, broken by hardship, felt he could not care for the little boy. He gave him away to neighbors and eventually returned to Missouri. LeRoy never saw his father again.

LeRoy grew up with James and Lizzie Pollock—uneducated, religious, Ohio-born farmers who were no better off than the McCoys. The Pollocks, who were in their mid-forties when they took LeRoy in, believed they should be compensated for raising the orphan. They exploited him during his youth, sending him out with a horse and plow to labor for local farmers and demanding that he turn over his earnings to them. To the young LeRoy the Pollocks were small-minded, hypocritical people, and it made no sense to him that they forced him to study the Bible and attend services at the local Presbyterian church while keeping him out of school a few days a week so he could attend to farm duties. He managed to graduate from the Tingley School at the age of nineteen.

Twice during his childhood LeRoy ran away from home. Once he went to Missouri, where he worked as a harvest hand; he returned home starving a few weeks later. Another time, inspired by the story of Huck Finn, an orphan like himself, LeRoy and a schoolmate named Ralph Tidrick built a rowboat and traveled down the Mississippi to New Orleans. They checked into a cheap hotel and worked in the kitchen for their room and board. Two weeks later Ralph's father mailed the boys train tickets back to Tingley. To keep LeRoy from running off again and abandoning his farm duties, his foster parents adopted him ten days before his twenty-first birthday. They didn't want to lose a cheap farmhand.

On the day he left home to meet his bride in Nebraska, LeRoy knew he would never return to Tingley to see his foster parents, nor would he ever practice their faith. He didn't even want their name. He visited a lawyer to request that his name be changed back to McCoy. The lawyer asked him for a large fee,

and it was more than LeRoy had. He could not afford his real name.

After marrying in Nebraska, LeRoy and Stella and their infant son traveled by train to Cody, Wyoming, the last stop on the Chicago, Burlington & Quincy Railroad. The prairie town of five hundred had been founded six years earlier by Colonel William "Buffalo Bill" Cody, who, in an attempt to draw settlers to Wyoming's Bighorn Basin, was constructing canals, irrigating the soil, and promising free land to anyone willing to build a house. For people as poor as the Pollocks, however, the boomtown offered virtually no opportunities. As LeRoy and Stella quickly learned, they could not claim land, for they could not build a house; they could not afford the considerable expense of freighting raw timber to Cody from across the Shoshone River. They ended up renting a tiny frame house on Bleistein Avenue, two short blocks from Buffalo Bill's new Irma Hotel, where LeRoy found work washing dishes.

The Pollocks remained in Cody ten years, but their situation hardly improved. LeRoy eventually left the Irma Hotel to join a friend from Tingley in a rock-crushing business, hauling boulders by horse and wagon from the banks of the Shoshone River to a plant where they were ground for construction. It was hard manual labor, and after six years he was too sick to continue. Meanwhile he had a large family to support. Besides Charles there were now two other sons, Jay and Frank, who had been born in 1904 and 1907. For lack of a better alternative, LeRoy accepted a job in 1908 as the manager of the Sanford Watkins sheep ranch, on Lower Sage Creek, and moved his family onto the ranch. Here, in a two-room frame house surrounded by wild sagebrush, at the base of the twin-peaked Hart Mountain, the Pollocks' last two sons would be born, the first of whom they named Sanford after their employer.

Stella went into labor with her fifth and last son early one afternoon in January 1912, and though the birth should have been her easiest, it was her most difficult. Later that day LeRoy rode into town on his horse to ask a Dr. Waples to come out to the ranch and assist the midwife with the birth. Stella struggled with

the delivery all through the night, and the following morning, in the predawn darkness of January 28, 1912, a healthy boy was born. He weighed more than Stella's other infants had, almost twice as much as the average newborn. As the Cody newspaper reported: "A fine son, weighing twelve pounds and a quarter, was born Sunday morning to Mr. and Mrs. Roy Pollock of this city. This makes five sons that have come to live in this happy family and the Pollocks are quite the envy of the whole community."

They named the boy Paul Jackson Pollock, although by the time he was three everyone called him Jack. The name was probably chosen after his mother's favorite town—Jackson, Wyoming, an open valley swept with sagebrush at the base of the Teton peaks. Stella was particularly enamored of Jackson from the moment he was born. She knew he was her last child, for Dr. Waples had told her that at age thirty-six, she was too old to have any more children. "He's my baby," Stella used to say, "Jack's my baby." Though Stella was not outwardly affectionate, she adored her sons and expressed her feelings by doing things for them. She was never idle. She had large, capable, graceful hands, described by one of her children as "the busiest hands I've ever seen," and Jackson's earliest impressions of life may well have been the image of his mother's hands in motion: churning butter, pumping water, canning preserves, pouring candles, kneading bread, sewing clothes, crocheting the unadorned edges of bedspreads, curtains, and handkerchiefs.

Many years later, when Jackson was in his twenties, he would offer a symbolic version of his birth that shares some interesting parallels with his actual birth. The painting *Birth* (Fig. 12), an early, undated work, is a semiabstract painting in which it is possible to decipher several recognizable forms. The central image consists of a woman lying flat on a bed, with an oversized fetus, painted fiery orange and blue, reeling inside her body. In the lower right corner a claw-shaped hand reaches toward the fetus, threatening to yank it from the womb. Beside it is a second hand, raised in a stop gesture, as if trying to stop the birth. Did Stella actually tell Jackson the details of his birth—how she labored through the night trying to force him from her womb?

How her efforts were impeded by his unusually heavy weight? Whether or not she did, Pollock envisioned the act of birth as a terrible ordeal, thrusting the fearful infant into conflict. That he chose two hands—the yanking hand, the halting hand—as symbols of this conflict is altogether appropriate, for it was the very problem of what to do with his hands and the abilities he was born with that would put Pollock in excruciating conflict with himself.

———

Soon after Jackson was born his father was diagnosed as having rheumatic fever and was advised by Dr. Waples to move to a warmer climate. That October, after the sheep had returned from pasture, the local newspaper reported: "LeRoy Pollock took the noon train out of Cody Thursday, his point of destination being San Diego, California, with a view of looking up a location."

The following month the newspaper noted: "Mrs. L. R. Pollock and five sons expect to leave in about two weeks for San Diego, California, where they will make their home. Mr. Pollock went out to San Diego about a month ago, where he is now at work at his trade. He has purchased a lot in the city and expects to build in a short time."

From mid-November through Thanksgiving Day, 1912, this notice appeared in the classified section: "For Sale—All my household goods, baby buggy, canned fruit and everything. Call at the house. Mrs. L. R. Pollock."

On Thanksgiving Day, 1912, Stella and her five boys took the train to San Diego. Jackson was ten months old. He never returned to Cody, and his memories of the town were based on photographs and the stories his family told. So the fact that Pollock was born in Cody, a town named for a frontiersman who slaughtered 6,570 buffalo, had virtually no influence on his youth, considering how little time he spent there. In later life, however, Pollock referred often to his Cody birthplace, mentioning it in every interview and usually before he mentioned anything else. "I was born in Cody," he'd start off, in a flat, soft, slightly strained

voice, as if the comment was supposed to mean something. He liked being identified with the fabled town of Cody and the wildness and virility of the American frontier, even if it wasn't his real heritage. On the other hand, Pollock's connection to Cody was perhaps more profound than it might have been had he grown up there, for in his imagination and in his art he really did live on the frontier, a place that was all the more authentic because he had to invent it for himself.

———

Though the Cody newspaper had reported in its "society" column that LeRoy had found a job in San Diego and purchased a piece of land, no such events had ever occurred. One imagines it was Stella who fabricated this news, unwilling to admit to the townspeople that her family was leaving Cody after ten years to live like drifters in a rented house in an obscure, fruit-growing suburb of San Diego. Better for people to think that the Pollocks were prosperous.

"L. R. Pollock and family, from Wyoming, are recent arrivals in National City," reported the *San Diego Sun* in December 1912. It was the last time the Pollocks would be mentioned in that newspaper, for their stay in National City was so short no one had time to take note of them. A month after the family's arrival a blizzard struck the area, killing the orange crop, bankrupting farmers, and convincing LeRoy that he never wanted to be a citrus farmer. By the time the city's 1913 directory was published, listing LeRoy as a "plasterer" who lived on Sixth Street, the family had already departed.

Again LeRoy went by train ahead of his family, this time traveling east, to Phoenix, Arizona. He was immediately fond of the city, and it seemed to him that Phoenix, which called itself the "City of Progress," really did offer hopes of advancement even to an impoverished farmer like himself. Land was cheap, loans were easy to secure, and the Roosevelt Dam, completed two years earlier, guaranteed that the land would be fertile. In September 1913, with a down payment of ten dollars, LeRoy purchased his first piece of land, a forty-acre truck farm six miles outside Phoe-

nix, on the road to Tempe. Then he sent for his wife and sons.

It was there, in the low-lying valley of the Salt River, that LeRoy and Stella spent the four happiest years of their lives. For the first time—and also the last—they were slightly prosperous landowners. They stocked their farm with Holsteins and Jerseys, the best dairy cows they could find. They planted corn, okra, tomatoes, sweet potatoes, and other seasonal vegetables, which, in the growing months, LeRoy sold downtown at the farmers' market. He paid off his mortgage, his savings grew. Besides selling produce at the market, LeRoy picked up extra money by selling milk to a nearby sanatorium and apricots to cities in the East. He won blue ribbons for his produce and was proud of his success. His sons recall how he'd lead them into the alfalfa fields and, pointing into the distance, tell them, "One day we'll own that land."

The three-room adobe house in which the Pollocks lived was small and cramped, encouraging the children to spend most of their time oudoors. They slept in the yard from the spring through the fall, in a huge brass bed that the five of them shared. On nights when the sky crackled with lightning the boys would run into their parents' bedroom all excited, dragging their rain-splashed mattress behind them. Most often, though, the sky was clear and glittery with stars, and the boys spent the nights beneath the tall cottonwood trees, with cottony wisps tumbling down around them. Though the outside world was already at war, LeRoy would later look back longingly on the four years the family spent in Phoenix, writing to one of his sons, "I wish we were all back in the country on a big ranch with pigs cows horses chickens. . . . The happiest time was when you boys were all home on the ranch. We did lots of hard work, but we were healthy and happy." The fullness and richness of the years they spent in Phoenix is perhaps best captured in this postcard from Stella: "We are having lots of wasting ears [of corn] watermelon and such fruit just going to waste there is so much of it the trees are almost broke down with weight I put up 59 qt of apricots last week I am making crab bullion today and baking bread."

Though LeRoy has been characterized before as a lackluster

farmer who drifted through life leaving little record of his existence, his sons would not agree with such a description. They considered their father an intelligent, sensitive, purposeful man and held him in high esteem. One day Frank, the middle son, returned home from school and reported that a teacher had denigrated the Industrial Workers of the World, joking to the class that IWW means "I Won't Work." LeRoy was outraged. Though by no means a political activist, he identified with labor's struggles and was acutely sensitive to any form of injustice. He taught his sons that life is harsh and unfair but that one can rise above it through inner fineness. If cultivating the land "gave him a deep inner satisfaction," according to his son Charles, so did the cultivation of his mind. He liked to listen to classical music, and though not a voracious reader, he traveled with a small library and often read aloud to his children from Dickens, Stevenson, and *Huckleberry Finn.* After LeRoy's death his son Sande would write to his brothers that their father's absence "will leave a gap in our lives which can only be filled by our untiring efforts towards those cultural things which he, as a sensitive man, found so sordidly lacking in our civilization."

While LeRoy tried to improve himself by cultivating inner qualities, Stella distinguished herself through appearances. Even in rural Phoenix she managed to live her life with style. Her sons recall how she loved to rub her face and hands with fragrant rosewater, put on a veiled hat and white gloves, and drive a team of horses into town. At the general store she would purchase her favorite magazines, *Country Gentleman* and *Ladies' Home Journal,* and at Goldwater's department store she would shop for fabrics, buying yards of fine silk pongee, imported from the Orient. She sewed her own clothes, as well as clothes for the boys: full, flowing shirts of gingham and chambray and knee-length corduroy trousers. In school photographs the Pollock children are invariably the best-dressed in their class, their clothes finely tailored and adorned with such details as military epaulets and fancy buttons. "You have to look important," Stella used to say, determined to fashion her sons into distinguished young men.

Not the least among the reasons for Stella's satisfaction in

Phoenix was her fierce pride in the talents of her eldest child. Charles, who was ten years older than Jackson, bore a distinct likeness to his mother, with thick, wavy hair, classical features, and a self-restrained, stoic demeanor that added to the sense of strength conveyed by his bulky figure. Like Stella, Charles was good with his hands and had shown an impressive ability for drawing from the time he was three or four years old. One day on the Phoenix ranch Charles picked up a grocer's pencil and drew a picture of a hog on a paper sack. His brothers marveled: *A hog. It looked exactly like a hog.* To encourage Charles, Stella sent him to weekly art classes at the home of a "drawing tutor," Mrs. Bidwell. Though LeRoy sometimes complained that the classes interfered with Charles's farm duties, Stella invariably defended her son. "He's entitled to it," she would say, quickly silencing her husband. It pleased her profoundly that Charles had natural taste—reflected, she felt, not only in his interest in drawing but in his fondness for sitting beside her as she sewed and admiring swatches of fabric. She often told Charles that she thought he would make an excellent jeweler, which seemed to her an ideal profession for a boy who possessed an instinctive appreciation of rare, beautiful things.

Jackson, by comparison, did not draw as a little boy. As much as he admired Charles, he made no outward effort to emulate his oldest brother, resisting the creative possibilities that lay within his grasp. A photograph dating from the time he was six years old shows him to be a pretty youth with fine blond hair, a dimpled chin, and a shy, sweet smile that hints at his sensitive disposition. His brother Sande, the closest to him in age, once described him as "the sweetest guy, the most unselfish boy. I never saw Jack cruel to any animal—dog, cat anything. He was gentle to an unnatural degree." Sande, a dark, small, self-sacrificing boy, instinctively felt protective toward his baby brother, as though recognizing a certain helplessness in Jackson that left him unequipped for the rigors of farm life. On most afternoons, while his brothers tended to their farm chores, Jackson, who had no chores, would simply wander around the barnyard with Gyp, the family dog, a white mongrel with a patch of black around one

eye. In his naïveté Jackson often got in trouble for allowing Gyp to drink from the buckets of fresh milk in the yard. His brothers all agreed that Jackson took after their father, for LeRoy too was fond of animals. He couldn't stand killing them, not even a chicken. It was Stella who slaughtered the poultry on the farm.

Four years after moving to Phoenix, Stella became disenchanted with the city. Farmers from the South were arriving in large numbers, planting fields once reserved for corn and alfalfa with long-staple cotton and replacing family-owned dairy farms with large operations staffed by itinerant farm hands. To Stella cotton farming was "low-down drudgery," and she wanted no part of it. She complained to her husband that Phoenix was becoming a cotton town, and a cotton town was no place to raise a family; she wanted to move. LeRoy, however, was unsympathetic, pointing out to his wife that they had managed to build up a first-rate stock of dairy cows, chickens, and hogs and that their farm represented a foothold into the future.

But Stella became obsessed with the idea of moving. One day she returned from town with a stack of postcards and a map of the western United States. She wrote to the chambers of commerce in most of the cities on the map and was answered with dozens of brochures. Night after night she read the brochures aloud to LeRoy, reeling off facts about distant cities, each with its promises of ideal climate and perfect location and opportunities for success. Though LeRoy still felt they had nothing to gain by leaving Phoenix, he grew tired of arguing with his wife, who, in her eagerness to leave Phoenix, could not be reasoned with. Besides, Stella had already made up her mind: she wanted to move to Chico, California. Though she had never visited the town, she had read in a brochure that Chico had tree-lined avenues and the largest oak in the world. She had read that Chico was the "Rose City of Butte County" and that Butte County was the largest olive-growing center in the state. What impressed Stella the most about Chico were its schools, which included a state college. She told her husband that Chico was a place where their sons could receive a good education.

In January 1918, against his better judgment, LeRoy auc-

tioned off his animals and sold his Phoenix farm. One month later he purchased an eighteen-acre fruit farm in Chico, California, a town he immediately disliked. The family's large white house was their first with running water and electric lights, but such modern conveniences were no consolation to LeRoy. He resented having to work as a citrus farmer but had no choice, for Chico was a citrus town in which all human effort was spent growing fruit, entering statewide agricultural contests, and staging pruning demonstrations; the town of nine thousand desperately wanted to become the citrus capital of the Sacramento Valley. When the Pollocks first settled in Chico, LeRoy went to farm bureau meetings to try to learn new techniques for pruning and spraying trees, but the truth was he just did not care. He missed working with cows, chickens, and hogs, and he longed for the Phoenix farm. Sometimes, after dinner, he would take a bottle from the pantry and sit down in the living room. Stella would tell him to put the bottle back. LeRoy would start chewing tobacco, but Stella didn't like tobacco any more than she liked alcohol. She would tell LeRoy to quit chewing tobacco in *her* house. LeRoy would end up sitting around the living room looking sad, and Stella would tell her boys, "Stay away from Dad. He's got the blues."

LeRoy was desperate to get out of Chico. He spoke to a local real estate man, Chris Sharp, who offered to trade the Pollocks' fruit farm for a small mountainside inn near Reno, Nevada. The prospect of running an inn did not particularly appeal to LeRoy but certainly seemed preferable to working as a fruit farmer. Less than two years after moving to Chico, LeRoy told his wife he wanted to move. Stella immediately opposed the suggestion, arguing that their sons were doing well in school and she had no intention of moving them to some backwater town whose educational system consisted of a one-room schoolhouse. But LeRoy was adamant, forcing his wife to agree to a compromise: they would move to the inn near Reno but leave their three older sons in Chico, arranging for them to board with a friend and continue at the local high school. The two younger boys would remain with their parents—though that too posed problems. Jackson,

age seven, had just completed the first grade at the Sacramento Avenue School, and his mother was upset at having to disrupt his schooling so soon after it had begun.

In January 1920 LeRoy acquired the Diamond Mountain Inn in Janesville, California, a tiny town near the Nevada border. The inn, named for the mountains that surrounded it and located on the town's one road, was a twenty-two-room establishment catering for the most part to gangs of road surveyors who needed a place to spend the night on the desolate stretch between Reno and Susanville. Unlike the other towns of Jackson's youth, Janesville really resembled the Wild West of legend. On cold nights old codgers who lived nearby would gather at the Pollocks' inn, sitting around the wood-burning stove in the dining room drinking whiskey and bragging about gunfights. At the Janesville School, Jackson and Sande met their first roughriders. In the months when the town was snowbound, local cowboys, armed with six-shooters, would sit in the back of the classroom making eyes at the pretty teacher.

As anxious as he had been to leave Chico, LeRoy only became more discontented after moving to Janesville. The job of running an inn, which required mainly that he clean the guest rooms and assist his wife in the kitchen, gave him none of the satisfaction he derived from farming. In retrospect it seemed to him that he had ruined himself irreversibly by selling the Phoenix farm, losing not only his land but the modest financial security he had worked so hard to obtain. He was furious with his wife, who, in her stubborn desire to improve her situation, had seemed instead to have trapped the family in obscurity. Though Stella tried to assure him that they could always acquire another farm, LeRoy was long past the point of listening to anything she said. Early one morning he packed up his belongings and left Janesville with a group of surveyors.

Stella was deeply upset by her husband's departure. Whatever differences the couple may have had, she seems to have genuinely loved LeRoy and refused to accept the possibility that their marriage was over. In the next four years she would move her

children to five different towns, following LeRoy around the West in hopes of bringing him back into the family. For Jackson, whose itinerant youth had already deprived him of any semblance of community or continuity, his father's departure signaled the complete loss of childhood security. Despite his mother's best efforts to see that he received the same advantages as his older brothers, Stella was incapable of providing Jackson with the attention and affection he needed. A rigid woman to begin with, she pulled deeper into herself in her husband's absence, internalizing her unhappiness and becoming a remote presence to her children. The deprivations of Jackson's youth left him with a weak, uncertain image of himself and an unfathomable sense of loneliness that no amount of acclaim or recognition could ever help him overcome.

Soon after LeRoy left, Stella talked with Chris Sharp, the real estate man back in Chico. With his stylish suits, fat cigars, and gregarious nature, Sharp struck the Pollock boys as the very opposite of their father. "Tell me where you want to go," he used to say to Stella, "and I'll send you." Stella asked him to find her a California dairy farm, thinking that her husband would return to the family if only they lived on a farm. She ended up trading the inn in Janesville for a twenty-acre dairy farm in the nearby town of Orland. In August 1921 the *Orland Unit,* according to its masthead "The Only Absolutely Honest Newspaper in California," announced on page one that "L. R. Pollock . . . will come with his family to this place to take possession of their Orland property about the first of next month, bringing his family to make their home at this place."

The Pollock family was considerably smaller than the newspaper item indicated. LeRoy, who was working as a surveyor for the U.S. Bureau of Public Roads, never visited his family in Orland. And Charles, the oldest son, had also moved away from home, to Los Angeles, where he found a job in the layout department of the *Los Angeles Times* and where he would soon be joined by his brother Jay. More important, Charles had enrolled at the Otis Art Institute, the most prestigious art school in the West. He had decided, at age eighteen, that he was going to become a great artist.

Charles's decision to pursue a career in art is almost startling considering the cultural isolation of his youth. The towns in which the Pollock boys grew up offered no evidence of a living tradition in the fine arts. Painting and drawing, if they were practiced at all, were considered little more than leisure pastimes for women. As an example of the frivolous status accorded the arts, one can look to the Fifth Annual Glenn County Fair, held in Orland two months after the Pollocks' arrival. The fair's so-called art department, according to the local newspaper, offered cash prizes for "paintings on china . . . contestants are also invited to design a lampshade." And it was not only in rural California that art was defined as painted plates and lampshades; the United States itself had yet to produce a self-sustaining tradition in the fine arts and was still dependent on Europe for its cultural identity.

On the other hand, Charles's decision to pursue a career in art seems almost inevitable given his natural talent for drawing and the reinforcement he received from his mother. Stella, as one might expect, was thrilled by his decision to study at a leading art school and harbored grand visions for his future. In 1923, when Jackson was eleven, the family visited Charles in Los Angeles and was immediately impressed by the suave and sophisticated young artist who greeted them. As Frank once exclaimed: "He was wearing spats, and we had never known anyone to wear spats before!" Inspired by their brother's example, the two younger Pollock boys, Sande and Jackson, soon declared that they too were going to be artists. As Sande has said, "Charles started this whole damn thing. He left home damned early. Charles was the fellow who had the intellectual curiosity all along."

Stella once told a newspaper interviewer that whenever Jackson was asked what he wanted to be when he grew up, he invariably replied, "I want to be an artist like brother Charles." Unlike his brother, however, Jackson had not yet demonstrated a facility for drawing. In his entire youth, according to his family, he did not produce a single sketch. This in itself is significant. It's almost as if Pollock suffered from "painter's block" years before

he ever picked up a paintbrush. As much as he wanted to be an artist, the subversive aspects of his personality prevented him from even trying. He was a solitary, withdrawn boy who seems from his earliest years to have felt dissatisfied with himself, as though conscious of a certain unworthiness that set him apart from his talented older brother. These feelings of inadequacy unleashed in him an anger so overwhelming that it all but paralyzed him during these years, while hinting at the makings of the fiercely competitive artist that Pollock would prove to be.

The farm in Orland, which the family had traded for the Janesville inn, soon fell idle. The land went untilled, the crops unharvested, the cows unmilked. Depressed by her husband's absence, Stella simply watched out for checks from LeRoy and waited for him to come home. To make matters worse, she realized after having purchased the property that it lay outside the central school district. Rather than attending the new modern school downtown, Jackson, Sande, and Frank had to go to an obscure one-room schoolhouse on the edge of town, a two-mile walk from their house. A group photograph of the Walnut Grove School's entire student body—twenty-five kids in grades one through eight—provides us with our first intimations of Jackson's relations to his peers. He is a large, intense, self-conscious blond boy who is standing by himself at the end of the middle row, conspicuously alone. While other children appear to be fidgeting, Jackson stands at perfect attention, his expression solemn, his arms rigid at his sides, as though making a deliberate effort to assume the correct pose and to minimize any differences between himself and the other children. This image of self-restraint contrasts sharply with his brothers' spontaneity, with Sande standing behind him (as Sande always would), smirking at the camera, and Frank, who is next to the teacher, obviously amused at having to stand there.

Unable or unwilling to run a farm by herself, Stella sold the Orland property in January 1923, eighteen months after purchasing it. As the Orland newspaper reported on page one, at considerable embarrassment to LeRoy, "Mr. Pollock found it impossible to attend to the development of the land and at the same time

attend to his duties in other parts of the state." It was the end of the family's real estate holdings. As partial payment for the Orland property Stella accepted a secondhand Studebaker Special, unwisely trading the security of farmland for the mobility of the automobile. For the first time she had a car and could go wherever she pleased, but she no longer knew where she wanted to go. She drove back to Chico to seek the help of Chris Sharp, who, taking pity on the family, generously offered to board them for the winter. In the spring, after LeRoy had visited his family in Chico and informed them that he had accepted a job in the Sierra Ancha Mountains in Arizona, Stella decided that she too would return to that state. Though LeRoy wasn't sure exactly where his work would take him, Stella was determined to be at least within a few hours' drive of him and moved her family to Phoenix.

The Pollocks' second stay in Phoenix was a difficult period for them. They lived in a small rented house on Sixteenth Street, in a rundown neighborhood, struggling to get along on occasional checks from LeRoy. For Jackson, who was eleven, it was a particularly unrewarding time. Whereas in Janesville and Orland he had attended school with his older brothers and could depend on Sande to watch out for him, Phoenix had a modern school system that separated students by grades. At the Monroe Grammar School, which occupied the largest school building in the Southwest, Jackson was an outsider among the other sixth graders. Besides being new to the school, he was a noticeably poor student and was repeating the sixth grade. As Sande once said, "His grades weren't passing in any school he ever went to." While this may be an overstatement, Jackson made no discernible effort to excel at his studies, as though hampered by a poor self-image that condemned him to failure before the school year even began.

One positive consequence of the family's second stay in Phoenix was that Jackson developed an interest in American Indian culture. He and Sande often visited the ruins near Pueblo, where they explored the cliff dwellings and fooled around with arrowheads. On Sunday afternoons the brothers sometimes stopped by a park downtown where Maricopas and Pimas from

nearby reservations traded their handicrafts for practical goods. The boys felt sorry for the Indians, who, as Sande later recalled, at times bartered their blankets or jewelry for as little as "a bag of beans." For Jackson, who grew up at a time when the West was synonymous with rootlessness and change, Indian culture offered a connection to the past.

The family's situation in Phoenix worsened over time as LeRoy's checks dwindled to almost nothing. With no means of support, Stella proposed to a widowed farmer named Jacob Minsch that she and her sons help him with his farm work in exchange for room and board. The irony is that ten years earlier the Pollock farm had bordered the Minsch farm. When LeRoy had stood in the alfalfa fields pointing into the distance and dreaming about acquiring additional land, he had been pointing to the Minsch land, where his wife was now working as a maid and his sons were reduced to farmhands.

One afternoon in the fall of 1923 Jackson was playing in the barnyard of the Minsch farm when he picked up a branch from the ground and tried to break it. But it wouldn't break. He walked over to a woodpile on top of which rested an ax in a block and started to remove the ax. A boy named Johnny Porter offered to cut the branch for him, insisting he was too young to handle a heavy ax. Jackson, surrendering the ax, placed the branch on top of the woodpile and pointed to the spot where he wanted it cut. As Johnny raised the ax above his head, Jackson continued to point. When the ax fell, a third of Jackson's right index finger was severed from his hand. He ran inside the house to his mother, who sewed up the wound and applied some sugar to it to help it heal.

Jackson's finger eventually healed, but it would always be deformed. He felt self-conscious about the injury. In later life, whenever he was photographed, he almost always switched his cigarette from his right hand to his left and concealed the maimed hand in a pocket or at his side or behind his back. One does not want to make too much of an accident, except to say that from childhood on, Jackson showed a tendency toward self-injury and that his first serious injury involved his hands.

33

In the spring of 1924, after school had let out for the year, Stella and her sons left Phoenix. With the hope of seeing her husband, who was laying roads in Arizona's Tonto National Forest, Stella accepted a job as a cook at Carr's Ranch, a summer resort on the edge of the forest. It turned out to be a disappointing time for her. LeRoy, based only thirty miles away in Miami, visited his family only once in the course of the entire summer. No longer could Stella pretend that distance alone accounted for her husband's long absences. Unable to reconcile with LeRoy, Stella decided it would be best to return to California, where she could at least rejoin her two older sons, both of whom were in Los Angeles. On the advice of a friend, she settled on Riverside, a prospering citrus town that was connected to Los Angeles by a trolley line. That September, after camping for a few weeks, the family rented a small frame house at 1196 Spruce Street, the first of their three addresses in Riverside in the next three years.

For Jackson, who was almost thirteen, the years in Riverside were a time of excruciating loneliness. Besides being a poor student, he had no friends at school, isolated from others by anxieties that left him all but incapacitated. His brother Sande already had a girlfriend—Arloie Conaway, the pretty daughter of orange growers, would later become his wife—but Jackson was much too shy around girls even to attempt conversation. Among boys he fared worse, wanting desperately to be part of a group but forced into solitude by his hostile distrust of his peers. While he managed to graduate from the Riverside middle school without incident, a troublesome event occurred in his freshman year of high school. One day Jackson showed up for an ROTC practice drill in a uniform that was slightly tattered, prompting a student officer to reprimand him for his appearance. In a fit of anger disproportionate to its cause Jackson grabbed the cadet by his coat and called him a "Goddamn son of a bitch" in front of the whole platoon. The outburst cost him his ROTC membership. Deprived of his one incentive for continuing school, Jackson dropped out of Riverside High in March of his freshman year.

He spent the remainder of the school year at home, afflicted by a discontent so profound that his mother and brothers found

it impossible to talk with him. He seldom showed any warmth or compassion, even in response to wrenching events. One day Jackson walked into the backyard to find his brother Frank crying uncontrollably. Cradled in his arms was Gyp, the family dog, who had died only moments before. "What are you crying about?" Jackson shouted angrily. "It's just a goddamn dog!" But two decades later, when Pollock was in his thirties, he visited a dairy farm and saw a litter of puppies. He picked one out for himself and named it Gyp.

Jackson's years in Riverside were not entirely without consolation. He grew closer to his father, whom he and Sande visited one summer at the Grand Canyon, making the trip in a used Model T, which they bought for twelve dollars. With LeRoy's help, the two brothers were able to obtain their first jobs, joining their father on a surveying team and assisting with the laying of roads along the northern edge of the canyon. For Jackson, who was fifteen, it was a rewarding, purposeful summer. As Sande later recalled, he was a conscientious worker and took pleasure in physical labor, as if rigorous work helped clear his mind of distractions. A photograph taken that summer shows Jackson seated on a cliff, leaning casually against a boulder. He appears in profile, his long blond hair combed straight back to reveal an impressively large forehead and fine Roman features. His gaze is steadied on the sweeping scenery before him, and a pipe dangles from his mouth. The image hints at Jackson's self-composure in the months he spent with his father.

LeRoy, however, was incapable of providing Jackson with a lasting sense of direction or purpose. He was a weak, melancholy, self-pitying man who, by his own admission, felt trapped by circumstance. "I am sorry that I am not in a position to do more for all you boys," he wrote to Jackson in Riverside, "and I sometimes feel that my life has been a failure—but in this life we can't undo the things that are past." It has been said that LeRoy had little influence on his son, but a lack of influence is of course its own kind of influence. To Jackson, his father was more vivid as an absence than as a presence, leaving him with a fierce need to find someone or something he could believe in completely. A

few months after Jackson dropped out of school, his family would make its last move—to Los Angeles—and Jackson would soon declare his ambition to become "an Artist of some kind." The unassuming phrase perfectly captures the dual aspects of the young man's personality: his need for a capital belief and at the same time a subversive unwillingness to commit himself to any one belief in particular.

2 Manual Arts High School

1928-30

In September 1928 Pollock joined the sophomore class of Manual Arts High School in Los Angeles, a public school specializing in the industrial arts. The school, a ten-minute walk from the Pollock home at 1196 Thirty-ninth Avenue, near Exposition Park, was a large, impersonal institution, with more than four thousand students and a standardized curriculum that took little account of individual needs. Although Manual Arts was a "boresome" place of "rules and ringing bells," as Pollock described it, it was in this unlikely setting that he recognized his ambition to become an artist. One class made school worthwhile for him. He studied art under Frederick John de St. Vrain Schwankovsky, or Schwanny to his students, a man who provided Pollock with the guidance and inspiration so sorely lacking in the rest of his school day, if not in his life.

Schwankovsky, a tall, bespectacled painter with a cropped mustache, a goatee, and long black hair, was a highly unorthodox teacher, known in Los Angeles for his espousal of occult mysti-

cism and his equally heretical advocacy of modern art. His customary outfit included a burgundy velvet jacket and sandals, and his appearance, at once refined and bohemian, confirmed his students' quaint notions of how an artist should look. "I'm going to make serious painters of you," Schwankovsky used to say, although he was much less interested in molding his students than simply joining them in the practice of art. Soon after Pollock started school Schwankovsky stirred up a citywide controversy by bringing models into the classroom and having his students draw from life rather than follow the traditional method of copying antique casts. "We are very fortunate in that this is the only school in the city [to] have models," Pollock wrote appreciatively to his brothers Charles and Frank, who had since moved to New York City. Charles was studying at the Art Students League, and Frank, who had followed him east, was studying part time at Columbia. "Altho it is difficult to have a nude and get by the board," Pollock continued, "Schwankavsky [sic] is brave enough to have them."

Under Schwankovsky's influence Pollock quickly fashioned an artistic identity for himself. Like his teacher, he grew his hair to his shoulders—"a style associated with European artists and poets like Oscar Wilde," according to a classmate. He subscribed to *Creative Arts* magazine, read modern poetry in the *Dial,* and in letters to his brothers abandoned capital letters ("my letters are undoubtedly egotistical but it is myself i am interested in now"). And in a notable display of bravado, he changed his first name to Hugo, after Victor Hugo, in the hope of impressing his English teacher, a lady he admired from afar. To his classmates, who continued to call him Jackson rather than Hugo, Pollock radiated an image of artistic vanity in spite of his shyness. To Harold Lehman, a classmate, he was "an immature person with fancy ideas but no discipline." Manuel Tolegian, another classmate, observed, "That fellow thought he was someone important, but to me he always seemed like an orphan." The sculptor Reuben Kadish, referring in particular to Pollock's flowing blond hair, once commented, "Jack didn't want to be mistaken for anything other than an artist."

In Schwankovsky's class, which met five times a week in a basement studio, Pollock first began to draw. He felt immediately dissatisfied with his work, and his high school image as a cocky young artist contrasts sharply with the insecure, self-disparaging person who emerges from his letters. Writing to Charles, his accomplished oldest brother, Pollock confessed to being "doubtful of any ability." He went on to offer a devastating appraisal of his earliest artwork: "my drawing i will tell you frankly is rotten it seems to lack freedom and rythem it is cold and lifeless. it isn't worth the postage to send it." While the asperity of these comments is surely related to Pollock's sense of unworthiness in the shadow of his older brother, his harsh self-criticism was not entirely unjustified. None of his high school drawings survives, but it may be said on the basis of later work that by no means was Pollock a precocious draftsman. As his brother Sande once said, "If you had seen his early work you'd have said he should go into tennis, or plumbing."

Whatever Pollock lacked in facility, however, he made up for in vision. It is rather extraordinary that in his first written appraisal of his artwork he should have faulted his drawing for lacking "freedom and rythem," qualities he considered important, if not the essence of drawing. While most students were trying to master perspective and learn how to draw a realistic likeness of a face, a hand, or a bowl of fruit, Pollock had no patience for such details. The rules of art ran against his instincts. Already he was seeking "freedom" from formal conventions, sacrificing detail to the whole. He could not achieve what he wanted; on the other hand, he fully intended to. "i think there should be an advancement soon if it is ever to come," he noted to Charles with characteristic self-disparagement, "and then i will send you some drawings."

At school Pollock felt uncomfortable among his peers. People "frightened and bored" him, he wrote, forcing him to remain within his "shell." But for all his timidity, Pollock had no difficulty befriending—and at times alienating—his fellow students in Schwankovsky's class. Philip Goldstein, a dark, angular, intense young artist who worshiped Piero della Francesca, would later

become well known as Philip Guston. He and Pollock spent many afternoons at the home of Manuel Tolegian, an affable, powerfully built youth of Armenian descent, who had converted a chicken coop behind his house into a studio for himself and his friends. Together, working in the dark, cramped, low-roofed studio, the three boys would pick out reproductions from their favorite art books and spend long hours copying the pictures. Both Guston and Tolegian had a natural talent for drawing; the studio walls, covered with pencil sketches after Uccello and Piero, offered testimony to their ability. Pollock's work, by comparison, was noticeably undistinguished. But no matter how frustrated he may have felt, he was unwilling to admit to his classmates that he considered his work lacking. To the contrary, Pollock would criticize his friends' work. "You think that's original?" he used to say, eyeing his schoolmates' copies of Renaissance masters. "What's so original about that?" Though Guston tended to ignore these boyish displays, Tolegian would become furious, reminding Pollock in his deep, booming voice that to be a great artist one first had to master anatomy, linear perspective, and so on. Pollock apparently delighted in rousing his friend to anger. He signed Tolegian's yearbook "For more and better arguments. Hugo Pollock."

Pollock preferred sculpting to painting or drawing. He and his friends sometimes visited a quarry near the Los Angeles River, where they purchased blocks of limestone and sandstone for carving. Pollock, who stored his materials in Tolegian's backyard, soon accumulated a huge pile of stones, much to the dismay of Tolegian's mother. Whenever she spotted Pollock arriving at her house with another block of stone, she would run to the back door and scream in her native Armenian, "What has this crazy man brought to my backyard?" With a chisel and a hammer Pollock chipped away at one block after another, and on weekend afternoons the backyard studio would reverberate with the sounds of his labors—the chime of the hammer as it struck the chisel, the plink-plink-plink of the chips as they splintered from the stone. His friends felt sorry for him, thinking he was no better at sculpture than at drawing. Nonetheless they recognized the

pleasure he took in carving. Tolegian described Pollock as "more at ease with a rock than a human being."

In his groping efforts at self-understanding, Pollock looked to Schwankovsky not only for artistic guidance but spiritual guidance as well. His teacher was a friend and follower of the noted Hindu philosopher Jeddu Krishnamurti, who, in the spring of 1928, had visited Los Angeles and founded a camp in the Ojai Valley, eighty miles north of the city. Schwankovsky, immediately impressed by the Hindu's ideas, asked him to give a talk to his students, and one Saturday afternoon, amid predictable controversy, the "world teacher" visited Manual Arts. For Pollock, who had never attended church in his youth or practiced any religion, theosophy was a virtual epiphany. With marked enthusiasm, he visited Ojai, read theosophical tracts, and shared his findings with his father, who, a month after school began, assured him, "I think your philosophy on religion is O.K." It is not difficult to understand Pollock's identification with Krishnamurti, a gentle, sensitive heretic who, according to his writings, had been unhappy in his youth and determined to find a goal, any goal, to which he could devote himself completely. His teachings, a paean to individual rebellion, confirmed a precept that Pollock had divined on his own: the moment you follow someone else, you cease to be your own leader. Appropriately, then, a year after starting school Pollock tired of following Krishnamurti, bluntly informing his brothers, "I have dropped religion for the present."

Early in 1929, during his second semester of school, Pollock joined Guston, Tolegian, and several others in his art class in the publication of a newsletter. *The Journal of Liberty* was flagrantly subversive, exhorting the student body to "awake and use your strength." Though issued only twice and consisting of a single mimeographed page, the *Journal* acquired impressive notoriety after attacking the school's sacrosanct department of physical education. In an unsigned editorial the students protested the school's emphasis on athletics and proposed, rather imaginatively, that varsity letters be awarded to "our scholars, our artists, our musicians instead of animated examples of physical prowess." Pollock, one of the founders of the newsletter, attended all

the meetings and made every effort to contribute suggestions, though it was hard for him to talk in a group. As he confided to Charles about one occasion when he ventured a comment, "I was so frightened I could not think logically."

One morning, a few hours before school began, Pollock and his friends sneaked into Manual Arts to distribute *The Journal of Liberty* throughout the building. They were slipping some copies under a classroom door when a janitor caught sight of them and started chasing the boys down the hall. He managed to catch Pollock, whom he reprimanded for trespassing. The following day Schwankovsky's class was interrupted by a visit from the janitor along with the school principal. A hush fell over the classroom as the janitor pointed to Pollock, singling him out as the student responsible for distributing the *Journal* on school grounds, a violation of policy. As Pollock was led from the classroom, his fellow revolutionaries remained curiously silent. "I wanted to graduate!" Tolegian explained. Pollock was suspended from school for the remainder of the year.

Guston eventually confessed to being the editor in chief of *The Journal of Liberty*, and he too was suspended from school. Unlike Pollock, he would never return to Manual Arts. He soon found work in the movie industry; in *Trilby*, starring John Barrymore, he played an artist, with a beret and a pasted-on beard. He continued his studies at the Otis Art School, where, on the basis of his talent, he was awarded a full scholarship. For Pollock, by comparison, it was a discouraging, unproductive time. It did not occur to him to apply to any art schools, for he had hardly found his bearings at Manual Arts. He very much wanted to return to school, and, accompanied by his mother, visited the principal to apologize for his behavior and request that he be readmitted. His mother asked if he could at least attend Schwankovsky's class, but to no avail. Pollock spent the remainder of the school year at home.

Pollock continued to see his friends from school, particularly Guston, who, though no longer editor of *The Journal of Liberty*, still managed to involve his friends in radical causes. He took Pollock to meetings at the Brooklyn Avenue Jewish Community

Center, in East Los Angeles, where aging Bolsheviks, most of whom spoke only Russian and Yiddish, tried to convert the boys to communism. Although Pollock had no interest in joining the Communist party, he developed a genuine appreciation for the revolutionary art the party was promoting. Lectures were given on the Mexican mural movement, and Pollock learned of Diego Rivera. "I certainly admire his work," Pollock wrote to his brothers, adding that he had managed to obtain a back issue of an art magazine containing pictures of Rivera's work. Though Rivera and his compatriots Orozco and Siqueiros had not yet painted any murals in the United States, the triumverate was rapidly becoming known outside Mexico for having inaugurated the most dynamic revival of fresco painting since the Renaissance. Compared to Los Angeles, whose art scene was dominated by the California Watercolor Society and the Western Painters Association, Mexico seemed to Pollock and his friends like Parnassus itself. "I have thought of going to Mexico city if there is any means of making a livelihood there," Pollock noted in a moment of daydreaming, an idea he soon abandoned for more practical plans.

After spending the summer in Santa Ynez, California, working beside his father on a surveying crew, Pollock returned to Manual Arts in September 1929—only to be suspended the following month. He was "ousted" from school, as he put it, after he "came to blows" with a gym teacher, presumably over his involvement with *The Journal of Liberty*. Convinced that he had been wronged, Pollock appealed to the principal for help, but the principal reprimanded him for arguing with the gym teacher and ordered him to "get out and find another school." Pollock didn't bother to protest the principal's decision, resigning himself to his hopeless reputation as "a rotten rebel from Russia."

With Schwankovsky's help Pollock was able to return to Manual Arts on a part-time basis the following semester. He signed up for two courses, drawing and clay modeling, only to find that he was no longer capable of summoning up enthusiasm for his studies. He felt discouraged and defeated, confiding to Charles, three days after his eighteenth birthday, that "although i feel i will make an artist of some kind i have never proven to my-

self nor any body else that i have it in me." Pollock's writing style, like his art, reveals a restless imagination. He was inattentive to detail, ignoring grammar, punctuation, and spelling while managing to express himself with undeniable force. His letter to Charles continues: "This so called happy part of one's life is to me a bit of damnable hell if i could come to some conclusion about my self and life perhaps there i could see something to work for. my mind blazes up with some illusion for a couple of weeks then it smoalters down to a bit of nothing the more i read and the more i think i am thinking the darker things become."

On Saturday nights that winter Pollock often joined his friends from school at the home of a flutist named Ora Pacifico, a recent graduate of Manual Arts. Ora, a sociable young woman, was known at school for her "musical jams," small, serious, high-minded affairs at which a group of young musicians performed a medley of classical pieces and Gershwin compositions for an audience consisting of "the artsy kids at school," according to one participant. It was at one of these concerts that Pollock first met Berthe Pacifico, Ora's younger sister, whom he immediately admired. An aspiring concert pianist, Berthe usually played the piano at the "jams" and sang as well, in a clear mezzo-soprano voice. She was an outgoing, strong-willed seventeen-year-old with a petite frame, fine, birdlike features, and radiant black hair that fell to her waist.

For all his shyness Pollock had no difficulty in winning Berthe's affection, much to the amusement of his friends. As Tolegian once remarked, with an edge of understandable envy, "He was extremely shy, so if he smiled at a girl or was open with her, she thought it was a big thing." Indeed, Berthe was quickly taken with Pollock's "beautiful smile" as well as his gentle but obvious adoration of her, recalling many years later the sight of him standing by the piano listening to her play, "happy as a little kid."

Exhilarated by Berthe's interest in him, Pollock pursued her energetically, stopping by her house at all hours of the day. Her family lived only two blocks away, on Forty-first Street, and Pollock liked to sneak in the back door and surprise her. "Jackson!"

she would exclaim as he sat down beside her on the piano bench and put his arm around her. "I didn't even hear you come in." Berthe usually told him to come back a few hours later, after she had finished practicing, but Pollock was insuppressible. "I'll just sit quietly in the corner," he'd say, though Berthe knew from experience that sitting quietly was not one of his talents. As she practiced, Pollock would horse around, waltzing about the living room by himself or singing along with the music in a voice Berthe described as "the lousiest." Berthe's mother thought he was charming and would sometimes dance with him in the living room. In the meantime Berthe practiced and practiced, determined to win a scholarship to music school. She considered herself artistic by nature and took great pride in the Spanish Jews from whom she was descended, including a court-appointed portrait painter for King Ferdinand and Queen Isabella of Spain. It never occurred to her that her boyfriend might be more talented than she was. Whenever Berthe suggested to Pollock that he show her his artwork, he was dismissive. "He felt he wasn't doing anything worthwhile," she recalled.

One day Pollock surprised her by asking if he could sketch her hair—not her face, not Berthe at the piano, simply her hair. Laughing at the apparent absurdity of his request, she agreed to indulge him. She sat down in a chair, and Pollock sat down behind her. He asked her to tilt her head backward and to shake her head gently so that her long black hair swirled freely. Working in pencil, Pollock sketched her swirling hair, an exercise that freed him from formal restrictions and that, unlike most other undertakings, he had no difficulty completing. After that it was always the same: Pollock would ask Berthe to make her hair swirl, and Berthe, though complaining that it made her neck hurt, would agree to do it anyway, all the while laughing and telling her boyfriend, "You're crazy!"

In June 1930 the three older Pollock boys returned from New York for the summer, and for Jackson it was an eventful time. Frank, who was studying literature at Columbia and working part time in the school's law library, had lots of stories about life in the city. The previous October, Frank had been standing in the hall

of his dormitory, with a towel around his waist, when someone ran down the corridor shouting that the market had crashed. "What market?" Frank asked. "The stock market!" the boy exclaimed. "Where's that?" Frank asked. "On Wall Street!" the boy said. "Where the hell is Wall Street?"

Charles, who was still studying at the Art Students League, would sit around the house making charcoal portraits of his brothers. His presence lent the household an air of purposefulness and encouraged Jackson to take himself more seriously. One day he and Charles visited Pomona College, in Claremont, to see a new mural by José Orozco, an experience of lasting consequence. On the far wall of the college's dining room was the twenty-foot-high figure of Prometheus, his massive arms plunged into flames. Orozco's *Prometheus,* rendered in a style based on the ancient cubism of the Aztecs and Toltecs, offered Pollock his first intimations of the power inherent in mural painting, if not in painting itself. He returned to the college several times that summer and was very interested in hearing his brother's stories about Orozco, whom Charles had actually met. That summer, Jackson learned, Orozco was painting frescoes at a college in New York along with a second muralist whose name Jackson also knew—Thomas Hart Benton, a Missouri painter, who, by coincidence, was Charles's teacher at the Art Students League. For Pollock, to see the work of Orozco and hear his brother's firsthand accounts of the New York art scene was to be initiated into a world much larger than the one he had known, and Manual Arts and his high school experiences suddenly seemed much less interesting.

One afternoon that summer Charles told Jackson that there was no point in his returning to Manual Arts in the fall. He'd be better off, Charles thought, accompanying his brothers back to New York and enrolling at the Art Students League. Pollock didn't have to be persuaded. He ran over to Berthe's house and announced to his girlfriend that, one, he was going to New York to become an artist, and, two, Berthe was coming with him. He had it all planned. They could live in Greenwich Village and Berthe could go to music school. "You're so naïve," Berthe said,

reminding him that he was eighteen years old, had not yet graduated from high school, and had no means of support other than his parents. Berthe fully intended to stay in Los Angeles and continue with her music. Pollock, disappointed by her answer, suddenly reconsidered the idea of moving. "I don't know which way to go," he told Berthe, a lament he repeated to her many times that summer. In his imagination, however, he was far less uncertain. As he later told his friend Tony Smith, he went to New York "to sculpt like Michelangelo."

3 Art Students League

1930-33

In September 1930 Pollock enrolled at the Art Students League of New York, a prestigious but unorthodox school sharing little in spirit with its palatial Renaissance-style building on West Fifty-seventh Street. The League in the thirties was a willfully informal institution; it issued no grades, kept no attendance records, and prescribed no course of study. Students were allowed to pick their own teachers, and for Pollock the choice was easy. Following the example of his brother Charles, he signed up to study under Thomas Hart Benton, a short, pugnacious, tobacco-chewing Missourian known as a leader of American Scene painting. His class met weekday nights from seven to ten, on the top floor of the school in a spacious studio with wood plank floors and a high pressed-tin ceiling. Among the few rules the League observed was that teachers give criticisms of their students' work twice a week. On Tuesday and Thursday nights Benton would run up the five flights, stick his head in the doorway, and shout in a gruff voice, "Anyone need me? Anyone need criticism?" If no one an-

swered, he ran down the stairs. Although Benton wasn't much of a teacher, Pollock conceived an immense admiration for him the moment he started school, and Benton, for his part, felt an "immediate sympathy" for Charles's kid brother. Many years later Pollock told an interviewer, "I'm damn grateful to Tom. He drove his kind of realism at me so hard I bounced right into nonobjective painting." It was a peculiar tribute to a man who in fact dominated the next eight years of Pollock's life.

On the surface Pollock could not have picked a more unlikely mentor than Benton, a sworn enemy of abstract painting. Born in the Ozark town of Neosho, Missouri, in 1889, he was the son of a congressman and the great-nephew of U.S. Senator Thomas Hart Benton, a feisty champion of Jacksonian democracy. As a child Benton had been discouraged by his parents from pursuing a career in art; they were afraid that such a profession might one day lead their eldest son to resemble the effeminate "scented dudes" they had known in Washington society. While defying his family's wishes by becoming a painter, Benton upheld its traditions in his art. An ardent populist, he believed that art should appeal to the man on the street. A patriot as well, he was determined to secure for American painting the prestige and prominence accorded the art of Europe. A zealous crusader, he truly believed in the power of his pictures to win wars, battle unemployment, and help the country fulfill its national destiny.

In 1908, after dropping out of high school, Benton went to Paris to study art. "What the hell," he once declared, "there wasn't any art in America." Like many other American artists, he drank at the Café du Dôme, saw the works of the French Impressionists at the Durand-Ruel Gallery, and learned about Cubism at the Académie Julian, a mecca for Americans abroad. He experimented with Synchromism, an American variation on Cubism founded in part by his friend Stanton Macdonald-Wright. But he quickly grew disillusioned. While other Americans in Paris were converting to abstract painting, Benton conducted himself like a foreign spy, quietly collecting evidence for the case he would soon launch against modern art. "It is absurd," he once said, "to stick a Cézanne water-color in the face of an average intelligent

JACKSON POLLOCK

American citizen and expect him to find much in it. The same goes for a Braque or a Kandinsky pattern. Most Americans on seeing them will say, 'If that's art, to hell with it.' "

After returning from Europe, Benton settled in New York and set about planning a highly ambitious project: a series of large paintings and Renaissance-style murals that would glorify American history and culture. His timing could not have been better, for the contemporary revival of fresco painting in Mexico had prepared the way for a mural movement in New York. Early in 1930 (a few months before Pollock arrived in New York) Benton received his first mural commission—from the New School for Social Research, which was under construction on West Twelfth Street. The school's director, Alvin Johnson, acting on a suggestion from the critic Lewis Mumford, invited both Benton and Orozco to decorate the walls of the school. Orozco, assigned to the dining room, painted an epic of class struggle that included portraits of Lenin, Gandhi, and the Mexican leader Felipe Carrillo Puerto. The Marxist ideas implicit in his murals caused many of the school's conservative patrons to withdraw their support. Benton's mural, to the contrary, offended the radicals, who, he later wrote, "were mad because I didn't put in Nikolai Lenin as an American prophet."

Entitled *America Today,* Benton's New School murals (which were purchased in 1984 by the Equitable Life Assurance Society and soon after put on permanent display in the lobby of its New York headquarters amid considerable publicity) consist of a series of nine separate panels based on his "sketching trips" across the country. For the previous five summers he had driven around in a Chevrolet truck sketching sharecroppers, prizefighters, burlesque dancers, and the sort of colorful people he believed captured the character of the country. But *America Today* might more suitably be titled *America Yesterday.* Although painted during the Depression, it makes no reference to the five million men out of work, the abandoned factories, or the empty trains stalled between cities. Instead Benton portrayed a country in motion—plowing, sowing, reaping, mining, building, traveling, and dancing, each action accentuated to the point of parody by the

50

bulging musculatures, mannered forms, and swirling rhythms that characterize Benton's style. For one brief moment when the country was on the verge of collapse, Benton offered reassurance that America's pioneer spirit could rescue it from the Depression. Conservatives applauded him, radicals lambasted him, and establishment critics began urging American painters to follow Benton's example and "sing in their native voices." Benton was forty-one years old when he finished the murals. Along with Grant Wood and John Steuart Curry, he was suddenly famous as a leader of Regionalist painting, and so assured was his reputation that, as he put it himself, "I improved my brand of whiskey."

Pollock arrived in New York in time to watch Benton complete his last three months of work on the New School murals. Pollock had great enthusiasm for the project, and almost every afternoon visited a loft around the corner from the school, where he could expect to find his teacher at work. (Among the ironies of Benton's career is that he never touched a brush to a wall; he painted the New School murals on movable panels.) There was always something that needed to be done, and Pollock quickly made himself indispensable. Often he "action posed," which means that he was asked to assume certain positions—tilt his head a certain way or look in a certain direction or raise his arm to a certain height—so that Benton could get the details right. When Benton didn't need a model, Pollock managed to make himself useful in other ways, eagerly volunteering to mix egg-tempera paints, wash out brushes, or even sweep the floor. Occasionally Benton would slip him a dollar bill, insisting that he deserved it for all his help. But watching Benton work was reward enough for Pollock. "Benton is beginning to be recognized as the fore most American painter today," Pollock boasted to his father sometime later. "He has lifted art from the stuffy studio into the world and happenings about him, which has a common meaning to the masses."

To his schoolmates Pollock was a solitary dreamer, clearly absorbed by Benton's teachings but too unsure of himself to try to accomplish anything on his own. No one ever thought he would be famous; to the contrary, many of his classmates felt

sorry for him. By now he was a tall, rangy youth, with unruly blond hair that fell in his eyes and a round-shouldered posture that suggested to many a lack of confidence. He shuffled his feet when he walked. People considered him shy, aloof, and somewhat threatening. In conversation he often seemed distracted but then suddenly would "give you a quick look as if to see whether he'd punch you in the nose or not," according to his schoolmate Reggie Wilson. The painter Will Barnet recalls him as "hurrying down the corridor with an angry scowl on his face." Pollock tended to make a better impression on women, around whom he retired his combative stance. Such classmates as Frances Avery and Yvonne Pène du Bois, whose father taught at the League, remember him in terms of his sweet smile, his gentle, self-effacing manner, and his threadbare clothes. Avery once invited him to her family's home for a Sunday-night dinner of roast chicken. He didn't say a word throughout the meal. After he left, Avery's mother wondered aloud, "Why couldn't that nice young man come to dinner without wearing overalls?"

Benton's course, "Life Composition, Painting and Drawing," met weekday nights in Studio 9. On most nights the dozen or so students in the class would pull up wooden stools and spend the three-hour sessions sketching from a life model. Benton taught them to draw the human figure according to his "hollow and bump" method, concentrating on muscles rather than surface detail. Pollock worked hard at the assignments but knew from the beginning that life drawing would never be his forte. Rather than stimulating him, the technical demands of his craft only frustrated him. Yvonne Pène du Bois remembers the sight of him hunched over his sketch board, struggling. "He couldn't draw," she said, "and he knew he couldn't draw, and I think it made him miserable." The painter Joe Delaney recalls Pollock's "jittery hands," as if even the task of holding a stick of charcoal set him on edge. Benton recognized from the outset that Pollock had little in common with his brother Charles, the perennial star pupil of every art class. Jackson's abilities, he later wrote, "seemed to be of a most minimal order."

Besides drawing from the figure, Benton also had his stu-

dents "analyze" reproductions of late Renaissance and Baroque paintings, breaking down the images into cubes, volumes, and linear movements. For Pollock, who had an intuitive sense of rhythm, the analytical exercises proved much less difficult than drawing from life. As Benton later wrote, "He got things out of proportion but found their essential rhythms."

Judging from his letters to his parents, Pollock felt satisfied with his progress at the League, however unpromising he may have seemed to his classmates. He accepted his limitations with remarkable equanimity, recognizing from the start that art was a process of evolution—not revolution—that would require of him a lifetime of hard work. "A good seventy years more," he joked to his father, "and I think I'll make a good artist." Writing to his mother, he confided with self-insight, "I have much to learn tecnequelly yet. I am interested and like it which is the main thing." Under Benton's influence he had finally acquired a sense of direction; for the moment that was enough. For the first time in his life he was "doing every thing with a definite purpose—with out a purpose for each move—thers chaos."

His first year at the League, Pollock lived with his brother Charles in a fifth-floor walk-up at 46 Union Square. The apartment, which had previously belonged to Benton, looked out on Union Square Park, a grassy patch on Fourteenth Street known as the place to talk about radical politics. The two brothers set up their easels in the living room, leaving neither with any privacy and exacerbating what was already a strained living situation. Although Charles had found a part-time job as an elementary-school art teacher, he worked only one day a week and spent most of his time painting at home. For Jackson, who attended school at night and was free during the day, it was difficult to work in his brother's presence. He couldn't concentrate on so much as a single sketch with Charles standing across from him dashing off drawings with obvious confidence and ease, reminding him of his mediocrity.

Charles tried his hardest to encourage Jackson, recognizing that his brother had a low opinion of his abilities. But Jackson resisted his help. He refused to show Charles his paintings, and in-

stead of hanging them up, used to turn them against the wall. Equally dissatisfied with his sketches, he developed an unfortunate habit of ripping them up. Charles would try to salvage them, collecting the scraps, placing them in a drawer and assuring his brother that his work was worth saving. But it was inconceivable to Pollock that his early work might ever be of interest; he didn't even bother to sign or date his paintings.

Such self-effacing behavior could alternate unpredictably with hostile outbursts. One night a few friends were gathered at the apartment when Jackson, who had been drinking, picked up a hatchet and started swinging it above his head. "He was trying to impress the girls," recalled Marie Levitt, his future sister-in-law. The girls started laughing, but Charles knew better. "Put that down," he ordered. Jackson continued to swing the hatchet, swiping a small oil painting that was hanging on the wall. He slashed his brother's painting in half.

Prohibition was still in force, and Pollock rarely drank during his student days. But drinking made him so destructive that he quickly acquired a reputation at school as a troubled youth. One night the League administration planned a moonlight sail for students, renting a large touring boat that cruised the Hudson River. Pollock, drunk on gin, started racing around the boat, removing light bulbs from their sockets and tossing them overboard. The moving boat grew darker, and students started to panic. "I'll go get them," Pollock volunteered good-naturedly as he climbed up on the railing of the boat and prepared to jump into the Hudson. Terrified that he would drown, his classmate Bernard Steffen wrestled him to the ground, dragged him to the boiler room, and locked him in there for the remainder of the boat ride. "When he was drunk, he was always doing some suicidal thing," said the sculptor Nathaniel Kaz, recalling one Saturday night when Lionel Hampton was performing in the League ballroom. Pollock passed out in the middle of the dance floor. To keep people from stepping on him, Kaz and a few others rolled him to the side of the room and shoved him under a bench, where he slept for the night.

For all his troubling behavior, Pollock had no difficulty win-

ning the affection of people who recognized his genuineness. Among his early supporters was Rita Benton, his teacher's wife, a plump, pretty, vivacious brunette of Italian descent. She was known among Benton's students for her Sunday night "spaghetti dinners"—lively, casual gatherings at which the Bentons provided the food and the students brought the drinks. One night that fall the Bentons invited the three Pollock brothers—Charles, Frank, and Jackson, the last of whom Rita had not yet met but had heard about from her husband. Rita was immediately charmed by him. Upon being served his dinner Jackson stared intently at his plate and, without a trace of irony, informed Rita that he had no idea how to eat spaghetti. "As kids we ate chicken and pork," Frank later explained, "not spaghetti!" Rita found this highly amusing and promptly gave Jackson a lesson in how to eat spaghetti with a fork and a spoon. After that Rita made a point of watching out for him, inviting him over for dinner at least once a week and having him baby-sit for T.P., her four-year-old son. One day that winter, when Pollock was sick with the flu, Rita sent biscuits and cream to his apartment. Benton too felt protective toward Pollock. He knew that he suffered from "a sense of ineptitude," a feeling he could empathize with, having been greatly frustrated himself as a young artist.

With Benton's help Pollock began his second semester at the League exempted from the school's twelve-dollar monthly tuition. Benton had managed to secure for him a merit-based scholarship, much to the dismay of his other students. "That fellow couldn't draw!" said Manuel Tolegian, who had just arrived in New York from Los Angeles and, at Pollock's urging, signed up to study under Benton. He was startled to discover that his high school friend had risen to prominence so quickly. For Pollock it was a good term. He grew closer to Benton, who, having recently finished his New School murals, spent most of his evenings in class sketching beside his students. ("I had a model there," he explained, whereas in his studio he couldn't afford to hire one.) Pollock, by comparison, was no longer interested in sketching from life. According to his classmate Frances Avery, he spent most of his time "fooling around" with the techniques of mural

painting under Benton's approving gaze. He was expert at making gesso panels, silky white boards suited for tempera painting. One night the painter Harry Holtzman, who was studying across the hall under George Bridgman, walked into Benton's classroom, noticed what Pollock was doing, and asked him a few questions about the unusual panels. "Pollock volunteered to make me a few," he later recalled, adding that Pollock "tailed after Benton like a puppy dog. Whatever Benton did, he wanted to do too."

To consider Pollock's earliest paintings—less than a dozen survive from his three years at the League—is to recognize his debt to Benton. Like his teacher, he painted in the Regionalist vein, depicting horse plowers, wheat threshers, and other agrarian subjects; not a single scene of New York City survives among his works. A small painting that has been catalogued as *Camp with Oil Rig* (*Fig. 1*) is a somber, mud-colored, Regionalist-style landscape showing a tall brown derrick, a couple of gray shacks, and two crooked poles for a clothesline. The sky swirls and the ground sways in a "hollow and bump" style reminiscent of Benton. But *Camp with Oil Rig* has nothing in common with the upbeat, flag-waving spirit of American Scene painting. Pollock has painted a melancholy scene. The workers are nowhere in sight, the shacks look closed up, a lone shirt flaps on the clothesline. One senses in this painting Pollock's obvious restlessness with the rhetoric of Regionalist art. Already he was striving for something more personal.

As much as he admired Benton, Pollock was incapable of submitting wholeheartedly to any one style or tradition. In his need to escape the political art of the thirties, he turned to the example of Albert Pinkham Ryder (1847–1917), whose work he would have seen at the Ferargil Gallery, where Benton also exhibited. ("The only American master who interests me is Ryder," Pollock boldly told an interviewer a decade later.) It is not difficult to understand his interest in Ryder, a solitary eccentric who for most of his years lived in a cramped garret on Eleventh Street, dressed in tattered rags, and personified the image of the romantic artist. He was well known in the thirties for his lunar seascapes

and nocturnal pastorals, haunting, poetic works that are the very antithesis of Benton's graphic, illustrative realism.

It is possible to discern Ryder's influence in Pollock's *Self-Portrait* (*Fig. 2*), one of his earliest known works. (He painted it on a gesso panel.) This small, eerie painting, like Ryder's own *Self-Portrait,* shows a crudely rendered head modeled in reddish pigments and heavily veiled in shadow. The similarities end there. Pollock's *Self-Portrait* is an unsettling work in which he depicts himself as a frightened little boy, his eyes wide with terror.

Like most young artists, Pollock didn't hesitate to copy the painters he admired. He unabashedly stole whatever images interested him, while translating them into an idiom of his own. Most of his early paintings consist of subject matter taken from Ryder—mournful-looking horses, solitary riders, ghostly little boats—transposed into rhythmic, swirling landscapes reminiscent of Benton. *Going West* (*Fig. 3*), one of Pollock's finest early paintings, is a spooky, moonlit landscape that shows a man in a broad-brimmed hat driving a team of mules and two wagons along a mountain road. The subject matter bears an unmistakable likeness to Ryder's *Sentimental Journey* (*Fig. 4*). But other aspects of the painting—the glowing yellow moon and the swirling halo encapsulating the scene—evoke Benton's *Moonlight Over South Beach* (*Fig. 5*), one of his most uncharacteristic works. That the Benton painting is a seascape did not deter Pollock from putting it to use in a western scene: a swirling body of water is transformed into whirling mountains. More important, Pollock did away with Benton's horizon line, melding earth and sky together in circular motion. Already he was striving for compositional wholeness, as if seeking in his art the kind of completeness he rarely knew in his life. Derivative as *Going West* is, it possesses an undeniable originality and is a good example of Pollock's talent for fusing disparate influences into a harmonious creation of his own.

Pollock did not make preparatory drawings for any of his paintings. This was somewhat unusual, as the customary practice in art school was to undertake a painting only after one had

planned it out in a series of drawings. But Pollock had no patience for the long, technical process by which a charcoal sketch is developed into a finished painting and did away with it. He apparently started his canvases with only a vague idea of how they would develop and figured it out as he went along.

———

In June 1931, after completing their first year at the League, Pollock and Tolegian planned a "sketching trip" across the country. Encouraged by their teacher and his fabled sojourns in the American heartland, they came up with the idea of hitchhiking home to Los Angeles and collecting "local color" as they traveled. Their goal was to amass enough raw material to fuel them with painting ideas at least until the end of the next school year.

No sooner had Pollock and Tolegian set out than they realized their plans would have to be changed. The highways outside the city were packed with homeless, unemployed men, and almost no one was offering rides for fear of being robbed. So much for their leisurely sketching trip. They ended up hopping freight trains from state to state, an adventure that Pollock took to with the ease of a veteran hobo. One day in Indianapolis the two boys were chasing a train when Tolegian started to slow down. "Run faster!" Pollock yelled, but his friend couldn't keep up. Pollock hopped aboard by himself and made the rest of the trip on his own. "My trip was a peach," he wrote a few weeks later. "I got a number of kicks in the but and put in jail twice with days of hunger—but what a worthwhile experience." The life of a hobo held a wondrous appeal for him, and it did not dampen his enthusiasm to discover that the interior of America bore little resemblance to the upbeat place depicted in Benton's murals. Poverty was everywhere. "The miners and prostitutes in Terre Haute," he wrote, ". . . their both starving—working for a quarter—digging their graves." Pollock labeled these instances of hardship "swell color," innocently parodying his teacher's ideas.

Three weeks after setting out, Pollock arrived home in Los Angeles bubbling over with tales about his trip. His parents, who by then had reconciled, were horrified to learn of his adventures

on the railroad. "I would have been worried sick," his mother wrote, "if I knew he had been bumming the freight train. He sure took lots of chances of getting killed or crippled for life. But he is here safe & I am sure glad."

Pollock spent the summer in Wrightwood, California, a mountain resort in the Angeles National Forest, where his father had rented a log cabin. Along with Tolegian, who had made the trip west in a mere nine days, he was able to find a job as a lumberjack. Every morning at dawn Tolegian picked up Pollock in an old, battered Ford and headed up a mountain path to the Cajon Pass, where the two young artists cut down trees, cleared away brush, and made way for a planned road. It was "sure hard work," according to Jackson's mother, "but better than nothing they just cut it down and trim it up so isn't as hard as cutting into stove wood. Can't cut very fast until they get used to hard work again and cools off a little, has been very hot."

One evening the boys were driving down the mountain path when they got into an argument. Tolegian told Pollock he was no good at working on a team: he pushed on the dragsaw when he was supposed to pull and pulled when he was supposed to push. "That's all I had to say," Tolegian later recalled. Pollock, enraged by this bit of criticism, pressed his saw against his friend's throat and raised it slowly, forcing Tolegian to lift his chin until he could barely see the road. When Tolegian let go of the wheel for a moment to try to grab the saw from Pollock's hand, the car swerved into the mountainside and was wrecked.

With the approach of fall Pollock contemplated his return to New York with anxious reluctance. He had hoped to work at his drawing that summer, but somehow the months had slipped away from him. He had also hoped to save up some money, but there was "damned little left" from his lumberjack job. Writing to Charles in a dejected mood, he questioned the point of returning to the League when "more and more I realize I'm sadly in need of some method of making a living." His mother had told him not to worry about money, for she was perfectly willing to help him out financially until he finished his schooling. "You're entitled to it," she often said, reminding him that his education was a necessary

part of his training as an artist. But Jackson could tell that his father thought otherwise. "Dad still has difficulties in loosing money—and thinks I'm just a bum—while mother still holds the old love."

———

For all his worries about his future Pollock returned to New York in the fall of 1931 eager to begin his second year at the League. Benton had managed to get him a part-time job in the school lunchroom, easing any financial pressures while conferring further legitimacy on his studies. Mornings Pollock studied under Benton. Afternoons he worked in the lunchroom, clearing tables, sweeping the floor, and quickly establishing himself among dozens of schoolmates as Benton's most ardent champion.

The lunchroom of the League was a popular artists' hangout, dominated by the figure of Arshile Gorky, an imposing, melodramatic Armenian-born painter who seldom came to school without his two Russian bloodhounds. Gorky worshiped the School of Paris and was already painting abstractly. His rivals accused him of copying Picasso, which invariably prompted Gorky to remark in his booming voice, "Has there in six centuries been a better art than Cubism? No!" Although Gorky never actually studied at the League, he could be found in the lunchroom most any afternoon with his friend Stuart Davis, who taught on the faculty. Davis had recently pioneered an Americanized version of Cubism in his *Egg Beater* series, four works based on fragmented images of a rotary egg beater, a rubber glove, and an electric fan, which he had nailed to a table in his studio and had used as his sole subject matter for an entire year. "That lunchroom was crazy," the sculptor Philip Pavia once said. "On one side you had Gorky and Stuart Davis, and on the other side you had the Jackson and the Benton crowd."

One day in the lunchroom Pollock overheard Gorky bragging to a group of students that he could probably convince Matisse to give a lecture at the League during his next visit to the United States. As other students listened in awe, Pollock walked

over to the table and angrily blurted out, "What do we need those Europeans for?" Gorky became furious and started screaming at him, "Where do you think the Renaissance came from?" Pollock sided with Benton on every issue, no matter how narrow his teacher's ideas. A major controversy erupted at the League after Benton learned that the school planned to hire the well-known German painters Hans Hofmann and George Grosz. Benton believed that a Depression-ravaged country should not be offering jobs to foreigners, an opinion Pollock adopted as his own and was more than willing to defend. "Pollock was posing as an artist," said his classmate Whitney Darrow, Jr., later a cartoonist for *The New Yorker*, "not with a beret, goatee, and flowing tie, but as an antieffete type, a rough American artist, based on what he had learned from Benton."

Pollock defended Benton's ideas not only in the lunchroom but privately as well. In long, rambling letters to his parents, invariably mailed after weeks of delay, he spoke proudly of his teacher and offered unequivocal endorsement of his ideas. Writing to his mother during his second year at school, Pollock asked her whether his brother Sande, who was still living in Los Angeles, had "heard Thomas Craven lecture there or not—he should have. I meant to write him about it, he is one critic who has intelligence and a thorough knowledge of the history of art. I heard that he was made quite a joke there which is not unlikely for the element of painters found out there." Thomas Craven, a tall, natty, acerbic art critic, was a close friend of Benton's and the leading champion of American Scene painting. He hated the French avant-garde, arguing in articles and books that such artists as Matisse and Brancusi produced meaningless decoration that was destined for obscurity since no one could understand it. Pollock could not have picked a more small-minded critic to admire. Many years later Craven would say of his onetime supporter: "All Pollock does is drink a gallon of paint, stand on a ladder and urinate."

In spite of his allegiance to Benton, Pollock's aspirations were not nearly as clear-cut as many of his schoolmates believed. In moments of daydreaming he still thought about becoming a

sculptor. Then again, he was also interested in mural painting. Either way, he had made a crucial decision: somehow he was going to become a great artist, willing himself into what he knew he already was. "And when I say artist," he wrote to his father, "I don't mean it in the narrow sense of the word—but the man who is building things—creating molding the earth—whether it be the plains of the west—or the iron ore of Penn. Its all a big game of construction—some with a brush—some with a shovel—some choose a pen . . . Sculptoring I think tho is my medium. I'll never be satisfied until I'm able to mould a mountain of stone, with the aid of a jack hammer, to fit my will." (At the time, sculptor Gutzon Borglum was carving his famous memorial on the face of Mount Rushmore, a project that received wide coverage in the New York newspapers and that Pollock must have been familiar with.)

Pollock's grandiose ambitions were in glaring contrast to his accomplishments. The most he could hope for at the time was that Benton might make him class monitor, a position he had applied for but felt "doubtful about getting."

In October 1932, after spending another summer in California, Pollock began his third year at the League. He was now living at 46 Carmine Street ("a happy Italian street") and, much to his satisfaction, could claim the distinction of being class monitor. His main responsibilities were hiring the models for class and assisting Benton with teaching demonstrations, in exchange for which he was exempted from having to pay tuition. He was highly conscientious in his duties, especially when compared to his teacher. One night when Benton failed to show up for class, someone started shouting, "What the hell are we paying for?" As others joined in the protest, Pollock left the classroom and returned an hour or so later with Benton in tow. On another occasion, Peter Busa complained to Pollock that Benton had yet to offer any criticism of his work. "You wait," Pollock reassured him. "When he comes through that door, he'll be right over to you."

That December, Benton was thrust into the limelight again with the unveiling of his series of murals for the Whitney Museum of American Art. Pollock had helped him install them—

they were hung in the museum's reading room—and lending to the excitement was the fact that the museum had opened only one month earlier, at 10 West Eighth Street. The Whitney murals, which continued the themes set forth in the New School murals, were no less controversial. *The New York Times* called the project a "conspicuous success," while Paul Rosenfeld of the *New Republic* found it so offensive he dubbed the room "the ex-reading room." A few days after the Whitney murals went on view, Benton was offered his largest commission yet: the chance to paint the history of Indiana for the Indiana Pavilion at the 1933 Chicago World's Fair. Ignoring his teaching duties at the League, he promptly set off for Indianapolis, not to return to New York until the following fall.

When Benton left, his class was taken over by John Sloan, a tall, dapper, sixtyish painter who was one of the founders of the so-called Ashcan school. His own work was highly realistic, a tendency he encouraged in the work of his students as well. For Pollock, who was long past the point of submitting to the rigors of realistic drawing, Sloan held little appeal. "We have a substitute," he reported to his father, "who I think little of, and I probably won't stay with him for long." He dropped out of the class in less than a month—and never studied painting in school again.

With Benton off in Indiana, Pollock decided to devote himself to sculpture. He was primarily interested in stone and mentioned to his parents that he was thinking of working in a quarry or a tombstone factory to learn "something about stone and the cutting of it." Although these plans never materialized—"I'm about as helpless as a kitten when it comes to getting my way with jobs and things"—Pollock did sign up for a couple of courses in sculpture. For two months he studied under Robert Laurent, who was born in Brittany and well known in the thirties for his voluptuous nudes. His class at the League met at night. Pollock also signed up for a morning class at Greenwich House, a settlement house near Sheridan Square that offered free classes in art and music.

Pollock's teacher at Greenwich House was Ahron Ben-Shmuel, a gruff, belligerent man whose massive carvings in gran-

ite and marble had names like *The Warrior* and *The Pugilist*. Pollock took an immediate liking to him and often stopped by his studio on Jane Street to watch him work. Ben-Shmuel's specialty was stone carving. Rather than have his students make art, he taught them how to shape rough, natural stones into square blocks—how to prepare a stone for sculpting rather than actually sculpt it. "So far I have done nothing but try and flatten a round rock and my hand too," Pollock noted good-naturedly to his father, "but it's great fun and damned hard work." He found it easy to submerge himself in his work, while recognizing that sculpture, with its cold-blooded, mechanical procedures, held none of the possibilities inherent in a single charcoal line. "I like it better than painting—drawing tho is the essence of all."

One Wednesday morning in March 1933 Pollock and his brothers received a telegram from their mother informing them that their father had died. The news was a shock to Jackson. He had known that his father was sick with endocarditis, but no one had told him how serious it was. Only a few weeks earlier he had naïvely sent his father wishes for a hasty recovery. "Well Dad," he had written, "by god its certainly tuff getting laid up. I hope you are better now ... and for heck sake don't worry about money—no one has it."

It was immediately agreed upon by Jackson, Charles, and Frank that they would not attend their father's funeral. They couldn't afford the trip to Los Angeles. Naturally they considered borrowing from friends, but a federal "bank holiday" had been declared that week and depositors had no access to their savings. Stella felt terrible. "I am so sorry you boys could not be at home," she wrote them soon after the funeral, "but knew it was impossible." She went on to offer a moving account of her husband's death. LeRoy had died at home, having joined his wife in Los Angeles a few months earlier. She had set up a bed for him in the dining room so he could look out the windows and see "the snow capped mountains with the beautiful green hills below sunshine fresh air and flowers." The day before LeRoy died was a

Saturday. At ten that morning he listened to a radio broadcast of President Roosevelt's famous inaugural speech ("The only thing we have to fear is fear itself . . ."), which he thought was wonderful. Sunday, after listening to the Tabernacle Choir on the radio, he started to have trouble breathing. A doctor was summoned. The doctor was standing in the doorway when LeRoy looked up at his wife. "Mother," he said, "I don't think I can last till morning." Stella cradled him in her arms and he died.

Contemplating his father's death, Pollock felt a keen sense of remorse. "I always feel I would like to have known Dad better," he confided to his mother, "that I would like to have done something for he and you—many words unspoken—and now he is gone in silence." He had never had a chance to prove himself to his father, and dejectedly he reflected on how little he had accomplished in his twenty-one years. He was still a student, "lazying" about the League, studying sculpture while waiting for Benton to return to New York. Suddenly it seemed to him as if his last three years at school had been spent in idle dreaming, and he vowed to his mother to get on with his career. "I had many things I wanted to do for you and Dad—now I'll do them for you, mother. Quit my dreaming and get them into material action."

A few weeks after his father's death Pollock left the Art Students League and set out in search of "material action." Exactly what he hoped to find he did not say, but the matter was irrelevant anyway. It was three years into the Depression; families were living in Central Park. With his schooling behind him and no prospects ahead, Pollock joined the ranks of the unemployed.

4 Life with the Bentons

1933-35

In September 1933 Benton and Rita returned to New York and moved into an apartment at 10 East Eighth Street, across from the Hotel Brevoort. It was easy to recognize their apartment from the street, for Benton's living room studio was lit with blue bulbs. Through the windows it almost looked like a Regionalist scene: Benton, dressed in work clothes, stooped before his easel, the blue light floating around him like a shining midwestern sky from one of his paintings.

No sooner had the Bentons settled into their new apartment than Pollock resumed his friendship with them. Having finished his schooling but not yet found a job, he took to spending most of his free time at their home. Afternoons, when Rita ran errands and Benton went uptown to the Art Students League to teach, Pollock would baby-sit for T.P., their six-year-old son. By the time Rita returned, Pollock had usually mopped the kitchen floor and cleaned the apartment from top to bottom; he couldn't do enough to please her. "Jackson adored my mother," one of the

Benton's children later said. "And my mother took care of him like a son."

To thank Pollock for his baby-sitting, Rita would have him to dinner a few times a week. Like all the members of the Benton household, he was expected to help with dinner. Carefully choosing an item within his budget, Rita suggested that he contribute to the meals by bringing a turnip. Pollock never failed to show up for dinner without a turnip in his hand.

Pollock got along well with the Bentons' little boy. During their afternoons together T.P. would climb up onto Pollock's lap and ask to be told about their friend Jack Sass, a make-believe hero from the West. In his travels on a stallion Jack Sass had seen all the spooky sights of western folklore—ghost towns, abandoned gold mines, unattended campfires burning through the night. He wasn't afraid of anything.

After Pollock had gone home for the day, T.P. would excitedly relate to his parents the latest adventure of Jack Sass. Benton listened patiently to the stories while thinking to himself that Jack Sass was the hero Pollock would never be. "Jack must have told him some big tales," he later wrote, "perhaps in compensation for his own poor and frustrated conditions. Jack Sass was Jack Pollock without the frustrations."

On the many occasions he ate at the Bentons' house Pollock was unfailingly polite, even on the nights when wine was served with dinner. But stories came back to the family about his "wild behavior" when under the influence, and one night that fall Rita was summoned to St. Vincent's Hospital after Pollock had injured himself in a drunken brawl. He had been returning from a party earlier in the evening when he spotted a wealthy-looking man walking a dog on lower Fifth Avenue. In a mischievous mood, he approached the man, got down on all fours, and petted the dog in a friendly manner but then jumped up suddenly with an angry look on his face. "You son of a bitch," he shouted. "You feed that dog when I'm starving." The man beat him up, and Pollock landed in the hospital suffering from head injuries and charged by the police with battery and assault. Though the charges were dropped, Pollock remained hospitalized for a few days, and it

was Rita who sat by his bedside and nursed him back to health. "My mother talked about that incident all the time," her son T.P. later recalled. "She thought it was horrible. To everyone in my family Jackson seemed so gentle."

Besides stopping by for casual visits, Pollock showed up at the Bentons' every Monday night to play in a band called the Harmonica Rascals. It had been founded by Benton a few years earlier after he had casually picked up a toy harmonica belong to T.P. and tried to play it. With the first few sounds he conceived a new ambition, deciding to collect folk songs on his trips across the country and teach them to his students and friends in New York. Using his own system of musical notation—he referred to the notes of the scale by number—he managed to collect hundreds of folk songs, and it wasn't long before his Monday-night gatherings were attracting some of the best fiddlers and guitar strummers in the city. Among his followers was Charles Seeger, whose son Pete once said that the first time he heard the famous traditional song "John Henry," it was played by Benton on the harmonica, with the elder Seeger accompanying him on the guitar.

For Pollock the main attraction of the Monday-night musicals was listening to Rita play the guitar and sing. He loved watching her perform, and his appreciation of her talents was no doubt heightened by his own ineptitude at singing or playing an instrument. As Benton later wrote, "Jack tried to play the harmonica with us but ran into some kind of 'bloc' about reading or playing the notes." To keep him from dropping out of the band, Benton gave him a Jew's harp, thinking it would be easier for him to play since he wouldn't have to read notes; all he had to do was hum into the instrument and pluck a single string. That too gave him difficulty, but at least he enjoyed it. "[I] can't play a damned thing," he wrote to his family, "but it kinda puts me to sleep at nite and I kinda get a kick out of it." It surely must have pleased him to discover that Benton thought he at least *looked* like a musician: *The Ballad of the Jealous Lover of Lone Green Valley* (*Fig. 6*), which was named after a folk song and exhibited at the Ferargil Gallery that April, includes a portrait of Pollock playing the Jew's harp, his blond bangs hanging in his eyes.

By now Pollock was living at 46 East Eighth Street, on the same block as the Bentons. He shared the fifth-floor apartment with his brother Charles and his brother's future wife, Elizabeth England. As the one who did the cooking and cleaning, Elizabeth came to resent Jackson and often complained to Charles that she failed to understand why he had to live with them. She was embittered by the fact that Jackson didn't have a job and couldn't contribute to household expenses. Sometimes Elizabeth returned home from work to find Jackson lying on his bed, lost in reverie and oblivious to the condition of his room. "Clean up this stinking mess or I'm calling the health department!" she'd scream as Jackson just lay there silently. Other days she found him sitting by the coal-burning stove in the kitchen, his feet propped up on a chair, waiting for his brother to come home. Elizabeth would lash out at him: "You've used up all the coal!" Pollock didn't bother to defend himself, knowing that Elizabeth hated having to live with him and that nothing he could say would change her feelings toward him. He was polite to her, thanking her for dinner on the nights she cooked and offering to help with the dishes. But he spent increasing amounts of time at the Bentons'.

Charles never criticized his brother, assuming all blame for the trouble he caused while continuing to encourage him with his art. One day Charles suggested to Jackson that he consider designing a mural for Greenwich House, which had just announced plans to commission an artist to decorate the building's lobby. The prospect of painting his own mural held a definite appeal for Jackson, and he quickly got to work preparing a proposal. On a sheet of heavy brown grocer's paper he painted two scenes, one of which, presumably based on Benton's Harmonica Rascals, shows a group of five musicians writhing to the beat of their music (*Fig. 7*). One of the musicians plays a fiddle, another a clarinet. The other instruments cannot be made out, however; the forms in the painting are so crude that even the musicians are barely recognizable. Pollock, as usual, sacrificed detail to the whole, ignoring the outward appearance of the scene while managing to capture the rhythm and animation underlying it.

Whatever the merits of his mural study, Pollock felt dissatisfied with it, realizing how inappropriate it was as a design for the

lobby of Greenwich House. He decided not to submit it after all and didn't even bother to finish it. It certainly would not have eased his frustration to read in *The New York Times* that May: "Greenwich House is exhibiting sketches submitted by Charles Pollock for a series of proposed murals . . ."

———

That summer Pollock was invited by the Bentons to join them at their beach home in Chilmark, Massachusetts, an isolated fishing town on the western edge of Martha's Vineyard. He arrived in August after accompanying Charles on a drive to Los Angeles to see their mother. The Bentons' place on the Vineyard was strikingly scenic, consisting of a weather-beaten cottage perched on a high hill that overlooked the harbor of Menemsha and a rickety barn, overgrown with roses, that served as Benton's studio. No sooner had Pollock arrived on the Vineyard than Benton and Rita told him that he too could have his own studio as well as private living quarters—providing he was willing to live in a chicken coop. Thrilled by the idea of having his own place, Pollock went to work renovating the coop, a small, squat, dilapidated shack adjacent to the barn. He cleaned it out, built a small table, and covered the dirt floor with wooden boards. He cut a large window in a wall. Benton helped him out by building a few shelves, soon to be stocked with painting supplies, and Rita brought over an army cot from the house. The coop was nicknamed "Jack's Shack," and it would be Pollock's summer residence for the next three years. "I am inclined to believe," Benton later wrote, "that he was happier during his Martha's Vineyard visits than in any other time in his life. Contented maybe is a better word."

Pollock's days on the Vineyard could not have been more simple. Mornings he helped out around the house, pumping water, mowing the grass, and volunteering to take on such projects as painting the trim of the house. Fond of gardening, he weeded the flower patch and planted new varieties. By noon Rita would have packed up a picnic lunch, and the foursome would set off on an outing, Benton and Rita walking side by side and

Pollock carrying T.P. on his shoulders. Pollock and the boy usually strayed off on their own after lunch to sail T.P.'s boat in Menemsha Pond or swim naked beneath the cliffs, accompanied by their make-believe friend Jack Sass.

In these peaceful surroundings Pollock found it easier to concentrate on his work. It was a highly productive time for him, and he turned out a series of watercolors and oil paintings loosely based on the view of Menemsha Pond from the window of his hilltop studio. Most of his Chilmark seascapes are small in size, crude in execution, and solitary in mood, and they bear far less resemblance to the actual landscape than to the ghostly, lonely "in-scapes" of Albert Pinkham Ryder. Typical of Pollock's Vineyard scenes is *T.P. Boat's in Menemsha Pond* (Fig. 8), a very small painting (it measures only 5" x 6") in which a tiny white boat floats on a still pond, oddly isolated from the harbor and clouds that swirl around it. In *Seascape* (Fig. 9)—widely regarded as one of Pollock's strongest early works—the mood is more urgent, with a small white sailboat heading into turbulent waters. The painting is dominated by the image of waves, which are rendered almost abstractly in thick, rough, roiling strokes of turquoise and black, each one intertwining with the next to form a flowing whole. *Seascape* offers a good example of Pollock's instinct for "allover" composition—practically every inch of the canvas is charged with equal intensity or emphasis—a significant feature of his later work.

Among the people Pollock met through the Bentons was Helen Marot, an elderly social reformer who summered in Chilmark and was a longtime friend of Rita Benton. At sixty-nine she was still attractive, with shiny auburn hair, a light complexion, and a caring, deferential manner that made people feel appreciated. She had achieved prominence earlier in life as a labor leader, author, and editor of the *Dial* but had grown disillusioned with social causes. As Lewis Mumford later wrote in his autobiography, "Overnight the Helen Marot I had known on 'The Dial' dropped the preoccupations of a whole lifetime, as if they were so many soiled garments." Seeking more fundamental insight into the human condition, she turned to psychology. By the time

she met Pollock she was teaching at the City and Country School, a progressive private school in Greenwich Village founded by her lifelong companion Caroline Pratt. The two elderly women took an immediate interest in Pollock, recognizing in his shy, hesitant manner a person of unusual sensitivity, and offered to help him however they could. They already knew his brother Charles, who taught art at their school on a part-time basis, and suggested to Jackson after meeting him in Chilmark that he too should consider working at the school. They offered him the job of janitor.

Having found his first full-time job, Pollock didn't hesitate to move out of Charles's apartment after returning from Martha's Vineyard in September 1934. In his eagerness to escape a strained living arrangement, he left the spacious apartment on Eighth Street for markedly inferior accommodations: a small unheated room one flight above a lumberyard at 76 West Houston Street, where he slept on a mattress thrown on the floor and cooked simple meals for himself on a tiny wood-burning stove. Impoverished as he was, Pollock was still better off than many of his neighbors. Houston Street was lined with Depression-style shanties, and it was rare that Pollock left his building without stepping over a sleeping derelict in the entranceway.

That October, Pollock's brother Sande arrived in New York from Los Angeles intent on pursuing a career in art. He had wanted to join Jackson and Charles in New York for many years, partly because he had missed them so much. It had made him sad to have to say goodbye to them at the end of each summer, and the last time had been the hardest. "I felt so sorry for Sanford," his mother had written to her sons in New York, "he broke down and cried he hated to see you leave would loved to [have] gone with you." Now Sande had finally come to New York, hitchhiking across the country and arriving in Manhattan with "34 cents in my pocket, and California clothes—not even an overcoat." He headed directly for Jackson's apartment and was startled to find his kid brother living in abject poverty. Excited anyway to be in New York, Sande moved into Jackson's apartment and, for lack of a job, accompanied Jackson every night to the school where he worked as a janitor.

Every afternoon around four the two brothers set off for the City and Country School, at Twelfth Street and Seventh Avenue. They shared Jackson's job, Sande helping him empty garbage cans, sweep floors, and, once a week, mop the hallways of the five-story building. "Much as Jackson hated the janitor job," Sande later recalled, "he did it conscientiously. If he was committed to doing something, he would do it right and not loaf." The job paid ten dollars a week, which was hardly enough to support the two brothers and forced them to depend on government handouts. They managed to get on the rolls of the New York Emergency Relief Administration—better known as Home Relief—a state-run welfare program that provided them with a meager stipend and a limited amount of food, consisting for the most part of bags of cornmeal and occasional scraps of meat. With the onset of winter their situation worsened. They stole to survive, sneaking coal and wood from neighborhood markets.

One winter evening Jackson and Sande were on their way to work when they stopped in front of New York University to observe a scene that had caught their attention. The university then housed the Gallery of Living Art, a leading collection of contemporary European paintings belonging to A. E. Gallatin, a wealthy Cubist painter and pharmacologist. Through the windows of the gallery Jackson and Sande could see Matisses and Braques gleaming against the walls, an odd backdrop to the pathetic group of hoboes clustered in front of the building, huddling between pillars to shelter themselves from the wind. The two brothers were moved by the scene—the beautiful paintings, the homeless men, art's utter uselessness in the face of hardship. At Sande's suggestion he and Jackson each painted the scene (the latter's work has since been lost) and exhibited the results at the John Reed Club, a center of radical art and politics on Sixth Avenue.

Benton and Rita were deeply concerned about Pollock's welfare, realizing that he could barely afford to feed or clothe himself, let alone pay for art supplies. They wondered what they could do to help him. Had he asked for a loan, they gladly would have given it to him, but as Rita later wrote: "Jack was a very

proud and sensitive young man. There was no way of giving him money." One day Benton suggested to Pollock that he consider decorating some plates and bowls—plates are much easier to sell than paintings, Benton told him—and exhibiting them in the "relief show" that Rita was planning to hold at the Ferargil Gallery that December. Pollock was not adverse to the suggestion; he accompanied Rita to a plate warehouse downtown, allowed her to buy him a stack of plates, and, working at the Bentons' apartment, decorated the china with designs that Rita later described as "most beautiful." On one of the plates he dripped and splattered paint, his first known use of the technique that later became his dominant one.

Rita had not long before convinced the owner of the Ferargil to turn over the gallery's basement to unknown, indigent artists, thinking it was the least she could do at a time when so many artists were struggling. She planned to hold a Christmastime exhibit, and Pollock was more than willing to help her out. Along with Manuel Tolegian, he cleared out the basement, built sculpture stands, and whitewashed the cinder-block walls. He assisted with sales too, visiting the gallery almost every afternoon that December to sit at a table in the entranceway and answer questions from visitors. The show received wide publicity, with *The New York Times* reporting: "Mrs. T. H. Benton Collection One of Several in Which High Standard Is Reached." Among the works on exhibit were Pollock's painted plates and bowls. As Benton had predicted, every one of the plates sold—to Rita. For years afterward Pollock's plates could be found on the fireplace mantel of the Bentons' home in Chilmark.

Benton encouraged Pollock to exhibit his work every chance he could get, be it in the basement of the Ferargil, at neighborhood centers like the John Reed Club, or in the outdoor art shows in Washington Square Park. Benton also recommended that he submit his work to the popular competition-exhibitions organized annually by the Brooklyn Museum, and it was at this venerable institution that Pollock made his museum debut. In February 1935, a month after the Ferargil show closed, Pollock and Benton (and more than a hundred others) participated in the

museum's "Eighth Biennial Exhibition of Water Colors, Pastels and Drawings by American and Foreign Artists." Pollock's entry, entitled *Threshers,* has since been lost, but the information he supplied for the catalogue helps clarify the nature of his youthful ambitions. Asked to provide a biographical sketch, Pollock stated that he was born in Cody, had studied under Benton, and, with notable bravura, went on to claim that he was represented by the Ferargil Gallery. He also stated that he worked in fresco, another instance of wishful thinking.

By now Pollock was working at a new job, having just been transferred by the city from Home Relief to Work Relief, a program established the previous spring to put the unemployed to work. He was hired as a "stone cutter," presumably having indicated on his application that he had studied stone carving under Ben-Shmuel and possessed certain skills. However promising the job may have sounded, it turned out to be no more challenging than his previous job as a janitor. As a so-called stone cutter, Pollock joined a crew of laborers who were sent around the city to clean public monuments. Not long after he started he was demoted without explanation to a "stone carver helper." Thus Jackson Pollock, who dreamed about painting frescoes and exhibiting at the Ferargil, spent his twenty-third year cleaning bird droppings from public statuary for sixty-five cents an hour.

That spring Benton decided after twenty-three years in New York to return to his native Missouri. Disheartened and depressed by recent attacks on American Scene painting, he had come to believe that the East Coast art establishment was dominated by Communist sympathizers unwilling to tolerate anyone who didn't share their ideas. Already he had been hooted down at the John Reed Club, where, he wrote, "an enraged Commie threw a chair at me and turned the meeting into a yelling shambles." For the past few months he had been sparring with Stuart Davis in the magazine *Art Front,* with Davis arguing that Benton's belligerent "nationalism" was only one step removed from fascism. According to Davis, Benton was a "petty opportunist ... who

should have no trouble selling his wares to any fascist government."

Establishment art critics came to Benton's defense, but no amount of favorable publicity could convince him to remain in New York. In farewell interviews in the local newspapers Benton railed against New York intellectuals and their uncritical embrace of communism. "They want to take the Marxist slant at everything," Benton told the *Herald Tribune*. "Why, gol ding it, the Marxian idea was built up in 1848. How can it be valid in every gol dinged detail today? Communism is a joke everywhere in the United States except New York."

With those parting words Benton left New York in April 1935 and settled in Kansas City, where he continued to paint in the Regionalist style until his death in 1975. It does not diminish his accomplishments to note that although he strove for half a century to free American art from European influence, he did not achieve this goal. He traveled the country more extensively than any artist before or after him, visiting the steel mills of the Northeast and the cotton plantations of the South and the corn fields of the Midwest, as if subject matter alone could define an American painting style. But for all his talk about being a Regionalist, Benton was essentially a Mannerist; he draped the figures of El Greco in farmers' overalls and continued the stylistic conventions of sixteenth-century Florence. Among the many ironies of his career is the fact that the student whose talents Benton described as "most minimal" and who worked in the abstract vein that Benton abhorred would one day accomplish exactly what Benton had sought for himself: Pollock would invent an American painting style. And among the many ironies of Pollock's career is that he no more thought about creating a national art movement than he imagined that he, a painfully shy person incapable of talking in public, would become its internationally known leader.

But in the spring of 1935 Pollock was devastated by the departure of Benton and Rita. Rita had assured him before leaving that he was welcome to visit them in Kansas City and to continue summering in Chilmark, but that wasn't much of a comfort. There would be no more spaghetti dinners, no musical jams, no

shows at the Ferargil Gallery. No more afternoons with T.P. No more walks down Eighth Street, when he could look up at the Benton's apartment and know from the blue light that somebody was home. For the past five years, ever since Pollock had arrived in New York, the Bentons had cared for him like a son, and with their departure, he lost all sense of purpose. "He was truly a lost soul," Tolegian wrote to Benton many years later. "When you and Rita left New York, he took to heavy drinking, even spoke to me of suicide a number of times." Three years would pass before Pollock acknowledged to himself that somehow he'd have to free himself from the burden of Benton's influence.

5 The Project

1935-38

At one point during the Depression, Pollock noted wryly to his family: "Bums are the well-to-do of this day. They didn't have as far to fall." He could have easily made the same claim about artists, who, accustomed to being poor, had little to lose from the collapse of the American economy. Many artists were actually better off in the thirties than before or after it, for by 1935 the government had created one of its more successful relief programs, the WPA Federal Art Project. Thousands of artists, most of whom had been supporting themselves with menial part-time jobs, were suddenly earning a respectable wage of $23.86 a week to paint on a full-time basis. Pollock, who was to work on the Project for the next eight years, once told an interviewer that he was "grateful to the WPA, for keeping me alive during the thirties."

The idea of a federal art program had first gotten under way in 1933 when President Roosevelt received a letter from a painter named George Biddle, a childhood friend of his from the Groton

School. Biddle suggested to the president that he consider starting an art program based on the example of the Mexican mural movement of the 1920s, explaining that the Mexican government had paid artists "plumbers' wages" to decorate the walls of the country. Roosevelt at first was ambivalent. Only one week earlier Diego Rivera had sparked a well-publicized controversy by painting a portrait of Lenin in a mural in Rockefeller Center. Ordered by the Rockefeller family to remove the portrait, Rivera had offered to balance it with a portrait of Abraham Lincoln; five days later he was forced to stop work. The incident served as a warning to Roosevelt, who later confided to Biddle that the last thing he needed was "a lot of young enthusiasts painting Lenin's head on the Justice Building."

Despite his reservations Roosevelt forwarded Biddle's letter to the Treasury Department, where it fell into receptive hands. By the end of the year the government had created the Public Works of Art Project, the first federally funded art project in this country. Although the PWAP was a small-scale undertaking that folded after five months, it seems to have allayed any fears the Roosevelt administration may have had about giving tax dollars to artists. As Harry Hopkins, the director of the New Deal programs, put it, "Hell, they've got to eat just like other people."

The government enlarged its relief activities to artists in August 1935 with the creation of the WPA Federal Art Project. To qualify for a job, an artist had to prove only that he was poor, a criterion that few had trouble meeting. Almost all of the future Abstract Expressionists worked on the Project. Willem de Kooning designed a mural for the Williamsburg Housing Project but was fired within a year when the government discovered that he wasn't an American citizen. William Baziotes taught art in Queens. Arshile Gorky, who ironically described WPA art as "poor art for poor people," painted a mural for the New York World's Fair, as did Philip Guston. As for Pollock, he joined Adolph Gottlieb, Mark Rothko, and Ad Reinhardt on the Project's easel division, which required them to produce about one painting a month for allocation to schools, post offices, and other government buildings. So basic was the experience of working on

the Project that Barnett Newman, who had a job in his family's clothing manufacturing business at the time and couldn't get onto the Project, regretted it for years afterward. "I paid a severe price for not being on the Project with the other guys," he once said. "In their eyes I wasn't a painter."

When Pollock first joined the Project he signed up for the mural division, deciding to pursue his early interest in public art. But he quickly realized that he had no patience for the teamwork required of mural painters. Within a few months he had switched to the easel division—the largest of the Project's sections—electing to work at home and produce about one painting a month for allocation to government buildings. As simple as it may have sounded, Pollock soon found himself subjected to a long list of regulations that made his earliest days on the Project a rather bewildering experience. Among the many rules enforced by the government was the one that artists on the easel division, who all worked at home, had to report to an office on East Thirty-ninth Street every morning and at the end of the day to punch a time clock. Failure to punch the clock resulted in the withholding of a paycheck. Pollock, who was not an early riser by nature, had difficulty meeting the 8:00 A.M. check-in. The artist Jacob Kainen recalls Pollock racing frantically toward the time clock seconds before the deadline, dressed in pajamas.

Within a year the government had dropped the time-clock policy in response to complaints from artists in Brooklyn and the Bronx, who were spending the better part of their workday in transit. But artists remained subjected to many other regulations that were no less confounding. For one, they were required to submit a painting to the government every four to eight weeks, depending on the size of the canvas. They were given four weeks for a 16" x 20" canvas, six weeks for a 24" x 36" canvas, three weeks for a watercolor. Even more absurd, a few months after the Project began, artists were ordered to stop signing their paintings, the rationale being that bridge builders and bricklayers don't sign their work, so why should painters? The basic assumption underlying the Project was that artists were no different from any other government employees and that paintings were just another

form of property. It is this mentality that helps explain why almost none of Pollock's WPA paintings survive: the majority were destroyed by the government.

When the federal government began phasing out the Project in the early forties, it disposed of the artwork in its possession as if it were so much scrap metal. In a typical incident in March 1941 the government decided to clean out a storage closet in which more than six hundred and fifty watercolors had accumulated; the paintings were incinerated. Among the destroyed watercolors, according to government documents, were works by Milton Avery, Jack Tworkov, Loren MacIver, I. Rice Pereira, Sande Pollock, and Jackson Pollock. Twelve of Pollock's watercolors were destroyed, and judging from their titles—*Sunny Landscape, Baytime, Martha's Vineyard,* and so on—they consisted of works he had completed during his summers in Chilmark.

In a separate incident in December 1943 the government quietly disposed of numerous other artworks by auctioning them off at a Flushing warehouse, along with scrap iron and other surplus property. Thousands of oil paintings, which had already been removed from their stretchers, were offered for sale by the pound. A plumber purchased the entire lot, thinking that the canvases could be used to insulate pipes. He later realized, however, that when pipes heated up they burned the oil paint, giving off an unpleasant smell. The plumber contacted a junk dealer, who purchased the canvases and sold them to Roberts Book Company, a curiosity shop on Canal Street. The owner of the bookstore heaped the truckload of ragged, mildewed canvases on long tables in the back room of the store. Among the first to pick through the stack was Herbert Benevy, an art collector and the owner of the Gramercy Art Frame Shop. His selection, purchased at three dollars a canvas, included works by Milton Avery, Alice Neel, Joseph Solman, Mark Rothko, and Jackson Pollock. Two of Pollock's paintings were rescued in this way.

———

In September 1935, after nine years in New York, Charles Pollock accepted a job in Washington, DC, as a staff artist for the

Resettlement Administration. Hired to work in the agency's "special skills" division, he joined a team of accomplished artists that included Ben Shahn and settled in Potomac, Maryland. He returned to New York only for occasional visits, and the days when Jackson could depend on Charles for unstinting personal support promptly ended.

Upon leaving New York, Charles turned over the lease on his apartment at 46 East Eighth Street to Jackson and Sande, who were still sharing a single room on Houston Street. Their new apartment, in the hub of Greenwich Village, was comparatively luxurious, occupying the entire top floor of a five-story building and including such novelties as hot-water plumbing and a private bath. At the far end of the floor-through was a large, sunny room with a view of Eighth Street, and Jackson didn't hesitate to plunk down his easel and claim the room as his studio. Sande, who had also joined the Project's easel division, set up a studio in a small, dark room adjacent to Jackson's—the first of his many concessions to his brother in the seven years they were to live together on Eighth Street.

From his earliest days on the Project's easel division Pollock had difficulty meeting his monthly requirement. The problem was that he had begun to feel impatient with painting in the Regionalist style. Cotton pickers, wheat threshers, and people playing instruments no longer held his interest as subjects, and he knew that somehow he would have to break free from Benton.

Pollock's problems were well known on the easel division. His fellow painters had heard that he had become "disaffected" from his work, according to Carl Holty. Weeks would go by during which he failed to stop by the Project office to hand in a painting or pick up art supplies, and people wondered where he was.

Pollock's supervisor on the Project was Burgoyne Diller, a former schoolmate of his from the League, who painted in the geometric style of Mondrian. In spite of their artistic differences, Diller recognized Pollock as a promising young artist and went out of his way to help him. At one point when Pollock had missed his monthly deadline, Diller stopped by the Eighth Street

apartment to see what the problem was. "The Project can't use this work," Pollock told him despairingly as he took Diller around his studio and showed him a few canvases that were obvious failures. "I'm in a bog," he said. "I can't do anything." Diller reassured him: "It's okay. You're on the Project. Go on." And so Pollock went on, handing in paintings that he couldn't believe anyone really wanted.

Not all of Pollock's paintings were accepted by the Project. Some were returned to him for additional work, others were rejected outright. Writing to Charles about a year after joining the Project, Pollock sounded understandably discouraged. "There's no news here—not having much luck with painting. Got my last picture turned back for more time . . . if it had been a good picture I wouldn't have consented."

Sande Pollock understood the difficulties his brother was facing. As one who had never been an admirer of Benton's and who in fact felt that Regionalism was "nonsense," he thought it only logical that Jackson should have reached a dead end in his work. Sande admired the Mexicans: Rivera, Orozco, and David Siqueiros, the last of whom he had studied with in Los Angeles. When, in the spring of 1936, Siqueiros opened a workshop in New York—it was located in a townhouse on Union Square—Sande suggested to Jackson that the two of them volunteer to work there.

In the next few months Pollock helped out at the Siqueiros workshop almost every afternoon. He found it an interesting place, for Siqueiros, more than anyone else Pollock knew of, took amazing liberties with his materials. The youngest and most militant of the "big three" Mexican muralists, Siqueiros believed that one couldn't paint revolutionary pictures with old techniques; it was necessary to devise new ones. While his work was realistic, he often started a canvas by placing it on the floor and spattering paint from a stick, as a way of generating images and getting ideas. Other times he worked with an airbrush, filling it up with Duco paint, a commercial lacquer used to paint cars, and spraying large surfaces. (His nickname was "Il Duco.") But the chief purpose of the workshop was to turn out posters, floats, and

other props for various Communist organizations. For Pollock, whose interest in politics was markedly superficial—he didn't vote once in the course of the thirties, according to city election records—it is safe to say that the workshop appealed to him primarily as a place to learn about new methods.

While most of the assistants at the Siqueiros workshop were assigned to specific projects, Pollock was far too independent to want to make posters and banners according to some visionary master plan. He never asked for assignments, and he wasn't given any. But his admiration for Siqueiros was genuine, and he was more than willing to help out at the workshop with routine chores. He mixed paint, sawed wooden panels, pasted, plastered, and ran errands, bringing to his tasks his usual eagerness to make himself of use. None of his coworkers took him very seriously, and several were quick to fault him for his ineptitude. "He couldn't draw," said Axel Horn, as a way of explaining why Pollock never made posters. Harold Lehman was no less cynical, later stating angrily, "He had no ideas."

But for all his seeming dullness, Pollock was paying close attention to the goings-on at the workshop. He was very interested in Siqueiros' techniques, and in fact tried them out in the privacy of his studio. In a work called Landscape with Steer, Pollock took a black-and-white lithograph of a steer and airbrushed the image with glowing bursts of red, orange, and blue. Another print, Figures in a Landscape, has some large black splatters on it. One senses from these works that Pollock was looking for a freer, more liberating way to paint. On the other hand, his efforts were rather half-hearted, as if splattering paint simply for the sake of being spontaneous didn't really interest him. First he'd have to figure out what he wanted to say with it.

For some time Sande Pollock had been trying to save enough money to have his high school girlfriend join him in New York. In July 1936, with seventy-five dollars in savings, he bought a train ticket and sent it to Arloie Conaway, who was living with her parents on their citrus farm in Riverside, California. At the end of the month the couple were married at City Hall—Jackson served as a witness—and Arloie moved into the Eighth Street apartment.

A quiet, kind, self-effacing woman, she had no thought of asking her husband when, if ever, Jackson planned on finding his own apartment. To the contrary, Arloie recognized Jackson as a hypersensitive young man who needed all the help he could get from Sande and tried not to interfere with the brothers' relationship. On nights when she could hear Jackson drunkenly ascending the hallway stairs, she went into her bedroom, closed the door, and stayed there for the remainder of the night as Sande sobered him up in the kitchen.

That September, Jackson decided to leave New York for an extended stay in Bucks County, Pennsylvania, where a couple of his former schoolmates were renting an old farmhouse. Sande at first opposed the idea, reminding his brother that, in addition to his obligations on the Project, the rent on their apartment was thirty-five dollars a month, half of which was Jackson's responsibility. But Jackson was adamant about leaving New York for the winter. He had accomplished very little work since joining the Project a year before and thought he might be more productive in rural surroundings; he certainly couldn't be less productive. Besides, he now had a car—Charles had left behind a Model T Ford when he moved to Washington—and could easily commute to New York once a week or so to attend to his obligations on the Project.

His stay in Bucks County proved to be an abject disappointment. His first week there he set up an easel on the front porch of the house and made every effort to dedicate himself to his work, only to find that his heart wasn't in it. His housemate Reginald Wilson later recalled Pollock as a "private, lonely person" who had difficulty applying himself to his work. He often went for long drives by himself, disappearing unaccountably for hours at a time. On the days he stayed home he was easily distracted and would drive into town a few times a day to run needless errands. Then, three weeks into his stay, he wrecked his car. "Jack had the misfortune of colliding with some bastard and as a result the old Ford has been permanently laid to rest," Sande reported to Charles. "The other man's car was damaged to the extent of eighty bucks which it appears Jack will have to pay." Depressed

by the car accident and the general bleakness of his situation, Pollock decided to return to New York a month after he had left, even though he had already paid rent on the farmhouse for the winter.

Back in the city, Pollock was as disconsolate as ever. He was in debt to his brother, who had helped defray the cost of the accident, and had fallen far behind in his work on the Project. He could no longer pretend that leaving New York was the solution to his problems; his trip to Bucks County had merely exacerbated them. It was at this discouraging moment, in October 1936, that Pollock met a woman who was to divert him from his worries, at least for a few months. Her name was Becky Tarwater. She was four years older than he was, and like other women in Pollock's life, Becky was a talented musician whom he admired from the moment they met. "He was really in love with Becky," Arloie later said. "He wanted to marry her."

Pollock first saw her at a party in Greenwich Village to which Sande and Arloie had taken him. A banker's daughter from Rockwood, Tennessee, Becky was a singer and banjo player who happened to be performing at the party. "He asked me if he could walk me home," Becky recalled years afterward, adding that she declined the offer since he appeared to be drunk. Later that night Becky was walking toward the subway on her way home when she heard a noise behind her. She turned around suddenly and saw Pollock standing in a doorway, peeking out and smiling at her. She laughed. She walked another block and turned around again. Pollock had advanced to another doorway and was still smiling at her.

Becky took an instant liking to Pollock, while recognizing him as a "troubled, sad person" whose problems went beyond her understanding. They usually got together at his apartment, with Pollock insisting that she join his family for dinner. Arloie, who did the cooking, never complained; she and Sande both felt relieved that Jackson finally had a girlfriend. But not much came of the relationship. On most evenings Becky showed up with her banjo and played for Jackson and his brother and sister-in-law late into the night. By midnight Sande and Arloie would have

gone to sleep, and Jackson would still be sitting in the living room, listening to Becky play. For all his intense affection for her, he was far too shy to act on his feelings, and as Becky later said, "It's almost embarrassing to think how unphysical we were."

Pollock was always reticent with Becky on the subject of his artistic aspirations. He never took her inside his studio or showed her his work. "It was the strangest thing," Becky recalled. "We never talked about his art, or what he wanted to do." Becky didn't bring up the subject herself, having sensed that Pollock felt thwarted in his work and would be disturbed by the mere mention of it. Curious nonetheless to see his studio, one night she wandered into the room. She was startled to find that there were no paintings in sight except for a single canvas lying on the floor. She picked it up and was about to admire it when Sande rushed over to her and gestured for her to put the painting down. "Don't say anything," Sande whispered to her, concerned that Jackson would become upset if he knew she had been inside his studio.

That January, after they had been going together for almost three months, Becky stopped by the apartment one night to tell Pollock that she was moving back to Tennessee to care for a sister who had Hodgkin's disease. Pollock was deeply shaken by the news, no matter that he had failed to establish even a semblance of intimacy with her. In a mood of desperation, he impulsively asked her to become his wife. Becky, while flattered by the proposal, politely explained to him that marriage was out of the question. "You felt this great suffering that he had," she later said. "I was troubled myself because my sister was sick, and I knew I couldn't help him."

On the day Becky left New York, Pollock took her out to lunch, at Schrafft's, and gave her a white gardenia as a going-away present. When he returned to his apartment that afternoon he found Becky's banjo lying on the couch; she had accidentally left it behind. "I will do what you wish with the banjo," he assured her in writing. "Keep it, love it, send it, etc."

After Becky left New York toward the end of January, Pollock entered a severe depression. By now he was no longer painting,

and the sight of a canvas filled him with anxiety and dread. Whenever Arloie glanced into his studio, he was hunched in a chair, his face buried in his hands. "Jackson," she'd call, "do you want to come have coffee with me?" But he didn't want to be disturbed. Unable to work, he took to heavy drinking, heading out at night to neighborhood bars and coming home so drunk that Sande, awakened from sleep by the familiar sound of him clambering up the stairs, would get out of bed to help him. One morning Arloie went into the kitchen and was startled to discover that the tablecloth had been ripped into shreds; Jackson had stabbed the table with a butcher knife. His condition had become sufficiently troubling to convince Sande and Arloie that he needed professional help, and at their urging, Jackson went to see a psychiatrist.

Sande thought it best to spare his other brothers as well as his mother any news of Jackson's problems; there was nothing they could do to help and there was no point in having them worry. But that July, Sande finally confided to Charles—who was now living in Detroit and working as a cartoonist for the newspaper of the Automobile Workers Union—that their brother was having "a very difficult time with himself." He went on to specify that in the past year Jackson had been drinking heavily and undergoing "a succession of periods of emotional instability" and that six months of psychiatric care had failed to stem his drinking. Sande's comments were made in response to a suggestion from Charles that he and Arloie consider moving to Detroit, as there were several job openings on the union newspaper. But Sande felt obligated to remain in New York and care for Jackson: "I would be fearful of the results if he were left alone with no one to keep him in check."

These were clearly difficult months for Pollock, but at least he could look forward to a month-long summer vacation with the Bentons. His supervisors on the Project had agreed to give him a leave of absence, and on July 21, 1937, he traveled to Chilmark. The visit started out on an inauspicious note—his first day on the Vineyard he was arrested for disorderly conduct after drunkenly chasing some girls on his bicycle—but on the whole it

proved to be a relaxing, happy time for him. He ended up staying a week longer than he had planned to: "I found I loved the island too well (life, flowers, real love of the earth)."

During his stay in Chilmark, Pollock received a letter from Becky Tarwater informing him that she had become engaged to a doctor in Tennessee. The news did not upset him; to the contrary, he appears to have been genuinely happy for her. It was clear to him in retrospect that he was in no position to be her husband. Writing to Becky on August 21, a few days after returning from Chilmark, Pollock sent her his best wishes and assured her that she had made the right decision by declining his proposal earlier that year. "At this time," he wrote, "I am going through a tremendous emotional unrest. With the possibility that I will do better in the future. I realize very well now that I couldn't have made a happy life for you. With the help of the broad Atlantic Ocean I have come to realize this." He enclosed a tiny painting of two red roses.

No sooner had Pollock returned from Chilmark than he found himself beset by familiar worries. "It has been very depressing," his letter to Becky continues, "coming back to this unnatural mass of human emotion but I am making all effort to settle my self to some good creative work." He felt ready to undertake some serious painting, and to help him along, Sande decided to close off Jackson's studio from the rest of the apartment, thinking that the added privacy would enable him to concentrate better. But it was only a matter of weeks before Jackson was once again stalled in his work and had lapsed into "serious mental shape," as Sande reported to Charles.

Early in December, while visiting New York on business, Benton stopped by the Eighth Street apartment and invited Jackson and Sande to join him in Kansas City for the Christmas holiday. While Sande declined, Jackson eagerly accepted and soon had convinced his supervisor on the Project to give him another leave of absence. Toward the end of December he left New York on a Greyhound bus; by the twenty-fourth he had arrived at the Benton's home on Valentine Street, from where he wrote to his brother Charles: "I am out here for a week or so, I like Kansas City

a lot. Saw some pretty swell country coming thru—I want to go back by Detroit and see what your doing." His last-minute decision to travel to Michigan seems reflective of a larger restlessness afflicting him at this time. In Kansas City the Bentons quickly noticed that something was wrong; Pollock no longer seemed content to spend his time with the family. He went out drinking almost every night, hanging out with a group of students from the Kansas City Art Institute, where Benton was then teaching. Early one morning he returned home from a party so sick from drinking that Rita took him to a doctor later that day. "He began escaping with alcohol quite early," Benton later wrote, "though my wife and I did not recognize this as a disease until he visited us in Kansas City."

Back in New York, Pollock's problems persisted. While he managed to stop drinking his first few weeks back, he was suffering from a constant feeling of anxiety and strain. Only one month after returning from his visit he felt he needed another vacation. As Sande put it to Charles in February, he "needs relief badly from New York." Pollock's one consolation was that Benton had already invited him to come along on a six-week sketching trip that summer. He was greatly looking forward to it, hoping it might provide him with fresh material and ideas.

But then everything went awry. That May the Project informed Pollock that it was unwilling to give him another leave of absence, given all the work days he had already missed. The news was more than he could tolerate. Devastated by the prospect of a summer in the city with no place or no one to escape to, he began a period of heavy, continuous drinking. Within two weeks, on June 9, he was fired from the Project for "continued absence." Two days later, at his own request, he became a patient at the Westchester Division of New York Hospital, in White Plains, New York—then known as Bloomingdale Asylum— a psychiatric institute specializing in the treatment of anxiety disorders.

At the hospital, a rambling stone mansion situated on a working farm, Pollock was given a private room overlooking the garden, and he began treatment for alcoholism. He remained there for four months—two months less than the average stay.

The hospital's program was a fairly traditional one in which the main emphasis was on occupational therapy; tranquilizers were not yet in common use. Patients were encouraged to work with their hands and perform simple tasks as a means of regaining their confidence, and Pollock took well to the program. Dr. James Wall later described him as a "very gentle young man" who was anxious and depressed when he first arrived but quickly made progress. "There was a lot of calming down to be done and building up of his self-esteem," the doctor said, adding that Pollock was a cooperative patient who seemed appreciative of the care he was receiving. Clearly he was pleased with the treatment; he gave the doctor a plaque and a bowl that he had made himself.

As part of his treatment Pollock was encouraged, along with the rest of the patients, to participate in the hospital's art program. But he did not paint during his hospitalization, choosing to avoid the agonizing problems he was facing in his painting. He did spend some time in the hospital's metal shop, where, working with sheets of oxidized copper, he made two plates and a bowl. It is significant that he chose sculpture over painting at this point, for he had always considered sculpture his natural medium. While painting tended to frustrate him, sculpting fortified him, reminding him of his earliest ambitions. As a high school student he had dreamed about "sculpting like Michelangelo," and it was to this monumental vision that he now returned. Among the works belonging to this period is an untitled round plaque on which he hammered a male figure that bears an unmistakable likeness to Michelangelo's Adam from the Sistine Chapel murals. Like the Michelangelo figure, who awaits the touch from God that will bring him to life, Pollock's Adam also awaits his own creation. He presses his palm against the rim of the plate, a womblike form from which he is about to be delivered. It's a telling image for a young artist who was struggling to break free from the past and be reborn as his own creator, as himself. Dr. Edward Allen, whom Pollock met twice a week for therapy during his hospitalization, later recalled him in terms of his "strong creative urge."

That September, on his release from the hospital, Pollock returned to 46 East Eighth Street and resumed his routines of the previous spring; he was soon rehired on the Project and continued to work at home. But something had changed irrevocably. Never again would he paint in the Regionalist style. Nor would he continue his friendship with the Bentons except in the most superficial sense. While Benton and his wife, as one might expect, continued to feel protective toward Pollock—"Tom & I & many others believe in you," Rita wrote him that fall—the world of security they offered him was one he had finally outgrown. Fortified by his four months in the hospital, Pollock felt ready to dispense with Benton's influence and begin the long search for a style of his own. He was about to start what can safely be called the second phase of his career.

6 Still Struggling

1939-41

By January 1939, four months after his release from New York Hospital, Pollock was drinking heavily again. It was clear to his brother Sande that he needed further professional help, and he took him to see a psychotherapist named Joseph Henderson, on East Seventy-third Street. The doctor, a Jungian by training, who had been in practice less than one year, at first doubted that he could be of any help as Jackson was so reticent. "Pollock was extremely unverbal," he has written, "and we had great trouble in finding a common language." Then one day Pollock brought the doctor some of his drawings. Intrigued by his work, the doctor encouraged him to bring in some more drawings and, in the course of the next eighteen months, analyzed them as if they were dreams. Pollock was usually quiet as the doctor offered his interpretations. He neither agreed nor disagreed, and there were long silences. But he seemed to appreciate the care he was receiving; he liked Henderson and was relieved to find somebody he could trust.

Pollock had been referred to Dr. Henderson by a friend of Helen Marot, the elderly teacher who had hired him some years earlier to work as a janitor at the City and Country School. Marot, an amateur psychologist then in her mid-seventies, took an active interest in Pollock's well-being, and the two of them became rather close at this time. She often stopped by 46 East Eighth Street to look at Pollock's work and was invariably impressed by it; she told all her friends that Pollock was a genius. Pollock sometimes returned her visits but usually on nights when he had been drinking. Her friend and neighbor Rachel Scott recalls one occasion when Pollock woke up the entire block by standing outside Marot's apartment shouting "Let me in, let me in," until the elderly woman got out of bed to open the door for him. Another time he showed up at her apartment in such a frightening condition that Marot telephoned Dr. Henderson to ask what she could do to help him. The doctor, who felt that Marot was helping Pollock satisfy an unfulfilled need "to give and receive feeling," told her the best thing she could do was to continue to be Pollock's friend.

There were other problems besides his alcoholism that year. His main worry was his job. As public criticism of the WPA mounted, layoffs were becoming increasingly common. Employees of the WPA were ridiculed in the press as "boondogglers" and "leaf-rakers," and there were rumors that the whole program was about to be shut down. For Jackson and Sande, who were each earning about ninety dollars a week on the easel division, the situation was nerve-racking. "Of immediate concern around here is the lay-offs," Sande wrote to Charles in January 1939. "There are one hundred and ten pink slips in the mail right now. The union is stirring and raising hell but frankly I can't see that we can do so very much about it." Two months later Sande wrote again to say that he and Jackson had been "investigated" by the government, presumably for Communist activities, and while neither was a fellow traveler, such inquiries kept them "in a constant state of jitters."

For all his troubles, Pollock was making genuine progress in his art. Many of his paintings belonging to this period show the influence of José Orozco, to whom Pollock turned at the end of

the thirties in an effort to break free from the style of his past. It is not hard to understand his attraction to Orozco, an idealist obsessed by injustice and oppression. His theme was eternal conflict, and he slammed it on wall after wall. "Christ, what a brutal, powerful piece of painting. I think it is safe to say that [Orozco] is the only really vital living painter." So wrote Sande Pollock of Orozco's frescoes at Guadalajara, which he saw in reproduction early in 1939. Jackson left no written response but certainly shared his brother's admiration of the Mexican. Around 1939 (the paintings are undated so one can only speculate as to the year) Pollock started painting violent pictures that owe a lot to Orozco. He painted scenes of people on fire and women giving birth to skeletons; he showed ritual sacrifices in which the victim tries to get away or else clutches himself in fear. The paintings mark a radical break from the lonely little landscapes that Pollock had been painting throughout most of the thirties.

A painting that has been catalogued as *Untitled (Naked Man with Knife)* (*Fig. 10*) is probably the most explicitly violent work of Pollock's career. It shows a ritual sacrifice. A naked young boy, who resembles the artist, clutches a knife with both hands and prepares to plunge it into his victim, who is trying to escape. His arms flail, his legs kick, his mouth screams. *Naked Man with Knife* is a painting about conflict, a continuing theme of Pollock's as he struggled toward artistic maturity. The style of the painting—with its massive forms, harsh diagonals, and dramatic light-dark contrasts—is reminiscent of Orozco, who offered Pollock a way of dispensing with Benton. The painting can be read as a private allegory of that very imperative.

Pollock produced many drawings in 1939, and they too show Orozco's influence. He borrowed the Mexican's ancient symbols—serpents, axes, maimed human figures—while yanking them out of context and fusing them together into images so frenzied they lack even a hint of coherent meaning. Yet perhaps Pollock intended his drawings only as personal jottings. For most of them were made for Dr. Henderson, who encouraged him to use the process of drawing as a way of gaining access to his unconscious.

In eighteen months of therapy with Dr. Henderson, Pollock

gave the doctor eighty-two drawings and one gouache as part of his treatment. The "psychoanalytic drawings," as they are known, later became the focus of vociferous scholarly debate. In 1970 Dr. Henderson sold the drawings to a San Francisco art gallery amid charges that he had violated his patient's confidentiality. Sixty-five of the drawings were exhibited the following November at the Whitney Museum of American Art. Though the drawings themselves offered few aesthetic revelations—the critic Lawrence Alloway dismissed them as "heavy-handed and banal, the work of a man who did not get going as an artist until 1942"—the simple fact that Pollock had undergone Jungian analysis inspired an outpouring of revisionist criticism that read specific Jungian meanings into Pollock's paintings. Throughout the seventies, fashionable Jungian phrases such as "the terrible mother," "the night sea journey," and "the union of opposites" were ubiquitous in Pollock criticism. The assertions tended to be doctrinaire and at times reduced Pollock's art to little more than systematic illustration of Jungian theory.

While there is no evidence to support the claim that Jung had a major influence on Pollock's art—like most painters, Pollock was much more influenced by art than by literature—it is safe to say that Pollock was interested in Jung. In one of his sketches from this period he noted "the four functions of consciousness" as defined by Jung (intuition, feeling, sensation, and thinking) and coded them according to color. Other sketches are abundant with such Jungian staples as mandalas and trees of life. And Pollock did subscribe to Jung's theories on creativity. Jung believed that art comes from the unconscious, from buried "primordial images" that the artist must seize and shape into art. This was no news to Pollock, who, long before he ever heard the word "unconscious" had been using his art (or trying to use it) as an expression of his deepest instincts. The problem was finding a vocabulary of forms, which Jung, of course, could not help him with. But Picasso could.

No other artist played as pivotal a role in Pollock's development as Picasso, and no painting was as pivotal as *Guernica*. Picasso's famous elegy for the Basque town of Guernica was first

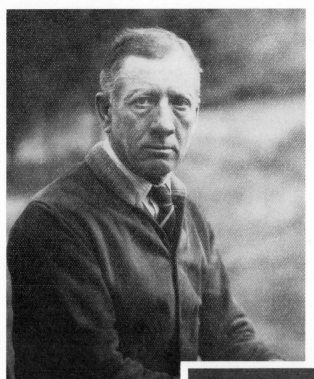

1. LeRoy Pollock, the artist's father, was orphaned at the age of three and grew up to be a fruit and dairy farmer. (Courtesy Frank Pollock)

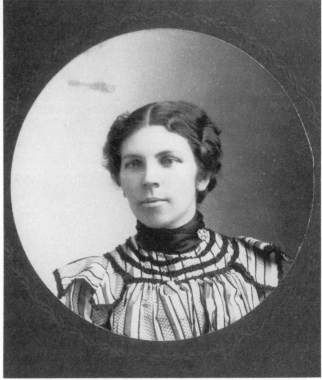

2. Stella Pollock, the artist's mother, was a gifted seamstress. The dress she is wearing in the photograph is typical of her handiwork. (Courtesy Frank Pollock)

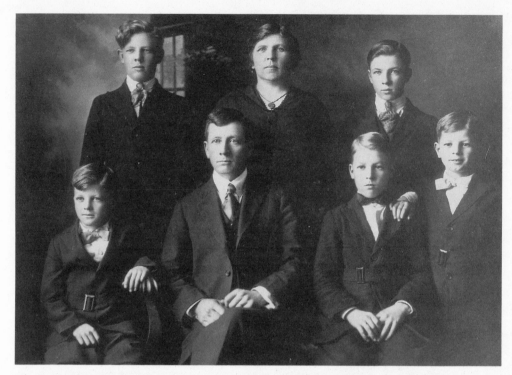

3. This family portrait was taken in Chico, California, when Jackson (far right) was five years old. In the top row, left to right, are brothers Charles and Jay. Brothers Sande and Frank are seated. The family was poor, but Stella made sure that her sons were well dressed. (Courtesy Frank Pollock)

4. The entire student body of the Walnut Grove School, Glenn County, California, 1922. Jackson Pollock, then ten years old, is in the second row, on the far left. His brother Sande is standing behind him, and his brother Frank is in the back row next to the teacher. (Courtesy Frank Pollock)

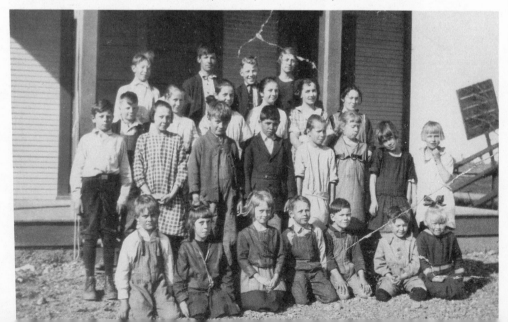

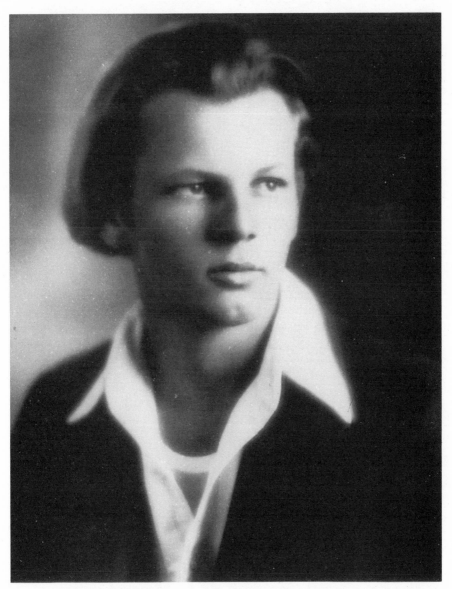

5. At the age of sixteen Pollock enrolled at Manual Arts High School, in Los Angeles. Soon after he declared his ambition to become "an Artist of some kind." (Courtesy Archives of American Art)

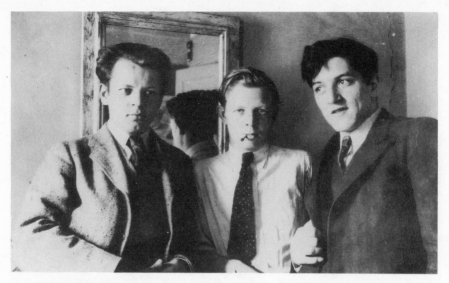

6. Following in the footsteps of his brother Charles (center), Jackson moved to New York to study at the Art Students League. Manuel Tolegian (right) was one of his classmates and a close friend. (Courtesy Archives of American Art)

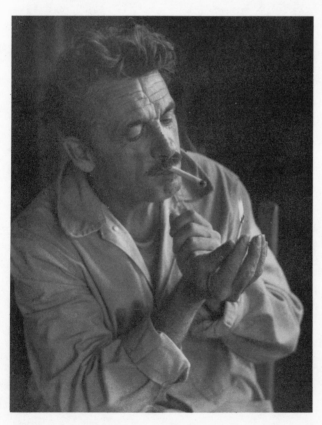

7. Thomas Hart Benton was Pollock's art teacher. He once said of his pupil: "Pollock was a born artist. The only thing I taught him was how to drink a fifth a day." (Courtesy Jessie Benton)

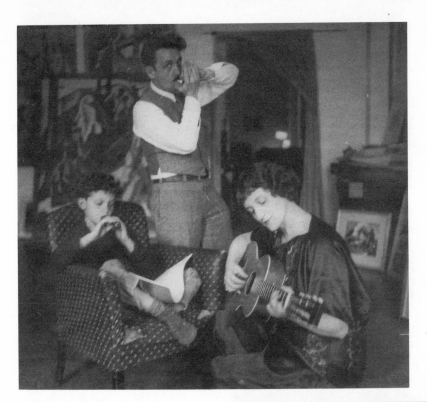

8. Pollock often joined Benton, his wife Rita, and son T.P. for a night of music-making at the family's apartment in Greenwich Village. Benton played the harmonica and Rita played the guitar. (Courtesy Jessie Benton)

9. Benton had a beach house in Chilmark, on Martha's Vineyard, where Pollock spent many of his summers. (Courtesy Jessie Benton)

10. In 1936 Pollock worked as an assistant to David Alfaro Si-
queiros (left), the youngest and most militant of the "big three"
Mexican muralists. (Courtesy Archives of American Art)

11. Another important influence on
Pollock was John Graham, an erudite
Russian émigré with firsthand
knowledge of Picasso and Cubism.
(Courtesy Max Granick)

exhibited in New York in May 1939 at the Valentine Gallery, on East Fifty-seventh Street. It was shown a second time in New York from November 1939 to January 1940 in a large Picasso retrospective at the Museum of Modern Art. Though the hundreds of works in the show have since become synonymous with high culture, the public was initially appalled by what it saw, and *The New York Times* felt obligated to warn its readers that they "may well turn in dismay or frank disgust from some of his art's grotesque phrases." These words of caution surely were meant to apply to *Guernica:* A dagger-tongued horse writhes in agony, a woman shrieks in a burning house, a mother holds a dead child. It's a painting as urgent as front-page news, with its newspaper tones of black, white, and gray and flattened forms pinned like headlines to the picture surface. *Guernica* proved that the Cubism of Picasso was not simply a set of aesthetic principles but a means of expressing overwhelming emotion—"the fear and the courage of living and dying," in the words of Eluard.

For Pollock, *Guernica* was an epiphany, awakening him to the power of abstract painting. For so many years he had failed to take heed of the Cubist revolution, blinded by his loyalty to Benton. But it was clear to him now that Picasso was the greatest living painter and one he would have to contend with if he harbored any ambitions of his own. Around 1939 Pollock produced a number of small paintings in the Cubist style. He also filled several sketchbooks with variations on *Guernica,* and approximately half of the drawings he gave to Dr. Henderson in the course of his psychotherapy relate directly to the mural's iconography. But this is not to imply that Pollock submitted to Picasso's influence wholeheartedly. To the contrary, *Guernica* galvanized his fiercest competitive instincts, and his work from this period shows far more independence than his earlier work. Among Pollock's sketches based on *Guernica* are some drawings of a bull—Picasso's alter ego—in which he splintered and fragmented the image as if threatening to do away with it altogether. But Picasso could not be reckoned with so easily, and Pollock's obsession with him would span many years.

"Jack is doing very good work," Sande reported to Charles in

the spring of 1940. "After years of trying to work along lines completely unsympathetic to his nature, he has finally dropped the Benton nonsense and is coming out with an honest and creative art."

But then again he found himself beset by all kinds of problems. As Pollock had feared, he was dismissed from his job on the Project. His layoff, in May 1940, was the result of a new rule requiring that artists be "rotated"—or terminated for at least a month once they had worked eighteen months. The layoff came at a bad time; Sande, who had been contributing to the cost of his brother's psychotherapy, had been laid off from his job the previous spring and had spent five months out of work before being rehired at a lower salary. "A winter of ups and downs with the latter in the majority," Sande reported to Charles a few days after Jackson's layoff. "I was off the Project from August to January. Just getting things leveled out and now Jack gets kicked off this week without much chance of getting back on."

Pollock tried hard to get his job back. In order to be rehired, he first had to be recertified for public relief—he had to prove that he was poor—which entailed visiting the offices of the Work Relief Bureau and answering a litany of questions from government clerks: Did he have a savings account? Property holdings? Support from relatives? Insurance policies that could be readily converted to cash? Had he considered joining the army? Was he aware that the army had openings for healthy young men? "It makes any one nervous," Sande wrote to Charles, "to have to go through such a humiliating experience and Jack is especially sensitive to that sort of nasty business."

Pollock remained out of work throughout the summer, and it was a terrible period for him. On June 4 Helen Marot died suddenly at the age of seventy-five. "The effect of this loss," according to Dr. Henderson, "was to push him back again into some of his old troubles, with an alcoholic binge as the outward symptom." Many of his drinking sprees ended in the detoxification room at Bellevue Hospital, where Sande would take him to help him sober up. Then, a few weeks after Helen Marot's death, Pollock learned that his doctor could no longer treat him. Dr. Hen-

derson was moving to San Francisco that fall and had no choice but to refer Pollock to another analyst. The news was more than Pollock could bear, for Henderson, at the very least, had been the one person who could sympathize with all his doubts.

One night that June, Pollock's high school friend Manuel Tolegian was awakened by the sound of smashing glass. He got out of bed and looked out the window of his apartment, at 28 Vandam Street. Pollock was standing across the street, beside a pyramid of rocks. "He broke a window on every floor of my building," Tolegian later recalled. "Tenants came running out of the building shouting 'What the hell is going on?' I ran downstairs and beat him up." It was the last time the two friends ever saw each other.

Later that summer Tolegian decided after ten years in New York that he was giving up his hope of becoming a great artist and moving back to Los Angeles to work in the family business. On the whole, he had not done poorly in New York. He had already had a one-man show at the Ferargil Gallery. And his harmonica playing—he had started out under Benton—had landed him a minor role in the Broadway play *The Time of Your Life*. But he could barely support himself and felt obligated to consider more practical plans.

Pollock, by comparison, did not consider any other career, although he had fared much worse as an artist than everyone he knew. In the ten years since he had come to New York he had received virtually no public recognition. He was twenty-eight years old, jobless, and drinking heavily. His brothers were married and having children, but Jackson didn't even have a girlfriend. The worst part was that besides failing to prove himself in the eyes of the world, he had not proved even to himself that he possessed genuine talent. As he lamented to Charles that summer: "I haven't much to say about my work and things—only that I have been going thru violent changes the past couple of years. God knows what will come out of it all—it's pretty negative stuff so far."

It was at this discouraging moment, in the fall of 1940, that Pollock befriended one person who believed in his talent un-

equivocally. His name was John Graham, he was fifty-nine years old, and he was highly regarded as a painter, critic, collector, dealer, and the author of a slim, esoteric book called *Systems and Dialectics of Art* (1937). While the date of their meeting is uncertain, it is generally agreed that John Graham was the first to "discover" Pollock.

"Of course he did," Willem de Kooning once said. "Who the hell picked him out? The other critics came later—much later... It was hard for other artists to see what Pollock was doing—their work was so different from his. It's hard to see something that's different from your own work. But Graham could see it."

John Graham was born Ivan Dabrowsky in Kiev in 1881, the son of minor nobility. After studying law at the University of Kiev, he worked on the staff of Czar Nicholas II and went on to serve as a cavalry officer in Archduke Michael's "Wild Brigade" during the First World War. During the Russian Revolution he was incarcerated in Red Army prisons and later offered several versions of his escape, the most colorful of which maintained that he fell before a firing squad and was taken for dead. After fleeing to Warsaw, Graham returned to Russia to join the counterrevolutionaries as a White Guard in the Crimea, a stronghold of opposition to the Soviet government. When the Bolsheviks secured power in 1920, Graham left the country and ended up in New York; he signed up to study at the Art Students League under John Sloan. During the 1920s he made frequent trips to Paris, where he exhibited his work at the Zborowski Gallery and sought out his idol, Picasso, whom he proclaimed "infinitely greater than the rest of them." Graham's sojourns to Europe ended abruptly with the Depression. Reduced to poverty, he hawked his paintings on street corners for fifteen dollars apiece and became an underground legend among a loose group of New York artists that included Arshile Gorky, Stuart Davis, Willem de Kooning, David Smith, and, by the end of the thirties, Adolph Gottlieb, Mark Rothko, and Barnett Newman. The painters prized Graham's erudition and his firsthand knowledge of the European avant-garde, for he kept them posted on the latest news from

abroad. As Graham scrawled in his diary shortly before his death in 1961, with characteristic theatricality, "I brought culture to the U.S. and didn't even have a social security card. The irony of it now."

Graham was a familiar sight along Third Avenue, haunting antique shops, jewelry shops, and fur shops in search of a rare find. "It was said," Thomas Hess once wrote, "that he could walk into any junk shop and find a beautiful object for 50 cents." Tall and regal, with imperiously arched eyebrows that crowned icy blue eyes, Graham looked like the displaced aristocrat that he was. De Kooning recalls the sight of him marching in a May Day parade shouting "We want bread!"—while waving hands encased in expensive chamois gloves. Graham knew almost every artist in New York and made a practice of stopping those he didn't know (he claimed he could tell them by their paint-spattered clothes) to introduce himself and invite himself up to their studios. He kept a list of the most promising artists in New York, and by 1940 it was headed by Jackson Pollock. After his first visit to Pollock's studio, Graham returned home and "couldn't stop talking about Pollock," according to his wife, Constance. "He said that Pollock was really crazy but that he was a great painter."

On the surface they were an unlikely pair—the courtly cosmopolitan Graham and his moody friend from the West. On his first visit to Pollock's studio Graham politely asked the young artist whether he had ever visited Paris, only to have Pollock blurt "Let Paris come see me!" To someone else the comment might have sounded like so much adolescent boasting, but Graham was tempted to take him seriously. He knew that Pollock was genuinely wary of French culture and couldn't help but admire him for it. For while many New York painters—Graham included—were then painting in a style so derivative of Picasso as to border on rank imitation, Pollock's work looked different. And though Pollock had not yet produced any great paintings, to glance around his studio was to suspect that one day he would. Graham recognized Pollock's originality.

"Graham probably wanted to be like Pollock," his wife once

said. "He wanted to be the sort of guy who could punch a police-man in the nose." She later recalled that on his first visit to their apartment—at 54 Greenwich Avenue—Pollock spent a few min-utes looking at the primitive sculptures exhibited in every room. Delighted by Pollock's interest in his art collection, Graham re-moved a few art books from the shelves of his extensive library and tried to show Pollock some reproductions. But Pollock re-fused to look. "Artists shouldn't look too much at what other art-ists do," he announced. "An artist should do what's in himself." He proceeded to give a short lecture on Graham's good friend Arshile Gorky, claiming he was doomed for mediocrity because he painted too much like Picasso. Pollock's stubborn, arrogant pronouncements at times made Graham angry, but even when he was angry, he knew that Pollock had a point.

One interest that Pollock and Graham had in common was primitive art. When the Museum of Modern Art organized the show "Indian Art of the United States" in 1941, the two men went to see it together. For Pollock the show was familiar terrain. In the lobby of the museum Navahos demonstrated sand paint-ing techniques, which no doubt evoked for him the lore of his childhood. As Sande once said: "In all our experience in the West there was always an Indian around somewhere." Pollock, who stated in 1944 that he had "always been very impressed with the plastic qualities of American Indian art," felt an instinctive affin-ity with native art, and, as usual, his enthusiasm spilled over into his work. In a number of his pictures he adopted a bold yellow-red-black color scheme. He also added arrows, slashes, and pic-tograph markings to his lexicon of signs and symbols. Pollock's easy identification with tribal art was applauded by Graham, who recognized immediately that Pollock was putting into paint the theories that Graham had set forth in writing. As a critic and aes-thetician, Graham believed that a primary purpose of a modern art was "to re-establish a lost contact with the unconscious . . . with the primordial racial past," to discover in one's art the sort of spontaneity and authenticity he discerned in the art of Picasso, primitive cultures—and Pollock.

Graham often told Pollock that he considered him "the

greatest painter in America." Whether or not Graham actually believed this—he told the same thing to de Kooning and many others—he offered Pollock essential moral support. He stopped by his studio at least once a week to see how his work was progressing and invariably had something nice to say.

Pollock looked to Graham for guidance in his work, and the older painter was to have a definite influence on him. But his influence was at most indirect. A few years earlier, in 1937, Graham had written an important article called "Primitive Art and Picasso," in which, as one might expect, he likened the work of Picasso to tribal art. He may well have given this article to Pollock in the course of their friendship, for Pollock made a number of pictures that are based on the reproductions accompanying the article. One of the reproductions showed an Alaskan Eskimo mask made from wood and feathers (*Fig. 11*). The mask had two holes in it—one directly above the other—and Graham felt the holes could be interpreted as either two eyes or two nostrils. This deliberate ambiguity reminded Graham of the distorted features one sees in the heads of Picasso, and the mask, he wrote, was reflective of "a master artist's freedom of speech." For Pollock, who wanted nothing more than to be a "master artist," the mask became a symbol of his struggle. He painted the image of the Eskimo mask into several paintings dating to this period, such as *Masqued Image, Composition with Masked Forms,* and *Naked Man,* in which a Picasso-like personage possesses, in the place of a head, a mask. But it is in the painting *Birth* that Pollock exploited the Eskimo mask for his strongest statement to date.

Birth (Fig. 12) is a painting of violent, enraged creativity. As the title implies, it shows a birth scene, but the image is almost impossible to make out. What we see instead is a series of discs that look like the Eskimo mask, each one interlocking with the next to form a powerful chain of activity. It is easy to discern the influence of Picasso here, for Pollock has managed quite effectively to appropriate the Spaniard's most daring innovations—his shallow space, flattened forms, and thick "cloisonné" outlines; his total dismantling of illusion. But in spite of the foreign influences, the painting is clearly the work of an American. Pollock

has sounded a distinctly native chord in his color scheme—red, white, and blue—a poignant prophecy of his imminent breakthrough (or birth, so to speak) as the first American painter to battle Picasso for a style of his own and to succeed.

In October 1940, five months after he was laid off from his job, Pollock was rehired onto the Project. But the job brought him no peace of mind. Layoffs were still common, the future of the Project was uncertain at best, and employees were being harassed for their political activities. Less than two weeks after Jackson rejoined the Project, Sande reported to Charles that a number of artists who had signed a petition to have the Communist party put on the ballot had consequently been fired; since Jackson and Sande both had signed the petition, they suspected they were next. "The irony is," Sande noted, "that the real Party People I know didn't sign the damn thing and it is suckers like us who are getting it. . . . Needless to say we are rigid with fright."

Adding to Pollock's worries was the possibility of being drafted. As the war in Europe worsened, it was beginning to seem inevitable that the United States would soon be involved. That October, Pollock registered with his local draft board as required by the government. He felt terrified by the prospect of military duty and discussed with his psychotherapist whether or not he was fit to serve, particularly in light of his alcoholism. Pollock was now seeing Violet Staub de Laszlo, a first-generation student of Jung, to whom Dr. Henderson had referred him upon leaving New York. Dr. de Laszlo, who felt that Pollock's main problem was his "great doubt about himself," tried to persuade him that joining the service could be a beneficial experience for him; she thought it might enhance his self-esteem. But Pollock was adamant about not wanting to serve.

On May 6, 1941, Dr. de Laszlo wrote the draft board: "I have found [Pollock] to be a shut-in and inarticulate personality of good intelligence, but with a great deal of emotional instability who finds it difficult to form or maintain any kind of relationship." The doctor also wrote that while there was no reason to believe Pollock was schizophrenic, "there is a certain schizoid disposition underlying the instability." She recommended that

her patient be given a special psychiatric examination, which Pollock underwent at Beth Israel Hospital on May 22. During the exam he indicated to a doctor that he had been institutionalized at New York Hospital three years earlier. The government requested proof of his hospitalization, which Dr. de Laszlo promptly supplied in writing. To his relief, Pollock was classified 4F.

So completely self-absorbed was Pollock that besides being unwilling to serve in World War II, he appears to have resented the small sacrifices the war demanded of him. When war broke out, travel restrictions went into effect, making it difficult for him to leave the state. In his sole written reference to the war during the years it was being fought, Pollock complained to one of his brothers that World War II was interfering with his vacation plans: "If it weren't for this god damned war I'd head west for a while." As the forties wore on, however, and the death toll grew, Pollock came to realize how fortunate he had been to be allowed to stay home and paint. In 1946 he noted appreciatively: "I have been able to paint all thru the war—and am very grateful for the opportunity and tried to make the most of it."

In the summer of 1941 Sande Pollock was laid off from the Project again, and five weeks passed before he managed to get rehired. The layoff came at a bad time, for the rent on his apartment had just been raised from thirty-five to fifty dollars a month, and he and Jackson had had enough trouble paying it even when they both were employed. Compounding their problems, their mother, who was now in her late sixties, was threatening to come to live with them. For the past few years Stella had been living in Tingley, Iowa, with her ailing mother, but with the old woman's death that July she was eager to leave the dreary farming town and join her children in New York. It seemed only logical to her that she should move in with Jackson and Sande, as she could not afford an apartment of her own.

Sande thought this was a terrible idea. In a series of letters to Charles, in Michigan, he tried to convince him that their mother would be better off anywhere but in New York. Not the least of his reasons was that her presence would be "extremely trying"

for Jackson, who was still struggling with alcoholism. There was also the problem of money. "I hate like hell to write a hard luck letter," Sande wrote that August, going on to say that the situation on the Project "makes for a helplessness that is almost overwhelming." Stella ended up moving to Michigan, where she would live with Charles and his family until moving to New York the following year.

In the three years that had passed since his release from New York Hospital not much had changed in Pollock's life. He was still on the Project, still struggling to meet his monthly quota, still drinking in spite of psychiatric care. But his obscurity and loneliness were about to end. In November 1941 John Graham mentioned to Pollock that he was organizing a show at McMillen Inc., an antique and fine-furnishings company on East Fifty-fifth Street. He wanted to include one of Pollock's paintings—how about *Birth*? Pollock was very pleased to be selected for the show, which promised to be an interesting one. Entitled "American and French Paintings," the exhibit would pair established Europeans like Picasso and Matisse with young Americans almost no one had heard of. One of them was de Kooning, another Lenore Krasner.

Those names were unknown not only to the general public but to Pollock as well. Lenore Krasner. Who was *she*? "A damn good woman painter," Pollock soon told his brother.

7 Enter L.K.

When Lee Krasner learned in November 1941 that John Graham planned to include her in the show "American and French Paintings," she was ecstatic that her work would be hanging in the same room as that of her idols Picasso and Matisse. But she was also curious: Who was Jackson Pollock and why didn't she know him? "I prided myself on knowing just about everybody in the New York art world," she later explained.

She asked around. She asked her friends in the American Abstract Artists group if they had ever heard of Jackson Pollock. No one had. Then one night she was attending an opening at the Downtown Gallery when she ran into the painter Louis Bunce, a former schoolmate of Pollock's at the League. Pollock, he told Lee, was a very good painter who lived right around the corner from her, on Eighth Street. Lee was then living in a studio on East Ninth.

The next day Lee walked over to his apartment. At the top of the stairs she was met by Sande Pollock, who pointed her to his

brother's studio. Jackson must have been surprised by this woman in his doorway, who told him boldly, "I'm Lee Krasner and we're in the same show." Lee Krasner was thirty-three years old, four years older than Pollock. She stood five feet five, with strong features and shiny auburn hair cut in a pageboy style.

Lee took in Jackson's features and realized she had seen him once before. Five years earlier she had been dancing at a loft party sponsored by the WPA Artists' Union when Pollock had drunkenly cut in. "He stepped all over my feet," she once said. "He never did learn to dance."

Pollock led her to his studio. Four or five canvases were hanging on the wall. "To say that I flipped my lid would be an understatement," she said. "I was totally bowled over by what I saw."

She invited Pollock to visit her on Ninth Street the following week, and he showed up as scheduled, entering through a narrow hallway that doubled as a kitchen and sitting down in the apartment's one room. Lee asked him if he wanted some coffee. Yes, he said. She stood up and went to get her coat from the hall closet.

"Let's go," she said.

Pollock looked bewildered. "But you offered me coffee," he protested.

Lee had never used her gas stove, and she didn't even know if it worked. When she offered her friends coffee, she meant "Let's go to the corner drugstore."

"I've never seen anyone so shocked to death when I told him," she later said.

They went out for coffee, once, twice, a dozen times, discovering mutual interests as if discovering the interests anew. He told her he was in Jungian analysis, and she was excited. "I was reading Jung on my own," she said, "so we had that as a common denominator." Naturally they also had art. He was Presbyterian and she was Jewish, but they worshiped the same god—Picasso. She told him about the first time she had seen *Guernica*, about how it had "knocked" her out of the room; she had had to circle the block five times before she could look again. They talked

about art constantly but never asked "What does your work mean?" or "Why do you do it?"—questions that would have seemed as absurd as "Why were you born?" They were both born painters, and they accepted each other's fates, talking about art only in terms of "shop talk," as Lee called it. She asked Pollock if he knew the other Americans who were going to be in Graham's show. Did he know de Kooning? No, Pollock said. So she told him about de Kooning. She promised she'd take him to meet de Kooning. She wanted to take him to meet *everyone*.

It was a union based on shared passions, yet also on differences of temperament. Even in the way they moved they complemented each other. Pollock moved like a heavy, lumbering bear, his arms hanging at his sides "like tree trunks," as William Phillips once wrote. Lee was lithe and graceful, a good dancer, able to move swiftly through the situations that made him falter. Pollock spoke in an agonized, halting way, as if the words had been torn from his flesh. Lee spoke aggressively, firing words like bullets. He was withdrawn; she was brazen. He avoided people, but she confronted them. She demanded justice, and since life is unjust, she was often angry. She sized up situations in seconds, usually with contempt. She was controlled and controlling, and because those qualities were so alien to him, he admired the way she took charge of things.

They complemented each other in their art too. By her own admission, Lee was overly disciplined. At the time she met Pollock she was a first-rate abstract painter who had mastered Cubism and was trying to unlearn her learning, to loosen up, to discover the kind of authenticity and vigor that come from direct feeling. He, to the contrary, was undisciplined. He was independent and original. From his earliest years his art had been distinguished by a quality that was felt rather than learned, and because hers was not, she recognized his genius.

"I was terribly drawn to Jackson," she said, "and I fell in love with him—physically, mentally—in every sense of the word. I had a conviction when I met Jackson that he had something important to say. When we began going together, my own work became irrelevant. He was the important thing."

A few months after they met, Pollock and Lee were walking along Varick Street one blustery winter afternoon when they ran into Clement Greenberg outside the U.S. Customs Office. He would later become Pollock's chief champion as well as the leading art critic of his generation, but in 1941 he was working as a customs clerk and writing articles on the side. Greenberg said hello to Lee, then glanced at her new friend, waiting for an introduction. "This is Jackson Pollock," she announced. "He's going to be a great painter."

"Oh," Greenberg moaned to himself, "that's no way to size up a human being."

To Lee Krasner it was the only way.

———

It is a cliché by now to say that Lee Krasner sacrificed her career for Jackson Pollock. It is also a falsehood. From childhood on she was determined to become a great painter, and she did.

She was born Lenore Krassner (she later dropped the second "s" in Krassner) on Schenck Avenue, in the East New York section of Brooklyn, on October 27, 1908. Her mother thought birthdays were frivolous holidays, and when Lee later asked about her date of birth, Anna Krassner replied curtly in Yiddish, "You were born on a cold day."

It was an immigrant household dominated by practical concerns and the problems of subsistence. Her parents, Anna Weiss and Joseph Krassner, had settled in Brooklyn among thousands of immigrants early in the century after arriving from Shpikov, a forest village near Odessa. Lee was the sixth of their seven children and the first born in the United States. Soon after her birth her parents closed their grocery store and moved to a two-family row house on Jerome Street, in Brooklyn. They rented a stall at the Blake Street Market, where they worked from dawn to late afternoon selling fish—pike, carp, and whitefish—which they hauled from Manhattan to Brooklyn by horse and wagon, keeping it fresh in ice-packed wooden crates. They worked every day except Saturday, the Jewish Sabbath. The Krassners were Orthodox Jews who required their children to attend Hebrew school and synagogue. At home they spoke Yiddish and Russian.

Lee quickly established herself as the family rebel. As a little girl, she was resentful that she and her mother had to sit upstairs at synagogue while the men sat downstairs. When she was twelve years old, she stormed into the living room one day to announce to her parents that she was through with Judaism.

Art became her new religion. She loved to draw and was good at it. She copied pictures of women from fashion advertisements in the newspaper. Her sisters would sit and watch, marveling at her ability to create beautiful women out of nothing. "She used to draw clothed women figures all the time," said her sister Ruth. "We were all aware of that—how marvelous it was to be able to put her pencil to paper and get a figure." The Krassner children had never seen art before, with the exception of a dime-store reproduction of Queen Isabella giving jewels to Columbus, which hung over the fireplace in the living room. By the time Lee was fourteen she was commuting daily by subway from Brooklyn to Manhattan to attend the Washington Irving High School for Girls, the only public school in New York that offered a special art program. She couldn't imagine becoming anything other than an artist.

Lee's mother sometimes complained that she was "too independent" for a young girl. Anna Krassner couldn't understand her defiant daughter, for it was not in Anna's nature to question tradition. One afternoon she was sitting at the kitchen table trying to learn to write her name in English. Her husband walked into the room, looked at her pad, and scolded her for attempting such nonsense. She put down her pencil and never tried again.

Lee's mother was a superstitious, fearful woman, and she made her children afraid of everything. Whenever it thundered, she gathered her daughters around her by the wood-burning stove in the kitchen and wouldn't let them go until the storm subsided. Sometimes, late at night, she would kneel on the bed that Lee shared with her two little sisters and peer out the window at Mrs. MacAvoy, the neighborhood kook, who would emerge from her house at the same time every night to talk to the moon, thinking she was talking to her dead husband. The Krassner girls would clutch each other beneath the bed sheet and scream.

Lee's father, by comparison, was stern and distant. But he too instilled in his children a belief in mystical powers. On cold winter nights he would sit by the kitchen stove smoking cigars and telling tales about life in the village of Shpikov. Most of them were about Pesa, his mother, who was known in Shpikov as a woman of magical gifts. Villagers would visit the old woman seeking forgiveness for their sins, which Pesa delivered by swinging a chicken above her head and allowing their sins to pass to the fowl in a ceremony known as kapores. "I'd sit close to him, and he'd tell the stories," Lee once said. "Oh, I was terribly scared at night, scared of the dark, still am."

To others, though, Lee seemed fearless, willing to defy any orthodoxy for the sake of her art. She studied at the Women's Art School of Cooper Union and continued her education at the National Academy of Design. Unlike the Art Students League, the Academy was a bastion of conservative, academic-style painting where students were required to draw from antique casts before being allowed to draw from life models. Lee, however, did not want to draw from antique casts. She was put on probation in January 1929, only four months after she started school. "This student is always a bother," a teacher jotted in her file. In December 1929 Lee was suspended from the Academy for "painting figures without permission," according to school records. That would always be true of her; she did things without permission.

She finished art school at the height of the Depression. Deciding she might as well be practical, she went to City College to get a teaching degree. Then she tore it up. "The last thing in the world I wanted to do was teach art," she said. She managed to support herself in the early thirties by painting stripes on china and hats ("I ruined more felt hats . . .") and donning silk pajamas to wait tables at Sam Johnson's, a Third Avenue bar and nightclub, where she got to know such Village intellectuals as Harold Rosenberg and Lionel Abel. "I remember Harold Rosenberg," she says, "because he never tipped."

She was rescued from waitressing by the Project, on which she worked primarily as a mural assistant. She resented having to carry out other people's plans and wanted to do a mural of her

own. Maybe she'd have a better chance if the government didn't know she was a woman, she thought. So she changed her name from Lenore to Lee, but her assignments remained the same.

While Pollock's studies at the Art Students League insulated him from the avant-garde movements of the thirties, Lee joined with the avant-garde early in her career. In 1937 she signed up to study under Hans Hofmann, the leading proselytizer of Cubist doctrine in New York. He had his own school on West Eighth Street. Born in Munich, Hofmann had lived in Paris from 1904 to 1914, when he worked with Matisse, befriended Picasso, and saw the emergence of Cubism firsthand, and he brought to his students a deep appreciation of modern European art movements. Hofmann spoke with a heavy German accent, and Lee had difficulty understanding him—her friend Fritz Bultman used to translate for her in class—but she had no trouble putting his theories into paint. Hofmann was very impressed with her work, and once tried to offer her a compliment. "This is so good you would not know it was done by a woman," he told her. Lee was furious at him, even though she knew that Degas had said the same thing to Mary Cassatt a half-century earlier.

Another of Lee's early mentors was Piet Mondrian, whom she befriended when he came to New York in 1940. She once escorted him to an exhibit organized by the American Abstract Artists, the group of abstract painters through which she had met him. Mondrian paused in front of each painting and asked her "Who is this? Who is this?" When they came to Lee's painting she proudly told him, "This is mine." "Very strong inner rhythm," he said. "Stay with it."

Lee learned early in life that to be an artist is to assert one's will, but to be a woman is to relinquish it. She was drawn to talented men, which usually meant making less of her own abilities. Her first love was Igor Pantuhoff. A Russian émigré, Igor had studied abstract painting under Hofmann along with Lee but was known as a portrait painter and had won the prestigious Prix de Rome before moving to New York. Igor was a man of sure charm and expensive tastes who refused to let poverty interfere with his ways. He always carried a hundred-dollar bill, and since no one could break it, he was often able to eat without paying for his

meal. His trademark was a fine camel's hair coat, which he had acquired by walking into a department store and announcing, "I'm Igor Pantuhoff. Great artist. Give me coat and I give you painting in return." The store manager said he wasn't allowed to give coats away. "But I'm Igor Pantuhoff! Great artist!" He got the coat.

Lee and Igor lived together for two years, sharing with Harold and May Rosenberg a twenty-three-dollar-a-month cold-water flat overlooking the Hudson River. May Rosenberg recalls the morning that Igor ended the relationship. "Igor couldn't understand what Hofmann was doing," she once explained. "Hofmann would look at Igor's work and say, 'No, that's wrong' and put a scratch across it. With their accents—Igor's Russian and Hofmann's German—they couldn't understand each other. So Igor just decided one morning that he was taking a bus across the country and going to become a great portrait painter."

Igor left New York without telling Lee, packing his suitcases and disappearing in the middle of the night. When she woke up, he was gone. A few weeks later she moved out of the room that she had shared with him and set up her own place on Ninth Street. On the walls of her studio she scribbled a few lines from Delmore Schwartz's translation of Rimbaud's *A Season in Hell:*

> To whom shall I hire myself out? What beast must I adore?
> What holy image is attacked: What hearts shall I break?
> What lie must I maintain? In what blood tread?

The lines were written in black crayon except for a few words—"What lie must I maintain?" Those were written in blue.

———

In November 1941 Lee received a postcard from her friend John Graham. "Dear Lenore," he wrote, "I am arranging at an uptown gallery a show of French and American paintings with excellent publicity, etc. I have Braque, Picasso . . . I want to have your last large painting. I will drop [in] at your place Friday afternoon."

"American and French Paintings," the show organized by

Graham, opened in January 1942 to favorable publicity. Pollock and de Kooning received the first reviews of their careers, though the comments were rather brief. "Pollack" was cited in *Art News* for his "general whirling figures" and de Kooning, identified in *Art Digest* as "William Kooning," was singled out as "strange." Lee wasn't mentioned at all, nor was John Graham, and none of the paintings sold. "The Americans looked very good," de Kooning once said, "but nobody paid attention. It was not like today. People just weren't buying American painting."

When the exhibit closed in February 1942, Pollock and Lee removed their paintings from the gallery and took them back to Lee's place on Ninth Street, where they were now spending most of their time. Pollock hung up his *Birth* on a wall dominated by Lee's Cubist still lifes. He told her he wanted her to keep the painting for herself. It was the first of many works he was to give to her over the years.

Pollock was looking at Lee's paintings one day when he offered her some advice. He told her to sign them. Lee, who had never signed her paintings, disagreed. She gave him a lecture on Mondrian, telling him Mondrian didn't sign his paintings because signatures clutter up the picture surface and ruin the geometrical purity of the design. "You have to sign your paintings," Pollock insisted. Lee started to tease him, saying the only reason he signed his canvases was because Benton did, and the only reason Benton did was because the Old Masters did. As Lee was talking, Pollock suddenly stood up. He loaded a brush with black pigment, walked over to a painting hanging on the wall, and across the bottom, in large, harshly slanted script, wrote "L. Krassner." He went on to the next canvas: "L. Krassner," and so on, until every painting in the room bore his mark.

Lee didn't take any chances after that. She signed her paintings. She also managed to register her protest, signing them in abbreviated form—"L.K."

While Pollock and Lee were spending most of their time by themselves, his circle of acquaintances was expanding. She introduced him to everyone she knew and often invited people up to his studio to see his work. He met her friends from the Hofmann

School, friends from the Project, and more friends still from the American Abstract Artists. But this is not to imply that Pollock's life became more social; to the contrary, Lee's became more solitary. Most of her friends found it difficult to talk to him as he seemed preoccupied with his problems. To Fritz Bultman, a student of Hofmann's, Pollock was a "human being in anguish." To May Rosenberg, the wife of the critic, he was simply "a guy in overalls who never said a word." Most of Lee's friends couldn't figure out what she saw in him.

To others Pollock seemed combative, and he often alienated people without intending to. Among the visitors to his studio was Alexander Calder, who was already well known as a sculptor; ten years earlier he had made his first mobiles, or "moving Mondrians," as he called them. An engineer by training, Calder noticed as he glanced around Pollock's studio that his work possessed none of the airy grace that was a distinguishing feature of Calder's own work. Paint was jabbed on thickly, forms were packed tightly together. "They're all so *dense*," Calder commented. "Oh," Pollock said good-naturedly, "you want to see one less dense?" He left the room and returned with the densest painting he had. Calder was not amused.

Another distinguished visitor to Pollock's studio was Hans Hofmann. He lived in the building next door, and Lee was eager to hear what her former teacher thought of Pollock's work. One day she invited him over. He spent a few minutes studying the unstretched paintings tacked on the walls, then offered a compliment for which Pollock would never forgive him. "You are very talented," Hofmann told him. "You should join my class."

Hofmann went on to question Pollock's methods. The teacher was surprised by the bareness of the room. There were no antique casts, no tabletops set with bowls of fruit, no still-life arrangements from which the artist could abstract. Hofmann, who believed that nature was the source of inspiration of all art, wondered whether Pollock felt the same. "Do you work from nature?" he said.

Pollock, in his most famous display of bravado, blurted angrily: "I *am* nature."

Pollock and Lee had both been on the Project now for seven years, he as an easel painter and she as a mural painter. But not too long after they met, in February 1942, the Project was reorganized as a division of the War Services Program. Artists were now required to report each morning to 110 King Street, where they were assigned to group projects relating to the war effort. They turned out material of all sorts: armbands for the Red Cross, pamphlets on air-raid precautions, posters announcing campaigns for victory gardens. This was precisely the sort of work that Pollock detested, as one who had no patience for teamwork. But fortunately he could not have had a more sympathetic supervisor. He worked under Lee, who, as a "supervisor of exhibits," had managed to have Pollock put on her staff.

Lee was in charge of a specific project—designing window displays to promote the war-training courses being offered at city colleges. She oversaw a team of about ten artists, who worked closely together. But Pollock remained notably uninvolved. Peter Busa, one of his coworkers, later recalled that Lee was "highly protective" of Pollock and never gave him any assignments. She allowed him to work on whatever he wanted, and he appears to have spent his time contentedly making drawings and gouaches. His work was put to resourceful ends; Lee later pasted it, along with pictures of soldiers and tanks, into large collages that may well have been the most inventive window displays the government ever commissioned.

Jackson was now spending very little time in his apartment. Sande decided there was no point paying rent on an empty bedroom; he might as well offer it to his mother, who had wanted to come east for almost a year. By May 5, 1942, Stella had arrived in New York, from where she reported to Charles: "Tuesday night almost ten o'clock Jack & I washed the dishes read a while and listened to the radio, he has just left for his girls home." Her letter went on to indicate that as a result of a new WPA rule prohibiting more than one person per household from collecting a paycheck, either Jackson or Sande would have to quit his job. With characteristic selflessness, Sande had already volunteered. He was planning on accepting a job in Connecticut with a company that

manufactured airplane parts. "He and his wife," Stella wrote, "will have to move which will be a job. Jack wants to keep this place."

That September, Sande and his wife and their newborn daughter moved to Deep River, Connecticut. It had already been decided that Stella would live with them; she couldn't remain in the city with Jackson, since he could barely care for himself, let alone his aging mother.

When Sande left New York, Lee moved into the apartment and took over his studio. She and Pollock were now working in adjacent rooms. Such close proximity necessitated that they maintain strict regard for each other's privacy, and it was instantly agreed that neither would enter the other's studio without permission. At the end of a workday, Lee would usually ask Pollock, "How did it go?" If it had gone well, he would invite her into his studio to show her the results. But even when he invited her in, he was touchy about her presence. Once Lee was in his studio when she picked up a paintbrush that had some wet pigment on it and accidentally sideswiped a black canvas. Pollock became upset. He walked into her studio and sat down and sulked. Lee apologized profusely, but Pollock continued to sulk for an hour.

After Lee moved in with Pollock, her art underwent a radical change. Overwhelmed by the power of Pollock's art, she felt disenchanted with the geometric Cubist style in which she had been working for the past five years. She no longer wanted to paint from nature, according to the methods of Hofmann; she wanted to paint from her imagination. One morning Lee entered her studio, loaded a brush with pigment, and for the first time in her life attempted to make a picture without looking at a model or a still-life arrangement. She made some marks on a blank canvas and waited for an image to evolve. Nothing happened. She put down some more strokes. The colors started running together and turned muddy and gray. For the next three years, in her struggle to find a style of her own, Lee produced little else but these muddy paintings. She called them her "gray slabs" and later destroyed them.

Pollock, by comparison, was experiencing his most re-

warding period of painting so far. Part of the reason was surely the support offered by Lee. No one had ever believed in him to the extent that she did, and because he considered her very talented, her faith in him meant that much more. In 1942 Pollock applied himself to his work with a renewed sense of purpose. He produced only three paintings, but it is generally agreed that they mark his arrival at artistic maturity.

8 Surrealists in New York

1942-43

By 1942 most of the leading figures in European art had arrived in New York as refugees from the war. André Breton, the "pope" of Surrealism, was living in a fifth-floor walk-up on Eleventh Street. Roberto Matta was on Ninth Street. Fernand Léger could often be spotted herding large groups of friends to restaurants in Chinatown. Mondrian, a jazz buff, visited the dance halls of Harlem. Max Ernst was living in a fancy townhouse on East Fifty-first Street with heiress Peggy Guggenheim, who had helped him escape from occupied France and then demanded that he marry her. Duchamp was already here, having divided his time between Paris and New York since 1915. Although Picasso, Miró, and Matisse chose to stay behind in Europe, virtually all the major Surrealists spent the war years in New York, and their presence had a significant impact on the local art scene.

Pollock was drawn into the Surrealist movement through Robert Motherwell, a twenty-seven-year-old painter from Aberdeen, Washington, who had studied philosophy at Harvard. A

slender, blond youth with an eager, deferential manner and a reverence for French culture, Motherwell was one of the few Americans to be accepted by the Surrealists. Already he had traveled to Mexico with Matta, studied in the studio of Kurt Seligmann, and been nicknamed affectionately by Breton *"le petit philosophe."* Motherwell first met Pollock in the fall of 1942 when he was trying to start a group devoted to the exploration of Surrealist ideas. At the suggestion of the painter William Baziotes, who knew Pollock from the Project, Motherwell paid a visit to 46 East Eighth Street. His first impression was of a "deeply depressed man" who possessed a definite intensity. "He was so involved with his uncontrollable neuroses and demons," Motherwell later said, "that I occasionally see him like Marlon Brando in scenes from *A Streetcar Named Desire*—only Brando was much more controlled than Pollock." Motherwell was eager to introduce his newfound friend to the Surrealists of his acquaintance.

Pollock, by now, was quite familiar with Surrealist art, which had been shown regularly in this country for more than a decade. De Chirico had exhibited in New York as early as 1927, Miró in 1928, Dali in 1933, and all of them were included in the Museum of Modern Art's celebrated exhibition "Fantastic Art, Dada, Surrealism" of 1936. But it was not until the Surrealists migrated to New York that Pollock became fully aware of their accomplishments. Their arrival coincided with a critical moment in American painting, when the political art of the thirties had been abandoned but a new style had yet to be defined. Pollock, along with many others, began looking to the Surrealists as a source of new ideas. This is not to imply that he had any interest in the melting watches of Salvador Dali. For Pollock the magic of Surrealism lay in its freedom from academic convention. He was a great admirer of Miró, whose fantasy creatures and playful calligraphy were to have a definite influence on him. Another Surrealist whom Pollock admired was André Masson, a pioneer of "automatic" drawing, who was living in Connecticut during the war years.

Unlike Cubism, which was essentially a painting style, Surrealism was an organized movement, with leaders and followers,

manifestos and magazines, exhibits and excommunications. It was founded in Paris soon after World War I by André Breton, a tall, magnetic poet with a large head and pronounced features invariably described as leonine. After studying medicine and serving as a doctor in psychiatric wards during the war, Breton developed an interest in the connection between dreams, madness, and poetry. In 1921 he made a pilgrimage to Vienna to meet Freud, whose writings were to be central to Surrealism. In 1924 Breton issued the first of his Surrealist manifestos. The goal of Surrealism was the radical transformation of human life, not only socially but at the deepest levels of existence. Its principal technique was "psychic automatism," or the exploration of the unconscious.

Despite its literary leanings, Surrealism found a following mostly among painters. With values colored by the First World War—pessimism, irrationality, intense subjectivity, and eroticism—the movement spread quickly outside France. Its early leaders were de Chirico in Italy, Max Ernst in Germany, Salvador Dali in Spain, and René Magritte in Belgium. By the 1930s most of the Surrealists had gravitated to Paris, where the movement continued to flourish until the outbreak of World War II.

By the time the Surrealists arrived in New York, the movement was essentially defunct. The painters Breton had recruited were all famous, and the advanced positions they had taken in the twenties had been widely accepted. No longer was anyone issuing manifestos or calling for revolution. For Breton, his five years in New York were lonely and depressing. He complained bitterly about having to live among "uncultivated" Americans and refused on principle to learn any English or visit the downtown cafeterias where artists congregated. He ran out of money and was forced to take a job with the Office of War Information reading propaganda news on the radio. At one point he became friendly with David Hare, the New York sculptor, and started a review called VVV, but it ended badly. His wife Jacqueline, who served as the review's translator, left him for Hare and took along his one child.

Of all the Surrealists living in New York, Pollock became

friendly with one. Born in Chile, Roberto Matta was a latecomer to Surrealism and a rarity among the émigrés in that he spoke English fluently and was interested in meeting American painters. He loathed Breton, whom he found insufferably rigid, and was determined to keep Surrealism from degenerating into an academy by starting an offshoot movement composed entirely of Americans. But first he would have to educate them, or so he thought. "I found that they were absolutely ignorant," Matta said of the painters he met in New York. "They knew nothing about Rimbaud or Apollinaire, and they were just copying the outward forms of Picasso and Miró." When Matta suggested to Motherwell that they start a group dedicated to exploring Surrealist techniques, Motherwell went to talk to Pollock.

Pollock at first was reluctant to get involved in Matta's group or, for that matter, in any activity connected with the Surrealists. He didn't speak French, had no interest in learning it, and resented the Surrealists' obvious disdain for American culture. He had already turned down a chance to participate in an important group show, "First Papers of Surrealism," which had been organized by Breton at the Whitelaw Reid Mansion in October 1942. "Jackson didn't like the Surrealists because he thought they were anti-American," David Hare once said. "And the Surrealists didn't like him because they expected to be courted all the time. Jackson wouldn't court them at all."

At the same time Pollock was genuinely interested in Surrealist art and the technique of psychic automatism, so he decided to join Matta's group. The meetings were held on Saturday afternoons in Matta's apartment on Ninth Street, and they lasted for a couple of months. Pollock rarely talked at the weekly gatherings—Matta once described him as *"fermé"* (closed up)—but was articulate when he did. Once Matta asked each of the artists in the group to give a definition of a flower. "A flower is a fox in a hole," Pollock said, and although no one was quite sure what the comment meant, its ambiguity only heightened its value. Another time Pollock stared for a few moments at the smoke rising from his cigarette. Which is the empty space, he wondered aloud, the smoke or the air? Pollock was interested in Matta's theory of

"psychic morphology," which maintains that forms, like feelings, are constantly undergoing change. Once Pollock mentioned that a good example of this theory could be found in Navaho art, where men step out of their skins to become thunderbirds. Motherwell started to elaborate on the subject, but Matta quickly silenced him. "The reason Jackson is successful," Matta said, "is because he doesn't talk too much."

Matta would give the artists assignments and once told them to illustrate time by drawing the hours of the day. Pollock drew an alarm clock that metamorphosed into a jumble of scribbles. When Motherwell noted that Pollock had successfully demonstrated Matta's theory about the evolution of forms—the clock had evolved into an abstract image—Pollock told Motherwell that he hated the word "abstract." If you draw a line, he said, it can be seen as either figurative (it can be a profile) or abstract (just a line). Pollock didn't like to label his art. An abstract image was as real to him as a figurative one. It all came from the same source, from inside.

Besides participating in Matta's group, Pollock joined his newfound friends in playing Surrealist parlor games. The stubborn nonjoiner sat in a circle with Motherwell, Baziotes, and their wives and drew blindfolded. He also played a game called "Male and Female": a sheet of paper is passed around a group and each person adds a random anatomical detail to create androgynous monsters. "Eventually," Motherwell once said, "we realized it was really sort of nonsense," and the group was disbanded. But Pollock seems to have gotten something from it. He was soon to produce a painting called *Male and Female*, which was probably titled after the game.

———

In 1942 Pollock produced only three paintings, but it is generally agreed that they mark his arrival at creative maturity. It took him twelve years to reach this point, and the results were impressive. One of the first things one notices about his 1942 paintings, as a group, is their size. Whereas previously his canvases had tended to be small—his early *Self-Portrait* had measured a tiny 5" x 7"—his new paintings were very large. *Male and*

Female is a vertical canvas standing about six feet high. The *Moon Woman* is just under six feet. *Stenographic Figure,* a horizontal painting, is five and a half feet long. Clearly Pollock was feeling more sure of himself, and for good reason.

Stenographic Figure (Fig. 13) is a semiabstract painting that appears to show a reclining female nude. Several critics believe that the painting actually shows two figures—a man and a woman—and they may well be right. The disagreement over the painting's subject matter seems somehow appropriate, for ambiguity is a theme of the work. Rather than creating a human figure, Pollock has given us mere hints of one. A blue triangle evokes a woman's head. Two red rings beneath it suggest breasts. A series of cursive black lines might be legs—or are they ribs? Nothing is spelled out. The woman is rendered in shorthand. There's a lot of tension in this work—between figuration and abstraction and, compositionally, between the large, binding rectangles that make up the painting's background and the free-form calligraphy activating its surface. *Stenographic Figure* is a good example of Pollock's increasing ability to thrash out his preoccupations in pure painterly terms; and that this work owes quite a bit to both Picasso and Miró does not diminish its strength.

Pollock continued to borrow heavily from artists he admired, while simultaneously nullifying almost all traces of his debt. *Male and Female (Fig. 14),* which is widely considered his first major work, bears some startling similarities to a painting by Kandinsky called *Striped.* (Pollock could have seen it at the Nierendorf Gallery in 1942.) The Kandinsky painting *(Fig. 15)* is an abstraction dating to 1934, when the artist was living in Paris. It consists of five vertical panels, or "stripes," against which floats a whimsical arrangement of circles, crescents, spirals, and other geometric forms. Two of the forms vaguely suggest human figures: one looks like a helmet and the other resembles a fetus. These two forms bear a distinct likeness to the two head-forms in Pollock's *Male and Female,* which, like the Kandinsky, also consists of five vertical stripes. That Pollock seems to have borrowed his format from Kandinsky is of course less important than what he did with it.

Male and Female is a symbolic portrait of a man and a

woman. The female figure, which occupies the left side, is a joyous tribute to femininity. Her head is a black half-moon, decorated with long-lashed eyes stacked one on top of the other à la Picasso. Her chest is a curving red mound, and her womb is a fat red curlicue. The male figure, like the female, embodies genital characteristics: whereas she is curvilinear, he is rigid and erect. The man and the woman stand close together, each one fully conscious of the other's presence. She bats her eyes at him, and he in turn opens his mouth as if about to gobble her up. Plainly he desires her, and a sense of sexual urgency is further suggested by the frenzied overlay of scribbles, scrawls, and Navaho-like slash markings that activate the picture's surface. In the upper left corner, black, white, and yellow pigment is splashed freely onto the blue background, an early herald of the "drip" paintings Pollock was to begin five years later.

The scholarly literature on this painting has centered, rather peculiarly, on what the work reveals about the artist's sexuality. Several writers believe that the figure on the left is actually a man; the red curlicue has been described as a limp phallus. Similarly, the figure on the right has been interpreted as a woman, the mechanical maw now a symbol of female aggression. Still other writers discern male and female characteristics in both figures; William Rubin, for instance, feels that the painting attests to the "bisexuality or sexual unsureness present in all individuals and usually repressed to the lowest levels of the psyche."

Indeed, there is struggle in *Male and Female*, but it seems too easy to describe it as only a sexual struggle. On another level altogether, Pollock's primary conflict here seems to be with his European predecessors. It is not accidental that he turned to Kandinsky to help him structure this painting, for Kandinsky was a master of geometric purity. But such purity is nowhere evident in the Pollock painting. It has a crude, brutish look that borders on barbarism. Pollock borrowed Kandinsky's structure and proceeded, so to speak, to deconstruct it. This painting was executed in 1942, a crucial moment, when Europe had already produced its last great art movement (Surrealism) and American painters finally had a chance to show the way ahead. *Male and Female*

seems to be saying that the future of art belongs to this country, not only in its hostile treatment of Kandinsky (a founder of abstract painting) but in its powerful invocation of American culture: the man and the woman in the painting look like Navaho Indian totems.

That Pollock completed only three paintings in 1942 was probably the result of external demands on his time. Since February he had been working full time for the War Services program. And as taxing as that was, by the end of the year he was spending most of his workday just trying to figure out exactly where he was supposed to be working. In October Pollock and Lee were both assigned to a vocational school in Brooklyn—to learn how to manufacture aviation sheet metal. A week after Pollock started school he was ordered back to Manhattan to rejoin the War Services program. He arrived in time to learn that President Roosevelt was folding the WPA, which was no longer needed since the war was creating work for millions. Lee was fired on the first day of 1943, and Pollock was fired January 30.

Soon after Pollock lost his job his mother visited him from Connecticut. "Well the WPA folded up," she noted to Charles on February 10. "Lee was let out the first of the year—she is taking a drafting course gets $17.00 a week while learning. Jack is going to take a course of some sort. He has done several new paintings very nice since I was down in November. Hope he finds something to do soon."

It was an exasperating time for Pollock, for besides being out of work, he suddenly found himself without any art supplies. (The Project had provided him with free supplies.) Hoping he might be able to trade a painting for some supplies, he went to talk to Lou Rosenthal, who owned a store on Eighth Street, across from his apartment. Was Rosenthal willing to trade twenty-five dollars worth of supplies for one Pollock painting? No, the businessman told him, he couldn't afford to; his apartment was already cluttered with paintings by unknown artists. So Pollock went to talk to Joseph Mayer, another art store owner, but Mayer too said he couldn't afford to trade.

In his frustration Pollock apparently took to shoplifting.

Mayer was in his store one day when he spotted Pollock stuffing tubes of oil paints into his coat pockets. "Can I help you?" Mayer asked. Pollock continued to pocket the paint. "No, thank you," he said arrogantly, "I can help myself." The kindly businessman didn't stop Pollock as he left the store.

In February 1943, after a month of unemployment, Pollock found a job with Creative Printmakers, a silk-screening shop on Eighteenth Street. He was hired on the night shift as "a squeegee man," a job that consisted of sitting at a table and pushing a squeegee back and forth across a screen to print designs on scarves and plates. It was tedious work, but he seemed not to mind it too much, relieved to have found any work at all.

Within two months Pollock heard about a job he very much wanted. The Baroness Hilla Rebay, director of the Museum of Non-Objective Art (later the Solomon R. Guggenheim Museum), was hiring young artists to help run the museum and was offering them monthly stipends in addition to free art supplies. In April Pollock went for a job interview—the museum was then located in a townhouse on East Fifty-fourth Street—and brought along a few of his paintings with hopes of impressing the baroness. In the course of the interview Rebay asked Pollock whether he had brought a résumé. A résumé? But weren't his paintings his résumé? A few days later Pollock sent the baroness a truly inventive résumé. "Biography" he scrawled sloppily at the top of a sheet of paper. After stating that he was born in Cody and had studied at the Art Students League, Pollock divided the page into three sections—"past," "present," and "extended present." He defined his past as "Subjective realism" and "Subjective abstract." He defined his present as "Subjective [and] Spacial reality," which branched off into "non-objective spacial intensity." He was open-minded about his future: "?"

He got the job.

At the museum Pollock assisted with sundry tasks. He ran the elevator, counted visitors as they came in, and was often sent down to the basement to help make frames. While he tended to his chores with his usual eagerness to make himself of use, he quickly acquired a reputation as a braggart. The painter and mu-

sician Leland Bell, a coworker at the museum, later recalled his amusement at Pollock's frequent jabs at the collection. Pointing to an Arp, Pollock would say, "I could do an Arp easy!" He was particularly hard on Paul Klee, who was fond of making small pictures and whose work, Pollock claimed, lacked monumentality. "Klee? I could do a Klee easy." No one took him very seriously.

From the day he started work, Pollock made a point of keeping out of the way of Baroness Rebay, a fanatical devotee of nonobjective art. She was a great promoter of Kandinsky and championed his belief that nonobjective painting was not so much an art movement as a mission to free people from material concerns. Businessmen in particular, the baroness believed, could benefit from abstract art, "as it carries them away from the tiresome rush of the earth."

The baroness required that all her assistants bring in their work on a monthly basis so she could criticize it. Pollock was glad to comply. For his first critique he brought in a drawing that was typical of his current style, combining Picasso-like figures with freely scrawled calligraphy. The baroness went rigid when she saw the drawing. With a long steel rod she pointed to a form that resembled a human figure. "This," she said in her German accent, "NO!" She tore his drawing in half.

But while the baroness was insulting Pollock, a much more influential member of the Guggenheim circle had already recognized his talent. Peggy Guggenheim owned a celebrated gallery called Art of This Century. The place was loathed by the baroness, who, as self-appointed guardian of Solomon Guggenheim's reputation, felt that his art-dealing niece had sullied the family name by propagating "mediocrity, if not trash."

No one in New York was to play a larger role as a collector, dealer, and art patron during the war years than Peggy Guggenheim. The daughter of a copper magnate, she had grown up on East Seventy-second Street with the Stillmans and Rockefellers for neighbors but fled her staid surroundings at an early age. She spent the twenties in Paris, where she became part of a group of American expatriate artists and writers, and in 1938 she opened a

gallery in London called Guggenheim Jeune. But she was much more interested in collecting art than selling it and soon closed the London gallery with hopes of starting her own museum. Her goal, she once said, was to buy "a picture a day," and she more or less succeeded at it. As the war raged she tramped through the studios of Paris with a shopping list in hand and quickly amassed a leading collection of modern art.

After arriving in New York as a refugee from the war—she managed to get her art collection to the U.S. by shipping it as "household goods"—Peggy Guggenheim opened a gallery, in October 1942, on the top floor of 30 West Fifty-seventh Street. (She called it a gallery-museum and, with characteristic stinginess, charged all visitors twenty-five cents admission.) Frederick Kiesler had helped her design the place, and it was surely the most eccentric-looking gallery in New York. In the room reserved for abstract art, frames were taken off paintings, paintings were taken off walls, the walls themselves were removed; the art, supported by brackets, jutted into space against a backdrop of undulating blue linen. A second room, reserved for Surrealism, was comparatively conservative, featuring concave walls of unfinished wood and a lighting system that alternately illumined and darkened bizarre exhibits; in one corner a whirring motor brought small Klees into view for ten seconds each. Art of This Century quickly became the principal gathering place for the European artists who were living in New York.

Peggy Guggenheim's detractors used to say that her success as an art collector was due entirely to her advisers, who told her what to buy. This is no doubt true, but it is to her credit that she chose her mentors well. Her primary advisers in New York were Marcel Duchamp, Alfred Barr—the visionary director of the Museum of Modern Art—and James Johnson Sweeney, an art and literary critic who was close to Barr and would soon be hired by him to direct the museum's painting and sculpture department. Another key figure at the gallery was a man named Howard Putzel, a rotund, nervous, chain-smoking art dealer from San Francisco who had worked for Peggy Guggenheim in Paris as a commission buyer and was her assistant at Art of This Century. He was to become a close friend of Pollock and Lee.

One day in 1943 Pollock and Motherwell visited the gallery along with Matta, who introduced the two young painters to Peggy Guggenheim. Their names were not unknown to her; Matta had been trying to convince her for some time to visit their studios and consider showing their work at the gallery. Peggy was not averse to the idea of showing Americans alongside Europeans. She was then working out the details of a large collage show scheduled for April. Dozens of artists were participating, including Kurt Schwitters, Ernst, Picasso, and Braque, all of whom had worked widely in collage and the last of whom is often credited with inventing it, in 1912. There was no reason why the show couldn't include some Americans as well, and acting on the advice of Matta, Peggy asked Pollock and Motherwell whether they were interested in submitting some collages to the show. Neither of the two had ever made a collage, nor was it something they had aspired to. But they had no intention of turning down the chance to exhibit at the most exciting gallery in New York. Collage? We love collage!

For purposes of mutual support Motherwell suggested to Pollock that they work together. Pollock agreed, which, says Motherwell, "I regard as something of a miracle, when I think of what a loner he was." Pollock even volunteered his studio as a work site, since it was the better equipped of the two. Together the two artists tore, pasted, and composed, trying to make collages that could hold their own next to Picasso's and Braque's legendary combinations of sheet music, cardboard, chair caning, playing cards, and the like. For Motherwell the experience turned out to be a revelation. He appreciated the quick-drying properties of collage, which eliminated the tedious problem of having to wait for oil paint to dry before going back to revise—and Motherwell's art had so far been a process of ongoing revision. He would make many more collages and was later to emerge (as was Lee Krasner) as a master of the medium. For Pollock the experience was also a revelation. He realized he did not like making collages. No amount of tearing or pasting could allow him to capture the spontaneity or immediacy of even one brushstroke or one sketched line. Unimpressed with his finished product, Pollock applied a match to the paper and burned the edges.

Pollock's debut at Art of This Century was somewhat anticlimactic. His name was misspelled as "Pollach" on the exhibition announcement, and his participation went unnoticed by the press, save for a lone reviewer who described his collage as "nice." The collage didn't sell. After the show closed, Pollock took it home and threw it away.

It was the last time Pollock went unnoticed. In April 1943, while the collage show was still on exhibit, Peggy Guggenheim announced plans to hold the first of her annual "Spring Salons," a competition-exhibition for young artists working in America. Advertisements were placed in the art magazines soliciting recent work by artists under thirty-six, and a jury was selected. Pollock, in accordance with the rules, dropped off a painting at the gallery, choosing to submit his *Stenographic Figure*. (At the time it was titled simply *Painting*.)

On the day set aside for jurying, Mondrian was the first of the judges to arrive at the gallery. As Peggy Guggenheim busily arranged paintings around the room, Mondrian walked over to Pollock's *Painting* and spent a few moments looking at it. "Pretty awful, isn't it?" Peggy asked him. "That's not painting, is it?" She came back twenty minutes later to find Mondrian still looking at the Pollock. "There is absolutely no discipline at all," she said. "This young man has serious problems . . . and painting is one of them. I don't think he's going to be included." She told Mondrian that she felt a little bit awkward about rejecting Pollock from the "Spring Salon" because Matta had endorsed him highly and so had her assistant, Howard Putzel. As Peggy Guggenheim talked, Mondrian continued to study the Pollock. He turned to her suddenly. "Peggy," he said. "I don't know. I have a feeling that this may be the most exciting painting that I have seen in a long, long time, here or in Europe."

As the other jurors arrived—they included Duchamp and Alfred Barr—Peggy ushered them across the room one by one. "I want you to see something very exciting," she told them. "It's by someone called Pollock."

The "Spring Salon for Young Artists" opened at the gallery in May 1943, and the show marked a turning point for Pollock. He

was singled out in the press as the one painter in the show—there were more than thirty altogether—who possessed unmistakable talent. Jean Connolly, who was then living with Peggy Guggenheim, reported in *The Nation* that the painting had made the jury "starry-eyed." A more objective viewer, Robert Coates, of *The New Yorker*, felt that most of the work in the show was amateurish but that "in Jackson Pollock's abstract 'Painting,' with its curious reminiscences of both Matisse and Miró, we have a real discovery."

The painting did not sell, but Pollock had accomplished the more difficult task of winning critical acclaim. Only six months earlier Peggy Guggenheim had listened almost indifferently as Matta had informed her of the existence of several young American painters whom she might want to include in the frequent group shows at the gallery. Now she was considering turning over the entire gallery to the work of one American—she was thinking of giving Pollock a one-man show. But first she needed to know whether he was capable of producing enough good paintings to justify such an event. She made an appointment to see his work, arranging to stop by his studio on the afternoon of June 26, the day the "Spring Salon" closed.

Peggy Guggenheim arrived at 46 East Eighth Street on Saturday afternoon, as scheduled. She knocked. No one answered. Where could they possibly be? she wondered angrily.

That morning Pollock and Lee had attended the wedding of their friend Peter Busa at his apartment in the Village. Only a few minutes before the nuptials began, Pollock, who was supposed to be best man, had helped himself to a few drinks and proceeded to fall facedown on the living room floor. He was dragged into a bedroom, where he slept contentedly until the ceremony ended, at which point Lee, in a frantic mood, rushed to his side to shake him into consciousness and remind him that today was the most important day of his life: Peggy Guggenheim was coming to his studio to see his work and decide whether she should give him a one-man show. As Pollock mumbled incoherently, Lee grabbed him by the arm and took him to a drugstore to sober him up with coffee.

Pollock and Lee were nearing their building when they spotted Peggy Guggenheim coming out. She was furious. Where had Pollock been? How dare he waste her time! When Peggy Guggenheim accompanied Pollock and Lee back upstairs, she became even angrier. The first thing she saw in the living room were paintings signed "L.K." She started to shriek. "L.K.! Who's L.K.? I didn't come to see L.K.'s work." It was the beginning of a long animosity between the two women. As Lee once said, never again could she look at Peggy Guggenheim without thinking, What a bitch.

Peggy Guggenheim didn't know quite what to make of Pollock, and she once described him as a "trapped animal who never should have left Wyoming." She wasn't sure whether she should give him a one-man show. For one thing, there was his personality. "Pollock himself," she has written, "was rather difficult; he drank too much and became so unpleasant, one might say, devilish, on these occasions." Furthermore, she was unsure about his art. She confided her reservations to James Johnson Sweeney. Peggy told Sweeney that the reason she was vacillating about Pollock was that she found his art "a little bit wild" and she didn't know how to classify him. That was reason enough, Sweeney assured her, to give Pollock a show.

Peggy also took up the matter with Howard Putzel. Like Sweeney, Putzel felt it was obvious that Pollock deserved a show. Furthermore, Putzel suggested that Pollock be offered some sort of monthly stipend so he could quit his job at the Museum of Non-Objective Art, where he was still the elevator man, and devote himself to painting on a full-time basis.

That July, Pollock received the news he had been hoping for. Peggy Guggenheim was going to give him a one-man show and had optimistically scheduled the opening date for November 9. That would make it the second show of the gallery's fall season; the first was "Masterworks of Early de Chirico."

For all her initial hesitation, Peggy Guggenheim gave Pollock her all-out support once she had decided she wanted to show him at the gallery. A more enthusiastic patron he could not have found anywhere. Besides offering him a one-man show, Guggen-

heim also invited him to paint a mural for the hallway of her apartment. Furthermore, she offered him a one-year contract by which he would receive a fixed income of $150 a month and a settlement at the end of the year if he sold more than $2700 worth of paintings. If he failed to sell that amount, Peggy was to receive pictures to make up the difference. In effect, for $150 a month, Peggy Guggenheim was to receive his entire output. At the time it sounded like a generous offer, and Pollock gladly accepted.

With those details settled, Lee took off for Huntington, Long Island, to spend a few days with her ailing father. Pollock kept her abreast of his dealings with the gallery. "Dear Lee," reads an undated postcard. "Have signed the contract and have seen the wall space for the mural—its all very exciting. See you Saturday. Love Jackson."

For Pollock it was a moment of triumph. For the first time since arriving in New York thirteen years earlier his future looked bright and his past had been vindicated. He had proved himself to everyone—to his brother Charles, beside whom he had seemed so lacking; to his classmates at the League, who said he couldn't draw; to Hans Hofmann, who had questioned his methods; to the Surrealists, who had dismissed him as an uncultivated American; to the Baroness Hilla Rebay, who had dared to tear his drawing in half. "Dear Baroness," Pollock wrote on July 21, 1943, "I wish to thank you for the two criticisms of my work that you gave, and for the very pleasant period of employment." This letter of resignation, coauthored by Lee, was sure to make the baroness seethe. "The Museum, 'Art of This Century,' has contracted my work for a one-man show this coming November, for which I must prepare. Trusting you found my services at the museum satisfactory, I am sincerely, Jackson Pollock."

9 *Mural*

1943-45

In July 1943 Pollock began to prepare for his first one-man show, which was scheduled to open in less than four months. The prospect of a show galvanized his fiercest energies, and the next few months were a wonderfully creative time for him.

In a mood of supreme confidence Pollock decided he would also tackle the mural commissioned by Peggy Guggenheim for the hallway of her apartment. "I want to have the painting finished for the show," he noted proudly to his brother Charles. Pollock wasn't sure yet what the subject of his mural would be. He knew only that the mural would be very large, about twenty feet long and nine feet high, and that it would be painted on canvas instead of on a wall. That way, as Duchamp had advised Peggy Guggenheim, it wouldn't have to be abandoned in case she moved.

Pollock soon realized that his studio was not large enough to accommodate a twenty-foot-long painting. So he decided he would knock down the wall separating his and Lee's studios,

which would increase his work space by about a third. Lee was not sympathetic. "And where am I supposed to work?" she wanted to know. They were having an argument about it when the sculptor Reuben Kadish stopped by to visit. Kadish, a friend of Pollock's since high school, suggested to Lee that she consider setting up a studio in a vacant room adjoining his own studio, on West Twelfth Street. Lee accepted the offer.

With that matter settled, Pollock took a sledgehammer and knocked down the wall separating the two studios. Lee assisted, and the two of them spent a long night packing the debris into metal buckets and hauling it downstairs. By July 29 Pollock was ready to start the mural. "I have it stretched now," he wrote to Charles. "It looks pretty big, but exciting as all hell."

For all his eagerness, Pollock decided he wasn't ready to start the mural after all. He needed more time to think about it. When his show opened, the twenty-foot-long canvas would still be blank.

The next few months were one of the most productive and prolific periods in Pollock's life. He completed about ten new paintings, among them such well-known works as *The She-Wolf*, *The Guardians of the Secret*, and *The Moon-Woman Cuts the Circle*. While there is no duplication from one painting to the next, one feature they do have in common is their intense invocation of American Indian culture. In *Moon-Woman* a bright red head decorated with mock war paint is wearing an elaborate feather headdress. Other works are abundant with such Indian staples as arrows, totemic stick figures, and a whole repertory of geometric markings, such as slash marks, X's, and zigzags. It seems entirely fitting that Pollock chose to borrow from American Indian art at this point in his career when he was struggling for a style that was free of European influence and eager to establish his independence of his predecessors abroad. Pollock once said in an interview: "An American is an American and his painting [is] naturally qualified by that fact, whether he wills it or not."

One of the more significant paintings from this period is *The She-Wolf* (*Fig. 16*), a large, horizontal canvas in which Pollock

took Picasso's bull by the horns. The image consists of a massive, heavily outlined beast set against a frenetic background of splashed and splattered pigments. While the title of the painting evokes the she-wolf of popular mythology—the foster mother of Romulus and Remus—Pollock's she-wolf is not a reference to a specific myth. In fact, she is not even a she-wolf. For despite the painting's title, the so-called she-wolf actually seems to consist of two animals backed into each other. On the left is a bull, an obvious reference to Picasso, a celebrator of the bullfight. On the right side of the painting is another image altogether—a buffalo as pictured on a United States nickel. The two animals are linked together by a fat red arrow that travels horizontally from the heart of the bull to the head of the buffalo, and this "heartline arrow motif," as it's known in Navaho art, is one among many allusions to Indian art in the painting. *The She-Wolf* is the offspring of a European bull and an American buffalo; it's Pollock's defiant answer to the legendary beast images of Picasso.

Pollock never offered interpretations of his paintings, and in the case of *The She-Wolf* he actively opposed interpretation. "*She-Wolf* came into existence because I had to paint it. Any attempt on my part to say something about it, to attempt explanation of the inexplicable, could only destroy it." The statement was made to Sidney Janis, the art dealer, who in 1943 was putting together a book called *Abstract and Surrealist Art in America*. He planned to reproduce *The She-Wolf* and had asked Pollock to submit a short statement about it.

If Pollock's statements offer little insight into his work, his titles are outright misleading. He never titled a painting until he was done with it, and it was not unusual for him to have Lee or his friends title his paintings for him. One day he was sitting in his studio with a newly completed work when James Johnson Sweeney stopped by to visit. Sweeney was still standing in the doorway when the painting caught his eye. Four totemic figures flank a central oval. Inside the oval a stick figure battles a beast. As Sweeney studied the painting Pollock told him, "That's Moby Dick."

"Pasiphaë," Sweeney shouted out across the studio, ignoring Pollock's comment. "That's Pasiphaë."

"Who the hell is Pasiphaë?" Pollock asked. Sweeney told Pollock about Pasiphaë, wife of King Minos, mother of the Minotaur by her intercourse with a bull.

"What's wrong with Moby Dick?" Pollock asked.

"It's a cliché," Sweeney said.

Pollock gave in and named the painting *Pasiphaë.*

It is worth noting that before he met Lee, Pollock left most of his paintings untitled. The few paintings he did title were given literal names, such as *Cotton Pickers, Red Barn, Menemsha Pond, Seascape,* and so on. In 1943 Pollock began giving his paintings highly evocative titles, such as *Pasiphaë, She-Wolf, Moon-Woman Cuts the Circle.* But his titles confuse things more than they clarify them, for his *She-Wolf* doesn't depict the foster mother of ancient Rome any more than his *Pasiphaë* depicts the Minoan queen. Some critics refer to Pollock's work of the early forties as his "mythological paintings," and while the label is certainly as valid as any other, Pollock's subject matter had no specific connection to ancient Greco-Roman myths.

While Pollock was working on major paintings such as *The She-Wolf* and *The Guardians of the Secret,* he was also turning out small compositions. He often worked on more than one project at a time. In the course of a single day he might interrupt work on a large painting—to allow the pigment to dry or to give himself time to think about it, and undertake a pencil-and-ink drawing or a gouache or a small painting. Among the smaller compositions belonging to this period are four untitled abstractions in which Pollock experimented with the technique of dripping paint. In a work that has been catalogued as *Composition with Pouring II (Fig. 17)* a wiry tangle of black-and-white lines, apparently dripped from a brush, is set against a background of swirling forms. The small composition possesses none of the soaring lyricism that distinguishes certain of Pollock's famous "drip" paintings but it does establish his interest in the technique that became his primary one four years later.

While Pollock was preparing for his show, Peggy Guggenheim was tending to the business side of his career. She wrote a press release and sent it out to newspapers and magazines. ("Jackson Pollock is 31 years old . . .") She also had a four-page

exhibition catalogue printed, which included an appreciation by James Johnson Sweeney. Lee was commandeered to fold and address the catalogues and spent several days at the gallery assisting with various projects, including the hanging of the show. Pollock himself was indifferent to the installation and chose not to get involved. It took all of Lee's patience to work alongside Peggy, an heiress of singular stinginess. One day Peggy noticed that Lee had made a mistake in addressing some envelopes that were already stamped. She bawled her out for wasting a few cents worth of postage.

One person whom both Pollock and Lee liked was Howard Putzel, the assistant at the gallery. He often stopped by 46 East Eighth Street to complain to Lee about the latest abuse he had suffered at the hands of his employer. "I don't know how I can face another day," Putzel would moan as Lee nodded sympathetically. Lee was more than willing to indulge him in his complaints as Putzel was one of the earliest admirers of Pollock's work and was very devoted to the artist. One day when James Thrall Soby, a curator at the Museum of Modern Art, stopped in at the gallery and spoke highly of a few Pollocks he spotted in the storage room, Putzel sent off a kind note: "Soby dropped in this afternoon and is mad about your work. . . . [He] predicts you'll be THE new sensation of the season, and moreover, that, unlike past season's sensations, you'll last."

About a week before the opening of his show Pollock received a copy of the exhibition catalogue. The introduction by James Johnson Sweeney, the first text devoted to Pollock's work, offered ardent praise. "Pollock's talent is volcanic. It has fire. It is unpredictable. . . . It is lavish, explosive, untidy. . . . What we need is more young men who paint from inner impulsion without an ear to what the critic or spectator may feel—painters who will risk spoiling a canvas to say something in their own way." At the same time Sweeney acknowledged that there was room for improvement: "It is true that Pollock needs self-discipline."

Pollock sent Sweeney a gracious thank-you note on November 3. "I have read your forward to the catalogue, and I am excited. I am happy—The self-discipline you speak of—will come, I

think, as a natural growth of a deeper, more integrated, experience. Many thanks . . ."

For all his polite comments, Pollock was upset by Sweeney's claim that he lacked self-discipline. Didn't Sweeney understand how much discipline it took to paint a work like *The She-Wolf?* His work may have *looked* undisciplined, but the effect was entirely deliberate. Pollock was determined to prove to Sweeney that he had erred in his judgment. He returned to his studio and painted a work called *Search for a Symbol,* an elegant, decorative painting in which biomorphic shapes float against a creamy pink background. Without waiting for the painting to dry, Pollock carried it up to the gallery and showed it to Sweeney. "Here," he said, "I want you to see a really disciplined painting." *Search for a Symbol* was added to his show at the last minute and put on display, as an amused reviewer noted, "wet with new birth."

Pollock's first show at Art of This Century, November 9–29, opened to generally favorable reviews. While some critics found his canvases overbearing, they were so impressed by Pollock's raw energy that they were willing to disregard the flaws. There was a crude strength to his painting that no one could ignore. With time and experience, it was believed, Pollock had a chance of becoming one of the best painters in the country. Already he had a distinctive style.

Robert Coates, of *The New Yorker,* who one year earlier had admired Pollock's entry in the "Spring Salon," remained enthusiastic. "At Art of This Century," he wrote, "there is what seems to be an authentic discovery—the paintings of Jackson Pollock . . . the effect of his one noticeable influence, Picasso, is a healthy one, for it imposes a certain symmetry on his work without detracting from its basic force and vigor."

Clement Greenberg, the reviewer for *The Nation,* found "surprise and fulfillment" in Pollock's first show. He was particularly fond of the smaller works, which he considered among "the strongest abstract paintings I have yet seen by an American." The larger paintings, by comparison, struck him as less successful, but perhaps that was inevitable given the enormity of Pollock's am-

bitions. "Being young and full of energy," Greenberg noted, "he takes orders he can't fill." Greenberg was to emerge as Pollock's most ardent champion after his second show.

In the three weeks in November that the show remained on view Pollock and Lee stopped by the gallery almost every day to see if any sales had been made. Lee often stayed for a few hours, hoping she might be able to interest visitors in Pollock's work. Peggy Guggenheim too worked hard at trying to sell the paintings, if for no other reason than that she was paying Pollock $150 a month and was eager to recoup the expense. But by the time the show closed, none of the paintings had sold. Pollock was poor as ever, and his hardest work still lay ahead—he had to finish the mural commissioned by Peggy Guggenheim.

With his show behind him, Pollock returned to his studio, prepared to devote himself to the mural. He had stretched the canvas in July 1943. Now it was December. The canvas was still blank.

When Pollock emerged from his studio after his first day of work on the mural, Lee didn't ask him how it had gone. She could tell from the look on his face that he had been unable to get started. The next day went no better. Nor the next week. Pollock couldn't get started.

He had wanted to paint a mural for many years, ever since his student days when he had visited Benton's studio and watched admiringly as his teacher produced giant murals about American history and culture. And though the mural movement of the thirties was over, Pollock's feelings about mural painting hadn't changed; it had never been his intention to paint a mural that would advance some social cause. What appealed to him about murals was their enormous size; a mural is larger than life. As one who was obsessed with a need to prove himself, Pollock no doubt saw mural painting as the ultimate test of his artistic prowess.

But the enormous size of the piece of canvas in his studio posed some very specific problems. How would he structure the mural? How would he manage to sustain tension over so large an area? Only a few weeks earlier Clement Greenberg had written in

The Nation that Pollock's one flaw as a painter was his inability to handle size. The larger the paintings in the show, Greenberg had written, had been less successful than the smaller ones, as the artist "takes orders he can't fill . . . spends himself in too many directions at once . . . [his] space tautens but does not burst into a picture."

After two weeks Pollock told Lee that her presence was interfering with his work. He asked her to leave the apartment for a few days. She went to Huntington to visit her parents. When she returned three days later the canvas was still blank.

Late one afternoon in January 1944 Lee's friend John Little stopped by the apartment. He found Lee pacing nervously. "Jackson's supposed to deliver that mural tomorrow," she told him. "He hasn't even started it."

When John Little stopped by the next day Lee was all smiles. "You won't believe what happened," she said. "Jackson finished the painting last night."

After a month of agonizing, Pollock had painted the mural in one night.

Working with both a stick and a brush, Pollock had created a syncopated arrangement of swooping black lines and whirling forms that charge the picture surface with "allover" intensity (*Fig. 18*). At first glance the mural looks wholly abstract, but the swooping black lines are actually totems, or stick figures, that have been partly obscured. There are eight of them altogether, and they are shown in profile, their back legs raised slightly as if in midstep. In their static gait across the canvas the tall, spindly figures give the painting structure, like a scaffold that holds everything in place. Against this rigid framework is a swirling overlay of turquoise and yellow strokes, each one intertwining with the next and uniting the figures in a rhythmic ritual procession. *Mural*, with its circling strokes and giant arabesques, is a cross between painting and drawing that hints at the crucial role of line in Pollock's future work.

Pollock was proud of the mural. When Peggy Guggenheim sent a truck to his studio in January 1944 to pick it up and transport it to her apartment on East Sixty-first Street, Pollock rode

JACKSON POLLOCK

along with the truckers. He arrived at Peggy's apartment to find that his patron was not home—she was at the gallery—but had assigned the job of installing the mural to her friends Marcel Duchamp and David Hare. It took the two artists only moments to figure out that the mural was eight inches too long for the designated spot in the hallway. Duchamp asked Pollock a touchy question: Would he mind very much if they cut eight inches off the end of the work? Pollock said it was fine with him.

While Duchamp was installing the mural, Pollock went upstairs to the living room and helped himself to a drink. He proceeded to get very drunk and telephoned his patron at the gallery to ask her to come home. Peggy said she couldn't come home; she had work to do. When Pollock called again, Peggy slammed down the phone. He continued to call throughout the afternoon and pleaded with her to come home. In her autobiography Peggy Guggenheim recounts that at one point during that difficult afternoon Pollock took off his clothes and wandered stark naked into a party being given by her roommate Jean Connolly. As the guests looked on in dismay, he urinated in the fireplace. Like other stories told about Pollock, this is one that many of his acquaintances are fond of telling but none quite remember having witnessed.

With his show behind him and the mural completed, Pollock entered a severe depression. He took to heavy drinking and surrendered to feelings of self-loathing and despair. A typically distressing incident occurred one day when Hofmann came to visit along with two of his students, Fred Hauck and Janet Chase, whom he hoped to introduce to Pollock. Halfway up the four flights they heard a loud noise. An easel came tumbling down the stairs. Hofmann picked it up and carried it back to the studio, where he found Pollock in frightening condition. When Hofmann asked him why he had thrown the easel down the stairs, Pollock started to cry. "I hate my easel," he said. "I hate art."

Pollock's drinking made Lee angry. She punished him by ignoring him, forcing him into solitude. When her friend Betsy Zogbaum came to pick her up for a dinner party one night, Lee didn't bother to introduce Pollock. "Who's that?" Zogbaum

asked. "He's nobody," Lee snapped. When Harold and May Rosenberg visited from Washington, where the critic was working for the Office of War Information, they too wondered about the silent man in the apartment. "I thought he was the handyman," May Rosenberg recalled. "I thought he had come to frame her paintings or stretch her canvas."

Pollock could no longer turn to his psychotherapists for help. He had stopped seeing Violet de Laszlo, the doctor who had gotten him out of the war, the previous summer at Lee's insistence. If he hadn't stopped drinking after five years of counseling, Lee figured, he never would. She told him the expense wasn't worth it. Dr. de Laszlo once commented: "Lee was very possessive and so she was threatened by anyone else on whom he was dependent."

Lee took Pollock to see her own doctor, a homeopathic physician named Elizabeth Hubbard. She practiced on East Seventy-third Street, on the ground floor of a brownstone. Pollock immediately liked the doctor, a vivacious, gray-haired woman who believed she could restore him to well-being with herbal remedies. Regardless of the efficacy of such treatments, Dr. Hubbard was one person whom Pollock could trust. Like his other doctors, she accepted him as he was, and he felt comfortable in her presence. He often stopped by her office to talk to her; if Dr. Hubbard was busy with another patient, she would send him upstairs to her apartment until she was free to see him. Her daughter remembers coming home from school on several occasions to find Pollock in the living room, and the sight was upsetting. "He'd just sit there with his head in his hands," she said.

In the meantime Pollock's artistic reputation was growing steadily. He did very little to promote himself, but that wasn't necessary; other people did it for him. One of his champions was his friend Robert Motherwell, who was also exhibiting at Art of This Century. He reviewed Pollock's show in the February 1944 issue of *Partisan Review*. "Certain individuals represent a younger generation's artistic chances," Motherwell wrote, going on to say, rather grimly, that most of those individuals were destined to fail. "There is disease and premature death; hunger and alcoholism

and frustration; the historical moment may turn wrong . . . the hazards are so great that no more than five out of a whole young generation are able to develop to the end." He felt that Pollock represented one of those five. He didn't say who the other four were.

That same month a magazine called *Arts and Architecture* ran an interview with Pollock, and the piece was accompanied by pictures of *The Guardians of the Secret* and *Search for a Symbol*—though the pictures and titles of the paintings were reversed. The editor of the magazine was a friend of Peggy Guggenheim's, and his original idea was to have Pollock write a short essay about his work. Pollock "obviously wanted to accept," Motherwell has recalled, "but was shy about his lack of literary ability." So Motherwell proposed that the magazine do an interview, with Motherwell asking the questions anonymously and Pollock supplying answers. In his enthusiasm Motherwell ended up answering several of his own questions.

Another devoted friend and supporter was James Johnson Sweeney. As a member of the acquisitions committee at the Museum of Modern Art, he had been trying for some time to convince the museum to purchase Pollock's *She-Wolf*. Alfred Barr was definitely interested, but felt that the price, $650, was too high. The museum asked Peggy whether she was willing to let the painting go at $450. She refused, and the deal appeared to be off. But the museum reconsidered in April 1944, when Sweeney wrote an article on contemporary art for *Harper's Bazaar* and illustrated it with a large color reproduction of *The She-Wolf*. On May 2 Pollock received a telegram: "VERY HAPPY TO ANNOUNCE THE MUSEUM BOUGHT SHE WOLF FOR $600 TODAY. LOVE PEGGY GUGGENHEIM."

It was Pollock's first sale to a museum and may well have been his actual first sale since the days, a decade earlier, when the Bentons had purchased an occasional work from him so he'd have some money. Pollock of course was pleased, but it was hard for him to get excited about the sale given his dismal financial situation. "I am getting $150 a month from the gallery, which just about doesn't meet the bills," he wrote to Charles that May. "I will have to sell a lot of work thru the year to get it above $150.

The Museum of Modern Art bought the painting reproduced in Harpers this week which I hope will stimulate further sales."

Motherwell once commented that Pollock was the first artist he knew "who mostly talked not about art but about money." Indeed, he was far from indifferent to money, and part of the reason was that he had so little of it. He didn't even have a telephone yet. As one who was determined to live off his painting—as opposed to teaching or holding any other job—Pollock worried constantly whether he could actually support himself. What would he do if Peggy Guggenheim decided not to renew his one-year contract? Would he have to get a job? What was he qualified to do? In the spring of 1944 Peggy Guggenheim renewed his contract for another year at the same figure of $150 a month. Pollock was relieved. His brother Sande noted that to Charles: "since it lets him paint he doesn't complain."

One day that spring Pollock was visited by Benton, who was in New York on business. The two painters had not met for several years but had followed each other's careers in the pages of the art magazines. Benton had read the reviews of Pollock's first show and was pleased to see that his onetime protégé was getting some recognition. But it turned out to be an awkward reunion. When Pollock took Benton into his studio, he knew that his former teacher could not possibly approve of the work he was doing. Benton always had hated abstract painting, and there could be no doubt that he would find Pollock's work distasteful. Benton tried to be polite. As Pollock later noted: "Said he liked my stuff but you know how much meaning that has."

From New York, Benton returned to Kansas City, where he soon started work on a new project—a mural for Harzfeld's, a department store downtown. Pollock, by comparison, was about to unveil before the New York art crowd a mural of nearly identical proportions. Benton's artistic reputation had faded; Pollock's was on the rise. It was their last meeting.

———

With the arrival of summer Lee suggested that they take a vacation, perhaps rent a house in Provincetown, Massachusetts. She had been there before while studying with Hofmann, who

moved his art school from New York to Cape Cod every summer. It was precisely the presence of Hofmann and his young disciples that made Pollock reluctant to visit Provincetown; he had no intention of spending his summer in "Hofmann's art colony," as he derisively referred to the town. On the other hand, he liked that part of the country and had wonderful memories of his summers in Chilmark. He once told an interviewer, "I have a definite feeling for the West—the vast horizontality of the land, for instance—here only the Atlantic gives you that." Provincetown, he decided, was fine after all.

They traveled to Cape Cod by train. Hofmann met them at the station in Hyannis and insisted on giving them a tour of the area before heading for Provincetown. But it didn't turn out as planned. In his enthusiasm to show them some dunes, Hofmann drove directly onto sand, and his car got stuck. When he stepped on the gas the tires sank deeper and deeper. Hofmann started cursing in German, but Pollock, for once, was unagitated. He calmly got out of the car and lifted it out of the sand. For the rest of the summer, whenever Pollock's name came up in conversation Hofmann had only praise: "Pollock? He's strong. He lifts cars."

It was a lazy, restless summer for Pollock and Lee. They lived in a rented house on Back Street, which was behind Commercial Street and a short walk from the beach. While both of them were hoping to get some painting done—they had shipped up rolls of canvas from New York—they got no further than talking about it. They hiked the dunes, swam in the ocean, collected shells along the shore. Pollock became friendly with the landlady and helped her almost every day with her gardening. "We get in for a dip at least once a day—" Pollock noted contentedly to his brother Sande and his mother in Connecticut. "I've taken a crew cut and look a little like a peeled turnip—or beet. Haven't gotten into work yet. . . . What are the chances of your coming up? Let us know and we'll work out some arrangements."

The summer was not without friction. Lee resented that Pollock had invited his family to visit. When his mother and brother Sande and sister-in-law Arloie showed up in late August for a

two-week visit she had them stay at a motel rather than put them up at the house. And she didn't get along with Pollock's friends either. One day Pollock introduced her to Bernard Schardt, a former classmate of his from the League who was also summering in Provincetown. Schardt and his wife immediately sensed that "Lee didn't think we were good enough for her," and the two couples never got together again. Such was Lee's devotion to Pollock's career that she had no time or patience for people who couldn't help him get ahead. But like most artists' wives, she was a gracious, charming hostess to collectors, art dealers, and anyone else who could advance his career. That summer she invited Howard Putzel to spend two weeks in Provincetown. He had just left his job at Art of This Century and was planning on opening his own gallery that fall. Putzel stayed in the house.

Besides inviting his family for a visit Pollock also extended an invitation to Ed and Wally Strautin, an older couple who had once been his neighbors on Eighth Street. Ed was a house painter and Wally was his wife. "So let us hear from you—telling, you will be up," Pollock urged the couple at the end of August. "It is really grand now not quite as warm as it was—but still damned swell swimming." The couple never visited, but the invitation stands as a reflection of Pollock's hospitality.

Back in New York, Pollock was feeling sufficiently composed to consider taking on a new project. He listened with interest when his friend Reuben Kadish suggested that the two of them try making prints under the guidance of Stanley William Hayter. A British-born artist, Hayter had an appreciable reputation as a master printmaker, painter, and the founder of a workshop called Atelier 17, which was then located on Eighth Street. He was highly esteemed among the Surrealists for his so-called automatic engravings, in which sweeping rhythms of line give off an illusion of spontaneous creation. Hayter's workshop was patronized by many of the Surrealists, which made it the sort of clubby place that Pollock tried to avoid. But Kadish felt sure that Pollock could benefit from Hayter's instruction. "I inveigled Jackson into trying it," Kadish recalled, "because I thought his work had a kinship to Hayter's prints." His opinion was shared by an *Art News* critic

who had noted, two years earlier, that Pollock resembled Hayter "in his general whirling figures."

In the course of the next six months or so Pollock visited Atelier 17 on many occasions. Most of the time he went in at night, after the other artists had departed. He sometimes stopped by in the afternoon, but only if the workshop wasn't crowded. The sculptor Peter Grippe (who took over Atelier 17 when Hayter returned to Paris), was once working on a print when he glanced up at the window and saw Pollock standing outside. He was peering in, looking to see who was there. Then he walked away.

At Hayter's workshop Pollock learned how to make engravings. He worked mainly with a burin, a short angled steel tool used to cut lines into metal plates. It was slow, tedious work. If Pollock applied too much pressure to the burin, the point broke. If he didn't apply enough pressure, the plate swung around into another position. The eleven engravings he completed at the workshop reveal his difficulty with the technique. His lines are generally awkward and labored, as if he drew them with his left hand. "He wasn't happy with the prints," recalled Reuben Kadish, who helped Pollock pull a few trial proofs. Hayter, who also helped Pollock print proofs, suggested that he consider printing editions, but Pollock wasn't interested. He took the plates home and dumped them in a corner of his studio. They would be printed posthumously when Lee discovered them two decades later.

Pollock's earlier experiences with printmaking had been equally unfulfilling. During his years on the Project, he had occasionally visited the printing workshop of Theodore Wahl, on Minetta Lane. "Jackson wasn't very serious," Wahl recalled. "He'd come up and say, 'I want to do a lithograph.' I'd flip him a stone, and he'd make a lithograph. He'd come back six weeks later, and it was the same thing. The problem with Jackson and printmaking is that you have to stick to the medium in printmaking—it's very technical—and Jackson couldn't stick to the medium." One day Wahl left Pollock alone in the workshop for a few hours. By the time he returned Pollock had abandoned his lithograph in frustration and helped himself to some tubes of oil

paints from the storage closet. He was sitting at a small wooden table peacefully absorbed in a painting he was working on. As Wahl drew closer he was dismayed to realize that Pollock was using the tabletop as his painting surface. Wahl was furious and threw him out of the workshop.

Pollock was not a master craftsman. His efforts at printmaking turned out to be no more rewarding than his earlier efforts at sculpture and collage. The more technical a medium, the more difficulty he seemed to have. His hands were not graceful; his fingers were large and thick. His right hand was missing part of the index finger lost in his boyhood accident with an ax. It was almost as if his hands got in the way of his art, preventing him from recording sensation as quickly as he experienced it. Genius is often defined as a range of ability, but Pollock's genius lay in his narrow, obsessive need to escape the technical demands of art. The medium he chose was painting, but even as a painter, he needed to escape the rules of his craft. Appropriately, he soon would invent a painting method that freed his hands from contact with the canvas.

In the fall of 1944 Pollock began to prepare for his second show at Art of This Century, scheduled for the following March. The twenty or so paintings belonging to this period are generally considered less successful as a group than his 1943 paintings, but it is easy to be sympathetic to them when one takes account of what Pollock was aiming for. At this juncture he turned his attention to questions raised by his mural—mainly, how could he achieve the "allover" intensity of the mural while freeing his art from the constraints of the human figure? Over the next two years Pollock continued to paint the human figure while subjecting it to decompositions of frightening intensity. The result finally was that the towering totems in his mural were broken down into anatomical fragments, such as disembodied eyes that glare from the interstices of abstract images. Pollock was struggling toward abstraction, or pure painterly expression. By breaking down the symbolic figures that had inhabited his art since he first saw *Guernica* five years earlier, Pollock also can be said to have been struggling, on a psychological level, to dispense with Picasso's in-

fluence. His 1944–46 paintings are the most violent of his career.

Among the paintings dating to this period are five untitled works that have horses as their subject, and they appear to have been inspired by the equine imagery in Picasso's "bullfight paintings." A painting that has been catalogued as *Horse* (*Fig. 19*) shows a mournful-looking horse lying on the ground, trying to raise itself on its forelegs. Clearly the beast has been injured. At Pollock's hands, Picasso's creation has been twisted and truncated and made to suffer both anatomical and spatial dislocations. Even the use of color is violent, with purples, reds, and golds colliding senselessly. Picasso often said that one must destroy in order to create. Of course he didn't mean that one must destroy Picasso, but that was the project that Pollock seems to have set for himself in *Horse* and many other works.

One of the better-known paintings from this period is *There Were Seven in Eight* (*Fig. 20*), a large horizontal canvas that measures about twelve feet long. The image consists of a wiry tangle of lines set against a background of densely packed forms. The lines, which do not delineate anything, slash the picture's surface with unruly force, and one senses Pollock's eagerness to be able to express himself here solely through line. As in his *Mural*, Pollock apparently started this work by painting eight totems, and parts of them are still visible; eyes, heads, and various anatomical fragments hover in the background. *Seven in Eight*, which is hard not to find labored and overwrought, was difficult for Pollock to complete. He kept going back to it, over a period of several months, to rework the surface. When Lee came into his studio one day and suggested that the painting looked finished, Pollock disagreed. He said he was trying to "veil the image," to cover up any remnants of the figures in the background. He would continue to work in a "veiling the image" style for the next two years, until he had phased out figuration altogether and found a way to express himself through line alone.

———————

In the year that had passed since Pollock had completed his mural hardly anyone had seen it, for the simple reason that it was

hanging in his patron's apartment. But Peggy Guggenheim was eager to show it off to the public, convinced that it represented the high point of Pollock's career. On March 19, 1945, she held a reception at her apartment to coincide with the opening of Pollock's second show. More than a hundred guests showed up, and their reactions to the mural were predictably varied.

Among the viewers was Clement Greenberg, of *The Nation.* He admired the mural enormously. "People said it just went on and on like glorified wallpaper," he later said. "I thought it was great." Seeing the mural marked a decisive moment in Greenberg's intellectual life. It was then that he realized that Pollock was something more than just a talented painter; he was nothing less than the one American artist who could give expression to the complex innovations of European painting while still managing to look quintessentially American. "I wanted to see somebody come along," Greenberg explained, "who could match the French so we could stop being minor painters over here." In Pollock he found him, an artist who had not only assimilated Picasso but had gone on to challenge him. Pollock, he believed, was the legitimate heir to the modernist tradition in art.

The two men became close friends. With Pollock's encouragement, Greenberg began stopping by 46 East Eighth Street on a regular basis to look around his studio and see how his work was progressing. A painter himself, Greenberg had grown up in the Bronx, the son of Polish immigrants, and had started drawing at the age of four. "I copied everything," he once said. "I got pretty good at working from nature." After studying literature at Syracuse University, he started his writing career as a literary critic but turned to art criticism in the forties, writing reviews for *The Nation* and longer, more theoretical pieces for *Partisan Review.* He had great confidence in his own opinions, which gave him an air of authority in spite of his ordinary appearance and polite, sometimes clumsy manner. On his visits to Pollock's studio Greenberg was always terse in his appraisals. "Mmm," he might say, admiring a painting, "that's good." He provided Pollock with essential support at a time when few people realized how good Pollock was.

Reviewing Pollock's recent show, Greenberg was ardent in his praise. "Pollock's second one-man show at Art of This Century establishes him, in my opinion, as the strongest painter of his generation and perhaps the greatest to appear since Miró. . . . There has been a certain amount of self-deception in School of Paris art since the exit of cubism. In Pollock there is absolutely none, and he is not afraid to look ugly—all profoundly original art looks ugly at first."

But no other critics seemed to like the show—not the few who reviewed it. Maude Riley, writing in *Art Digest,* confessed straightforwardly: "I really don't get what it's all about." Parker Tyler, writing in the Surrealist magazine *View,* likened Pollock's designs to "baked macaroni." Robert Coates, of *The New Yorker,* an early admirer of Pollock's work, didn't bother reviewing his second show and neither did the critic of *The New York Times.*

By the time Pollock's second show closed, none of the paintings had sold. And in spite of the flurry of publicity he was still fairly obscure. "At this time," Greenberg explained, "Ben Shahn was considered the best living American painter, and he sold." Pollock, by comparison, had yet to be invited to participate in such routine art events as the Whitney Museum "Annuals," yearly surveys of contemporary art that generally featured well over a hundred artists. That Greenberg had singled out Pollock as "the strongest painter of his generation" had little effect on his reputation, for Greenberg had no more of an audience than Pollack did. Five years would pass before Pollock and his tiny supporting cast traveled from the periphery of the art world to center stage.

Figure 1. *Camp with Oil Rig,* undated. (Courtesy Mr. and Mrs. John W. Mecom, Jr.)

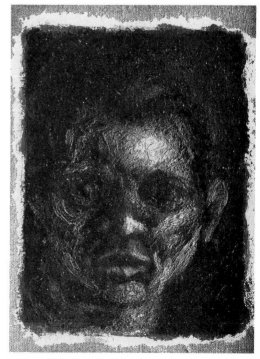

Figure 2. *Self-Portrait,* undated. (The Pollock-Krasner Foundation)

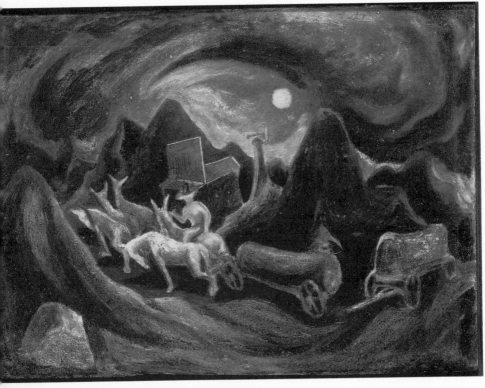

Figure 3. *Going West,* undated. (National Museum of American Art, Smithsonian Institution; gift of Thomas Hart Benton)

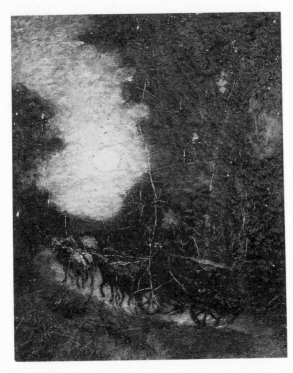

Figure 4. Albert Pinkham Ryder, *Sentimental Journey.* (Courtesy Canajoharie Library and Art Gallery)

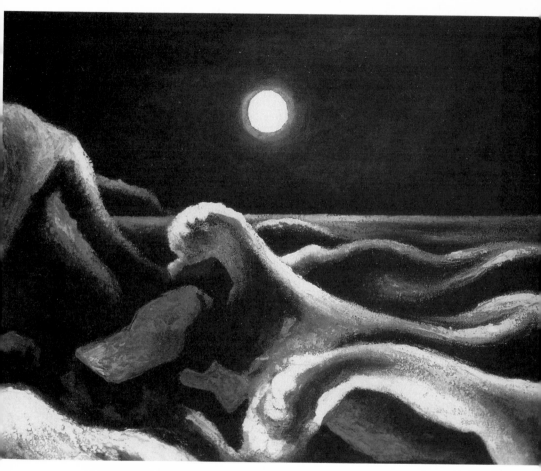

Figure 5. Thomas Hart Benton, *Moonlight Over South Beach.*
(Courtesy Sotheby's, Inc., New York)

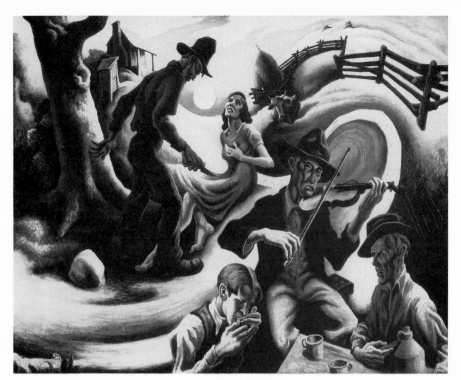

Figure 6. Thomas Hart Benton, *The Ballad of the Jealous Lover of Lone Green Valley*, 1934. (Spencer Museum of Art, University of Kansas)

Figure 7. Mural study for Greenwich House, detail, undated. (Courtesy Charles Pollock)

Figure 8. *T.P.'s Boat in Menemsha Pond*, undated. (The New Britain Museum of Art; gift of T. P. Benton)

Figure 9. *Seascape*, 1934. (The Pollock-Krasner Foundation)

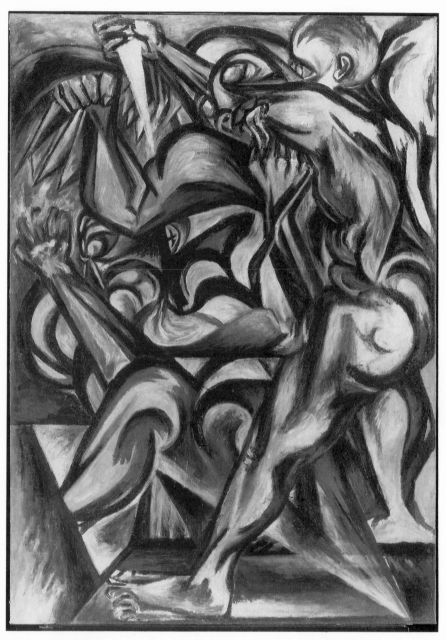

Figure 10. *Untitled (Naked Man with Knife)*, undated. (The Tate Gallery, London)

Figure 11. Eskimo mask, Hooper
Bay Region of Alaska. (University
Museum, University of Penn-
sylvania)

Figure 12. *Birth*, undated. (The Tate Gallery,
London)

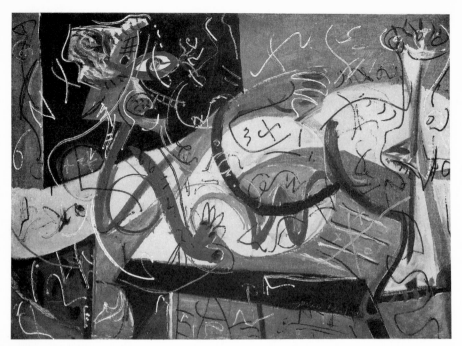

Figure 13. *Stenographic Figure,* 1942. (The Museum of Modern Art, New York; Mr. and Mrs. Walter Bareiss Fund)

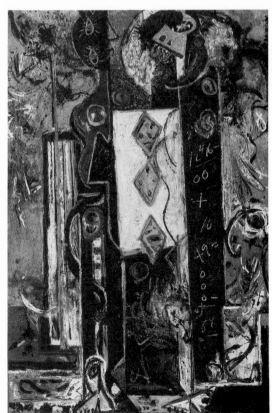

Figure 14. *Male and Female,* 1942. (Philadelphia Museum of Art; gift of Mr. H. Lloyd)

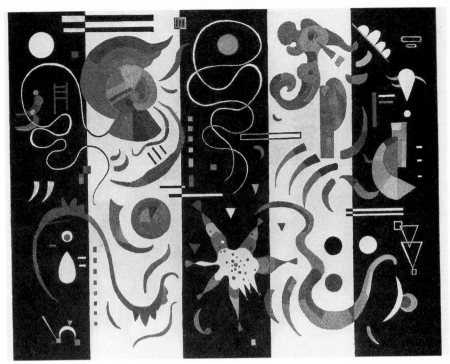

Figure 15. Vasily Kandinsky, *Striped*, 1934. (Solomon R. Guggenheim Museum)

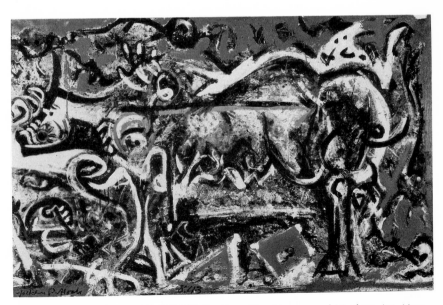

Figure 16. *The She-Wolf*, 1943. (Collection, The Museum of Modern Art, New York)

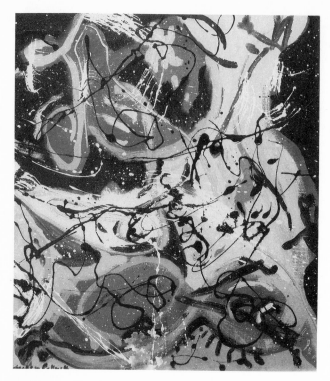

Figure 17. *Composition with Pouring II*, 1943. (Hirshhorn Museum and Sculpture Garden, Smithsonian Institution)

Figure 18. Pollock in front of the portable mural commissioned by Peggy Guggenheim. (Courtesy Archives of American Art)

Figure 19. *Horse* (Private collection)

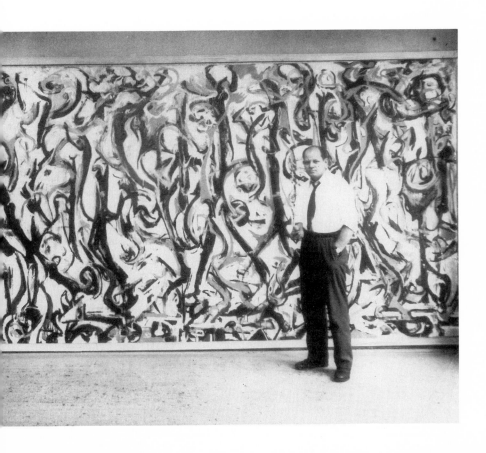

Figure 20. *There Were Seven in Eight,* ca. 1945. (The Museum of Modern Art, New York; Mr. and Mrs. Walter Bareiss Fund and purchase)

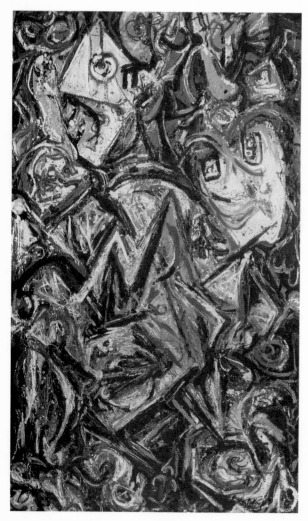

Figure 21. *Troubled Queen,* undated. (Private collection)

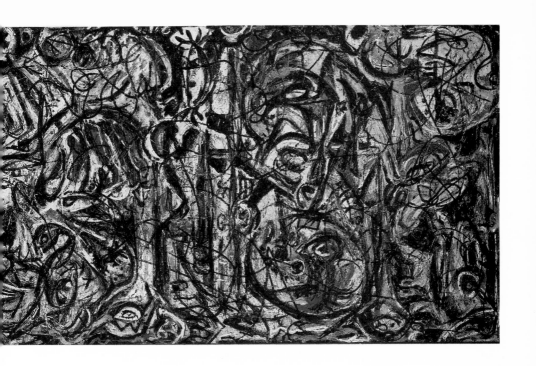

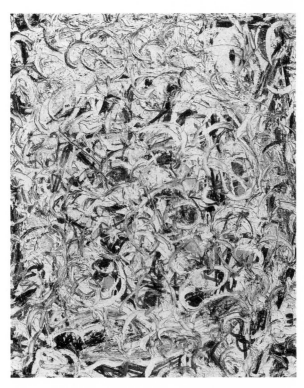

Figure 22. *Sounds in the Grass: Shimmering Substance,* 1946. (The Museum of Modern Art, New York; Mr. and Mrs. Albert Lewin and Mrs. Sam A. Lewisohn funds)

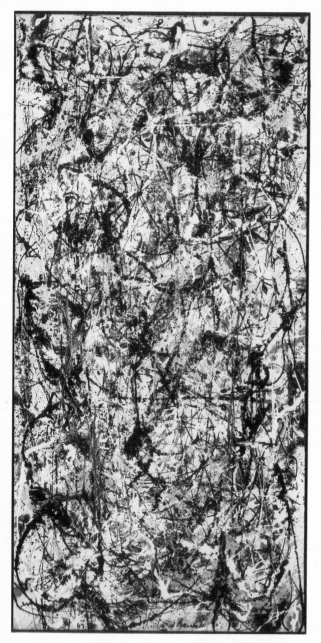

Figure 23. *Cathedral,* 1947. (Dallas Museum of Art; gift of Mr. and Mrs. Bernard J. Reis)

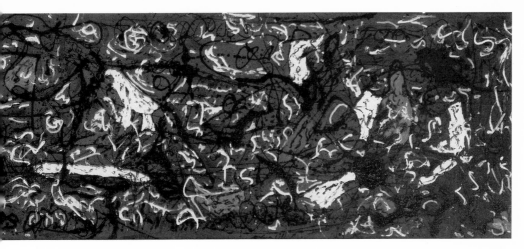

Figure 24. *White Cockatoo*, 1948. (Private collection)

Figure 25. Pollock pretends to paint *Number 32, 1950* for photographer Rudy Burckhardt.

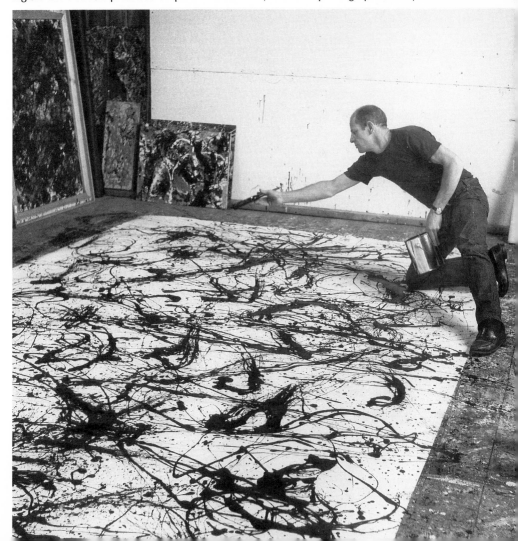

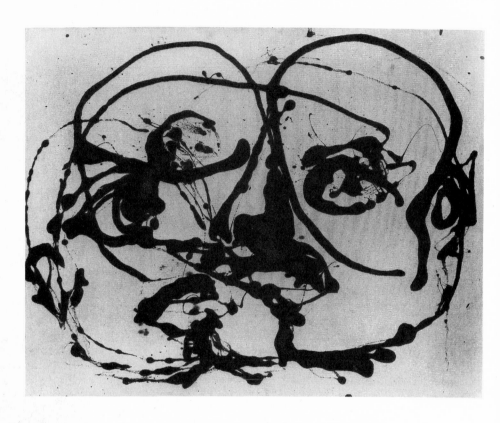

Figure 26. *Number 24, 1951*, 1951. (Private collection)

10 The Springs

1945-46

In August 1945 Pollock and Lee took the train to East Hampton to spend a few weeks with their friends Reuben and Barbara Kadish. The Kadishes were renting a two-room fishing shack in Amagansett, a tiny village near the eastern tip of Long Island. While the house was not very comfortable—it was small and cramped, with a leaky roof and no piped water or electricity—any inconveniences were more than compensated for by the splendor of the surroundings. Pollock took immediately to the area, with its pristine beaches and flat, tranquil land, and his vacation was a happy time for him. "I just remember this lovely person and what a nice time we all had," Barbara Kadish once commented. To her husband Pollock was an endearing friend. One day the two men went fishing, and Pollock hooked a blowfish. As he reeled it out of the water the fish puffed up. "Jack was jumping up and down," Kadish recalled. "He was so excited."

The Kadishes had rented the summer house with hopes of purchasing their own house in the area, and though Pollock had

no such intention, one day he and Lee accompanied their hosts on a house-hunting outing. A real estate agent showed them a farmhouse on Fireplace Road, in the hamlet of The Springs. As Lee was looking around the house she started thinking that maybe she and Pollock should move to the country. Certainly it would help him overcome his drinking, she thought, as he seemed so relaxed in the country. But when she suggested that they sublet their Eighth Street apartment and rent a house in Springs, Pollock looked astounded. "Leave New York?" he said. "Are you crazy?" Lee admitted it was a preposterous idea. "I don't even know why I said it."

But moving to Springs no longer seemed crazy after Pollock returned to his hot fifth-floor walk-up on Eighth Street. The moments of well-being he had enjoyed in the country vanished upon his return, and he began to think seriously about moving to Long Island. Several people he knew were already living out there. The critic Harold Rosenberg had a summer place in Springs, and Robert Motherwell had recently bought some property in East Hampton, where he was building a house.

Within a week Pollock had made up his mind: he and Lee were buying a house in the country. Lee was surprised by his decision. "Jackson," she reminded him, "we have no money to buy a house. Have you gone out of your mind?" The next morning they were on the train.

They returned to Fireplace Road, in Springs. The house they had seen the previous week had been sold but another had become available. The Victorian farmhouse, built in 1893 by Henry Hale Parsons, stood two and a half stories, with pale-brown shingles and a wide-eaved roof. In back, wetland meadows stretched for nearly a mile before sloping off into the waters of Accabonac Creek. To Pollock and Krasner it was a perfect country house, complete with five grassy acres and a small barn that could be converted into a studio. The house had neither heating nor plumbing, but these were minor details to the excited young couple. No obstacle seemed insurmountable at the moment, not even the $5000 price. After making a few inquiries, they found a local bank willing to give them a mortgage of $3000 if they could

produce $2000. Pollock and Lee had forty dollars between them.

Back in New York, Lee paid a visit to Peggy Guggenheim, who was sick in bed with the flu. Lee told her all about the dream house in Springs, then mused wistfully, "If only I had two thousand dollars." Peggy Guggenheim reminded Lee that she ran a gallery, not a bank.

Lee returned the next day. She told Peggy Guggenheim she felt sure that Pollock would stop drinking if he moved to the country. "Why don't you get a job?" Peggy Guggenheim suggested. Lee said she couldn't get a job because she had to paint. "Why don't you go ask Sam Kootz for the money?" Peggy asked sarcastically, referring to an art dealer who had opened up a gallery down the street earlier that year and to whom several of her artists had already defected. So Lee went to talk to Sam Kootz. Sure, Kootz said, he'd be happy to lend Lee the money—providing, of course, that Pollock switched to his gallery. Lee brought the news back to Peggy Guggenheim. She exploded. "How could you do such a thing? And with Kootz of all people! Over my dead body you'll go to Kootz!"

Peggy Guggenheim eventually agreed to lend them the $2000, for the simple reason that "it was the only way to get rid of Lee." She worked out a new two-year contract with Pollock effective March 1946. Pollock's monthly stipend was raised from $150 to $300, with Peggy Guggenheim subtracting $50 a month until the loan was paid off. In exchange she acquired ownership of his entire output save for one painting a year, which Pollock was allowed to keep for himself. (This contract became the basis of a well-publicized lawsuit in 1961, when Peggy Guggenheim charged that Pollock had defrauded her by failing to turn over fifteen paintings created during the two-year period. She sued Lee for $122,000. The suit dragged on for four years before Peggy Guggenheim decided to drop the charges and accept in settlement two Pollock paintings then worth $400.)

That October, a few weeks before their move, Pollock and Lee decided that they wanted to get married. As one who could be thoroughly conventional in matters of social conduct, Pollock felt it would be wrong to live together without the sanction of

marriage in the conservative community of Springs; the neighbors might take offense. Lee agreed, and one day she asked him when they'd be going to City Hall to apply for a marriage license. "City Hall?" Pollock said. "That's a place to get a dog license. This has got to be a church wedding or else no wedding at all."

Lee, who had been raised as an Orthodox Jew, was adamantly opposed to marrying in a church. Pollock was sympathetic and offered to get married in a synagogue. Lee set about searching for a rabbi willing to marry them, but she couldn't find one, and arguments erupted. She felt exasperated by Pollock's insistence that they be married by a representative of organized religion—any religion. It seemed irrational to her, for as far as she knew, Pollock's parents not only failed to observe their faith but were "anti-religious—that's a fact." In later life she once commented that Pollock wanted to marry in a church to compensate for the lack of churchgoing in his childhood.

As to the question of whom they should ask to serve as the two witnesses to the ceremony, Pollock entrusted the matter to Lee. She eventually decided on May Rosenberg, a close friend of hers, and Peggy Guggenheim, who she felt should be included for business reasons. One never knew with Peggy, Lee reasoned; she might be insulted if they didn't ask her to participate, and surely they didn't want to alienate Pollock's patron. Besides, Lee thought, if Peggy served as a witness, maybe she would offer to give them a reception. It would be good for Pollock's reputation.

Bubbling with excitement, Lee walked over to Tenth Street to see May Rosenberg. "Jackson wants to get married," she told her, "and he wants you to be a witness."

"Harold and I would love to be witnesses," May Rosenberg told her.

"No," Lee said, "not Harold, just you."

Next Lee went up to Fifty-seventh Street to talk to Peggy Guggenheim, who said she'd be happy to be the second witness. But then a week later she realized that she had previously agreed to meet a collector for lunch on the day of the wedding. She told Lee she couldn't be a witness. "Besides," she said, "you're married enough."

When Lee told Pollock that Peggy Guggenheim had backed

out, Pollock said he was backing out too. If the wedding was going to be this complicated, the wedding was off. Lee ignored him, and she and May Rosenberg took care of the details. "I got out the phone book," May Rosenberg recollected, "and called every church listed. When they heard that an Orthodox Jew was marrying a Presbyterian, they weren't interested. Finally I tried the Dutch Reformed Church. They agreed to do it. I told them we wouldn't be having any people and we needed a second witness. They thought I was from out of town. Who in New York doesn't have two friends?"

On October 25, 1945, at one in the afternoon, Jackson Pollock and Lenore Krassner were married in a ten-minute ceremony at the Marble Collegiate Church, at Fifth Avenue and Twenty-ninth Street. May Rosenberg served as a witness. The second witness was August Schulz, a janitor who worked at the church. After the ceremony May Rosenberg took the newlyweds to Schrafft's for lunch.

———

The first Monday in November 1945 Pollock and Lee packed their belongings into a meat truck they had borrowed from May Rosenberg's brother, a butcher, and drove the hundred or so miles from New York to Springs. The rural hamlet would later become part of the most fashionable art colony in the country, but in 1945 the southern fork of Long Island was frontier territory compared to places like Woodstock or Provincetown. Its best-known painters were long gone. William Merritt Chase and Childe Hassam had settled in Southampton in the late nineteenth century, when painting from nature was still the object of art. Thomas Moran, who died in 1926, once had a studio in downtown East Hampton, where he painted panoramic views of the Rocky Mountains. The area was discovered by Surrealists during Word War II, when André Breton, Max Ernst, and their friends could often be spotted at Coast Guard Beach. As for the hamlet of Springs, the first settler from the New York art crowd was Harold Rosenberg. He liked to point out that he purchased his house in the year "1944 B.J.—Before Jackson."

Pollock and Lee spent their first months in Springs making

their new house habitable. They tore down walls and turned the first floor of the house into one big room. The floor was painted white enamel, which reflected the light and filled the room with brightness. Together they decorated, hanging paintings on walls, plants from the ceilings, and copper pots on the pegboard in the kitchen. They collected stones, shells, driftwood, glass shards, and curiously shaped gourds and displayed their finds on window ledges and tabletops. The upstairs had three rooms, one of which was sunny and spacious and faced Accabonac Creek. They chose it as their bedroom, furnishing it simply with twin beds and a heavy oak chest. A second bedroom, which faced north and looked out on treetops, became Pollock's temporary studio. Within a year he would move out into the barn.

Neither the fresh coats of paint nor the modest decorations could ease the harsh conditions under which Pollock and Lee spent their first winter in the country. The ramshackle farmhouse was chilly and drafty, and their only source of heat was a coal-burning stove in the kitchen. At night the house got so cold that the water in the toilet sometimes froze, and Pollock would have to melt it with a blowtorch in the morning. To make matters worse, it was hard to get coal for the stove, since wartime shortages persisted even though the war was over. "No coal as yet and wood burns like paper at $21 a cord," Pollock noted in a postcard to Ed Strautin, his former neighbor on Eighth Street, soon after his arrival.

In spite of the hardships, Pollock's earliest letters from Springs reveal a profound fondness for his new surroundings. "I opened the door this morning and never touched ground until I hit the side of the barn five hundred yards away," he wrote in the postcard to Strautin. "Such winds. It's all very nice, tho a little tuff on a city slicker."

His enthusiasm did not waver as the winter months wore on. "It was good to get your Xmas card," he wrote to Louis Bunce, who was now teaching art in Portland, Oregon. "How have you been—? how is the painting coming?—how about the west?— Lee and I are trying the country life for a while—we really love it here—a good feeling to be out of New York for a spell."

That Thanksgiving, Pollock's mother came from Connecticut to visit them, and her stay was the social highlight of his first season in the country. It was a quiet, solitary time for him, particularly because he did not own a car and had to limit his travels to places he could visit on foot or on a bicycle. But he did have one friend who lived nearby. Robert Motherwell owned four acres in East Hampton, where he was building a house from a Quonset hut with the help of the noted French architect Pierre Chareau. While working on the hut Motherwell was staying in a rented farmhouse in Springs. He and his wife Maria, a Mexican dancer, would stop by the Pollocks' a few times a week to drive them into town for groceries, and occasionally the two couples had dinner together.

Other than the Motherwells, Pollock had little contact with his neighbors during his first few months in the country. Springs was a close-knit community of about 360 people, and most of the families had been there for generations. They socialized regularly at meetings of The Springs Village Improvement Society, The Springs Brotherhood Society, and The Springs Chapel Society, the last of which sponsored weekly bingo games. Pollock, as one might expect, elected not to join any of the community groups, but he did meet a few of his neighbors at Dan Miller's general store, where farmers and fishermen congregated to drink pop and exchange gossip. The local residents, or "Bonackers" (named for Accabonac Creek), were curious about their new arrival. They had learned a little bit about him from Mrs. Elwyn Harris, who shared telephone number 492-002 with the Pollocks and knew that the quiet painter from New York could be surprisingly loquacious. "He used to drink a lot," Mrs. Harris once said, "and tie up my line talking to his artist friends from New York." Springs was one more place where Pollock was never quite at home.

Pollock's third one-man show at Art of This Century was scheduled to open in March 1946, only four months after he had moved to Springs. He prepared for it in an upstairs bedroom. The inconvenience of having to work in cold, cramped temporary quarters with a plumber installing pipes in an adjacent bathroom

and an occasional field mouse peeking in did not seem to hamper him. That first winter he completed eleven new paintings as well as some gouaches, working with speed and sureness and apparent indifference to the change in his surroundings.

Troubled Queen (Fig. 21), a large vertical painting that measures about six feet high, is a violent picture that shows two decapitated heads emerging from a thicket of slashing lines. One of the heads is a triangle pierced by a single eye. The other head is heart-shaped, with two square eyes, a smear of a mouth, and a troubled expression that suggests she is the queen of the painting's title. And she has good reason to be troubled. She appears to be suffocating, as if choked by the fat, zagging lines and broken arcs that glut the picture surface and squeeze out any semblance of space. Paint is jabbed on thickly, enhancing the sense of airlessness that pervades the painting. It's as if the artist feels entrapped by the style in which he is working, and one senses Pollock's eagerness here to dispense with figurative images and achieve a means for direct and spontaneous expression. The title of the painting—as well as such other titles as *The Little King, White Angel, High Priestess, Moon Vessel,* and *Circumcision* (named by Lee)—carries poetic or mythological weight, but the poetry lies in the crude handling of paint rather than in the subject matter.

Pollock's third show at Art of This Century (April 2–20) opened to disappointing reviews. Only two critics bothered to review it, and neither was particularly admiring. Clement Greenberg, writing in *The Nation*, confessed to feeling let down by Pollock's latest work and thought that none of the pictures in the show measured up to certain of his earlier works. But Greenberg still managed to come through with praise: "What may at first sight seem crowded and repetitious reveals on second sight an infinity of dramatic movement and variety. One has to learn Pollock's idiom to realize its flexibility. And it is precisely because I am, in general, still learning from Pollock that I hesitate to attempt a more thorough analysis of his art."

Pollock and Lee visited New York for two weeks when his show opened at the beginning of April. They had been gone from

New York only seven months, but the city to which they returned was a different place. The war was over, and New York was no longer the home of the international avant-garde. The Surrealists had gone back to Europe, and Peggy Guggenheim was planning on closing the gallery and joining them. Paris was still the fountainhead of modern art, "and every move made there is decisive for advanced art elsewhere," Greenberg wrote in 1946. Once again American art students were signing up to study at the Académie Julian or Bourdelle's Académie de la Grande Chaumière, and older painters who had started their careers during the Depression, when they had been too poor to afford the obligatory stint in Montmartre, were planning extended trips abroad. Pollock, by comparison, had no interest in going to France. "Everyone is going or gone to Paris," he noted to his friend Louis Bunce. "With the old shit (that you can't paint in America). Have an idea they will all be back."

In the three years that had passed since Peggy Guggenheim had arranged to give Pollock his first show, she had added the names of many other young Americans to the gallery roster. Baziotes had his first show in October 1944 and was followed that fall by Motherwell and the sculptor David Hare. Mark Rothko had his first show in January 1945. So too there were shows by Charles Seliger, Richard Pousette-Dart, Robert De Niro (the actor's father), and Janet Sobel, a grandmother from Brooklyn. There were so many shows by American artists that some of the Europeans had left the gallery in disgust and gone to Samuel Kootz's place down the block. To Pollock, who kept abreast of the goings-on at the gallery, the art of his American contemporaries was of definite merit, which helps explain his sentiment that New York had become as vital an art center as Paris. "Baziotes, I think, is the most interesting of the painters you mentioned," he noted to a friend that spring. "Gorky has taken a new turn for the better. . . . Gottlieb and Rothko are doing some interesting stuff—also Pousette-Dart."

But his strongest praise was reserved for primitive art. "The Pacific Islands show at the Museum of Modern Art ["Arts of the South Seas"] tops everything that has come this way in the past

163

four years." One wonders what show he was thinking of four years earlier—perhaps the American Indian show that he had seen with John Graham in 1941.

During their trip to New York, Pollock and Lee stayed at their former apartment at 46 East Eighth Street, their pied-à-terre for the next five years. The front part of the apartment had been taken over by James Brooks, a reserved, soft-spoken painter from St. Louis who had worked on the Project during the thirties and had recently returned to New York after three years in the army. Pollock liked the quiet midwesterner but ended up angering him practically every night by coming home drunk and causing a stir. Jay Pollock, who had taken over the other half of the apartment, would calm things down. Jay had played football in high school, and Jackson knew better than to antagonize his older brother. "Jack would get pie-eyed and start arguing," Jay once said, "but I told him right off I wouldn't stand for that kind of thing. Jack sometimes looked like he was real aggressive, but he was chicken." But Jay was willing to indulge his kid brother in other ways. One day Jackson asked Jay whether he could have a collection of Navaho blankets and rugs that his brother had purchased in a crafts shop in Los Angeles, offering to give him a painting in exchange. Jay agreed to the trade, even though he knew he would never take the painting because he was not an admirer of Jackson's work.

Back in Springs, Pollock felt anxious. His last show had closed on April 20, 1946, and his next show was scheduled to open on January 14, 1947, leaving him less time than usual to prepare. He couldn't blame the poor scheduling on Peggy Guggenheim. He had specifically requested that she try to give him one more show before she closed her gallery, even if it meant having to return to his studio and produce a new body of paintings before he was quite ready. Faced with the pressures of the studio, Pollock's house in the country and the work it demanded of him suddenly became a burden. "The work is endless—and a little depressing at times," Pollock complained the first week in June. "Moving out here I found difficult—change of light and space—and so damned much to be done around the place. But I feel I'll be down to work soon."

But he did not get down to work, at least not immediately, allowing himself to be diverted by the pleasures of the country. He settled into a relaxed routine that consisted of sleeping as late as eleven, lingering groggily over a breakfast of coffee and Camel cigarettes, and setting off at about noon to fritter away the day. Almost every afternoon he rode his bicycle to the nearby Bossey farm, on Accabonac Road, to pick up groceries, such as butter and milk. On one of his visits to the farm he impulsively bought a baby billy goat, which he put in his backyard and allowed to nibble at the grass. On another visit he picked up a puppy, a white mongrel with wide patches of black around the eyes. He named it Gyp, after the dog of his childhood, and took it along on his daily outings in Springs.

That first summer in Springs everything filled Pollock with wonder, no matter how banal. "I pulled a ligament in my elbow," he wrote to Ed Strautin, "—so have learned to wipe my ass with my left hand—an entirely new sensation."

One by one, Pollock befriended his neighbors, whose initial suspicions about the painter from New York evaporated once they got to know him. One of his neighbors was an elderly woman named Mrs. Pigeon. By the time Pollock set off on his daily outings she had usually managed to finish a wash and hang it up on a clothesline. To Mrs. Pigeon's delight, Pollock would stop by on his bicycle and act astonished that she had accomplished so much in the morning.

Pollock occasionally visited the George Sid Miller dairy farm, which was a few hundred yards north of his property. He didn't have much to say to the dour old farmer but got along well with his farmhand Charlie. The two men could spend hours in the horse stable smoking cigarettes and admiring the animals. One day Charlie stopped into Dan Miller's general store and told its proprietor: "That old Pollock, lazy son-of-a-bitch, ain't he, Dan?" The grocer asked Charlie what he meant. "Why," Charlie said, "I never see him do a day's work, did you?" A few days later Dan Miller told Pollock that Charlie had called him a lazy son-of-a-bitch. Pollock was amused. "Instead of being offended," Miller once said, "he loved Charlie all the more. That's the kind of guy he was—he was a tremendous man."

With the arrival of summer Harold and May Rosenberg moved out to Springs from their apartment on East Tenth Street. They lived on Neck Path, around the corner from the Pollocks, and the two couples saw one another often. Pollock got along reasonably well with Rosenberg, an imposing, voluble, dark-haired poet who already had an appreciable reputation as an art and literary critic. Though trained to be a lawyer, he had been writing for *Partisan Review* since the late thirties and had gotten to know most of the artists in New York when he had worked on the Project as a mural painter. Compared to Greenberg, who had a polite, self-effacing manner, Rosenberg was as mighty in person as he was in his writing. He stood six feet four, spoke in a booming voice, and was a dazzling conversationalist with a knack for coining memorable phrases. (While working part time in advertising, he came up with the idea of Smokey the Bear.) He was "one of the intellectual captains of the modern world"—to borrow from Saul Bellow, whose protagonist Victor Wulpy is transparently modeled after Rosenberg.

Pollock and Rosenberg admired each other immensely, but both were too stubborn to admit it. They were fond of exchanging insults. Pollock used to say that Rosenberg's ideas got in his way as a critic. Rosenberg countered that Pollock painted "like a monkey." The critic was a frequent visitor to the Pollock household, and on a typical visit wouldn't even wait to sit down before taking note of one of Pollock's paintings and launching into a lecture. In his loud voice he might relate the painting to any one of a number of his favorite topics, ranging from the Eighteenth Brumaire to Kierkegaard's "despair of the aesthetic" to the teachings of Hans Hofmann. As Rosenberg talked, Pollock would become saturnine, and it was only a matter of minutes before he uttered his familiar accusation that Rosenberg knew nothing about painting and was "full of shit."

Pollock seemed to delight in rousing Rosenberg to anger and tended to behave rambunctiously in his presence. May Rosenberg recalls an afternoon when the two couples were driving to the beach and Pollock threatened to urinate in the car if Rosenberg didn't pull over. "You will wait until I pull over," Rosenberg

said like a stern parent, prompting Pollock to whine that he couldn't wait. On another occasion, in the middle of a dinner party at the Rosenbergs' home, Pollock drunkenly started harassing his host. "That's a lot of shit!" he shouted repeatedly, rudely interrupting a serious discussion. Rosenberg tried to ignore him but finally became exasperated and told him firmly: "You have clearly had too much to drink. What you need now is not to go on interrupting but to go upstairs and take a nap." Like a penitent child, Pollock smiled sweetly and headed upstairs.

Their first summer in Springs, Pollock and Lee entertained frequently. Clement Greenberg came out for the July Fourth holiday and was followed by various relatives, the art dealer John Bernard Myers, and Ed Strautin, their former neighbor of Eighth Street. Friends have consistently described Pollock as a gracious, accommodating host who seemed to enjoy having company. He was fond of taking visitors for a tour of his property as well as to his studio to look at his work. And he also liked to cook for his guests. While he was never an avid eater himself—smoking and drinking had the predictable adverse effects on his appetite— Pollock took pleasure in the ritual of preparing a meal. One of his specialties was spaghetti and meat sauce prepared according to a recipe he had learned from Rita Benton. But even "Rita's Spaghetti" was something of an extravagance to the impoverished couple, and they were much more likely to serve a clam dish made with clams they had caught in the bay behind the house. John Bernard Myers recalled the sight of Pollock coming through the back door with a bucket of fresh clams, looking rather pleased. Back in the kitchen, he knifed them opened with noticeable deftness. "The movement of knife into shell never faltered," Myers has written. "He seemed to open each mollusk with a single jab and slice."

Pollock's main project that summer was preparing the barn for use as a studio. For starters, he had the barn moved from behind the house to the northern side of the property, so that it wouldn't obstruct the view of the bay. Cleaning out the barn took all summer. The previous owner of the property, a land surveyor, had left the barn cluttered with heaps of broken ma-

chinery and scrap metal, and Pollock seemed to enjoy sorting through it. He discarded the machinery but kept the scrap metal, piling it up neatly in the backyard with plans of using it someday for sculpture. The small brown barn (it measured about eighteen by twenty-four feet) had neither heat, insulation, nor electricity, and Pollock decided he would leave it that way for the time being, even if it meant he could paint only when it was light out. His renovations to the barn were modest. He built cabinets and shelves for his materials, boarded up a window, and cut a new window that was above eye level so that he wouldn't be distracted by the view. On the walls of the barn he hung his own paintings.

At the end of the summer Pollock moved into the barn to prepare for his fourth show at Art of This Century. The result was fifteen new paintings that belong to two series—*Accabonac Creek,* which was begun in the upstairs bedroom, and *Sounds in the Grass.* In spite of the titles the paintings contain no overt references to the landscape. The strongest of his 1946 works mark a critical juncture between the "veiling the image" style of his past and the "drip" paintings he began the following year. *Shimmering Substance (Fig. 22),* which is widely regarded as a key transitional work, is a small, bright painting composed of hundreds of curling yellow and white brushstrokes, the cursive gestures packed tightly together to form a mesh of sensation. Paint is applied in thick, buttery textures, as if squeezed directly from the tube. While it is possible to make out some dark images hovering beneath the surface, Pollock doesn't allow them to become identifiable. He has "veiled the image" so thoroughly that the veil has become the image. In other words, *Sounds in the Grass: Shimmering Substance* is totally abstract.

This in itself, of course, was not a breakthrough. An artist such as Mondrian, whom Pollock admired enormously, had long ago rejected representation in favor of pure abstraction, searching for ideals based on the simplification of shapes and colors. For Pollock, however, abstraction was not a philosophical choice but a last resort, the only hope left for forging a vehicle that could fully accommodate his emotions. It took him sixteen years to arrive at a style that was totally abstract, and that he felt ambivalent

about abandoning the human figure seems certain. (Even Picasso never completely gave up the figure, for fear that his work would degenerate into meaningless pattern.) But by 1946 Pollock had no choice. He felt hampered by the human figure, for it prevented him from recording sensation as quickly or intensely as he experienced it. And so he did away with recognizable imagery in favor of direct expression. It would later be said that Pollock stripped painting to its fundamentals, exploiting the two-dimensional limitations of his medium for maximum effect. But Pollock thought no more about defining his medium than he did about formulating theories or founding a movement. He turned to abstraction not to define the limits of art but to escape them.

After finishing *Shimmering Substance* Pollock invited Lee into the barn to look at the painting. "That's for Clem," he told her. He knew that Clement Greenberg would admire the work, which, like the mural he had painted for Peggy Guggenheim, was an "allover" painting. Unlike a conventional painting, with its illusion of deep space, an "allover" painting consists of undifferentiated forms dispersed evenly across the picture surface. There are no breaks in the composition, and the only way to take in the painting is all at once. Rather than being an imitation of something else, an "allover" painting is an object in its own right. It is utterly self-contained and doesn't pretend to be anything other than what it is. This distinction between painting as a window on reality and painting as its own reality was one of the crucial issues to the founders of modern art, and it is for that reason that Pollock felt Greenberg would admire his latest work. He was right.

Greenberg was the only critic to review Pollock's 1947 show, but such was his ardor that it almost compensated for the lack of interest among other critics. "Jackson Pollock's fourth one-man show in so many years at Art of This Century," he wrote in *The Nation* in February 1947, "is his best since his first one and signals what may be a major step in his development." The rest of the review was probably incomprehensible to the readers of *The Nation,* who had not yet developed an ear for Greenberg's formalism any more than they had developed an eye for Pollock's art. Readers must have wondered what Greenberg meant by his con-

cluding remarks: "Pollock points a way beyond the easel, beyond the mobile, framed picture, to the mural, perhaps—or perhaps not. I cannot tell."

With those few words Greenberg introduced his famous death-of-the-easel-picture theory. He believed that Pollock was not just a great painter but a historical force that could free modern art from its subservience to Cubist tradition. Greenberg, who had started his writing career during the radical thirties, applied Marxist ideas about historical inevitability to painting. He defined the evolution of art since Manet in terms of the gradual elimination of illusion and felt that Pollock's primary accomplishment consisted of going beyond Picasso and Braque; he eliminated more illusion than they had. The Cubists had flattened out space while continuing to differentiate between shapes. Pollock's "all-over" paintings, with their even dispersion of accent and emphasis, broke down all hierarchical distinctions. "The dissolution of the pictorial into sheer texture," Greenberg wrote in *Partisan Review* in 1948, "into apparently sheer sensation, into an accumulation of repetitions, seems to speak for and answer something profound in contemporary sensibility. Literature provides parallels in Joyce and in Gertrude Stein."

Though Greenberg is now known as one of the chief theoreticians of postwar art criticism, his writings were mocked and scorned in the forties. His colleagues at *Partisan Review* made fun of him. Philip Rahv, the magazine's coeditor, felt that Greenberg was overly dogmatic and that the reason he was pushing Pollock so hard was that he expected to ride in on his success. Delmore Schwartz, who had studied philosophy in college, was suspicious of Greenberg's ideas. Greenberg often cited Kant's theory of beauty in support of his formalism, prompting Schwartz to start a nasty rumor that Greenberg had read only the first thirty pages of Kant's work. When the magazine's publisher suggested at a staff meeting one day that *Partisan Review* award an annual prize for literary achievement, James Johnson Sweeney, a member of the advisory board, provoked a burst of laughter by proposing, "Give the winner an easel painting!"

It was not only at *Partisan Review* that Greenberg was subjected to insult. When the mass-circulation magazines began to

take note of the new art on Fifty-seventh Street, it was Greenberg, not Pollock, who was the focus of the publicity. In December 1947 *Time* reported that Greenberg had recently singled out Pollock as "the most powerful painter in America" in an article for the British magazine *Horizon*. Bewildered by Greenberg's appraisal, *Time* ran a picture of Pollock's painting *The Key* (reproduced upside down) beneath the sarcastic headline "The Best?"

Pollock of course was grateful for Greenberg's support, and he didn't begrudge him his theories. To Pollock theories were like titles, reassuring the public that his paintings meant something while freeing him from the tedious task of having to specify what that meaning was. When Pollock applied for a Guggenheim fellowship in October 1947, he was asked to propose a project. His statement reveals Greenberg's influence, if not his direct participation. "I believe the easel picture to be a dying form," Pollock wrote, "and the tendency of modern feeling is towards the wall picture or mural. I believe the time is not yet ripe for a *full* transition from easel to mural. The pictures I contemplate painting would constitute a halfway state, and an attempt to point out the direction of the future, without arriving there completely."

Thomas Benton, whom Pollock had asked to write a letter of recommendation, was understandably perplexed by the project Pollock proposed but had no doubts about his originality. "Very much an artist," Benton wrote of his former student. "In my opinion one of the few original painters to come up in the last 10 years. Gifted colorist. Whether or not he lives up to what he intends, money would not be wasted. Highly recommended." Greenberg and Sweeney also wrote recommendations.

In applying for the fellowship Pollock was asked to answer several questions. Have you any constitutional disorder or physical disability? "None," Pollock wrote. Give a list of the scholarships or fellowships you have previously held. "None," he wrote. State what foreign languages you have studied. "None." Of what learned, scientific, or artistic societies are you a member? "None." In what field of learning, or of art, does your project lie?

"Creative painting," Pollock wrote.

He was not awarded the fellowship.

11 "Grand Feeling When It Happens"

1947-48

By 1947 Peggy Guggenheim was eager to close her gallery and re-
turn to Europe. She felt disillusioned by her six years in New York.
Her husband, Max Ernst, had run off to Arizona with a young
painter named Dorothea Tanning, and many of the artists to
whom she had given their first one-man shows, such as Mother-
well and Baziotes, had left Art of This Century for other galleries.
Furthermore, for all her efforts to promote Pollock, his reputation
remained negligible. The Museum of Modern Art had failed to
include him in its important 1946 exhibition "Fourteen Ameri-
cans," and his pictures had never really sold; she was stuck with
so many of them, she started giving them away so she wouldn't
have to ship them back to Europe. Among the paintings she de-
cided to part with was *Mural*, which she gave to the University of
Iowa after several other institutions, including Yale, had said they
didn't want it. (Years later, after Pollock had become famous,
Peggy Guggenheim tried to get the mural back by offering the
college a Braque, but to no avail.) To add to her problems, she

was under contract to continue paying Pollock three hundred dollars a month for one more year, and she felt she couldn't leave New York until she had found an art dealer willing to take over the contract. But no one was interested.

Many art dealers had opened galleries along Fifty-seventh Street in the years following the war, but only two or three were showing the work of the American avant-garde. One of them was Sam Kootz, a tall, affable southerner who had opened his gallery at 15 East Fifty-seventh Street in 1945. Kootz had already proved his commitment to the vanguard by showing Motherwell, Adolph Gottlieb, and Byron Browne, even if it meant selling Picassos from his back room to keep the gallery solvent. But for all his enthusiasm for American art, Kootz told Peggy Guggenheim that he wasn't willing to take on Pollock. To put it frankly, he said, he didn't want to work with an alcoholic. Only a few weeks earlier Pollock had staggered into the gallery on a Saturday afternoon and drunkenly shouted, "I'm better than all the fucking painters on these walls!" Kootz had asked him to leave.

Across the hall from Kootz was Betty Parsons, a trim, energetic artist and art dealer, with wide-set blue eyes and short gray hair that framed a strong face. Parsons had started her dealing career in the early forties from the basement of the Wakefield Bookshop, where she gave Saul Steinberg his first show and listened sympathetically to almost every artist who sought her attention. Steinberg once drew a portrait of Parsons as a cocker spaniel, with a high, philosophical forehead and a slightly worried expression; it is a measure of her open-mindedness that she thought it was a good likeness.

Parsons considered herself lucky to have opened her gallery just before Art of This Century closed, in time to inherit many of the artists who had shown there. She gladly volunteered to take on Rothko, Clyfford Still, and Hans Hofmann. Pollock, however, posed a problem. She could not allow herself to take over his contract with Art of This Century and assume the responsibility of paying him thirty-six hundred dollars a year when it was inconceivable that his annual shows would gross that much. Peggy

Guggenheim was willing to compromise. She said she would continue paying Pollock's monthly stipend until his contract ran out if Parsons would just give him a show. Parsons felt she had no choice. As she put it, Pollock "was dumped in my lap because nobody else would risk showing him."

In May 1947 Peggy Guggenheim closed her gallery. She eventually settled in Venice, where she purchased the Palazzo Venier dei Leoni, converted the servants quarters into galleries, and opened her own museum. She spent the rest of her days riding the Grand Canal in her private gondola, sleeping in a sterling silver bed designed by Alexander Calder, and acquiring a reputation among the Venetians as the "last duchess." If her departure from New York marked the end of her adventures among the avant-garde, the same could be said of André Breton, who had returned to Paris to find that Existentialism had replaced Surrealism as the prevailing intellectual rage. Surrealism was dead in Europe. In New York the movement seemed to pass into instant eclipse with the closing of Art of This Century. The exit of the Surrealists from New York after the war cleared the stage for a new avant-garde.

The stage, in the late 1940s, became the Betty Parsons Gallery, which was once described by Greenberg as "a place where art goes on and is not just shown and sold." When Pollock joined the gallery in May 1947 he was one of a group of young Americans who were in roughly the same position. Most had started their careers during the Depression and had worked on the Project. After fifteen years or so they were still poor, still unknown, and still living downtown in cold-water flats. But the history of art was about to be rewritten. Within the next three years Pollock, Rothko, Clyfford Still, and Barnett Newman would paint their signature images and unveil them before the public at the Parsons Gallery. In 1947 Still showed his jagged vertical forms set against dark color fields. In 1948 Pollock showed his "drip" paintings. In 1950 Rothko showed his floating rectangles, and Newman showed his "zip" paintings—flat color fields seared by thin, vertical stripes. Later the four painters would be grouped, along with several others, under the rubric of Abstract Expressionism—the term had already been used by Robert Coates in

The New Yorker—but their paintings resembled one another only in the most general ways. They each painted large, virile, single-sign images that expressed, as Rothko once said half jokingly about his own art, "basic human emotions—tragedy, ecstasy, doom, and so on." Parsons nicknamed the group the Four Horsemen of the Apocalypse.

From the day he joined the Parsons Gallery, Pollock was set apart from the other painters by the recognition he had received from Clement Greenberg. They had read in *The Nation* that Pollock was "the strongest painter of his generation," an appraisal that understandably irked the rest of the so-called generation. Pollock's occasional visits to the gallery tended to heighten the resentment. He came in from Springs to attend many of the openings but only to alienate people by insulting the shows. Parsons later said that he divided all exhibits into one of two categories—"awful" or "terrible." While this is surely an exaggeration, the sculptor Herbert Ferber had said of Pollock that "he wasn't the sort of artist to compliment someone else's work." He seemed to enjoy his coveted status as the best of the young Americans and pretended that he had no need for anyone's friendship or approval. One day Bradley Walker Tomlin, a genial artist from Syracuse, New York, who was one of the pioneers of "allover" painting, asked Pollock a simple question: how did he keep his pigments from running together? "I can't tell you that," Pollock said angrily. Tomlin recognized in his comment the defensive posturing of a painfully insecure man, and the two of them became good friends.

Not everyone was as willing as Tomlin to indulge Pollock in his adolescent behavior. The best-known painter at the gallery after Pollock was Rothko, and the two geniuses did not get along. Rothko was large and stocky, with a high, balding forehead and deep-set brown eyes that peered at the world through thick glasses. His suicide in 1970 has given rise to the caricature of a doomed, solitary figure, and Rothko in fact did have a tendency toward moodiness. He hated critics and curators and called the Whitney Museum "a junkshop." He once wrote that exhibiting a painting is a "risky and unfeeling act. . . . How often it must be permanently impaired by the eyes of the vulgar and the cruelty of

the impotent who would extend their affliction universally!" But Rothko was considerably less high-sounding in ordinary conversation. He was an affectionate, generous friend to many artists, which helps explain why he resented Pollock. Rothko considered the star of the gallery a self-promoter who cared about little else than furthering his own reputation. As he wrote to Barnett Newman in June 1947: "Pollock is a self contained and sustained advertising concern."

Newman did not share this opinion. Whenever anyone picked on Pollock, Newman stood up for him. "Jackson doesn't need anyone to help him paint his pictures," Newman used to say, a comment that pleased Pollock enormously. Although Pollock was not a defender of Newman's art, he was fond of "Barney" Newman, a warm, gregarious intellectual with a hefty build and a thick, flowing mustache. Newman considered himself an anarchist, but like most anarchists, he was constantly organizing groups. He ran for mayor of New York in 1933, on the platform of improving parks and creating a Department of Clean Air. He and Pollock both liked baseball and used to go to Ebbets Field together to root for the Brooklyn Dodgers.

Barnett Newman could always be found at the gallery on Saturday afternoons, standing around talking to visitors. He was a brilliant conversationalist, fluent in such wide-ranging topics as ornithology, geology, linguistics, and particularly primitive art. His rivals accused him of being an ideologue, which once prompted Newman to remark that "aesthetics is for the artist as ornithology is for the birds." By late afternoon on Saturdays, Newman had usually managed to attract a small group of artists to the gallery. No one could compete with his conversation, but there was one painter who could silence it. Pollock liked to annoy Newman. He'd listen attentively as Newman spoke, nodding his head in agreement and then interrupting suddenly. "Barney, you know what I think?" he used to say. "I think you're a horse's ass." In Pollock's vocabulary, the phrase was a compliment.

Besides Newman, the only other artist at the gallery whom Pollock became very close to was Tony Smith, a large, bearded,

erudite architect and sculptor who was in charge of hanging all the shows. The two men had first met several years earlier at a party in the Village, and Smith's first impression had been of a "sullen, intense, miserable" person who made him think, I've got to get out of here. I can't stand that guy. But he felt very different on his second meeting with Pollock, and they quickly developed a friendship of quiet understanding and affection. Smith often drove out to Springs for the weekend. He and Pollock could spend hours at the kitchen table talking about nothing. "He was always telling me the local news," Smith has recalled, "what everyone was doing, people I had never heard of. He would give me a thumbnail sketch to fill me in. He seldom talked about art, but when he did it was often in relation to his own community. . . . He'd mention some old lady, or a retired broker, who had taken up painting. I would say, 'What of it? What the hell difference does it make to you?' "

Betty Parsons could never quite relax in Pollock's presence. On his visits to the gallery he tried to make conversation with her, but she sensed his discomfort, and it made her nervous. Pollock often asked Parsons about her travels. He wanted to know what Europe was like. He asked her about the Orient too, and his questions struck her as odd. "There was a desperation about him," Parsons once said. "When he wasn't drinking, he was shy, he could hardly speak. And when he was drinking, he wanted to fight. . . . I would run away."

A few months after Pollock joined the gallery, Betty Parsons visited him in Springs one day to help plan his upcoming show. Barnett Newman and his wife Annalee, who worked for the New York City Board of Education, drove her out. In the evening Pollock and Lee and their guests sat down on the living room floor and sketched together, experimenting with fine-nibbed Japanese pens that Newman had brought as a gift. Parsons watched closely as Pollock drew. At first his drawings were graceful. But soon he was pushing too hard on his pen and the point broke. He broke three pens in a row. He became angry, cursing the pens that would not do what he wanted them to.

"He had tremendous drive and passion," Parsons once said,

"and it was too much for him. Whatever he did wasn't enough. Some people are born with too big an engine inside them. If he hadn't painted, he would have gone mad."

————

In August 1947, three months after he joined the gallery, Pollock returned to the barn to prepare for his first show at the Parsons Gallery. His frustrations vanished the moment he began to work. "I'm just now getting into painting again and the stuff is really beginning to flow," he wrote to his friend Louis Bunce at the end of August. "Grand feeling when it happens."

He worked steadily through the end of the summer and the fall. As the weather grew chillier he could hear the wind coming through the cracks in the barn and feel the cold air streaming in. By October he was heating the barn with a pot-bellied kerosene stove and bundling up in layers of clothing; his customary outfit was a thermal shirt, a sweat shirt, and a hip-length dungaree coat. Lee worried constantly that the kerosene stove would cause a fire. The small wooden barn even smelled flammable, pungent with the greasy scent of oil and turpentine. Tubes and cans of paint lay open on the wide-planked wooden floor. Dozens of paintings leaned against the walls. Lee suggested to Pollock that he store his finished works in racks, but Pollock insisted on keeping his work within view. As he painted he could look up and see his earlier work: past informing present. His 1947 paintings grew out of his past art but broke with it too; in some ways they broke with the entire history of art.

"Every so often," de Kooning once said, "a painter has to destroy painting. Cezanne did it. Picasso did it with cubism. Then Pollock did it. He busted our idea of a picture all to hell."

In the summer of 1947 Pollock produced the first of his so-called "drip" paintings.* Not the least among his innovations was

————

* The convention among contemporary art critics and academics is to disdain the commonplace term "drip" paintings in favor of the more fashionable usage "poured" paintings. The term was originated by William Rubin to distinguish between dripping, as an act of casting paint droplets across a canvas, and pouring, which implies a continuously applied line of paint. But though the term "poured" has about it the air of

the technique by which they were created. Instead of using an easel, Pollock placed his canvas on the floor and applied paint from sticks, trowels, and hardened brushes. He walked around the canvas as he worked, tossing paint from all four sides. At some point Pollock realized that he would not have to stop to dip the stick into a can of paint if he poured the paint directly from the can. So he placed a stick in a can of paint, tilted the can, and allowed the pigment to run down the stick and onto the canvas. Sometimes he tilted the can just a bit to produce a slow, dribbling line. Sometimes he tilted it at sharper angles so the paint fell faster and landed harder, forming a puddle. He experimented with a wide range of paints—artist's oils, industrial enamels, plumber's aluminum paint, and, most often, ordinary house paint, which he chose because of its fluidity and low cost.

One of the most common misconceptions about Pollock's working methods is that he produced his "drip" paintings almost instantaneously. To the contrary, he tended to work in stages. It was not unusual for him to interrupt work on a canvas and tack it to a wall in the barn so that he could contemplate his next step. Sometimes he waited a few days before returning to the painting, sometimes weeks. In the meanwhile he worked on other paintings; he was always working on more than one painting at a time.

Pollock was not the first painter to employ the technique of dripping paint. Several critics believe he got the idea from Siqueiros, who as early as 1936 was laying his canvas on the floor

technical orthodoxy ("I can tell you that they are not *drip* paintings at all," insists *The New York Times* critic John Russell. "Poured, poured, not dripped."), it also smacks somewhat of the pedantic. Pollock's dripping is a term and an image that has entered the century's vocabulary, and to eradicate it simply because of the movement of the artist's hand during the act of creation seems unnecessarily fussy. "Pouring" ultimately is no more accurate a description of a man flinging, spattering, and tossing paint than "dripping" and conveys none of the appropriate active imagery. "Dripping," in fact, was Pollock's term of choice to describe his art, and it has become so universal that even the French refer to his 1947–50 works as "Le Drippings." Considering the attention that has already been paid to Pollock's technique, one would hope that any additional coinages would refer to the paintings themselves rather than to the method by which they were created.

and splattering Duco from a stick to help generate images. Other critics say the idea came from Hans Hofmann, who in 1940 enlivened the surface of a painting called *Spring* with an overlay of drips. And surely Pollock knew that Max Ernst, while visiting Matta's summer house in Cape Cod in 1941, had filled a tin can with paint, punctured a hole in the bottom, and swung it over a canvas; his "oscillation" paintings were exhibited by Betty Parsons at the Wakefield Bookshop in 1942. By no means was Pollock the first to drip, but he was the first to use the technique as a means of making a major creative statement.

A lot can be said about Pollock's technique, and a lot has been said. What is by far the most relevant point was made by Pollock himself in an unpublished interview in 1949. "I don't have any theories about technique," he said. "Technique is the result of saying something, not vice versa." As to what his paintings said, Pollock never specified.

The seventeen "drip" paintings that Pollock produced in 1947 generally consist of dense, tangled arrangements of tossed and flung lines. At first, in a picture such as *Galaxy*, Pollock spattered paint to obscure an image that had begun as a human figure. But soon the spattering took over, and images started evolving out of the flow of paint. *Cathedral* (*Fig. 23*), a large, vertical painting in which hundreds of looping black lines arch against a whitish ground, hints at the soaring quality of later work. In *Full Fathom Five* Pollock embedded actual objects in the wet paint: a key, a comb, the caps from tubes of paint, a handful of tacks, cigarette butts, burnt matches—mementos of the painting's creation as well as metaphors for its status as a real physical object whose meaning lies entirely in the use of materials. There is an amazing sense of movement in these paintings as countless linear rhythms and tensions counteract one another to form an indivisible whole. The only way to look at a "drip" painting is all at once.

The key element in the "drip" paintings is line, as opposed to color or form. As many critics have pointed out, Pollock was essentially drawing in paint, or endowing the painted line with the immediacy and spontaneity one tends to associate with pencil

sketches. His line is novel not only because of the way it is applied but also because it doesn't define shapes or mark the edge of a plane—the two traditional functions of drawing. Instead it travels freely, following its own path as it breaks away from the tedious conventions of description and illustration. Color is of secondary importance and rarely calls attention to itself. Pollock generally avoided strong, saturated hues in favor of black, white, and aluminum, which evoke the monochromy of pencil sketches and serve to dramatize the linear quality of his work.

For Pollock the "drip" paintings were a vindication. As one who had been obsessed from childhood with his inadequacies at drawing, he finally had become the draftsman of his ambitions. It is worth recalling that at the age of eighteen, in his first written appraisal of his work, Pollock had confided to his oldest brother: "my drawing i will tell you frankly is rotten it seems to lack freedom and rythem." The comment is rather remarkable in that no painter is better known for the freedom and rhythm of his draftsmanship than Pollock. The technique of dripping paint allowed him to create a flowing, continuous, gigantic line, a kind of superhuman calligraphy that brought his sense of drawing into harmony with the scale of his ambitions.

Soon after he had finished preparing for his show, Pollock was visited by Ralph Manheim, a translator of German literature, and his wife, who lived nearby in Springs. As was his customary practice, Pollock invited his visitors into his studio. When Manheim learned that the paintings had yet to be titled, he volunteered a few suggestions, and within a few hours he and his wife Mary had titled the majority of the works. Many of the titles relate to the idea of metamorphosis, such as *Alchemy, Prism, Sea Change*, and *Full Fathom Five* (the last two from Shakespeare). Titles such as *Phosphorescence, Shooting Star, Magic Lantern,* and *Comet* seem to have been inspired by the ubiquity of aluminum paint, the color Pollock used most often after black and white.

The first written appraisal of Pollock's "drip" paintings apparently came from his mother. She visited Springs for Thanks-

giving and was impressed by the paintings in the barn. "Jack was busy getting his paintings stretched for his show which is the 5th of Jan," she noted to one of her children, "he has done a lot of swell painting this year."

————

In January 1948 Pollock and Lee came to New York for the opening of his show at the Parsons Gallery. The debut of his "drip" paintings turned out to be an abysmal disappointment, arousing little interest from either critics or collectors. The seventeen paintings on exhibit were priced as low as $150, but only one sold (the purchaser was a friend of Peggy Guggenheim's). Friends stopped by the gallery to offer their congratulations but couldn't afford to buy anything. One day Herbert Ferber, who also exhibited at Parsons, asked Pollock whether he would be willing to trade a "drip" painting for a Ferber sculpture. "Sure," Pollock told him, "pick any one you want." Ferber picked *Vortex*, one of the smaller paintings in the show. ("I didn't want to seem greedy," he explained.) Under the terms of his contract Pollock was allowed to keep one painting for himself. He chose *Lucifer*, the largest painting in the show, but later had to give it away to settle an outstanding doctor's bill. After the show closed, Pollock's first "drip" paintings were shipped to Peggy Guggenheim. In the next few years she gave away all but two to museums in such places as Omaha and Seattle.

The critical reaction was surprisingly tame. Newspaper reviewers simply ignored the show. While commentary appeared in four magazines, none of them ran reproductions, so the public had no idea of what the paintings looked like. The only admiring critic was Clement Greenberg, but once again his review was probably unintelligible to most readers. He seemed more interested in his death-of-the-easel-picture theory than in the art it described and never mentioned Pollock's new technique. "Since Mondrian," Greenberg wrote in *The Nation*, "no one had driven the easel picture so far from itself; but this is not altogether Pollock's doing. In this day and age the art of painting increasingly rejects the easel and yearns for the wall."

————

The three other critics who reviewed the show didn't know quite what to make of it. They all agreed that the paintings possessed vitality but wondered whether they meant anything. Robert Coates, of *The New Yorker*, one of Pollock's earliest admirers, felt that while some of the paintings "have a good deal of poetic suggestion about them," there are times when "communications break down entirely." An unsigned reviewer in *Art News* was also ambivalent, admiring Pollock's use of aluminum paint and the "beautiful astronomical effects" it produced while concluding that his work suffered from "monotonous intensity." Alonso Lansford, the reviewer for *Art Digest,* described the work as "colorful and exciting," though he kept his comments short as if waiting to hear what others thought before committing himself: "It will be interesting to see the reactions to his present exhibition."

Thus began 1948, the year in which Arshile Gorky died, Willem de Kooning had his first one-man show, and Clement Greenberg bemoaned, in article after article, the social "alienation" and "isolation" suffered by young American painters. For Pollock the year brought the severest hardship he had known since the Depression. Three weeks after his show closed, his contract with Peggy Guggenheim expired and his monthly payments ended. Under the terms of his new contract with Betty Parsons, he was entitled to receive any money from the sale of his work minus a one-third gallery commission. All this was academic, however; his income from the gallery that year was zero. "I am very worried about Pollock," Parsons wrote to Peggy Guggenheim in Paris on February 26. "I hope he will be able to go on painting; his finances seem very precarious." Six weeks later Parsons wrote again: "I am still very worried about the terrible financial condition of the Pollocks."

For Pollock the poverty was humiliating. As one who was determined to support himself on his painting, he felt deeply frustrated by the lack of sales. Lee offered to get a job—she had a degree in teaching—but Pollock wouldn't allow it and "made a real issue of it," according to Lee. He was too proud to have his wife support him, even if it meant living in dire poverty. That

winter was one of their hardest ever. They still had only a couple of stoves and a fireplace to heat the farmhouse, and they were forced to borrow money in order to get by. Parsons lent them a few hundred dollars. Dan Miller allowed them to take groceries from his general store on credit. After running up a sixty-dollar bill at the store Pollock tried to settle his debt by offering Miller a painting. The grocer accepted and hung a small "drip" painting (*Untitled*) in his store. Customers laughed at the work, and many of them commented that they wouldn't hang it in an outhouse. Someone started a rumor that Pollock painted with a broom. A decade later Miller sold his painting to a Paris art dealer for seventeen thousand dollars and bought a small airplane with the money.

Not everyone was as willing as Dan Miller to barter his goods or services for the paintings of a destitute artist. One day Pollock telephoned William P. Collins, who owned a local fuel company, and invited him to visit his studio. Collins accepted the invitation but only to decide that he wasn't willing to trade his heating fuel for artwork. Charlie Smith, a pilot at the East Hampton airport, recalls an afternoon when Pollock pulled up at the airport in his Model A Ford and drunkenly stumbled into the terminal. He asked Smith to come outside. The pilot accompanied him to his car and was surprised to find five paintings leaning against it. "Yeah?" Smith said, after glancing at the paintings. Pollock told the pilot he could keep all five if he flew him to New Haven, a twenty-five-minute ride. He explained that his mother and brother lived in Connecticut and, "I have to see them." Smith couldn't believe he was serious. "Airplanes cost money to run, y'know," he told Pollock. "They burn gas."

With the arrival of summer Pollock's fortunes improved slightly. James Johnson Sweeney managed to convince the Eben Demarest Trust Fund, a Boston arts foundation, to award Pollock a fifteen-hundred-dollar grant, to be paid in quarterly installments. Pollock, who took real pleasure in improving his property, kept busy with various outdoor projects. He puttered in Lee's vegetable garden, planted rows of mimosa trees, painted the house, and gave serious thought to building a white post-and-rail

fence along the edge of the property. One day he and his friend Tony Smith were gazing out the living room window when Pollock started talking about the fence. A fence, he said, would make his property look more like a farm. Smith couldn't help but laugh. "What do you think you have here?" he teased. "A Maryland horse farm?"

For all his tinkering around the house, Pollock was not as handy as one might suppose. While he definitely enjoyed gardening, cooking, and carpentry, he had limited patience for whatever projects he undertook. He brought his intensity to bear on even the simplest tasks and tended to get frustrated rather easily. Edward Hults, a local plumber in Springs who assisted Pollock with many home-improvement projects, later recalled that "he was reckless with tools ... he'd throw them around, kick them even." One day Hults arrived at the house to find that Pollock had impulsively ripped out some beams while trying to install plumbing for an upstairs bathroom. "Why," Hults exclaimed, "if there'd come any wind the house would have collapsed!"

New neighbors arrived from New York, easing the oppressive isolation of the country. John Little, an abstract painter whom Lee knew from the Hofmann school, purchased a barn on Three Mile Harbor Road. Wilfrid Zogbaum, a fashion photographer and sculptor, bought a farmhouse a few hundred yards south of the Pollocks on Fireplace Road. Pollock became good friends with both men, retiring the aggressive stance he assumed among his colleagues at the Parsons Gallery. He had no need to prove himself "the strongest painter of his generation" among his neighbors in Springs, who acknowledged, hands down, that he was the master among them. To John Little and Wilfrid Zogbaum, Pollock was a gentle, appreciative friend. He often stopped by Zogbaum's house to bring him homegrown eggplants. He visited John Little too and lent many hours to the renovation of Little's house. When his friends returned the visits, they could expect to be welcomed graciously by Pollock and his latest pet, Caw-Caw, a mischievous black crow that provided amusement by poking holes in tubes of oil paint and stealing clothespins from neigh-

bors' clotheslines. At least one particular incident endeared Pollock to Zogbaum. One day the sociable "Zog" showed up with Wilfredo Lam, insisting that Pollock acquaint himself with the Surrealist painter. Zogbaum left the two artists alone under a tree and returned an hour later, eager to see how they were getting along. He found them sitting silently. Pollock looked up and explained. "Wilfredo doesn't speak any English," he said, "and I don't speak any French."

As Pollock languished in Springs his reputation was advancing abroad. Six of his works went on exhibit that summer at the Venice Biennale, the largest and most prestigious of the great European art fairs. The six Pollocks were part of a show mounted by Peggy Guggenheim, who, as a leading art patron in Venice, had been invited to exhibit her collection at the fair. She was given her own pavilion, alongside those of Great Britain, France, and Holland, prompting her to comment wryly, "I felt as though I were a new European country." The United States also had a pavilion, but it would be some time before Pollock was exhibited in Venice as an official representative of this country. (Featured in the U.S. pavilion that summer were such conservative choices as Benton, Pop Hart, and Andrew Wyeth.) Pollock's appearance at the 1948 Biennale marked his international debut, and it apparently went well. "I am glad you took on Pollock and only wish he could sell," Peggy Guggenheim wrote to Parsons in 1949. "Here in the Biennale he was considered by far the best of all the American painters."

Back home, however, Pollock seemed to be attracting only ridicule. Resistance to his art had been mounting steadily ever since his Parsons show had closed. In February 1949 James Plaut, the director of the Institute of Modern Art in Boston, announced that the museum was changing the "modern" in its name to "contemporary" to disassociate itself from certain modern painters whose work signaled "a cult of bewilderment." The museum statement did not mention any artists by name, although a followup story in The New York Times specified that the name change in Boston represented a necessary effort to distinguish the "experimental meanderings" of such artists as Pollock and Gorky

from art that possessed meaning. That May a group of artists headed by the painter Paul Burlin planned a well-publicized protest meeting at the Museum of Modern Art to oppose the name change in Boston, and while Pollock was not among the thirty-six official organizers, he and Lee both attended.

Meanwhile *Life* magazine finally caught on to the events on Fifty-seventh Street and was perturbed to discover that the latest movement in the fine arts bore no resemblance to the cultural renaissance that Henry Luce's publications had envisioned for the coming American century. Confounded by "the strange art of today," *Life* presented its readers, in October 1948, with a "Round Table on Modern Art" in which fifteen leading cultural figures were asked to evaluate the work of Pollock, de Kooning, and other "young American extremists." Pollock's *Cathedral* was submitted to the panel of experts, eliciting a round of praise from Greenberg and Sweeney and predictably patronizing comments from the others:

Sir Leigh Ashton, director of the Victoria and Albert Museum in London: "It seems to me exquisite in tone and quality. It would make a most enchanting printed silk."

Aldous Huxley, novelist: "It raises a question of why it stops when it does. The artist could go on forever. I don't know. It seems to me like a panel for wallpaper which is repeated indefinitely about the wall."

A. Hyatt Mayor, curator of prints at the Metropolitan Museum of Art: "I suspect any picture I think I could have made myself."

Theodore Green, professor of philosophy at Yale: "A pleasant design for a necktie."

While much has been made of Pollock's "victimization" by the mass media and the "torment" he suffered from a public that did not understand him, Pollock in fact tolerated his detractors with remarkable composure. He knew better than to hope for a sympathetic reception from such purveyors of mass culture as *Time* and *Life*. He had written to a friend about a year earlier, "Have had fairly good response from the public (interested in my kind of painting)," clearly accepting the fact that avant-garde art

lies outside the parameters of popular taste. By the time the *Life* "Round Table" appeared, in autumn, Pollock had already returned to the barn and begun to prepare for his second show at the Parsons Gallery. Inside his studio the only critic who mattered was himself.

The thirty-two paintings that Pollock completed in 1948— twice as many as in the previous year—continued his earlier innovations in "dripped" paint while breaking new ground. A year after pioneering his new technique Pollock felt comfortable enough with it to venture a few risks. For one thing, the works became larger: *Summertime* stretches eighteen feet long, and *Number 5, 1948* is eight feet tall. His style, in general, became looser and more open, the poured lines no longer burying the canvas from edge to edge; he allowed the canvas to show through. By 1948 Pollock had become master enough not only to make his own rules but to break them as well. Defying his own abstract style, he reintroduced figurative imagery into the art. In the *Wooden Horse* he glued onto the canvas the head of a wooden hobbyhorse (which he had found beneath John Little's kitchen floor while helping with renovations one day). In *White Cockatoo (Fig. 24)* he again toyed with conventional form; fleshy masses of red, white, and blue pigment rest in the interstices of loopy black lines like birds in bare tree branches. In *Number 1, 1948*, described by Greenberg as "a huge baroque scrawl in aluminum, black, white, madder and blue," Pollock put himself into the painting. He pressed his paint-smeared hands against the canvas, creating a series of hand prints reminiscent of early cave markings. (Though the prints made with his left hand remain unaltered, the prints made with his right hand were touched up to conceal the fact that his fingertip was missing.) By 1948 Pollock's loops of flung paint had become a force to reckon with as they brazenly ensnared wooden horses, white cockatoos, hand prints, and any other forms that got in their way. Conventional forms are suggested but only to be subordinated to line, and the paintings remain abstract. Pollock was testing the limits of his mastery with a sureness that borders on bravura.

In 1948 Pollock decided to dispense with titles; there was no

point in encouraging viewers to look for anecdotal meaning in his work when the only meaning lay in the use of paint. Instead he started numbering his paintings—Number 1, Number 2, Number 3, and so on, though not necessarily in the order in which they were conceived. While descriptive titles such as *White Cockatoo* and *Wooden Horse* have been picked up over the years to help keep the paintings straight, none of these titles were Pollock's. As far as he was concerned, titles only complicated things. Commenting sometime later on why he did away with them, Pollock told an interviewer: "I decided to stop adding to the confusion."

By December, when Pollock had finished preparing for his second show at Parsons, he felt sufficiently fortified to confront his worst problem: he decided he was going to stop drinking. That Christmas he and Lee traveled to Deep River, Connecticut, to spend a week with his family, and his mother soon reported exuberantly, "There was no drinking. We were all so happy ... hope he will stay with it he says he wants to quit and went to the Dr. on his own." The doctor to whom she was referring was Dr. Edwin Heller, a general practitioner who had founded a medical clinic in East Hampton the previous year. Pollock first visited Heller for a minor ailment but soon started returning on a weekly basis, determined "to leave it alone everything wine to beer for they were poison to him," as his mother wrote. Lee was amazed by Pollock's recovery and often asked him how Dr. Heller had managed to cure him of his alcoholism when three psychotherapists and one homeopathic physician had failed, as had she. Pollock told her simply, "He is an honest man. I can trust him."

Lee wondered how long the recovery could last. Pollock's mother wondered too, and she was afraid that the pressures surrounding his next show, in January 1949, would lead him to start drinking again. "When he has his show will be a test and a hard one for Jack. If he can go through with that without drinking will be something I hope he can."

Pollock fulfilled his mother's hopes. By the time his show closed, in February, he was still on the wagon. In April 1949 his mother visited Springs and was thrilled to find that he still hadn't

had a drink. Writing to Charles, she mentioned the visit to "Jack and Lee was so nice to be there and see them so happy and no drinking he can serve liquor to others He feels so much better says so." Not even his doctor's death the following year, in March 1950, sent Pollock back to alcohol. He stayed on the wagon for two years, from the fall of 1948 to the fall of 1950. It has been reported elsewhere that Pollock was able to overcome his drinking through the help of tranquilizers he received from Dr. Heller, but there is no evidence to substantiate this claim and ample reason to doubt it. As Stella Pollock wrote: "The Dr. doesn't give him anything just talks to him." And as the doctor's widow has said: "My husband didn't believe in substituting one drug for another. He treated Pollock with sympathy." While the cause of Pollock's abstinence can no more be known than the cause of his drinking, surely it wasn't coincidental that he gave up alcohol at a time when his work was going better than ever and he no longer needed to doubt his talent, or doubt that his talent would be realized.

Pollock's second show at the Parsons (January 24–February 12, 1949) opened to impressive publicity. Clement Greenberg as usual went all out. Writing in *The Nation*, Greenberg confessed that *Number 1, 1948* (the painting with hand prints) "quieted any doubts this reviewer may have felt—and he does not in all honesty remember having felt many—as to the justness of the superlatives with which he has praised Pollock's art in the past." He went on to say he knew of no other painting by an American that could begin to compare with *Number 1* and that the work was as well contained "as anything by a Quattrocento master."

None of the other reviewers, as usual, shared Greenberg's enthusiasm. But the substance of their comments was perhaps less important than where the comments appeared. While only one year earlier the newspapers had totally ignored Pollock, they now took note of the "young American extremist" whose *Cathedral* had appeared in *Life* magazine. For the first time, Pollock was widely reviewed—and mocked. Emily Genauer of the *New York World-Telegram*, one of the easier-to-upset critics, felt that most of the paintings "resemble nothing so much as a mop of tangled

hair I have an irresistible urge to comb out." Sam Hunter of *The New York Times,* later an eloquent defender of Pollock's art, was ambivalent. The show, he wrote, "reflects an advanced stage of the disintegration of modern painting. But it is disintegration with a possibly liberating and cathartic effect and informed by a highly individual rhythm." Hunter's comments left various people wondering whether it was not only painting but criticism that had disintegrated. A week after the Hunter piece appeared, *Time* magazine reprinted it beside a sizable reproduction of *Number 11, 1948,* captioned "Cathartic disintegration." The magazine item identified Pollock as "the darling of a highbrow cult," failing to mention that the cult consisted of himself, his wife, Greenberg, and maybe two or three others.

One of the many ironies of Pollock's career is that the mocking publicity he received from *Time, Life,* and the major newspapers accomplished what Greenberg's praise never had: it helped sell paintings. By the time his second show at the Parsons Gallery closed, nine paintings had sold, compared to one the previous year. The purchasers included a Philippines sugar heir, a president of a publishing company, a trustee of the Philadelphia Museum of Art, and a lawyer. Best of all, the Museum of Modern Art purchased its second Pollock, *Number 4, 1948,* for $250. The museum had acted cautiously, choosing one of the smaller works in the show. (A year later it traded the painting for the larger and bolder *Number 1, 1948,* with hand prints.) Still, Pollock was deeply pleased by the museum purchase, and as Lee once said, "The museum never knew what they did by buying that painting." She was referring to the phone call that Pollock placed to a local plumber. After four chilly winters in Springs, Pollock gave himself a present. He installed heating and hot water in the house.

12 "The Greatest Living Painter"

1949-50

In February 1949 Pollock was visited in Springs by Arnold New-
man, a thirty-year-old freelance photographer on assignment for
Life. The magazine had provided Newman with no specific in-
structions as to how to photograph Pollock, indicating only that it
needed some pictures in both black-and-white and color for a
feature story to be published that summer.

Pollock was happy to spend a day with Newman posing for
pictures. Tailed by his dog Gyp, he took the photographer (and
the photographer's assistant) behind the house toward the bay
and then around the corner to Dan Miller's general store. He also
took them inside his studio and posed for pictures in the barn.
When Newman asked him a few questions about his technique,
Pollock offered to demonstrate. He placed a fresh sheet of canvas
on the floor of the barn, kneeled on top of it, and with slow stud-
ied movements dripped paint from a stick. He proceeded to pick
up a can of sand, and crouching on his heels, added pinches of
earth to his painting. Pollock, who had never painted for a pho-

tographer before and almost never allowed anyone to watch him work, was willing to paint for the five million readers of *Life*. In a denim jacket, blue jeans, and paint-spattered work boots, he crouched on the floor and ran earth through his fingers, giving a performance as the rough, rugged all-American genius of his ambitions.

In the course of the day Pollock took note of a peculiar irony: Newman, a freelance photographer, was better off than he was. He had arrived in Springs in a chauffeur-driven car; he had his own assistant. Both Newman and the assistant were being paid for the story, whereas Pollock, of course, was not. Pollock was the "famous artist," but everyone except him seemed to be profiting from his fame. Pollock was standing outside the barn when he turned to Newman suddenly. "I'm a little bit short of cash," he said. "Can you lend me a $150?" He disappeared for a moment and returned with a painting, leaning it against the barn without saying anything. Newman declined the sale, explaining politely that he was getting married the following month and had to save his money.

Besides agreeing to be photographed, Pollock had also consented to be interviewed by the magazine. Later that winter he visited the offices of *Life*, along with Lee, and met with editor Dorothy Seiberling. What did his art mean? the interviewer asked. Who were his favorite artists? Was it true that cigarette ashes and dead bumble bees could be found in some of his paintings? "He talked," Seiberling later recalled, "but you felt it was agony for him. He twisted his hands. Lee had to amplify whatever he said." Even with Lee's help, his answers failed to satisfy the editors and were never published. To read them is to understand why. While his answers were consistently interesting, Pollock refused to explain his art or himself. Asked why he didn't paint realistically, Pollock told the interviewer: "If you want to see a face, look at one." When asked how he felt about hostile critics, Pollock replied: "If they'd leave most of their stuff at home and just look at the painting, they'd have no trouble enjoying it. It's just like looking at a bed of flowers. You don't tear your hair out over what it means."

JACKSON POLLOCK

Life's feature story on Pollock appeared on August 8, 1949, along with pieces on the return of Austrian war prisoners, George Bernard Shaw's ninety-third birthday celebration, and the rage for dime-store clothing. "JACKSON POLLOCK—Is he the greatest living painter in the United States?" Thus read the headline in *Life.* The article explained:

> Recently a formidably high-brow New York art critic [Clement Greenberg] hailed the brooding, puzzled-looking man shown above as a major artist of our time and a fine candidate to become "the greatest American painter of the 20th century." Others believe that Jackson Pollock produces nothing more than interesting, if inexplicable, decorations. Still others condemn his pictures as degenerate and find them unpalatable as yesterday's macaroni. Even so, Pollock, at the age of 37, has burst forth as the shining new phenomenon of American art. . . .

Five million copies, five million reactions. In White Plains, New York, a doctor who had treated Pollock at Bloomingdale Asylum a decade earlier sent his congratulations, while requesting that Pollock drop him a line about his mental health and the "adjustment you have made since you left the hospital." In Rockwood, Tennessee, his old girlfriend Becky Tarwater considered sending a note but decided against it because "maybe it would seem exploitative." In Deep River, Connecticut, the local newspaper interviewed Pollock's mother, who confessed she did not "completely understand" her son's art. In Cody, Wyoming, the town was in an uproar. Although the article in *Life* presented Pollock as a paint-slinging cowboy from Cody, no one in that town remembered his having lived there. An investigation was launched by *The Cody Enterprise,* which reported that the "Pollock controversy is similar to that of movie cowboy Roy Rogers who claims Cody as his home. . . . Cody does not disclaim such noted sons, but is only careful to check on their authenticity." Meanwhile, back home in Springs, the farmers and fishermen could not believe their eyes. What was Jackson Pollock, of all people, doing in America's favorite magazine? "A good many of them made peace with themselves," according to Dan Miller, "by figuring that *Life* magazine was crazier than Pollock."

Pollock was proud of the article in *Life*. It may have poked fun at him, but it also ordained his position as the leading painter of his generation. (For years afterward he kept a stack of copies of the August 8, 1949, *Life* on a kitchen shelf and made sure that everyone saw it.) At the same time, Pollock felt uneasy about having posed for the article. He had always prided himself on his independence, so what was he doing in *Life* magazine, implicitly appealing to middle-class America for its support? Pollock first saw the article when his friends James Brooks and Bradley Walker Tomlin arrived in Springs from New York carrying a few copies. Tomlin opened the magazine and tried to show Pollock the pictures of himself. Pollock refused to look. Perhaps he recalled the day, not so long before, when Tomlin had asked him a question about his technique. "I can't tell you that," he had growled. For *Life*, however, he had revealed all, exploiting his art for the sake of his public image. "He couldn't read the article while we were there," Brooks later recalled. "He was too embarrassed."

Soon after the article was published Pollock was sitting at his kitchen table one day with his friend Tony Smith. Out the window they could see Pollock's Model A parked in the driveway. Pollock asked Smith if he had read the article in *Life*. Then he asked Smith if he thought he should be driving a better car. "The Model A's a good car," Smith said. "What the hell kind of car do you want?"

"Oh, I don't know," Pollock said. "Maybe a Cadillac."

He was only half joking. He soon bought from a used-car dealer in Southampton a Cadillac convertible—a 1941 model with a bashed front fender but a Cadillac nonetheless. It cost him four hundred dollars. "In many ways," Smith once said, "Jackson was a straight American boy. He wanted what most people want." He just wanted it much more.

———

To drive by the farmhouse on Fireplace Road was to know that someone important lived there. The short dirt driveway, which had remained empty for so many seasons, was now crowded with cars on almost any weekend afternoon as neighbors in the Hamptons appeared out of nowhere to meet the

painter they had seen in *Life*. Friendships were formed, invitations extended, favors offered without second thought. Rosanne Larkin, a potter, invited Pollock to try his hand at the potter's wheel in her studio in East Hampton. Berton Roueché, a genial Missourian who wrote about medicine for *The New Yorker*, offered to write a piece about Pollock for the magazine; it appeared the following year. Valentine and Happy Macy, East Hampton socialites who had made their money in radio stations and newspapers, casually sent over a truckload of spare antique furniture, including a red velvet Victorian couch and a massive oak table. Those who met him recognized his genuineness and helped him however they could. None of his neighbors did more than Alfonso Ossorio.

Born in Manila to a family of sugar growers, Ossorio had grown up in England, studied at Harvard, and established a modest reputation as a painter in 1941, when Betty Parsons gave him a one-man show at the Wakefield Bookshop. Although he continued to exhibit with Parsons for the next two decades, it was primarily as a patron that Ossorio would be appreciated. He had first met the Pollocks in January 1949 when he bought a "drip" painting for fifteen hundred dollars, more than twice as much as anyone had ever before paid for a Pollock. Lee, who was expert at cultivating collectors, promptly suggested to Ossorio that he and his lifelong companion, the dancer Ted Dragon, consider summering in East Hampton. She took the couple house hunting and eventually found them a perfect country nest—the seventy-acre Albert Herter estate, complete with a rambling Italianate mansion overlooking Georgica Pond. Ossorio nicknamed the place The Creeks, and it became a private showcase for the dozen or so Pollocks he purchased from the artist in the next few years.

Ossorio first visited the studio in Springs on a matter of business. One summer afternoon he showed up with the painting he had purchased the previous January and claimed that it needed some repair work. Pollock glanced quickly at *Number 5, 1948*, a large, red "drip" painting, and realized that Ossorio was right. While working on the canvas Pollock at one point had yanked a stick from a can of hardened paint and inadvertently picked up a

scab that had formed on the surface. Ever democratic in his use of materials, Pollock had tossed the scab onto the painting. Months later the still-wet scab had slid across the canvas, bending the image out of shape.

Pollock politely offered to repair the painting and suggested to Ossorio that he leave the work with him for a week or so. In reality, though, Pollock had no intention of being reduced to a mere restorer. When Lee came into the studio a few days later to see how the repair was progressing, she screamed. Ossorio's painting no longer existed. Instead of repairing the work Pollock had repainted it, creating an entirely new image. "You don't know Ossorio," Lee scolded. "Maybe he won't like it." Ossorio, however, didn't mind a bit. He said he had learned a worthwhile lesson: "Don't let an artist repair his own picture unless you want it to be improved."

In many ways it was an impossibly awkward relationship— the painfully shy painter and his compulsively social patron. Pollock tended to be "very silent" on the occasions when Ossorio visited his studio, neither agreeing nor disagreeing as the collector walked around the barn and commented, for instance, that his paintings represented "the merging of two cultures—Eastern contemplation and Western action." It was not unusual for Ossorio to bring gifts on his visits to Fireplace Road, and he gave Pollock lavish monographs on Goya, Van Gogh, and others. While Lee once complained to Ossorio that he was taking up too much of her husband's time, Pollock tolerated the collector good-naturedly; he was appreciative of the person who bought his paintings and worshiped his genius while asking nothing in return. One day Ossorio mustered the courage to show Pollock one of his own paintings. Pollock looked at it for a long time without saying anything. Then he pointed to a form in a corner that resembled a melting ice-cream cone. "This painting of yours," he said, "it's all about this." The collector was delighted by Pollock's comment and repeated it for years afterward to all his friends.

So great was Ossorio's devotion and so copious his means that he offered Pollock and Lee a free place to stay in New York

City. He owned a remodeled carriage house at 9 MacDougal Alley in the Village and suggested to Lee one day that she and Pollock use it on their next trip to the city. On Thanksgiving Pollock and Lee left Springs for an extended stay in Ossorio's carriage house. Their departure was announced in *The East Hampton Star,* which, after ignoring Pollock for years, suddenly took note of the celebrity in its backyard (although it failed to note the correct spelling of his name). "Mr. and Mrs. Jackson Pollack," the newspaper reported, "are spending three weeks in New York while Mr. Pollack is holding a one man exhibition of his paintings. Mr. Pollack, one of the popular modern artists, has made his home at Springs for the past few years."

Pollock's third show at the Parsons Gallery (November 21–December 10, 1949)—his first since the spread in *Life*—opened to wide acclaim. The exhibit, consisting of thirty-four "drip" paintings, was reviewed favorably in *The New Yorker, The New York Times,* and the art journals. While Carlyle Burrows, of the New York *Herald Tribune,* the lone dissenter, griped that the paintings looked "more than ever repetitious," the insult carried none of the vitriol of insults past. No longer did critics liken Pollock's art to "baked macaroni" or "tangled hair." The snide tone of earlier criticism had been replaced by one of respect. "Late Work by Kandinsky, Pollock and Others," read the headline on the Sunday arts page in *The New York Times,* reflecting Pollock's new stature as a painter who deserved to be taken as seriously as Kandinsky. The sales figures were appropriately impressive, with the purchasers ranging from friends on Long Island like Valentine Macy and Harold Rosenberg to such professional investors as Mrs. John D. Rockefeller III. The show, according to Pollock's mother, was "the best show he has ever had and sold well eighteen paintings and prospects of others they both are fine he is still on the wagon."

The three weeks he had planned to spend in New York City stretched into three months, with Lee insisting there was no point returning to the farmhouse in Springs in the dead of winter. They might as well stay in New York, she reasoned, and take advantage of the free apartment at 9 MacDougal Alley, or "Nine

Mac," as Pollock called it. Besides, staying in the city would allow them to attend the many dinner parties to which they were invited, the many receptions at galleries and museums: the reception at the Whitney, on Eighth Street, where, six days after his Parsons show closed, his *Number 14, 1949* went on exhibit; the reception at the Museum of Modern Art, where, the month after the Whitney show came down, his *Number 1, 1948* went up. He attended many parties, his sobriety adding a new layer of absurdity to already absurd events. Among them, as Lee wrote to Ossorio, was "an insane dinner party given by a Mr. & Mrs. Lockwood, whom we didn't know, and who weren't there." One night, after returning home from yet another dinner party, Lee realized that a woman who Pollock thought was Mrs. Herbert Ferber was not Ferber's wife at all but the wife of a cartoonist. So that Pollock would know whom he had met, "I wrote out a list of the names of the people we had dinner with."

To the outside world he had become, in the words of *Life*, the "shining new phenomenon of American art." To fellow artists, however, Pollock's exalted status carried no more credence than his earlier rank, bestowed by Greenberg, as "the strongest painter of his generation." While no one doubted Pollock's seriousness, artists resented the claims about his superiority. At the same time they wondered, if not Pollock, who was the best? Many thought it was Willem de Kooning, the Rotterdam-born painter who had arrived in New York as a stowaway in 1926. After painting houses in Hoboken and making displays for A. S. Beck Shoe Stores, de Kooning had gained an underground reputation in the thirties as a master of the human figure. Although he had not had his first one-man show until 1948, at the age of forty-four, his refusal to exhibit before he felt ready (and de Kooning never felt ready) only heightened the respect he commanded among artists. Unlike Pollock, who tended to alienate painters with his surliness, de Kooning had a large, loyal following. The most conspicuous of his admirers was the abstract painter Milton Resnick, who, like de Kooning, wore a wool sailor's cap and could often be overheard saying "Terrific, terrific" in the broken Dutch accent of his mentor.

One day de Kooning and Resnick were wandering along Fifty-seventh Street when they ran into Pollock. His show had opened a few days earlier and he was interested in hearing what his colleagues felt—at least he thought he was. Pollock asked the two painters whether they had seen his show; they said they had. "What did you think?" he asked quietly. De Kooning said nothing. Resnick said he had a question about one painting in particular called *Out of the Web*. Pollock had cut large amoeboid shapes "out of the web" of dripped pigment, exposing the brown Masonite board on which the canvas was glued. Resnick told Pollock he didn't get it—what were those pieces of Masonite doing in the middle of a "drip" painting? Pollock thought for a few seconds before blurting out his answer: "Big form," he said. As his colleagues looked at him uncomprehendingly his face turned red. "Big form," he said again. Resnick said he understood. "You mean big like Picasso big?" "Yeah," Pollock said, nodding his head as the two painters laughed at him.

Ever since the article in *Life*, his circle of acquaintances had been expanding steadily. Yet he found himself more alienated than ever from his fellow painters. De Kooning once said, "Pollock broke the ice." While the comment has been taken (and quoted on dozens of occasions) as a tribute to the revolutionary nature of Pollock's art—as if he had made it possible for a whole generation of painters including de Kooning to advance in their art—the comment was actually a reflection, and not necessarily a flattering one, on Pollock's popular appeal. What de Kooning was saying was that Pollock was the first of his generation to interest the general public in abstract American painting; he broke through the ice of mass indifference. But never did de Kooning openly acknowledge an artistic debt to Pollock. The two men were not so much colleagues as competitors, each representing entirely different values. De Kooning, who came from the country that produced Vermeer and Rembrandt, prided himself on his links to tradition as surely as Pollock was pleased by the notion of his Cody boyhood and the challenge to tradition it represented. De Kooning's acknowledged status as the more learned and intellectual of the two painters did not offend Pollock; to the con-

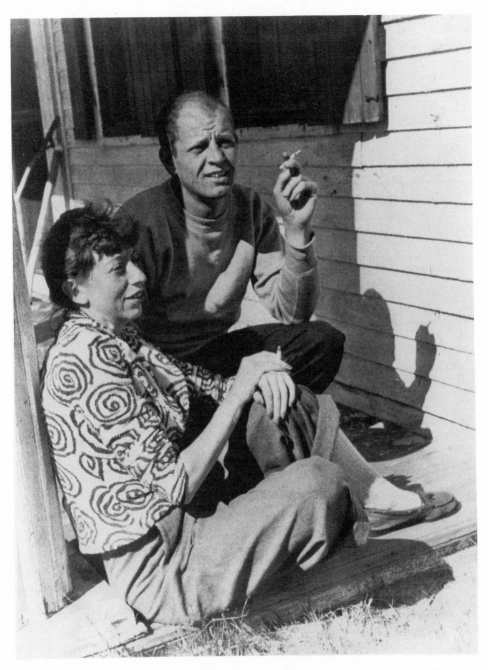

12. In the summer of 1944 Pollock visited Provincetown with Lee Krasner. They married the following year. (Courtesy Nene Schardt)

13. Peggy Guggenheim, who ran the gallery Art of This Century, gave Pollock his first one-man show. (Photograph by Gisele Freund, courtesy The Peggy Guggenheim Collection)

14. Betty Parsons, an artist herself, became Pollock's art dealer in the late forties. (Photo by Alexander Liberman)

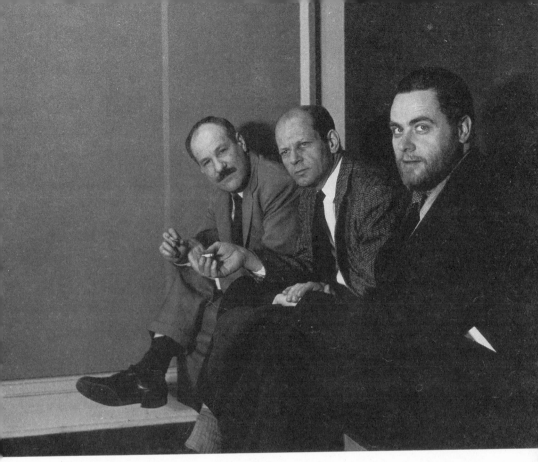

15. Pollock was friendly with several of the artists who showed at the Parsons Gallery, particularly Barnett Newman (left) and Tony Smith. (Photo by Hans Namuth)

16. Clement Greenberg, the art critic, was Pollock's most ardent champion. He had a weekly column in *The Nation* and wrote longer pieces for *Partisan Review*. (Courtesy Sue Mitchell)

17. Harold Rosenberg, the art critic, coined the phrase "action painting." (Photo by Fred W. McDarrah)

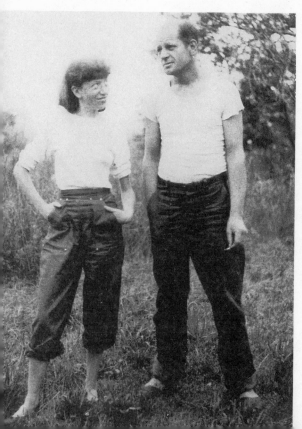

18. After fifteen years in Greenwich Village, Pollock moved to the country. He and Lee bought a five-acre farm in Springs, East Hampton, for $5,000. (Courtesy Ronald Stein)

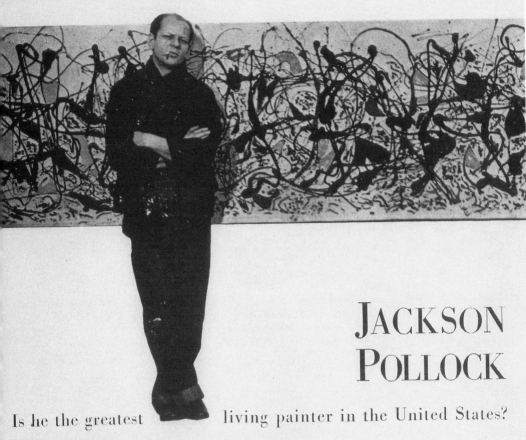

JACKSON POLLOCK

Is he the greatest living painter in the United States?

"NUMBER TWELVE" reveals Pollock's liking for aluminum paint, which he applies freely straight out of the can. He feels that by using it with ordinary oil paint he gets an exciting textural contrast.

Recently a formidably high-brow New York critic hailed the brooding, puzzled-looking man shown above as a major artist of our time and a fine candidate to become "the greatest American painter of the 20th Century." Others believe that Jackson Pollock produces nothing more than interesting, if inexplicable, decorations. Still others condemn his pictures as degenerate and find them as unpalatable as yesterday's macaroni. Even so, Pollock, at the age of 37, has burst forth as the shining new phenomenon of American art.

Pollock was virtually unknown in 1944. Now his paintings hang in five U. S. museums and 40 private collections. Exhibiting in New York last winter, he sold 12 out of 18 pictures. Moreover his work has stirred up a fuss in Italy, and this autumn he is slated for a one-man show in *avant-garde* Paris, where he is fast becoming the most talked-of and controversial U. S. painter. He has also won a following among his own neighbors in the village of Springs, N.Y., who amuse themselves by trying to decide what his paintings are about. His grocer bought one which he identifies for bewildered visiting salesmen as an aerial view of Siberia. For Pollock's own explanation of why he paints as he does, turn the page.

19. Pollock became a household name after he was featured in *Life*.
(Copyright Arnold Newman)

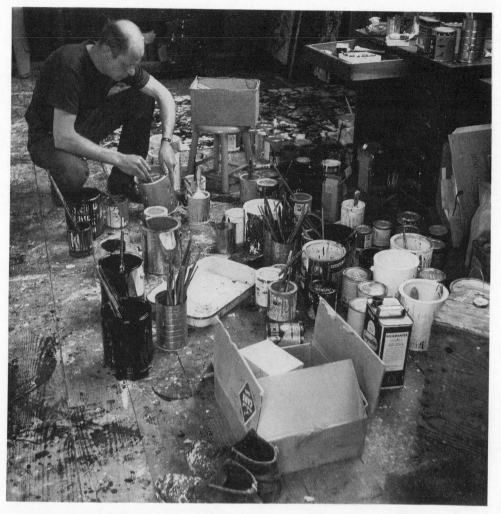

20. Pollock was often asked to demonstrate his novel "drip" technique. Here he poses for photographer Rudolph Burckhardt . . .

21. . . . with Lee at his side.

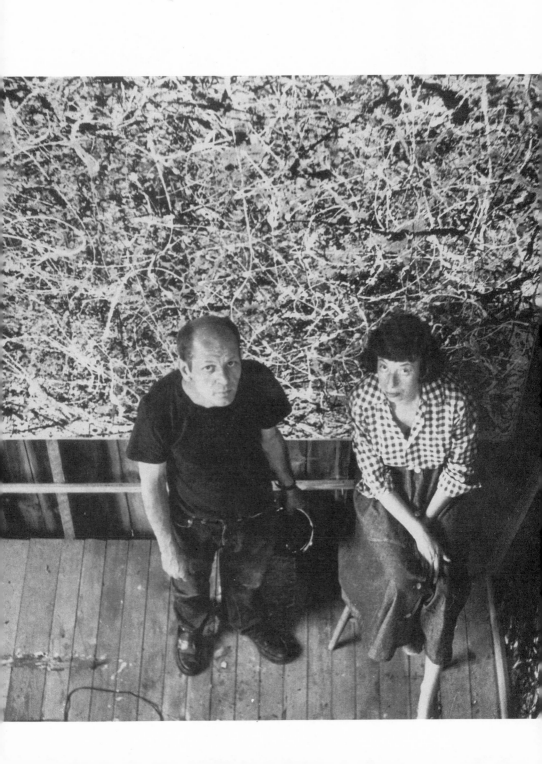

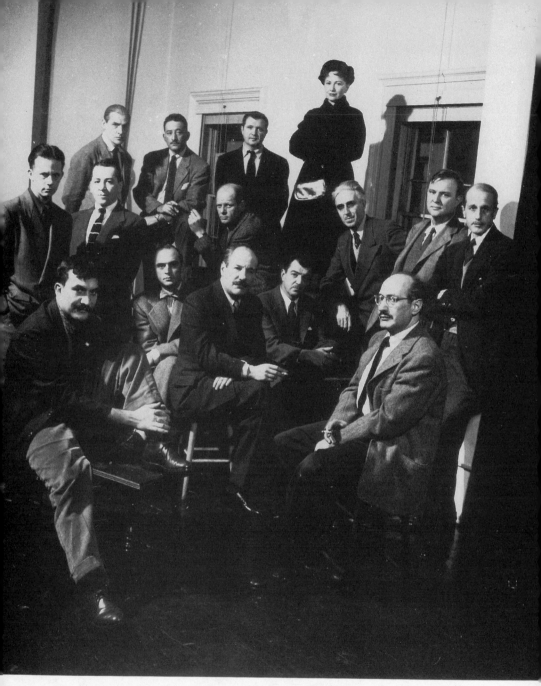

22. This picture of the so-called "Irascibles," which appeared in *Life* magazine in January 1951, is the only group portrait of the Abstract Expressionists. Top row, left to right: Willem de Kooning, Adolph Gottlieb, Ad Reinhardt, Hedda Sterne; middle row: Richard Pousette-Dart, William Baziotes, Jackson Pollock, Clyfford Still, Robert Motherwell, Bradley Walker Tomlin; seated: Theodore Stamos, Jimmy Ernst, Barnett Newman, James Brooks, Mark Rothko. (Photo by Nina Leen, *Life* magazine, Copyright Time, Inc.)

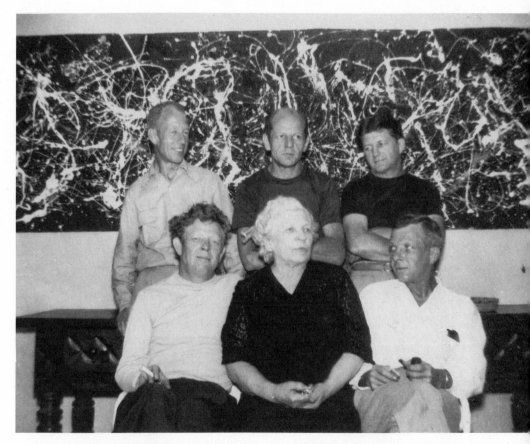

23. The Pollock brothers and their mother gathered in Springs in the summer of 1950 for their first reunion in more than a decade. Charles Pollock (seated left) was then an art professor in Michigan. Sande (standing right) owned a printing shop in Connecticut. Frank Pollock (standing left) was a rose grower in California, and brother Jay (seated right) was a printer. (Courtesy Archives of American Art)

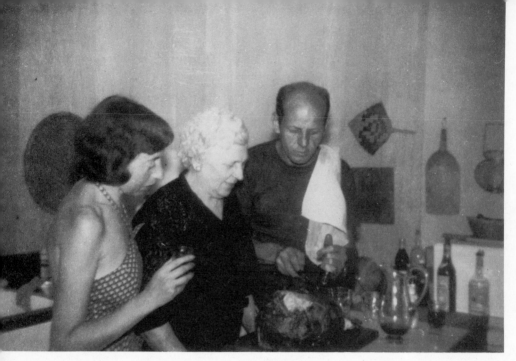

24. Pollock carves a holiday roast as his mother and wife look on.
(Courtesy Archives of American Art)

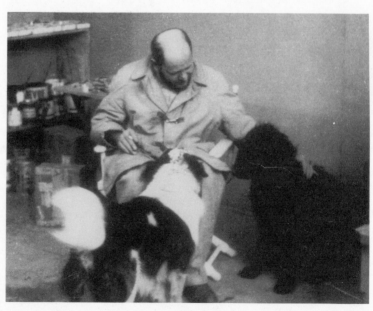

25. Pollock virtually stopped painting in the last years of his life. He
is shown here in his studio with his dogs Gyp and Ahab. (Courtesy
Archives of American Art)

trary, he turned it into a weakness. He often accused de Kooning of being a "French painter," referring to his reverence for Cubist tradition. Another of Pollock's favorite jabs at de Kooning was, "You know more, but I feel more."

Though Pollock socialized often that winter, he remained significantly absent from activities at the new headquarters of the avant-garde—The Club. The celebrated hangout had been founded by de Kooning, Resnick, and their cronies after deciding that they needed a meeting place more conducive to conversation than the inhospitable Waldorf Cafeteria. (The cafeteria's management had started harassing artists, limiting tables to four, and forbidding smoking.) In the fall of 1949 they rented a loft on the fifth floor of 39 East Eighth Street, equipped it with folding chairs and a coffeepot, and thus founded the Eighth Street Club. At first a casual haunt, The Club was soon sponsoring panel discussions ("Has the Situation Changed?") and Friday-night lectures ranging from Lionel Abel, "The Modernity of the Modern World," to Dr. Frederick Perls, "Creativeness in Art and Neurosis." Membership eventually swelled to a 150, though Pollock, the perpetual nonjoiner, did not join The Club. He did make one appearance in the winter of 1950 but left before the lecture was over. As Harold Rosenberg once said, "Jackson didn't like doing things with coffee."

———

One day in May 1950, soon after returning to Springs, Pollock received a phone call from Barnett Newman. Lee answered the phone and told Newman that Pollock was in the barn and could not be disturbed. Newman said it was urgent. He was calling from the apartment of Adolph Gottlieb, on State Street in Brooklyn, where he was meeting with Rothko, Reinhardt, and others to finish drafting a letter of protest to the president of the Metropolitan Museum of Art. The letter, signed by eighteen painters and ten sculptors, announced a boycott of "American Painting Today—1950," a big exhibition-competition that the Metropolitan was planning for December. The artists felt it was futile to enter their work in the competition since the Met had chosen a

jury "notoriously hostile to advanced art." The only thing missing from the short letter of protest, Newman told Lee, was Pollock's signature.

As Lee walked to the barn to get Pollock she grew angrier by the second. Why hadn't Newman asked her to sign the letter? Wasn't *she* an artist, and an activist as well? She thought about the many protests she had attended in the thirties, the picket lines she had marched on. It only made her angrier to think that while she had been excluded from the protest, her husband, who hardly knew a picket line from a police line, had suddenly become indispensable to art-world politics. She listened silently as Pollock talked to Newman, explaining politely that he could not come to New York to sign the letter but, yes, he was willing to send a telegram to Gottlieb's studio saying he supported the protesters. The telegram went out that day. "I ENDORSED [sic] THE LETTER OPPOSING THE METROPOLITAN MUSEUM OF ART 1950 JURIED SHOW STOP JACKSON POLLOCK."

It turned out to be the most publicized event ever staged by the Abstract Expressionists. The story was carried on page one of *The New York Times,* on May 22: "18 Painters Boycott Metropolitan; Charge 'Hostility to Advanced Art.' " The next day the *Herald Tribune* ran a damning editorial, headlined "The Irascible Eighteen," the name by which the artists would soon be identified in a famous group photograph in *Life.* The magazine's art editor, Dorothy Seiberling, initially suggested to Newman that the photograph be shot on the steps of the Metropolitan Museum, with the artists carrying their paintings under their arms. While willing to pose for *Life,* the artists rejected the Metropolitan as a locale. Newman thought they should be photographed "like bankers," not outcasts, and Gottlieb insisted on "neutral territory." *Life* accommodated them, scheduling the photography session at an anonymous studio on West Forty-fourth Street. This time Pollock had no trouble getting to New York. He rode the train from East Hampton, on November 26, along with James Brooks, to meet his fellow protesters on the neutral territory they had requested, which turned out to be a high-ceilinged photography studio with a drab linoleum floor, windows that faced an alley, and a back-

ground curtain that no one bothered to close. Photographer Nina Leen told the group to arrange itself on the chairs and stools scattered about the room. "How do you want us to sit," Newman jested, "according to our voices?" Leen said she did not care. The burly Newman plunked himself down on a stool in the front row. Pollock sat down behind him, on a higher stool, placing himself in the center of the group.

The black-and-white portrait that appeared in *Life* in January 1951—"Irascible Group of Advanced Artists Led Fight Against Show," the caption stated—showed fifteen painters who resembled bankers only if one assumes that their bank was about to collapse. Rothko, clutching himself self-protectively, eyes the photographer with a suspicious sideward glance. De Kooning, glaring intently from the back row, looks like a blond Kafka. The gaunt, ashen-faced Clyfford Still could be cast as the Grim Reaper. "If some of us look angry," Motherwell once said in reference to the tedious, hour-long session, "the anger was probably at the photographer." Pollock, however, seems to be enjoying his second appearance in *Life*. Gamely he turns his head over his shoulder and raises a cigarette. He is as handsome as Gary Cooper. He is leaning toward the camera, betraying no signs of discomfort with either Nina Leen's lens or the central position he occupies in both the photograph and the eyes of the public despite his marginal role in organizing the protest.

"There was only Jackson Pollock. He was the center of the universe." Thus Marie Pollock, his sister-in-law, referring to an unhappy family reunion held in Springs that summer. The get-together, the family's first in seventeen years, had been organized by Stella after learning that her son Frank, a rose grower, would be coming to New York from California to attend a convention for nurserymen. She convinced her other sons to join her in Springs for a day-long reunion. Charles, who was now an art professor, came from East Lansing, Michigan; Jay, a printer, from Springfield, Ohio; and Sande, with whom Stella was still living, from Deep River, Connecticut. The four brothers arrived with their wives and children, eager to see their famous kid brother. Over the years they had followed his career closely, with Stella, a

voluminous correspondent, keeping them posted on every development—his exhibitions ("he had a wonderful show"), his sobriety ("still on the wagon"), and of course the article in *Life* ("just swell . . . be sure to get it").

On the day his family arrived in Springs, Pollock had something else on his mind besides the reunion. He had not long before been selected, along with de Kooning, Gorky, and four others, to represent the United States at the 1950 Venice Biennale; three of his "drip" paintings remained on view at the fair throughout the summer. While Pollock had decided against accompanying his work to Venice, he was eager to hear what the Italian critics thought about his work. On the day of the reunion he received in the mail one especially compelling review, "Piccolo discorso sui quandri di Jackson Pollock," by critic Bruno Alfieri. Although Pollock could no more understand the text of the piece than he could its title, he read it again and again, for in the jumble of foreign words was one word he did understand—"Picasso." The critic had compared him to Picasso, and Pollock refused to put down the article until he knew whether the comparison with his rival was favorable.

As his guests spent the day entertaining themselves in his living room, Pollock remained seated at the kitchen table poring over the article. Whenever his relatives wandered into the kitchen to freshen up their drinks or see what he was doing, Pollock asked them the same question: "Do you know any Italian?" No one did. Pollock asked them to look at the article anyway, pointing to one line in particular: "E al confronto di Pollock, Picasso, il povero Pablo Picasso . . . diventa un quieto e conformista pittore del passato." His relatives read the line. They grew angry. "Is Picasso more important than your family?" asked sister-in-law Alma, prompting outraged stares from both Pollock and Lee. Pollock did leave the kitchen long enough to pose for some group photographs, but judging from his expression, he resented having to participate. When Frank Pollock mentioned casually that he was thinking of staying an extra day, Lee dropped a hint. "You know, Jackson," she said very loudly, "Betty's coming tomorrow." It was the last time Stella Pollock planned a reunion.

As Pollock must have suspected, the comparison with "po-

vero Picasso" was favorable. Critic Bruno Alfieri had written that Picasso, compared to Pollock, was "a quiet conformist, a painter of the past." The rest of the article, however, was grossly unflattering. The unflattering parts Pollock had no difficulty understanding for *Time* magazine reprinted them in English in November 1950. The news item, entitled "Chaos, Damn It!" reported that Italian critics had tended to "shrug off" Pollock's appearance in Europe and that the only critic who "took the bull by the horns" was Bruno Alfieri. He was quoted as describing Pollock's art like this: "Chaos. Absolute lack of harmony. Complete lack of structural organization. Total absence of technique, however rudimentary. Once again, chaos." Although *Time* left out the line about Picasso, it did manage to squeeze in the absurd bit of news that "Pollock followed his canvases to Italy."

Pollock was outraged by the item in *Time*. How could they not mention the part about Picasso? Didn't they know what was newsworthy? Angrily he fired off a telegram to the magazine. "Sɪʀ," he wrote. "Nᴏ ᴄʜᴀᴏs ᴅᴀᴍɴ ɪᴛ. Dᴀᴍɴᴇᴅ ʙᴜsʏ ᴘᴀɪɴᴛɪɴɢ ᴀs ʏᴏᴜ ᴄᴀɴ sᴇᴇ ʙʏ ᴍʏ sʜᴏᴡ ᴄᴏᴍɪɴɢ ᴜᴘ Nᴏᴠ. 28. I'ᴠᴇ ɴᴇᴠᴇʀ ʙᴇᴇɴ ᴛᴏ Eᴜʀᴏᴘᴇ. Tʜɪɴᴋ ʏᴏᴜ ʟᴇғᴛ ᴏᴜᴛ ᴛʜᴇ ᴍᴏsᴛ ᴇxᴄɪᴛɪɴɢ ᴘᴀʀᴛ ᴏғ Mʀ. Aʟғɪᴇʀɪ's ᴘɪᴇᴄᴇ." The magazine attempted a reconciliation but only succeeded in driving Pollock to new levels of exasperation. It published his telegram on December 11, along with an editor's note explaining that the most exciting part of Mr. Alfieri's piece, "at least for Artist Pollock," was probably the statement that he "sits at the extreme apex" of the avant-garde.

———

One bright June day Pollock was visited in his studio by Rudy Burckhardt, a photographer, and Robert Goodnough, a painter and critic. They arrived on assignment from *Art News* magazine, which was planning a feature story called "Pollock Paints a Picture." The idea of the article was to follow a painting through its various stages of creation from first to final stroke. Pollock had already agreed to cooperate with the magazine, promising, by telephone, to start a new painting and attempt to finish it in the presence of the writer-photographer team.

When the visitors from *Art News* arrived at his studio, how-

ever, they quickly learned that Pollock had no intention of honoring his promise. He could not be bothered, for his attention was focused on something else. "I can't decide whether this painting is finished," he said, gesturing toward a black, spidery painting lying on the floor of the barn. Never before had he limited his palette solely to black nor created such a bold image. It consisted of sweeping black arabesques, flung dramatically against the stark white expanse of the canvas. Starting a painting in black was not unusual for Pollock, but in the past he had always gone on to embellish the image with color in a process that was somewhat akin to developing a charcoal sketch into a finished painting. This time there was only black, and he wasn't sure whether he should leave the painting in such elemental form. His decision was further complicated by the huge proportions of the canvas. At roughly nine feet high and fifteen feet long, *Number 32, 1950,* as the work was later titled, was his first mural-sized painting since his mural for Peggy Guggenheim six years earlier, and Pollock had to be sure that the bare-boned black image was capable of commanding or structuring all that space. He had been agonizing over the question for some time and was not about to resolve it in the presence of *Art News.* Still, he did want to be in the magazine. He proposed a solution. "I'll pretend I'm painting," he told Rudy Burckhardt, proceeding to pick up a stubby brush and a can of paint and to kneel on top of the black mural. As Burckhardt photographed him, Pollock moved a dry brush across the canvas and pretended for posterity that *Number 32, 1950,* the result of much hard work, had been created with a few carefree tosses of paint.

Pollock later decided that the mural was, in fact, finished. He considered it one of his best works, an appraisal that many share. In some ways it represents the climax of his career. Twenty summers earlier Pollock had visited a school outside Los Angeles and had seen his first mural, Orozco's *Prometheus.* He had soon after arrived in New York and watched admiringly as Benton and the Mexicans covered wall after wall with Depression-era murals. He had dreamed about painting his own mural, yet so inadequate were his skills that he had been unable to secure a mural com-

mission on the WPA or elsewhere. By 1950, however, Pollock had not only mastered the tradition of mural painting but subverted its very purpose. Unlike the murals of the thirties, *Number 32, 1950* does not popularize a philosophy or call for revolution. It *is* a revolution, shattering our notions about what is monumental in art. It can be argued that Pollock's accomplishment was to wed the public world of the mural with the private world of his psyche in a way that was utterly new; but while that explains his newness, it doesn't explain his accomplishment.

Pollock's accomplishment was to reinvent the simplest element of art—line, "the essence of all," as he had written with remarkable prescience two decades earlier. *Number 32, 1950 (Fig. 25)* shows him at the height of his powers, capable of creating not just a mural but a great work of art with the aid of nothing more elaborate than a naked black line. No form, no color, just line. He can do whatever he wants with it, tapering it into filigreelike delicacy or thickening it until it is heavy as mud. He can make it tauten, slacken, halt, plunge, soar, race, and fly, and reinvent it inch by inch to accommodate the subtlest nuances of feeling. Because he was unable to express himself through the readymade techniques of art, Pollock devised his own techniques, and in the process he became a great draftsman whose facility with line can withstand comparison with predecessors as formidable as, say, Ingres or Botticelli.

On July 1, 1950 Pollock attended an art opening at Guild Hall, a long, low, whitewashed brick building at the southern end of Main Street in East Hampton. On exhibit was a show called "Ten East Hampton Abstractionists." The list of participants was impressive, particularly for a small-town community center. Besides Pollock, the show also included Lee Krasner, James Brooks, John Little, Wilfrid Zogbaum, Buffie Johnson, and several others who had settled in the area in the five years since Pollock had moved to Springs. Pollock was standing alone at the opening when a young photographer from *Harper's Bazaar* introduced himself. His name was Hans Namuth and he was renting a house for the summer in nearby Water Mill. In his thick German accent Namuth told Pollock that he greatly admired his work and would

like to photograph him sometime, though not necessarily for *Harper's Bazaar*. For a moment Pollock looked reluctant. "Well," he said, "why not?"

When Namuth telephoned later that week to set up an appointment, Pollock was encouraging. As he had once promised *Art News*, he now promised Namuth to start a new painting and perhaps even finish it in the photographer's presence. But when Namuth showed up the following afternoon with two Rolleiflexes hanging from his neck, Pollock regretted having made the offer. He and Lee met the photographer in the driveway, and Pollock told him abruptly, "The painting is finished." He did not plan to do any more work that day, he said. Hesitantly Namuth asked if he could see the studio anyway. Pollock and Lee took him inside the barn and allowed him to look around. A large, wet painting was lying on the floor. Namuth studied it through the ground glass of his camera. Pollock studied it too. Suddenly, overcoming any doubts, Pollock picked up a brush and a can of paint and began to toss pigment, his movements slow and deliberate. Within a few minutes he had quickened his pace, working with speed and apparent sureness. Namuth started to shoot. He finished one roll of film and switched to the other camera. Then he reloaded both cameras. For thirty minutes Pollock continued to paint as the loud, rapid clicks of the camera shutter resounded in the barn like applause.

Namuth returned the following weekend to show Pollock the photographs. Pollock studied them closely, pleased with the results. "Do you have any more?" he asked. Namuth had no more but offered to come back the following weekend. And the weekend after, and the weekend after that. Throughout the summer of 1950 Hans Namuth returned every weekend to photograph Pollock inside his studio. As surprising as this is, given the shy, self-conscious person Pollock was, even more surprising is that some of his best-known paintings were created as Namuth snapped away.

The year 1950 was the most prolific of Pollock's life. He completed about fifty-five paintings—compared to about forty the previous year—and they include some of his largest and most

widely praised works. *One,* an enormous, mural-sized painting that measures roughly nine feet high by eighteen feet long, was begun soon after Pollock finished *Number 32, 1950* (the all-black mural) and explores some of the ideas set forth in the earlier work. The painting consists of giant weaving rhythms of black, white, and tan that cohere almost magically into a harmonious whole. As in the best of Pollock's work, the countless movements and tensions even one another out so that the final effect is one of balance, but precarious balance. It's as if a thousand different sensations have been merged, but just barely, and only by a superhuman act of creativity. *Autumn Rhythm,* the third of the three murals dating to this period, resembles *One* not only in size but in color. Once again, the painting consists of linear rhythms of mostly black, white, and tan, which suggest the colors of a pencil sketch and serve to remind us of Pollock's draftsmanly genius. But there is nothing intimidating or haughty about the painting; to the contrary, the mood is almost intimate.

It is hard to determine from Namuth's photographs exactly which paintings Pollock was working on as he was being photographed. But it can be said with certainty that he did paint *Autumn Rhythm*—or rather that he painted part of it—in front of Namuth. Photographs document the painting's creation: Pollock picks up a can of black Duco and, with a stubby brush, drips some paint onto a black canvas. He steps onto the painting and tosses pigment with wide, sweeping motions of his arm. He crouches, he stands up, he walks around the canvas continuing to apply paint until the entire surface has taken on the activity of weaving rhythms. This first phase finished, he tacks the painting to a wall in the barn for a period of contemplation and study. Clearly Pollock felt sure of himself in front of the photographer, and perhaps the experience was in some ways liberating for him. As one who was obsessed by a need to prove himself, he seemed to derive a special satisfaction from showing off his mastery in front of an audience. Painting a picture such as *Autumn Rhythm* with a photographer recording his every gesture was no small feat for a man who had once been unable to complete so much as a pencil sketch in the presence of his schoolmates.

Every weekend after Namuth had finished shooting he would go inside the house with Pollock and show him the photographs he had taken the previous week. By the end of the summer Pollock had looked at more than five hundred photographs, many of which have become well known. Pollock crouches above a canvas, his balding forehead creased into intense concentration. Pollock flings paint, moving so quickly his arm is a blur of light. He liked the way he looked in the photographs—they show him in his moment of triumph—never anticipating the skewed reactions they would bring to his art. The Namuth photographs, which were first published in 1951 and have been widely reproduced since, drew attention to Pollock's technique and helped give rise to a popular image of the artist as a wild, brutish paint-flinger. In 1952 Pollock would pick up a copy of *Art News* one day and read that "At a certain moment the canvas began to appear to one American painter after another as an arena in which to act . . ." To Pollock's dismay, his art would be labeled "action painting" and its creator would be lionized as an existentialist hero whose defiant, solitary actions counted more than their outcome. This trivialization of his art angered Pollock greatly, but it probably never occurred to him that Harold Rosenberg's famous essay on action painting might not have been written had he not posed for the pictures.

At the end of the summer Namuth mentioned to Pollock that he wanted to make a film. Although he had never made a film before, he felt that even a short, amateurish "home movie" could capture Pollock in ways that photographs, however polished, could not. Pollock said it was fine with him, and the first weekend in September, Namuth arrived in Springs with his wife's Bell and Howell Turret. He climbed up to a hayloft in the studio, and, holding the movie camera in his hand, shot until the film ran out. Soon afterward he showed the results to his friend Paul Falkenberg, a film editor, who was sufficiently impressed with the seven-minute short to suggest that Namuth undertake a second movie, this one in color, and to offer to help him scratch together two thousand dollars to finance it. The color movie, unlike the earlier effort in black-and-white, required that camera lights be

installed in the barn, Since the barn had no electricity, Pollock volunteered to move his studio out-of-doors. He made a second concession as well. Although he had already finished preparing for his upcoming show at the Parsons Gallery by the time the filming began, he agreed to paint one more painting so the film-maker would have something to film. For four consecutive weekends in early autumn he worked on one painting, placing it in tall, damp grass and dripping pigment as Namuth shot the eleven-minute documentary. Later Pollock destroyed the painting, perhaps because he considered it merely a prop.

One day Namuth proposed to Pollock that he consider starting a new painting—and that he paint it on glass. If the sheet of glass could somehow be secured in a horizontal position a few feet above the ground, Namuth could crawl beneath it and shoot from below, recording the loops of paint as they fell through the air. Pollock thought it was an interesting idea and offered to build a platform that could support the glass.

The painting-on-glass segment of the movie was shot on a cold, sunny afternoon in late October. Namuth lay down in the grass on his back beneath the four-by-six sheet of glass. He rested the movie camera on his chest and focused the lens on Pollock. The camera records Pollock's actions as he starts work. He arranges some pebbles and wire mesh on the painting surface, binding the materials in place with a few tosses of black pigment. He is not satisfied. He wipes the glass clean. "I lost contact with my first painting on glass, and I started another one," he says in a sound track that was recorded later. He starts all over again, rearranging the pebbles and wire mesh along with shells, bits of string, and other materials. As he works he looks down at his painting. Through its transparent surface he sees the photographer sprawled beneath him.

By the time Namuth finished shooting the painting-on-glass segment of the movie, the sun had begun to set. The two men went inside the house. A dinner party was in progress. Namuth went into the living room and joined the guests by the fireplace. Pollock did not stop to say hello or to warm himself by the fire. He walked directly into the kitchen. He took out two large glasses

and a bottle of bourbon and filled the glasses all the way up. He called Namuth into the kitchen. "Hans," he shouted, "come have a drink with me." Namuth walked into the kitchen. Behind him were Ossorio and Lee. The threesome stood there startled as Pollock lifted a glass of alcohol for the first time in two years and emptied it. Namuth and Ossorio were startled because they had never seen Pollock drink before. Lee was startled because she *had* seen him drink before; she had seen him drink away his life, and hers too, and when Pollock emptied the second glass, her face went white. The guests tried to pretend that nothing unusual was happening as Pollock proceeded to tear a string of cowbells from the kitchen doorway and threatened to hit his friends. "Let's sit down for dinner," Lee said. Pollock sat down at the head of the table and started insulting Namuth. Suddenly he picked up the dinner table and sent a roast beef skidding to the floor. Lee picked up the roast beef and washed it off. She put it back on the table. Pollock lifted the table again, this time sending the dishes crashing across the room. "Coffee," Lee announced, "will be served in the living room." Pollock went outside to his car and drove away.

The guests tried to make sense of the ugly events they had witnessed. Perhaps it had something to do with the cold weather—had he poured the drink simply because he was cold?—or perhaps with the movie, or perhaps with the death of Dr. Heller seven months earlier. No explanation seemed adequate as they considered the fact that the past two years of Pollock's life, sober years, had been his most rewarding ever. He had been featured in *Life.* He had sold many paintings. His work had been sent to the Venice Biennale. Most important, in the past few months alone he had completed his first mural-sized "drip" paintings—*Number 32, One,* and *Autumn Rhythm.* What had led Pollock to take the drink and consequently to return to heavy drinking? Various writers have argued that Pollock felt "tormented" by his public success, yet success is too easy an answer; Pollock was tormented long before he was successful. A more plausible answer lies in his art. By October 1950 Pollock had done everything he could do with his "drip" technique. Although

some of his contemporaries would continue to turn out their trademark images for many years—Rothko, for instance, painted floating rectangles for more than two decades, and Motherwell painted his "Spanish Elegies" for more than three decades—Pollock felt compelled after four years to abandon the style that had won him both personal satisfaction and public acclaim. So fierce was his hatred of authority figures that once he became one, once he had mastered his own style, he had no choice but to rebel against his own mastery. As he had turned against Benton in 1938 and against Picasso in 1944, Pollock, in 1950, turned against himself—with the disastrous result, as in earlier times, of heavy, suicidal drinking. If he had not taken the drink on that last day of shooting, one suspects he would have taken it soon afterward. On the other hand, the experience of making the movie surely helped precipitate the inevitable. How absurd he must have felt making that painting on glass, an invisible canvas through which he could see a camera lens pointed at his face.

Pollock left the glass painting in the backyard for a few weeks. It collected leaves and dirt and weathered the rain. He eventually brought it inside and cleaned it off. He titled it *Number 29, 1950*. He talked about hanging it on the porch and perhaps even setting it into the house, like a window, but never did.

13 The "Black" Paintings

1951

Pollock's fourth show at the Parsons Gallery opened on November 28, 1950. The opening reception, which was held that evening from four to seven, was something of an event in itself. About a hundred people showed up, and not even the most begrudging could fail to be impressed by the power and vitality of Pollock's latest work. At one end of the gallery was *Autumn Rhythm*, which took up an entire wall. The opposite wall was taken up by *One*. There were thirty-two paintings altogether, and they were hung from floor to ceiling. The effect was dazzling; some people likened it to walking into a meteor shower. Among the guests was Pollock's brother Jay, a printer, who noted appreciatively to his brother Frank: "The big thing right now is Jack's show. . . . [The opening] was bigger than ever this year and many important people in the art world [were] present. Lee seemed very happy and greeted everyone with a smile, Jack appeared to be at home with himself and filled the part of a famous artist."

For all the excitement generated by the show, the critical re-

sponse was somewhat disappointing. Robert Coates, of *The New Yorker*, was still questioning whether Pollock's paintings meant anything and felt that *One* and *Autumn Rhythm* bordered on "meaningless embellishment." Howard Devree, of *The New York Times*, was similarly doubtful and asked his readers rhetorically: "Does [Pollock's] personal comment ever come through to us?" The art journals, by comparison, reviewed the show very favorably. *Art Digest* called it Pollock's "richest and most exciting to date," and *Art News* singled it out the following January as one of three best one-man shows of the year. (Pollock was ranked second, after John Marin and ahead of Alberto Giacometti.) The *Art News* citation was an honor of the highest order, but Pollock was past the point of deriving satisfaction from such distinctions. No amount of praise could ease his self-doubts. He told Greenberg in the early fifties that he didn't know where his paintings came from—unless they were bad paintings.

Pollock and Lee spent most of the winter in New York City, where they once again stayed in Alfonso Ossorio's carriage house at 9 MacDougal Alley. It was to be a difficult winter for Pollock as he struggled with the familiar problems of depression and drinking. On January 6, 1951, three weeks after his show came down, Pollock confided to Ossorio, who was in Paris: "I found New York terribly depressing after my show—and nearly impossible—but am coming out of it now." By the end of January, however, he was no better off: "I really hit an all time low—with depression and drinking—NYC is brutal." Unable to control his drinking, he surrendered to a dismal routine that consisted of waking up late in the afternoon and heading out for the bars. No matter where his nocturnal wanderings began, they usually ended at the Cedar Street Tavern, the legendary artists' bar.

The Cedar Street Tavern, at University Place and Eighth Street, was rather ordinary-looking. It had drab green walls, some booths and tables in the back, and not much to distinguish it from other bars in Greenwich Village save for a round neon sign that hung outside, casting a green halo above the street. The Cedar was a "no-environment," to borrow a phrase from de Kooning, and it was precisely its nondescript character that ac-

counted for its popularity among artists when they first started going there in the forties. There was no pool table, no jukebox, no television, nothing to interfere with the serious business of talking about art. By the early fifties, however, the quiet conversations had ended. As the artists became well known, so did their bar, and even the most casual of passersby began pausing out front and glancing through the glass in the door to survey the scene inside. Looking in, one could see who was there. On a good night one might see Franz Kline or Philip Guston or maybe even de Kooning. On a great night one might see Pollock, standing up front by the bar, holding a glass of Scotch, surrounded by art students and various young admirers who had come to the Cedar Street Tavern for the chance to see him.

There are many stories about Pollock and the Cedar bar, most of which make him out to be a mean, violent drunk. One story alleges that he tore the bathroom door off its hinges, and another story has him ripping the toilet from the wall. He supposedly punched out de Kooning, Kline, and many others. But as Clement Greenberg once said, "I used to ask people, 'Who, exactly, has he hit?' and then they couldn't remember. Jackson's violence—what a joke. He had a *horror* of violence." Pollock did like to flirt with violence, though. Drunk, he teased, taunted, and bullied, and no one was spared his obnoxious behavior. Standing up front by the bar, with his customary double Scotch, Pollock would deliver a well-known monologue to the admirers clustered around him. "What are you involved with? What are you *really* involved with?" he would ask belligerently, glaring at some hapless fellow and daring him to answer. "You're all a bunch of horses' asses!"

By this time, just about every art student in the country was familiar with Pollock's work. He had become a hero to a generation of young artists who admired his total freedom with paint. But Pollock had no interest in winning followers, and those who got to know him at the Cedar were generally disappointed to find that he could be crude as any other drunk. Audrey Flack, then a twenty-year-old art student at Yale who idolized Pollock "like a movie star," recalls her disgust upon first meeting him. She was

sitting at the Cedar one night when Pollock came in, sat down next to her, and "pulled my behind and burped in my face." Larry Rivers, the painter and saxophonist, was another devout admirer whom Pollock managed to offend with his churlish behavior. One night at the Cedar, Rivers left his table to go to the men's room and was dismayed to learn upon his return that "while I was in there, Pollock asked [my date] if she'd like to leave with him."

But not everyone came away with such a negative impression of Pollock. Helen Frankenthaler, then a promising young painter fresh out of Bennington College, had the chance to meet Pollock on many occasions through her friendship with Clement Greenberg. She recognized him at once as a painfully diffident man who tended to lose his bearings outside the context of his work. "One couldn't entertain a dialogue with him about life or art," she has said. "One experienced the man quiet or the man wild. I guess he was his true self when painting. That's where he lived."

Pollock's favorite drinking companion was Franz Kline, a short, stocky, good-natured painter who had grown up in the coal-mining country of Wilkes-Barre, Pennsylvania. He had a trim mustache and thick black hair, which he combed straight back to reveal a heart-shaped face and small, sad eyes that slanted downward. Kline had painted figuratively until the late forties, when one day he enlarged a drawing of a rocking chair with a Bell-Opticon magnifier and conceived the idea of his famous black-and-white abstractions. "Dali once told me," Kline has said, "my work was related to John of the Cross, whom he called the 'poet of the night.' Not having read him I wouldn't know." Kline's speaking manner was rambling and ardent, larded with frequent references to the Brooklyn Dodgers, railroads, automobiles, Wagnerian opera, and every aspect of art history, though he never went on at length about his own work. He and Pollock both believed that real artists didn't talk about their art, and anyone who did was suspect. One morning after an evening when Kline had participated in a panel discussion at the Museum of Modern Art, he was awakened around dawn by a hammering on

the door. He opened it. Pollock, still out from the previous night's carousing, barged in. He faced Kline angrily. "I heard you were talking yesterday," he said.

Lee seldom accompanied her husband to the Cedar. "I loathed the place," she once said. "The women were treated like cattle." She hated the tough talk, the horsing around, the sight of her husband drunkenly slapping strangers on the back as if he were one of the guys. Whom was he kidding? She blamed the Cedar for his drinking, reasoning that if he did not go to the bar he would not drink, and it frustrated her to be unable to keep him away. Pollock, in turn, seized every chance to heighten her frustration. One of his favorite strategies was to pretend that he was drunker than he actually was. A typical incident occurred one night when Kline and his sidekick, a young painter named Dan Rice, dragged Pollock home to 9 MacDougal Alley to find Lee standing outside her bedroom at the top of the stairs. "Don't bother bringing him up," Lee shouted. "I don't want a drunk in my bed." Pollock collapsed in the entryway, face first, and lay there as if unconscious. Lee continued to scream, failing to notice as her husband lifted his head, turned it toward Kline, and flashed his friend a wink.

Sober, he could barely remember what had happened the night before. But he remembered enough to know that he had been drunk, and the thought left him utterly dejected. Only one year earlier he had believed he was finally "above water," yet realized now that "things don't work that easily I guess." He asked his wife to try to understand. "It's a storm," he assured her. "It will pass." He tried to show her how sorry he was, buying her roses, baking her bread, and even telephoning Betty Parsons one day to suggest that she give Lee a show. Parsons was opposed. "I don't show husbands and wives," she told him, but Pollock insisted that she at least give Lee the courtesy of a visit. Lee always forgave Pollock for his nasty, drunken behavior. She knew his drinking depressed him even more than it depressed her. "Life's not worth it," he often told her despairingly. "The whole thing isn't worth it." One day that winter he returned home with a will. "If my wife, LEE POLLOCK, survives me then I give, devise and bequeath to her my entire estate."

Pollock thought he might feel better if he left New York. An arts group by the name of Momentum had invited him to Chicago to help jury an exhibit, and though "jurying was something I swore I'd never do," he figured "the experience might do me good." On February 7 he flew to Chicago, his first time on an airplane. "Flew out and back alone—and liked it, flying." Maybe it reminded him of other experiences: riding freight trains, driving his Ford, traveling at fast speeds, and capturing for one brief moment an exhilarating sense of change, risk, and release. The airplane ride turned out to be the only good part of the trip. In Chicago, Pollock visited Werner's bookstore, on Michigan Avenue, two blocks south of the Art Institute, and joined two other jurors in an effort to select 60 works, from more than 800 entries, for a show called "Exhibition Momentum 1951." The Momentum group had asked Pollock to participate in order to ensure that advanced artists received fair and adequate representation but regretted its choice as soon as the jurying began. Each time juror Max Weber, the distinguished American Cubist, recommended a work for the show, Pollock would respond the same way— "That's awful." He meant what he said. He judged the art of his contemporaries by the same harsh standards he applied to his own art, and by that criterion almost everything failed. "The jurying," he later wrote, "was dissappointing and depressing—saw nothing original being done." The New York *Herald Tribune* was surely referring to Pollock when it reported the following month, "If one juror had his way, the show would have numbered less than ten items all told."

Back in New York, at 9 MacDougal Alley, Pollock found himself as disconsolate as ever. He missed his house in Springs and wanted to go home but had already committed himself to various projects in New York. He spent considerable time that winter writing and recording a narration for the color documentary that Hans Namuth had filmed the previous year. Pollock, in his own words, was "not too happy" about having to talk in the movie but had agreed to do it anyway after coproducer Paul Falkenberg assured him that his statement need not be elaborate. Together Pollock and his producer wrote a six-minute statement that was based for the most part on earlier statements. "My home

is in Springs, East Hampton, Long Island" it begins. "I was born in Cody, Wyoming thirty-nine years ago." Soon after he recorded the narration, Pollock visited the producer's studio one day to watch the finished movie. Not one minute after it had begun he became exasperated. Falkenberg, without consulting him, had added Balinese gamelan music to the sound track. "Paul," Pollock told him angrily, "this is exotic music." The producer tried to explain, saying that the free-flowing rhythm of the music reminded him of Pollock's art. "Paul," Pollock said, amazed that the producer could fail to understand, "I'm an American painter." That was the end of the Balinese gamelan music. The eleven-minute documentary was first shown that summer at the Museum of Modern Art—with music by composer Morton Feldman. Of Brooklyn.

For Pollock the long, troubled winter was not entirely without consolations. He at least managed to complete a few dozen ink drawings; "feel good about them," he noted. It had been a number of years since Pollock produced a significant number of drawings; he had more or less stopped making drawings in the years he was making "drip" paintings. But his 1951 drawings, like his earlier "psychoanalytic drawings" for Dr. Henderson, were probably intended more as personal notations than public statements; he ended up recycling most of them into other works. Some he pasted into collages. Dozens more he soaked in Rivit glue and pasted to a pyramid-shaped wire armature to create a sculpture (*Untitled*), which was exhibited that spring at the Peridot Gallery, on Twelfth Street, in a show called "Sculpture by Painters." Critics admired the sculpture—"Jackson Pollock stops the show with a writhing, ridge-backed creature," gushed *Art News*—but Pollock took no pride in the work. He thought it was trivial. On the day the show closed he drove to the gallery to pick up his sculpture. Realizing it was too large to fit in the trunk of his car, he tossed it into the street and stomped on it until it was flat. He took it home and later threw it away.

More and more Pollock was being singled out in the press as the leader of American painting. His work was exhibited throughout the year in a succession of group shows at the major

New York museums, with even his detractors acknowledging that he had become, as Henry McBride, the conservative critic, put it, "the chef-d'école, such as it is; and that is always something." Pollock's contemporaries, however, did not consider him any kind of "chef-d'école," and the distinction was one that Pollock himself would have quickly disavowed (not least because it was French). He was uninterested in winning followers, and even his art, in some ways, seemed to spurn disciples. For as is true of any artist whose style is intensely personal, it is difficult to borrow from Pollock without lapsing into crude imitation. Why would any serious artist want to drip paint when Pollock held the patent on the technique? De Kooning's style, by comparison, was more traditional and easier to appropriate, and many young artists, like Grace Hartigan, Joan Mitchell, and Alfred Leslie, already owed a debt to his thrusting brushwork and elbow-action style. The extent of de Kooning's influence became evident in May 1951 when a group of Club members organized the "Ninth Street Show," the most celebrated art event of the year. It consisted of sixty-one works by as many artists, hung in a defunct antique shop in a building that was about to be torn down. Hundreds of people attended the opening-day celebration—a banner was raised above Ninth Street—generating the feeling that something substantial had been accomplished in American art. For Pollock, however, the "Ninth Street Show" was merely another reminder of his solitariness. He authorized Betty Parsons to send one of his paintings down to Ninth Street, and by the time the show opened, he had returned to Springs.

"Mr. and Mrs. Jackson Pollack," *The East Hampton Star* noted on May 10, "have returned to their home after spending the winter in Chicago and New York." It was only a matter of days before Pollock was back in his studio and finally able to overcome the drinking and dissipation of the previous months. He worked hard that summer, avoiding all distractions, as he prepared for his next show at the Parsons Gallery, which was scheduled for November. It was a productive summer for his wife as well, for Lee too was preparing for an upcoming show at the Parsons Gallery—her first one-woman show. At Pollock's urging,

Parsons had recently come out to Springs to look at Lee's work and had been favorably impressed. She scheduled Lee's show for October.

Every day around noon Pollock headed out to the barn and Lee went upstairs to the bedroom that served as her studio. They did not see each other again until dinner time. "How did it go?" Lee would invariably ask him, though she could tell from the look on his face exactly how it had gone. "Not bad," Pollock would say, assuming it had been a good day. "Would you like to see what I did?" He sought her support, and she sought his, neither of them taking account of the disparity in their reputations. In fact, sometimes it was hard to determine exactly who was ahead of whom, and their ranks were not as clearly defined as Pollock might have liked. When Pollock and Lee participated that summer in a group show at Guild Hall, Lee came away with a second prize of seventy-five dollars. Her husband placed third, for a mere fifty dollars.

Almost a decade had passed since a young Lee Krasner had stood before her easel wondering how she, like Pollock, might imbue her art with direct and spontaneous feeling. The result of her earliest efforts had been a series of frustrating "gray slabs." She had destroyed them in 1945, hosing them down until the paint peeled from the canvas. A breakthrough had soon followed, however. Between 1946 and 1949 she produced about forty paintings known as her "Little Images." These dense, small-scale, "allover" abstractions consist of tight organic forms applied in thick impasto and repeated rhythmically in parallel rows. Lee considered her "Little Images" mature, eloquent statements, yet she still sought to loosen up her style and acquire a more improvisatory approach to painting. In the summer of 1951, while preparing for her show at Parsons, she sensed that another breakthrough was imminent. She summoned her husband to her studio one day, and Pollock too noticed the change. "Lee is doing some of her best painting," he wrote in June, "—it has a freshness and a bigness that she didn't get before—I think she will have a handsome show." It is hard to evaluate Pollock's appraisal, for Lee, doubting her own accomplishments, later destroyed eleven

of the fourteen paintings that she exhibited in her show. Not until after her husband's death did she produce the work that assured her reputation as a leading Abstract Expressionist.

"This has been a very quiet summer," Pollock wrote in August, "no parties hardly any beach—and a lot of work." From May through September he secluded himself in his studio and worked with fanatic purpose, producing twenty-eight "black paintings" (titled *Number 1* through *Number 28*) that mark a radical break from the style of his past. In most of the paintings Pollock limited himself to monochromatic hues of black and reddish-brown, thinning his pigment to a watery consistency and soaking it into raw, unprimed canvas. By abandoning color he gave his art a sense of urgency, which carries over into the subject matter as well. The human figure suddenly returns, with heads, faces, and mutilated limbs emerging from the webs and tangles of black. The most common and crudest of the images is a decapitated Roman head, its high, balding forehead and classical features bearing an unsettling likeness to the artist. Sometimes the head is merely suggested; other times it is obscenely explicit, floating lifelessly against the stark expanse of the canvas (*Fig. 26*). Even considered abstractly, many of the paintings have a morbid, funereal feeling about them, their stained and blotted off-white surfaces at times resembling blood-soiled bandages.

Pollock's "black" paintings are difficult works. Critics remain divided over whether they measure up to his earlier achievements, and some have argued that his return to traditional drawing (that is, using line to define form) marks the onset of Pollock's decline. Yet whether or not one considers the "black" paintings successful, it is hard not to be sympathetic to them when one takes account of the emotional necessity that impelled them into existence. Where once there were soaring ribbons, there is now a hangman's rope, severing heads from bodies and serving as a metaphor for Pollock's violent break with his past. His "black" paintings can be seen as a rebellion against his "drip" paintings. The violence of the subject matter, with its frequent references to sacrifice and mutilation, harks back to earlier times: to 1938, when Pollock turned against Benton, and to 1944, when he

turned against Picasso. What distinguishes the "black" paintings from those earlier cycles of figurative work is that Pollock no longer "veiled his imagery." Instead he left the human figure exposed, as if unconsciously propelled toward a revelation and confession of guilt. Many critics consider the "black" paintings an anticlimatic finale to the heroic drama of his "drip" paintings, but in some ways they constitute the most heroic episode of his career. There is something at once pathetic and impressive in Pollock's need to violate a style as soon as it came within his grasp, even when the style happened to be the one he had struggled all his life to define.

In terms of technique, the "black" paintings are not significantly different from earlier paintings. Pollock continued to work on the floor, dripping industrial paint from sticks, dried brushes, and occasionally basting syringes. But instead of tacking a single sheet of canvas to the floor, he unrolled as much as twenty feet of canvas at a time and painted the works side by side. The method allowed him to sustain his impulses from one painting to the next, and it was not until afterward, in long sessions of cutting and editing, that he thought about each image as a separate aesthetic entity. "Should I cut it here?" he asked Lee. "Should this be the bottom?" The last step was signing his canvases. Pollock hated the finality of signing his works and usually waited until they were about to be picked up by truck and taken to the gallery before dipping a brush in black and signing his name to them in a fiercely slanted script.

In October, having finished preparing for their respective shows, Pollock and Lee left Springs for a two-month stay in New York. They were both eager to hear what the critics thought of their latest work. Many people had wondered where Pollock's "drip" paintings would lead, if anywhere, and not even his admirers could have anticipated his return to the human figure. Pollock imagined their surprise at his "black" paintings, suspecting that "the non-objectivists will find them disturbing—[as will] the kids who think it simple to splash a Pollock out." His immediate concern, however, was Lee's show, which was scheduled to open six weeks before his own. It had never been Pollock's in-

tention to overshadow his wife; to the contrary, he wanted her to stand on her own and win the acclaim he felt she deserved. He helped her hang her show, and when it opened, on October 15, he was careful not to monopolize attention at the reception held in her honor. The printmaker Jacob Kainen, who arrived at the Parsons Gallery a few minutes before the reception began, recalls watching Pollock head for the exit as soon as a crowd assembled. "This is *Lee's* show," he politely told a guest, slipping out the door.

Lee's show turned out to be a dismal disappointment, arousing little interest from either critics or collectors. None of the fourteen paintings sold. The reviews were patronizing, with the critic of *The New York Times* detecting in her work "feminine acuteness." When the show closed, Lee was forty-three years old, had never sold a painting, and was a $126 dollars in debt to Betty Parsons.

Pollock's show at the Parsons Gallery, which opened on November 26, was even more disappointing. Of the sixteen "black" paintings on exhibit, only two sold, bringing him less than twelve hundred dollars. He went to the gallery almost every day hoping to hear from Parsons that additional sales had been made. On one visit there he noticed that someone had defaced *Number 7, 1951*, scribbling obscenities on the canvas. On another visit he ran into de Kooning's dealer, Charles Egan. "Good show, Jackson," Egan said, "but could you do it in color?" Pollock felt bitter and betrayed. He had gone beyond the style of his past, but the collectors only wanted more of the same. Already the "drip" paintings were considered vintage Pollock, the rest a lesser investment, a fact Pollock was reminded of every time he walked into the gallery and noticed that the small red dot signifying a sale had been placed beside only two paintings, and not even large paintings.

One day Pollock visited Clement Greenberg, who was no longer writing about art for *The Nation* and had not reviewed a Pollock show in three years. "My paintings aren't selling," Pollock told him. Greenberg tried to help, summoning up the old panegyric for an article in *Partisan Review* and a second in *Harper's*

Bazaar. ("If Pollock were a Frenchman . . . people would already be calling him *'maître'* and speculating in his pictures.") Still, the "black" paintings did not sell. Pollock thought that perhaps the collectors would be more receptive if his art were less expensive. What about prints? He authorized six of the "black" paintings to be photographically reproduced and printed as serigraphs in editions of twenty-five. The printing was done by his brother Sande at his shop in Essex, Connecticut. Pollock visited one day to see how the work was progressing and told his brother, "All I want is five hundred dollars."

By the time his show closed, on December 15, Pollock was drinking heavily again. Lee had once believed that she could nurse and nurture him into abstinence but was beginning to acknowledge that his pattern of behavior could not be broken: the surge of creative activity, the surrender to alcohol. The cure, if it existed, was not within her, and she sought outside help. Earlier that year she had taken Pollock to see Ruth Fox, a therapist on Lexington Avenue who specialized in alcoholism. The therapist put Pollock on a drug called Antabuse, which, when combined with alcohol, induces wretched nausea. Pollock took the drug but also kept drinking.

By the end of 1951 Lee was willing to consider any treatment, no matter how far-fetched. She listened hopefully as Dr. Elizabeth Hubbard, the homeopathic physician whom Pollock had been seeing sporadically for more than a decade, told her about a chemist by the name of Grant Mark, on East Sixty-fifth Street. He had recently invented a formula for "total well-being" called Grant Mark's Emulsion, which was made out of various organic substances including guano—bird droppings. Pollock was willing to try it. For the next three months Lee poured her husband a cold glass of emulsion at breakfast and dinner, making sure that he consumed the prescribed amount of one quart per day. Once a week Pollock drove to the chemist's office to pick up another seven quarts. The bills ran into the hundreds of dollars. On one of his trips to the doctor Pollock stopped off for a drink before returning to Springs and arrived home drunk. Lee met him at the front door. "Where's the emulsion?" she asked. Pollock realized

he had left the seven bottles in New York but couldn't remember exactly where. He and Lee tried to figure out where they might be, for the substance was too expensive to forget about. But they never found the missing bottles. Of his experience with Grant Mark, Pollock wrote to Ossorio the following March, "I feel I have been skinned alive."

Pollock and Lee had returned to Springs a few days after his show came down; Lee reasoned that if she got him out of the city, perhaps he would not drink. But being in Springs turned out to be no better than being in New York. Night after night, holed up in the farmhouse, Lee watched her husband get drunk. When he ran out of beer, he got into his battered Cadillac and drove to Dan Miller's to buy another six-pack, and for Lee, watching him get into the car was even worse than watching him drink. She was afraid that he would have an accident. She started buying the beer herself, stacking it by the case in the kitchen.

Pollock was having terrible nightmares. One night he dreamed that he was standing on a high structure and his brothers were trying to push him off. Another night he dreamed that he was looking at a vacuum cleaner when suddenly it became one of Peggy Guggenheim's Lhasa terriers. The dog attacked him and made a hole in his stomach. A third dream involved a car crash. "Two cars," he wrote, "—the one I am driving rams into the first car which my wife has left and run away from. Between the two wrecked cars is a dead boy."

Three days after Christmas, at ten o'clock at night, the East Hampton police station was notified by telephone of an automobile accident in Springs. A patrolman was sent to the scene. "Weather clear," the police report begins. "Jackson Pollock . . . driving a 1941 Cadillac Conv . . . went off North side of road, hitting three mailboxes (in triangle of intersection) of Louse Point Road . . . hitting telephone pole #30 with right front wheel, continuing on for 55 feet in a SW direction, hitting a tree head on."

The East Hampton Star ran the story on page one. "Jackson Pollock, Artist, Wrecks Car, Escapes Injury."

14 *Blue Poles*

1952

By January 1952 Pollock had become exasperated with Betty Parsons. His paintings were not selling, and as Parsons was the first to admit, "I never pushed sales very hard. Most dealers love the money. I love the painting." Such blithe indifference to the financial side of her business was understandably unnerving to Pollock, who, unlike his dealer, did not have a wealthy family to fall back on. Besides, as he had recently learned, Parsons could be penny-pinching despite her claims to the contrary. She had been squabbling with him over money since the previous spring, when Pollock, in an attempt "to get out of my financial mess," had considered applying for a mural commission. Parsons promptly reminded him that her status as Pollock's art dealer entitled her to a share of his outside earnings: "If you cannot give me 15%, then give me 10%, if not 10%, 5%," and so on. The matter dragged on for months, with Pollock complaining to a friend that "Betty sailed last Sat. . . . As usual there was no time to plan or discuss things." The Betty Parsons Gallery, once described by Greenberg

as "a place where art goes on," had become a place where arguments went on.

Pollock was not alone in his dissatisfaction with Parsons. Rothko, Newman, and Clyfford Still felt she had opened up the gallery to every second-rate painter who had ever asked for a show and that concentration on a few good artists—mainly themselves—would yield better financial results. They asked her to drop almost everyone else from the gallery, a request that went ignored. One by one, artists began threatening to leave the gallery. Pollock wasn't just bluffing. At the end of January, a few weeks after his contract expired, he informed Parsons that he had no intention of signing a new contract with her. Furthermore, if she couldn't sell his paintings, he would sell them himself; he wanted all the paintings in her possession returned to him immediately. Such impulsive demands made Parsons "very anxious," as she wrote to Pollock on January 31. She insisted that he stay with her at least until May, which would give her a chance to sell the paintings from his last show.

Pollock's disputes with Parsons were his way of venting his frustration over a problem that was not her fault: no one wanted to buy his paintings. In spite of Pollock's reputation, there were very few serious collectors in the fifties, and a handful at most were willing to speculate in contemporary American art. In short, there was virtually no market for Pollock's work, and as Greenberg often tried to explain to him, "Since Manet, the best art has never gone over fast." This explanation was of no consolation to Pollock. For years critics had been announcing with a grandiosity worthy of Barnum that New York had replaced Paris as the center of contemporary art—yet what exactly did this mean if he couldn't sell his paintings? In Europe he was even less appreciated. His first one-man show in Paris opened in March 1952, at the Studio Paul Facchetti, a photography studio and gallery on the Rue de Lille. Of the fifteen works on exhibit only two sold, and adding to this indignity was the fact that the owner of the gallery did not return his paintings or pay him for the ones that had sold until Pollock sent a friend into the gallery a year later to see to those details.

In May 1952 Pollock left the Parsons Gallery for one that seemed to offer better prospects. The Sidney Janis Gallery was located across the hall from Parsons at 15 East Fifty-seventh Street, but the two galleries had little in common other than their address. Janis, a short, bespectacled, one-time shirt manufacturer from Buffalo, New York, was a prosperous businessman who dealt mostly in blue-chip European moderns such as Mondrian, Léger, and Kandinsky. Pollock had already exhibited in two group shows at the gallery—he and Lee had exhibited together in a show called "Man and Wife"—and he knew that Janis, though occasionally gimmicky, at least had a flair for generating publicity and attracting wealthy collectors. No one could say that Janis wasn't enterprising. A few months earlier Lee had mentioned casually to Janis that her husband was looking for a new dealer. "Do you think the market for Pollock has peaked?" he wondered. "It hasn't even been scratched," Lee insisted. Janis scheduled a show for Pollock for November of 1952.

It has often been said of Betty Parsons, half-jokingly, that she lost interest in an artist as soon as he became successful; Janis, to the contrary, made his reputation by waiting for an artist to become successful before inviting him into the fold. In the next few years many of the artists at Parsons, including Rothko and Still, would follow Pollock across the hall to the Janis Gallery. Parsons was indignant at the exodus from her gallery but helpless to stop it. In the end she couldn't even hold onto the physical space her gallery occupied. In 1963 after accusing Janis of convincing their landlord to have her evicted—which Janis vigorously denied—Parsons sued the landlord. She lost, and Janis took over her space.

Pollock's departure from the Parsons Gallery signified the end not only of the gallery's most adventurous days but of the larger adventure of Abstract Expressionism. The major discoveries had all been made, and what was once the radical vanguard was beginning to seem quite familiar. So entrenched was Pollock's reputation that when he participated that spring in a prestigious group show at the Museum of Modern Art called "14 Americans," the critics were bored. "The edge is gone," lamented *Art News* editor Thomas Hess. "We say: 'Yes, Jackson Pollock . . . it's about time he got here.'"

One spring afternoon Pollock visited the Parsons Gallery to remove his unsold paintings from storage and carry them across the hall to his new gallery. Maybe Janis would be able to sell them, but maybe not, and for the moment it did not really seem to matter. Even if he never won a wide audience, he at least had one friend who appreciated his gift. Late that afternoon he telephoned Tony Smith and asked him, "Can you come up to the gallery and help me?" Smith, who was surprised by the request since Pollock rarely asked for help with physical work, arrived a few minutes later. Pollock met him by the elevator and led him into the storage area, where he picked up a painting, *Number 25, 1951,* a self-portrait in black. He returned to the hallway, pushed the elevator button, and waited for the doors to open. He shoved the painting at his friend. "Here," Pollock said, "get out of here."

Judging from the many items about Mr. and Mrs. Jackson Pollock that appeared in *The East Hampton Star* throughout the spring and summer, the local townspeople may well have concluded that the town's most celebrated couple had an enviable existence. Together they exhibited at Guild Hall, won prizes, hosted at least one reception, and donated their paintings to deserving civic causes, such as The Springs Village Improvement Society, which held a raffle in August. The winners of the raffle, according to the newspaper, came away with "a bicycle, an automobile tire, a Polaroid camera, an electric iron, an electric whipper, and to Lionel Jackson of East Hampton, a Pollock painting."

In reality it was a strained, anxious period for both painters. One of their many problems was that Lee no longer had a place to exhibit her work. Parsons had recently told her that if Pollock insisted on leaving the gallery, she too would have to leave. "I still respect you as an artist," Parsons had told her, "but it is impossible for me to look at you and not think of Jackson and it is an association that I cannot have in here." The news was a "very severe shock" to Lee, who could not help wondering whether her status as Pollock's wife explained not only why she was dropped from the gallery but why she had been invited to exhibit in the

first place. Her confidence was completely undermined, and a year would pass before she was able to paint again.

For Pollock, getting down to work was even more of an ordeal. On one hand, he was eager to start painting again, for his move to the Janis Gallery had galvanized his competitive instincts. But for the first time in almost a decade no direction seemed clear to him. In the early months of 1952 he attempted a few "black" paintings, reworking his style of the past year as if hoping it might provide some clues to what he should do next. But the "black" paintings did not lead to any new developments. The more time he spent in his studio, the more anxious he became.

His friends tried to help him but to no avail. A particularly pathetic incident occurred one night after Pollock telephoned Tony Smith and said that he was feeling very depressed. Smith arrived in Springs a few hours later and found Pollock alone in the barn. He was holding a long carving knife and drinking bourbon. The kerosene stove was lit, with flames shooting from the end of the pipe toward the roof. "For crissakes, Jackson," Smith told him, "put it out." Pollock put out the fire but only to relight it a few minutes later. On the floor of the barn lay an unfinished painting. "What have you got here?" Smith asked, noticing that the work was unlike any others. It consisted entirely of circles, applied with a very light touch, and it made Smith think of something that George Grosz had once said: "A painter who works in circles is near madness."

As Smith looked around the studio, he realized that Pollock had done virtually no work in the past few weeks. The problem, he thought, was that Pollock was still trying to work in black. "You will never get back to any objectivity," Smith told him, "unless you go for color." Partly because Smith wanted Pollock to start working in color again but mostly because he was as drunk as Pollock, he proposed that the two of them make a painting together. He unrolled an enormous sheet of canvas on the floor of the barn and squiggled some orange paint from a tube. Pollock suddenly perked up. "So, that's how you do it," he mumbled drunkenly. "Here's how I do it." By the end of the night the two

friends had sloshed a thick layer of paint on the canvas, which, in Smith's words, "looked like vomit." When Smith told Pollock he was going inside the house because he was cold, Pollock said, "I'll stay here and pray." He promptly passed out.

About a month later Tony Smith returned to Springs one Sunday afternoon along with Barnett Newman and his wife. The guests were sitting in the living room when Newman suggested that Pollock take them out to his studio and show them the painting he had made with Smith, thinking it would be fun to see it. But Newman regretted the request as soon as he entered the barn. Emptied paint tubes littered the floor, and bottles of bourbon lay on their sides. The smell of stale smoke hung in the air. It was obvious that Pollock had not returned to his studio since Smith had last visited, and an awkward, embarrassed hush fell over the barn. Newman felt sorry for Pollock and thought to himself that if he could just get Pollock to handle some paint again maybe he'd overcome his block. Newman asked him a question about his technique: how did he manage to squeeze pigment from a tube so that it stretched tautly across the canvas? Pollock offered to demonstrate, picking up a tube of orange and with one hard squeeze forcing its entire contents onto the painting he had started with Smith. Newman too tried the technique, and together the two friends heaped more pigment onto the hopeless painting.

At the end of the summer, with his show at Janis less than three months off, Pollock returned to his studio and attempted to summon up the will to work that had eluded him for almost a year. For lack of a better alternative, he went back to color, sometimes squeezing it sparingly into the crevices of "black" paintings, sometimes splashing it loosely across large areas. In the mural-sized *Convergence* he poured rivulets of red, yellow, blue, and white directly on top of a "black" painting and thereby succeeded in burying his style of the past year. But what looked like an escape was in fact another trap. Instead of breaking new ground Pollock had returned to his "drip" style of the late forties. He had begun to repeat himself, a process that was so contrary to his creative instincts that he was virtually incapable of it. In 1952

his output declined. He produced sixteen paintings that year, fewer than half as many as in the year before and fewer than a third as many in 1950. *Blue Poles,* widely considered one of his greatest paintings, helps explain the difficulties he was facing.

Blue Poles was conceived after Pollock went back to the painting he had made with Tony Smith and Barnett Newman. By daylight the image looked grotesque, and he knew it would have to be destroyed. But the Belgian linen on which it was painted, measuring roughly seven feet high and eighteen feet long, was too valuable to be discarded (it had cost him about fifty dollars), and he decided he would try to salvage it. One day that summer he repainted the entire canvas, creating a mural-sized "drip" painting that was bluish in tone and dense in texture. After tacking the painting to a wall in his studio for a period of consideration, Pollock decided it "didn't work." The painting, though monumental in size, possessed none of the monumental calm of his earlier murals. Its weaving rhythms of paint, instead of balancing one another, simply sat on the canvas like so much slop. Part of the problem was color. For fear of repeating himself, he had forced himself to work in strong hues, which made it that much more difficult to integrate the disparate parts of the image into a single, overwhelming whole.

Over the next few weeks, in at least six work sessions, Pollock tried to save the painting. "This won't come through," he told Lee many times, despairing at his inability to recapture the coherence of his earlier work. Finally, in frustration, Pollock tried a solution that he had not used in more than a decade. He superimposed eight vertical "poles" on the image, spacing them at equal distances and tilting them slightly at opposing perpendicular angles. The massive blue poles, with their rough, cragged edges, accomplished what his "drips" alone no longer could; they charged the painting with a formidable sense of order and restraint. For Pollock *Blue Poles* was a victory, but a narrow one. His creative powers had begun to dissipate, and the device of the "poles" attests to his desperation as surely as the invisible underlayers by Newman and Smith.

Pollock's inaugural show at the Janis Gallery, with *Blue*

Poles, Convergence, and ten other paintings, opened in November to wide critical acclaim. It was reviewed favorably in *The Nation, The New York Times, The New Yorker,* and the art magazines, with *Art News* voting it the second-best one-man show of the year (after Miró). For Pollock, however, the show was a terrible disappointment. He telephoned the gallery often, hoping to hear that sales had been made, but the best news Janis could offer him was that a collector or two had stopped into the gallery and promised to consider his work. A typically exasperating incident occurred when a collector from Baltimore who had agreed to buy a certain "drip" painting backed out because the painting in question was four inches too long for his living room wall. By the time the show closed only one painting had been sold—*Number 8, 1952*—and it was not even a large painting. Pollock received a check for a thousand dollars, his entire earnings from the gallery that year.

His humiliation was keen. He had moved to the Janis Gallery out of anger with Parsons, yet realized now that his anger had been unjustified. It was not Parsons' fault that she had been unable to sell his paintings. The simple fact was that no one could sell them. The public did not want his paintings; it did not want *him.* In his frustration Pollock telephoned Sidney Janis one night when he was drunk and yelled into the phone: "This is Jackson Pollock and I hear you like my painting. Why don't you buy one?"

When Pollock's show closed Janis removed *Blue Poles* from its wooden stretcher, rolled it up, and placed it in storage in an unlocked stairwell. A year later Lee expressed concern that the painting might crack if left in that position. Janis didn't have room to store the painting unrolled, so he sent it back to Springs. In January 1954 *Blue Poles* was shipped back to the Janis Gallery and shown for a second time in a group exhibition called "Nine American Painters Today." This time the painting sold. It was purchased by the collector Fred Olsen at the urging of Tony Smith, who was designing a house for the Olsens in Connecticut. Olsen paid Janis $6000, of which Pollock received $4000. Two years later Olsen sold the painting to collector Ben Heller for

$32,000. In September 1973 Heller sold it to the Australian National Gallery in Canberra for $2 million, then the highest price ever paid for a work by an American artist.

———

One voice was missing from the chorus of praise accompanying Pollock's first show at the Janis Gallery. Clement Greenberg did not review the exhibit. He felt that Pollock's new paintings marked a falling off from his earlier work and that for the first time Pollock had produced "not bad paintings, but paintings where the inspiration was flagging."

As a loyal friend, Greenberg decided to keep his opinions between Pollock and himself; there was no need to castigate him publicly. Besides, Pollock had already produced more than enough evidence to justify his reputation as the greatest painter of his era and had nothing to apologize for. Greenberg continued to champion him; if he couldn't promote the new paintings, he'd promote the old ones. In the fall of 1952 he organized the first retrospective of Pollock's career. It consisted of eight works, dating from 1943 to 1951, hung in a barn on the campus of Bennington College.

For Pollock the retrospective was not so much a tribute as a tribulation. Already Greenberg was burying him, acting as if his career had ended with his 1951 "black" paintings. And as much as Pollock recognized the shortcomings of his 1952 paintings, he resented having to hear about them from Greenberg. Perhaps it was inevitable that Pollock and his champion would have a falling out. It happened on November 16, when Pollock, along with Lee, visited Bennington for the opening of his show. The reception was a small, genteel affair, hosted by the painter and art teacher Paul Feeley and attended by faculty members and students. At one point during the party Pollock walked over to the bar and started pouring himself a drink when Greenberg caught sight of him and said to himself: "The last thing I want is for Pollock to get drunk at Bennington." Taking no account of what the guests might think, Greenberg loudly ordered Pollock to put down the drink. Pollock became embarrassed, blushing notice-

ably as he tried to conjure up the appropriate comment. Only three words came out, but their message was unmistakable. "You're a fool," Pollock told Greenberg. Almost two years would pass before they spoke to each other again.

Within a few weeks Pollock's anger with Greenberg had paled compared with his anger at another critic. At least Greenberg understood his art, which was more than Pollock could say for Harold Rosenberg. In December 1952 Pollock picked up a copy of *Art News* and learned that his art, according to his neighbor Harold, could best be defined as an "encounter" between the artist and his canvas. "At a certain moment," the article began, "the canvas began to appear to one American painter after another as an arena in which to act. . . . What was to go on the canvas was not a picture but an event."

Pollock was appalled by Rosenberg's famous essay on "action painting." Even though the article did not mention any contemporary painters by name, Pollock felt sure that the piece was about him. It had to be, for it even included a comment he had once made to Rosenberg. The previous summer, a time when he was having difficulty getting down to work, he had casually referred to his canvas as an "arena," perhaps thinking of Picasso's *corridas*, or bullfights. The last thing he had meant to imply was that he considered the canvas "an arena in which to act," but there was his word, completely out of context, with Rosenberg building a theory around it and caricaturing him as a Promethean paint-flinger who cared more about the act of hurling paint than making good paintings.

Rosenberg later denied that Pollock's use of the word "arena" had given him the idea for the article, and indeed, one does not have to be a philosopher to recognize the piece as a variation on the existentialist fashions of the fifties or to suspect that it was inspired by the Hans Namuth movie in which Pollock literally becomes an actor. But that did not lessen Pollock's frustration. To the outside world he was suddenly an "action painter," a title that must have struck him as cruelly ironic. His creative powers had begun to wane. Inside his studio the action was virtually over.

15 Final Years
1953-56

The next four years of Pollock's life were dominated by a struggle against alcoholism and depression. He did manage to produce a few good paintings but agonized constantly over whether he was "saying anything." So severe were his self-doubts that one day he called his wife into his studio and, gesturing toward a finished painting, asked her without a trace of irony, "Is this a painting?" Unable to work, he lost all sense of purpose. He talked about suicide but did not attempt it with means any faster than alcohol. He took to spending long hours at local bars, particularly Cavagnaro's, on Newtown Lane, whose owner recalls the sight of him "pulling up in his coupe at eight-thirty or nine in the morning for his double Grand-Dad on the rocks." His days often ended at the East Hampton police station, where well-intentioned officers, who knew he was someone important, let him off with a mere reprimand for his drunken recklessness. A typical incident occurred in April 1953 when he drove his Model A into the opposing lane of traffic on Main Street and forced a motorist off the

road. On other occasions driving a car was altogether beyond his powers. "Found Jackson Pollock outside on sidewalk lying down," notes one item in the police blotter.

The summer of 1953 was Pollock's last period of sustained creative activity, and the ten or so works he completed are a tribute to his persistence in the face of fanatic self-doubt. In most of his late works Pollock rejected his celebrated "drip" style for a style resembling the European moderns, as if heeding Picasso's dictum that "To copy others is necessary but to copy oneself is pathetic." Pollock's *Easter and the Totem,* an elegant painting with pretty swatches of pink and green pinned flat against vertical planes, has often been likened to Matisse's *Bathers by a River. Sleeping Effort,* with its vibrantly colored undulating forms, evokes both Matisse and Kandinsky. In *Portrait and a Dream,* a long horizontal canvas rigidly divided into two sections, a big Picasso-like head balances a wiry tangle of black-and-white lines. There is an undeniable strength to these paintings, but what finally comes across is an emptiness beneath the surface. *The Deep,* which shows a huge floe of ice split down the middle by a crack, seems oddly contrived; unable to recapture the meaning that had unfolded almost magically in his earlier work, Pollock turned to heavy-handed symbolism.

When Pollock's second show at the Janis Gallery opened in February 1954—it was Janis who had Pollock switch back from numbering to naming his paintings so he'd be able to keep them straight—the critics were approving. "To begin with they're really painted, not dripped!" gushed Emily Genauer in the *Herald Tribune.* Pollock, however, was long past the point of driving satisfaction from good notices. He recognized his 1953 paintings for what they were: an admirable effort to continue working at a time when he wasn't quite sure of what he wanted to say. For so many years he had raced forward, testing limits, pushing at extremes, discarding discoveries as soon as he came upon them; but he could no longer sustain this momentum. For the second consecutive year he had failed to move forward, and unable to move forward, Pollock quickly lost faith in his abilities. In 1954 he completed only one painting. In 1955 he completed *Search* and *Scent.*

In the last year of his life he completed nothing. Many of his friends agreed among themselves that the reason Pollock stopped painting was that he had already done everything he could, and whether this is true we can of course never know. But as the sculptor David Smith wrote to Adolph Gottlieb: "I don't agree that he had shot his bolt. He had shot a bolt but he had been bolting for fifteen years, and he had other bolts left. But bottles won."

Unable to work, Pollock began a precipitous decline. He drank heavily and continuously, consuming as much as a quart of whiskey a day. Sober, he abruptly descended into gloomy depressions and was overcome with unabashed self-pity. A gesture as slight as a compassionate glance from a woman could reduce him to tears. In a typical outburst Pollock started to cry one night in the middle of a dinner party after Cile Lord, his neighbor, asked him how he was doing. "I'm an old man," he repeated between sobs as he reached for her hand. On other occasions he confessed to feelings of utter worthlessness, announcing to anyone willing to listen that he had never learned how to draw. One day he was visited by the writer Selden Rodman, who planned on interviewing him for a book. When Rodman and his wife Maia asked to see his work, Pollock led the couple outside to the barn. Upon realizing the door was locked, he smashed two windows and climbed inside. After a few minutes Rodman went back to the house, and Pollock, alone with Maia in the studio, started to cry uncontrollably. She took his head in her hands and tried to console him, which only made Pollock cry harder. As he wept he pointed to some paintings leaning against the wall and asked her, "Do you think I would have painted this crap if I knew how to draw a hand?"

Such desperate pleas for sympathy alternated unpredictably with outrageous displays of arrogance. Greenberg recalls his disgust one day after showing Pollock a book on Rubens. Glancing quickly at the reproductions, Pollock proclaimed, "I can paint better than this guy!" At a dinner party one night at the home of Herbert Ferber the guests were appalled when Pollock, gesturing toward a worn rug slung over the couch, announced to Adolph

Gottlieb: "Your work is just like this rug. It's full of holes." Friends who had known Pollock in better days began avoiding his company, refusing to subject themselves to the obscene harangues that accompanied his drinking. But sometimes they didn't have a choice. Harold Rosenberg, who had emerged not long ago as de Kooning's chief champion, came to dread the sound of Pollock pulling up in his Model A, invariably after midnight. With the engine still running and the headlights beaming, Pollock would wander around the critic's yard and holler at the house, "I'm the best fucking painter in the world."

Pollock, who had always eschewed the camaraderie of artists, became more social toward the end of his life. Drunk, he sought out fellow artists, wanting to be part of a group. He took up with de Kooning, forcing himself to ignore the fact that in March 1953 de Kooning had unveiled his *Woman* series at the Janis Gallery and replaced Pollock as the sensation of Fifty-seventh Street. The art historian Sidney Geist recalls arriving at the Cedar one night to find Pollock and de Kooning sitting outside on the curb, passing a bottle between them. "Jackson, you're the greatest painter in America," de Kooning was mumbling drunkenly, slapping him on the back. "No, Bill," Pollock blabbered, "you're the greatest painter in America." They kept at it until Pollock passed out. On other occasions, however, Pollock and de Kooning were not so mutually admiring. One night at the Cedar, Pollock started taunting his friend about his illegitimate daughter. De Kooning punched him in the mouth, drawing blood. The crowd that had gathered around them urged Pollock to hit de Kooning back, prompting him to utter his famous retort: "What? Me hit an artist?" The two painters made up, but as Greenberg wrote to his friend Sue Mitchell: "The reconciliation isn't real. The fact is, they don't like each other: Bill not really liking anybody, & Jackson, with all his capacity for love, seeking out people he doesn't like . . . & then having trouble with them."

———

The spring of 1954 was a particularly difficult time for Pollock. Ever since he had moved to the country, the arrival of spring

had been a reminder that soon it would be time to return to his studio and prepare for his next show. This time, however, there would be no show. Pollock went into the barn almost every afternoon and stayed there until evening, but he couldn't get down to work. When he returned to the house at the end of each day Lee did not ask him how it went; she could tell from the look on his face that he wasn't working. As if to trick himself into working, Pollock ordered new art materials. He called up Rosenthal's in the Village and placed extravagant orders for fresh rolls of canvas and dozens of tubes of oils. But the materials would remain unopened. As the weeks went by, it became harder for Pollock to stay inside his studio. Sometimes he came back to the house a few minutes after he'd left and headed for the refrigerator to get a beer. On other days he didn't go out to the barn at all but started drinking as soon as he woke up, beginning with beer and graduating to whiskey by afternoon. His wife tried to be gentle. "Remember how good your painting used to be when you weren't drinking?" she'd say, but her comments only reminded him of what he no longer was. Being in his house was worse than being in his studio, for he hated having to suffer his wife's disappointment in him.

One June morning Pollock woke up early, drank some beer, and drove to Bridgehampton to see de Kooning and Kline, who were sharing a red Victorian farmhouse on Montauk Highway for the summer. He tried to get de Kooning to wrestle with him on the lawn, but de Kooning, who wasn't a morning drinker, didn't feel like wrestling. Pollock started sparring by himself, shooting his fists at an imaginary opponent. Suddenly there was a loud snap and Pollock fell down. His ankle broken, he spent the rest of the summer on crutches.

Pollock's broken ankle was one more reminder of his rapidly deteriorating physical condition. With his bloated face, hazy features, and swollen, nicotine-stained fingers, he no longer was the commanding presence he had been only a year or two earlier. But even in his ruined condition, Pollock's reputation as well as his misery gave him an aura of genius, and he found himself surrounded by various new admirers. The most determined was

probably Ben Heller, a clothing manufacturer and fledgling art collector, who, on his first visit to Pollock's studio, offered to purchase *One* for eight thousand dollars—the top price that Pollock ever received for a painting. Heller and his wife became frequent visitors, stopping by to sit with Pollock as he listened to records or to take him to the beach, even though he could not swim because of his broken ankle. Another devoted couple were Sheridan and Cile Lord, young artists who had recently settled in Springs. Lord was a painter of realistic landscapes, and though Pollock criticized his work—"You can't do that kind of painting anymore!" he'd insist—the young painter adored him anyway. In February 1955, eight months after he had broken his ankle, Pollock was wrestling with Lord in his living room when suddenly he sat down and clasped his ankle. He had broken it again.

Important people wrote to Pollock offering their condolences. "All my sympathy," wrote James Johnson Sweeney, director of the Guggenheim, while suggesting that Pollock visit the museum to see his own work. Greenberg, traveling in Europe, hoped Pollock's break was "knitted by now" and, by the way, "Saw two Pollocks in Rome." The art dealer Martha Jackson—"I hear you have broken your leg again"—got in touch with Pollock about buying a few of his paintings. One day she drove out to Springs to look at his work, and as they were discussing prices, she offered to barter her car as payment. It was quickly agreed: two "black" paintings for one dark-green 1950 Oldsmobile convertible.

On his good days Pollock talked about taking trips. He told his wife he wanted to go out west, and he invited the Lords to come with them. So too he talked about going to Europe. He had never seen the Louvre, after all, or the Sistine Chapel or the Goyas or El Grecos he had admired for years in reproduction. He drove to Riverhead, the county seat, and took out a passport, but then he wasn't so sure. One day when the painter Milton Resnick was visiting, Pollock told him: "What do you think? I'm going to Europe."

"Okay," Resnick said, "well, so?"

"I don't know if I want to go," Pollock told him.

"What do you want to do?" Resnick asked.

"I hate art," Pollock said.

"Sure," Resnick said. "Everybody does. So you're going to Europe. What do you want me to tell you?"

He never signed his passport, never went to Europe.

As Pollock's condition worsened, his career progressed on its own. His paintings were exhibited in one group show after another, and honors accrued. In November 1955 Janis organized a retrospective spanning fifteen years of Pollock's career, and as *Time* magazine noted, "friend and foe alike crowded the exhibition in tribute to the champ's prowess." The following May, Pollock learned that the Museum of Modern Art, which was planning a series of one-man shows called "Works in Progress" for leading contemporary artists, had chosen him to start the series. Curator Andrew Ritchie had originally proposed that de Kooning go first, but Alfred Barr overruled him, arguing that Pollock was "more deserving." Museum directors were magnanimous and deferential to Pollock's reputation, in spite of his churlish behavior. When the Whitney Museum showed three of his paintings in an important group show called "The New Decade," Pollock became livid upon noticing that the exhibition catalogue claimed he had "worked for a time with Hofmann." He telephoned the museum and angrily cursed at a curator, prompting director John I. H. Baur to send him a polite apology.

Not the least among Pollock's frustrations was that Lee had been painting steadily since 1953, the same year he had begun having trouble. Though he had no reason to resent her work, he did resent the fulfillment she derived from it. In the summer of 1955 Lee was working particularly hard, preparing for a one-woman show at the Stable Gallery. On most days she went upstairs to her studio in the morning and did not emerge again until dinner time. She felt excited about her new work—large-scale, lavishly colored collage paintings that she made by cutting up her early paintings and reassembling the pieces into bold, arresting designs. As if in recognition of her accomplishment, she changed her signature from the self-effacing "L.K." to her full name. Her surge in confidence owed little to her husband, who, while occa-

sionally supportive, could also be cruelly belittling. Cile Lord recalls her embarrassment one night when Lee walked out of her studio wearing a bathrobe and asked Pollock if he could go to the barn to get her some Sobo glue. Pollock refused. On another occasion Pollock embarrassed his wife in front of Eleanor Ward, the owner of the Stable Gallery, who visited Lee in Springs one day to select the paintings for her show. The threesome went out to dinner that night, and Ward recalls her "shock" when Pollock complained to her, "Can you imagine being married to that face?"

Though Lee was still determined to help her husband, Pollock would not allow it. Ashamed of his condition, he resented her constant efforts to nurse and nurture him into health and took to staging childish protests. One of his favorite games was refusing to eat the food she put down in front of him. "I don't want food, I want tea," he told her one afternoon while friends were visiting. After Lee had gotten up from the table to brew him some tea, Pollock said, "I don't want tea!" and he poured a shot of whiskey into the teacup. He humiliated her often in front of friends, subjecting her to obscene name-calling. "Don't pay any attention to him," Lee would say sternly as friends cringed in embarrassment. She punished Pollock by ignoring him, refusing to give him the satisfaction of even a disapproving glance. Deprived of her affection, Pollock would become remorseful, apologizing profusely and insisting he could not help himself. In the summer of 1955, in an effort to save their marriage, Lee went into analysis, and Pollock started seeing Ralph Klein, a clinical psychologist who practiced in Manhattan. Every Monday Pollock and Lee went into the city together to see their respective doctors.

Pollock's Mondays in the city invariably ended at the Cedar Street Tavern, where, unlike at home, he knew he could find an appreciative audience. The bar reverberated with excitement whenever he walked in. "Pollock's here!" people would say, looking up from their dinners and drinks, watching as he stood by the bar and ordered a whiskey or Scotch. Young artists he may or may not have known would walk up to him to say hello. "Hiya,

Jackson," "Hey, Jackson," "Hey, pal," they'd shout, slapping him on the back and punching him on the arm as they offered to buy him drinks. To Pollock the camaraderie meant more than it ever had in the past. At a time when he felt like a failure, he was still a hero at the bar. And though his wife had practically stopped talking to him, there were women who came to the Cedar just to get a glimpse of him. One of them was Ruth Kligman.

Pollock first met Ruth in March 1956 when he spotted the pretty brunette sitting in a booth at the Cedar with a friend. Emboldened by his drinking, Pollock barged into the booth and took her hand in his.

"You have such warm eyes," he told her.

"Thank you," she said.

"Don't thank me," he said, "it's true."

After that brief encounter, Ruth, a twenty-five-year-old art student, couldn't stop thinking about Pollock, who by now was forty-four. The following Monday she called up the Cedar, asked to speak to him, and invited him over to her apartment, on Sixteenth Street. When Pollock arrived a few minutes later he seemed very tense. "I'm married," he blurted out awkwardly. Then he broke into hysterical sobbing. Moved by this outburst, Ruth vowed to herself that she "would always love him and be there no matter what." Pollock saw Ruth on Mondays after finishing with the doctor.

As far as Lee was concerned, the less she knew about Pollock's affair with Ruth the better. She never asked him why he stayed over in the city every Monday night, nor did she say anything about the dozens of long-distance calls between Springs and New York listed on their phone bill. But it eventually became impossible for her to ignore the affair. In June, Ruth moved to Sag Harbor, and Pollock visited her often, taking her out to local restaurants and driving her around town in his Oldsmobile convertible. One July morning Lee stepped out on her back porch and there they were, walking out of the studio, where they had spent the previous night. "Get that woman off my property before I call the police," Lee shouted. Pollock and Ruth ran off laughing. Lee was furious, but after calming down she assured herself that the

affair would never last. It would only be a matter of months, she figured, before Ruth realized that caring for Pollock was no more glamorous than caring for any other drunk. To give things time to cool off, Lee decided she would go to Europe for a month or two. "When I get back," she told Pollock, "that girl better be gone."

On July 12 Lee sailed on the *Queen Elizabeth* to Le Havre, en route to Paris. A few minutes before the boat was scheduled to leave she almost backed out. "I can't go," she told her friend Day Schnabel, who had taken her to the dock. "Jackson needs me." She wanted to talk to him. She called him up in Springs and pretended that she had left her passport at the house. A few minutes into the conversation Lee told him, "Oh, I just found my passport." They hung up, and she boarded the boat.

Ruth moved into the farmhouse. She couldn't believe how pretty it was, especially the kitchen: the polished copper pots hanging on wallboards, the fancy canned foods lining the shelves, sunlight pouring in and making everything bright. She and Pollock spent most of their time sitting at the kitchen table, smoking and drinking and ignoring the knocks on the front door. Pollock talked about getting back to work, but both of them knew he never would, and the more he talked about it, the gloomier the house became. One day when they were sitting around doing nothing Pollock said, "You know I'm a painter, don't you?"

Postcards and letters from his wife arrived regularly. "I miss you and wish you were sharing this with me," Lee wrote after a week in Paris, during which time she visited all the galleries, went to a flea market with Pollock's old friend John Graham, and saw the Louvre, describing it as "overwhelming—beyond belief." She went on to the south of France, where she visited Van Gogh's "last painting place" and found the country "unbelievably beautiful." She had planned on continuing to Venice and staying with Peggy Guggenheim in her palazzo on the Grand Canal, but Pollock's former dealer refused to see her. Peggy Guggenheim felt that Pollock and Lee had "minimized what I had done for him," never sending her so much as a thank-you note for showing Pollock's work abroad. So Lee skipped Venice, heading back to Paris

at the end of July. Since all the hotels were booked, she stayed with the painter Paul Jenkins and his wife in their apartment on the Rue Decrès, a short walk from the Montparnasse Cemetery. "It would be wonderful to get a note from you," she reminded her husband.

In Springs Ruth was finding it harder to live with Pollock every day. Sitting around the house got to be boring after a while, especially since he was always feeling sorry for himself. To divert herself from his misery she tried to paint, working in Lee's studio. But she promptly abandoned her efforts after calling Pollock upstairs one day to look at her work. He studied a painting in silence, then let her have it: "Why the hell do you want to be a painter?" Ruth wished they could go out more often, but Pollock rarely wanted to go anywhere. One night they went into town to see a movie, a grade-B war picture about a man who is discharged from the army and can't find a job. Halfway through the movie Ruth glanced at Pollock and noticed that he was crying. Soon he was sobbing loudly. Ruth led him out of the theater and asked him what was wrong. "The movie," Pollock said, "the guy in the movie, he was so lost, so disconnected." Ruth decided she needed to get away. A month after moving in, she concocted a story about having to go to New York to see her psychiatrist, and she left Springs on a Thursday morning, promising she'd be back Saturday.

That Saturday, August 11, dawned hot and humid. In the morning Pollock drove to the East Hampton train station to await the 7:05 from New York. Ruth got off the train with a friend, Edith Metzger, a twenty-five-year-old beautician from the Bronx whom she had invited out for the weekend. On the way back to the house Pollock pulled over at Cavagnaro's. "Why are we stopping here?" Ruth asked innocently. The two women ordered coffee, and Pollock had a beer.

Back at the house, Ruth and Edith changed into their bathing suits and asked Pollock to take them to the beach. Pollock said he didn't feel like going to the beach. He helped himself to some gin and spent most of the afternoon crying.

By evening Pollock was feeling a little better. He made his

guests a steak dinner and offered to take them to hear pianist Leonid Hambro of the New York Philharmonic, who was performing that night in East Hampton. On the way to the concert Pollock pulled over to the side of the road. Roger Wilcox, a neighbor, recognized the Oldsmobile convertible and walked over to see what was wrong. Pollock was sitting behind the wheel, with Ruth and Edith beside him. "Hey, Jackson, aren't you going to the concert?" Wilcox asked him. "I feel pretty sick," Pollock told him. "I'm just going to stay here and think about it."

Pollock decided he wanted to go home. By the time he reached Fireplace Road, he was speeding. He started driving recklessly, taking the curves much too fast. "Let me out!" Edith screamed, but it was too late. As Pollock was rounding a sharp bend about a quarter of a mile from his house, he lost control of the car. He crashed into two small elms.

The first call came into the police station at 10:15 P.M. Officer Earl Finch was dispatched to Fireplace Road. "Two dead at scene of accident," he reported. Edith Metzger was found crushed to death beneath the car. Ruth Kligman was thrown clear and was taken to Southampton Hospital with major injuries; she survived. Pollock was killed instantly when his head hit a tree.

Clement Greenberg placed the call to Europe. After trying to locate Lee in Venice, he called Paul Jenkins in Paris to ask him if he knew where Lee might be. Yes, Jenkins said, she's standing right next to me. "Stay calm," Greenberg told him, then he relayed the bad news. Lee could tell from the way they were talking that something terrible had happened. Instinctively she sensed what it was. "Jackson is dead," she screamed, breaking into uncontrollable sobbing.

16 Lee by Herself

Pollock's death was reported in every major newspaper and magazine. *The New York Times* ran the story on page one. *Newsweek* listed it in its "Transition" column, beneath news of Ed Sullivan's rib injury, Gene Kelly's separation, and Edward G. Robinson's divorce. *Time* magazine called him the "shock trooper of modern painting," and *Life* titled its obituary, "Rebel Artist's Tragic Ending." His death in a car crash at the age of forty-four helped enhance his public image as a paint-flinging cowboy who came out of nowhere to shock the civilized world with the rawness of his vision.

Lee flew home from Paris on Monday, August 13. She immediately set to work planning the funeral, and friends who visited her to offer their condolences commented on her remarkable self-control and composure. No detail escaped her attention. When the painter James Brooks mentioned that he didn't have a dark suit to wear as a pallbearer, Lee gave him one of Pollock's. Friends and neighbors who tried to console Lee found them-

selves consoled by her. Cile Lord remembers walking into the house to find it crowded with friends. Lee walked up to her and told her, "Don't say anything," and then put her arms around her.

Thomas Hart Benton and Rita Benton first heard the news on Sunday afternoon. They were sitting on the porch of their home in Chilmark when Herman Cherry and de Kooning, who were summering in the area, stopped by the house and said they had something to tell them. Benton invited the two men inside and offered them chairs, but no one sat down. Benton took the news hard. De Kooning offered to fly him to the funeral, but Benton just shook his head and said that he "couldn't take it." Before the two visitors left, Rita opened up a drawer and showed them a heap of clippings about Pollock that she had saved over the years.

The funeral was held on August 15 at the Springs Chapel, a nondenominational church down the road from Pollock's house. Lee had asked Greenberg to deliver the eulogy, but he declined, refusing to praise "this guy who got this girl killed." Greenberg told Lee to get someone else. "Get Tony Smith," he said, "get Barney Newman!" Lee, as protective of Pollock in death as in life, thought no one else besides Greenberg deserved the honor, so no friends spoke at the funeral. The brief service was conducted by a Presbyterian minister who had never met Pollock, and afterward the two hundred people crowding the small church dispersed to the nearby Green River Cemetery, in Springs. Pollock was buried at the far end of the cemetery, apart from the other graves, on a grassy hill shaded by white oaks. Later a huge, sloping boulder was erected on his grave, a reminder of his early ambition to "mould a mountain of stone . . . to fit my will." A plaque on the stone bears only his name and dates.

Among the mourners at Pollock's funeral was his mother. At eighty-one, suffering from phlebitis, Stella managed as always to remain composed. "He is gone and we cant bring him back his work is over and he is at rest but we cant forget him," she wrote to a cousin, while marveling at the outpouring of sympathy. "I never saw so many lovely flowers at a funeral yard and house full of friends. Cable grams Telegraph letters from all over the world."

Lee, in the weeks following the funeral, stayed in Springs and tried to make sense of events. She lived in the house on Fireplace Road, surrounded by Pollock's paintings and memories of their marriage. But being in Springs without him was more than she could bear. When she tried to paint, she found she couldn't even get started. She decided to rent an apartment in New York City, where she remained for the next two years.

At first she was tormented by the thought that she was somehow responsible for Pollock's death. The accident would not have happened, she felt, if only she hadn't gone to Europe. "I had to realize," she later said, "that things would have happened in the same way even if I had been sitting right here in my living room."

The period following Pollock's death turned out to be the most rewarding of Lee's career. In the first eighteen months alone she produced seventeen new canvases—large, radiant abstractions that mark a decisive break from the frustrated small-scale pictures of her past. Her paintings of the late fifties are distinguished by brilliant bursts of color and bold, swooping lines, as if the tight, coiled gestures in her earlier "Little Images" had suddenly uncoiled and sprung into action. The paintings have titles such as *April, Earth Green,* and *Easter Lilies,* metaphors for Krasner's artistic renewal. When the works were shown at the Martha Jackson Gallery in 1958, the critics were admiring.

In 1958, after two years in New York City, Lee decided to return to Springs to see if she could get any work done there. "The second attempt was very beautiful," she said. "I wasn't depressed at all. Then, at a point during that time, I took over the barn. There was no point in letting it stand empty." She had a friend paint the floor, so she wouldn't have to see the splatters and splotches left behind by Pollock.

Lee naturally was eager to exhibit her new paintings, but her combative personality sometimes worked against her. In 1960 Clement Greenberg, who was then an adviser to French & Company Galleries, offered to give Lee a show. A few weeks later Greenberg paid a visit to Springs and saw the works she planned to exhibit: a series of large turbulent canvases in umber and

cream, with such titles as *Polar Stampede, Charred Landscape,* and *White Rage.* With characteristic self-righteousness, Greenberg told Lee he was "disappointed" by her latest work. Lee was furious. "As of this minute," she told him, "my show is canceled." She went on working in the same style.

As the years passed, honors accumulated. She was given a major exhibition at the Whitechapel Art Gallery in London in 1965 and at the Whitney Museum in 1973. Art critics everywhere acknowledged her status as a leading Abstract Expressionist. In 1981 a show called "Krasner/Pollock: A Working Relationship" was held at New York University to advance the idea that Krasner had had a large influence on Pollock's work. While many people thought that the idea behind the show was preposterous, no one denied that Krasner was a painter of genuine talent who could certainly hold her own next to Pollock.

Much of Lee's time continued to be taken up by Pollock's career. As executor of his estate she served his artistic reputation as faithfully after his death as she had during his lifetime. She set high prices on the paintings and sold them off at a very slow rate, strengthening the market for his work. Some people accused her of having forced up the prices for her husband's work, while others commended her for her business acumen. Her friend John Little once commented: "The three greatest dealers in the U.S.? Pierre Matisse, Leo Castelli, and Lee Krasner."

One of the cruel ironies of Pollock's career is that his death created a demand for his work. Only a few weeks after the funeral Alfred Barr telephoned Sidney Janis to say that the Museum of Modern Art, which previously had been unable to raise $8000 to purchase *Autumn Rhythm,* now wanted to buy the painting. Janis told Barr he would get back to him. He conferred with Lee, who insisted that the price be raised to $30,000. Barr was livid when he heard the news and gave up any hope of acquiring *Autumn Rhythm.* But the Metropolitan bought it immediately, establishing a new price range for Pollock—and for his contemporaries. As a result of the sale, Janis explained, "we had a little less trouble selling a de Kooning for $10,000 than we had a month earlier trying to sell one for $5000."

The prices continued to rise over the years to levels that as-

tounded everyone. By the 1980s a millionaire artist such as Andy Warhol could say jokingly about his dead colleague, "I wish I had as much money as Jackson Pollock."

Besides managing the business side of Pollock's career, Lee made herself available to virtually anyone who was interested in Pollock's work. She granted dozens of interviews to graduate students, professors, and journalists, and much of her time was taken up with explicating her husband's career. No matter how many times she was asked the same questions, she answered good-naturedly, and she seemed to enjoy recalling the details of her life with Pollock. Looking back, she was likely to remember the good times. "There were many happy moments," she once said. "I remember any one of them. I remember sitting with Jackson on our country porch—sitting there for hours, looking into the landscape, and always at dusk, when the woods ahead turned into strange, mystifying shapes. And we would walk in those woods, and he would stop to examine this or that stone, branch, or leaf. . . . His moodiness and depression would vanish, and he would be calm—and there would often be laughter. I remember Jackson's laughter. It was wonderfully outgoing, it was warm, and there was such joy in it."

As Lee grew older she became sick and took to spending most of her time by herself in her apartment on East Seventy-ninth Street. She suffered from crippling arthritis, which made it difficult for her to walk. She could hardly paint because of the pain in her hands. As the illness worsened she had to use a wheelchair and could sometimes be spotted in Central Park being wheeled by one of her nurses.

One consolation was that the Museum of Fine Arts in Houston and the Museum of Modern Art in New York jointly organized her first major retrospective in 1984. Lee traveled to Houston that October for the opening of the show. Friends agreed that she was delighted by the exhibition, although those who tried to congratulate her were invariably rebuffed. "Too bad it's thirty years too late!" she'd say.

After returning from Houston, Lee took to her bed and never painted again. But even in sickness she remained as interested as

ever in the goings-on of the art world. She often had her assistant, Darby Cardonsky, sit by her side and read her art reviews from newspapers and magazines.

———

Lee died at New York Hospital on June 20, 1984, at the age of seventy-five. Her death certificate does not specify what she died of beyond "natural causes."

She left behind an estate valued at twenty million dollars. Most of the money was to be given away. Her will authorized her executors to establish a foundation to assist "needy and worthy artists."

Lee didn't leave any burial instructions, but her relatives knew what she wanted. While visiting Pollock's grave with a nephew a few years earlier, Lee had admired a small boulder lying at the edge of the woods. That stone now marks her grave. An ordinary rock, it rises but a foot off the ground and is barely noticeable beside the huge stone on Pollock's grave. Even in death Lee continues to enhance Pollock's stature.

NOTES

Pollock's personal papers can be found at the Archives of American Art, a division of the Smithsonian Institution, in Washington, DC. These papers include letters to him, copies of his own letters, photographs, reviews of his exhibitions, medical records, and various other documents, and are referred to in the notes as "Pollock Archive."

If the source of a quotation is not cited, it is from an interview with the author.

Pollock's letters remain in private hands unless otherwise noted.

Chapter One: Origins
PAGE

16. "Great Grand Pa Boyd:" letter from Stella Pollock to her cousin Irene Crippen, n.d.
17. "Word has been received": *The Tingley* (Iowa) *Vindicator,* Jan. 29, 1903, p. 2.
20. "A fine son": *The Park County* (Wyoming) *Enterprise,* Jan. 31, 1921, p. 5.
20. "He's my baby": interview with Frank Pollock, July 1983.
21. "Mrs. L. R. Pollock and five sons": *The Park County* (Wyoming) *Enterprise,* Nov. 16, 1912, p. 5.

22.　In September 1913, with a down payment of ten dollars, LeRoy purchased: land deed document, Maricopa County, AZ.

23.　"One day we'll own": Frank Pollock interview.

23.　"I wish we were all back in the country": letter from LeRoy Pollock to Frank Pollock, July 12, 1931.

24.　"will leave a gap in our lives": letter from Sande Pollock to JP and others, n.d.

25.　"He's entitled to it": Frank Pollock interview.

25.　"the sweetest guy": unpublished interview with Sanford (Sande) McCoy by Kathleen Shorthall of *Life* magazine, Nov. 2, 1959. (Note: In the forties Pollock's brother Sande changed his last name to McCoy, the name of their father before his adoption by the Pollock family. Both names are used here.)

26.　In January 1918 . . . LeRoy sold his Phoenix farm: land deed document, Maricopa County, AZ.

27.　he purchased an eighteen-acre fruit farm in Chico: land deed document, Butte County, CA.

27.　"Stay away from Dad": Frank Pollock interview.

28.　In January 1920 LeRoy acquired the Diamond Mountain Inn: land deed document, Lassen County, CA.

30.　"He was wearing spats": Frank Pollock interview.

30.　"Charles started this whole damn thing": Sande McCoy to Shorthall.

30.　"I want to be an artist like brother Charles": Undated article in the scrapbook of Irene Crippen of Des Moines, Iowa (Stella's cousin). She believes the article is from the *Des Moines Register* c. 1958.

31.　Stella sold the Orland property in January 1923: land deed document, Glenn County, CA.

32.　"His grades weren't passing": Sande McCoy to Shorthall.

33.　"a bag of beans": ibid.

33.　Jackson was playing in the barnyard: interview with Frank Pollock and Marvin Jay Pollock, July 1983.

34.　"Goddamn son of a bitch": Sande McCoy to Shorthall.

35.　"It's just a goddamn dog": Frank Pollock interview.

35.　"I am sorry": letter from LeRoy Pollock to JP, Dec. 11, 1927, in Francis V. O'Connor and Eugene V. Thaw, eds., *Jackson Pollock: A Catalogue Raisonné of Paintings, Drawings and Other Works*, 4 vols. (New Haven: Yale Univ. Press, 1978), Vol. 4, pp. 205–06 (hereafter cited as *Catalogue Raisonné*).

Chapter Two: Manual Arts High School
PAGE

37.　"boresome" place of "rules and ringing bells": letter from JP to Charles Pollock, Jan. 31, 1930, *Catalogue Raisonné*, Vol. 4, p. 209.

38.　"I'm going to make serious painters of you": interview with Manuel Tolegian, July 1983.

38. "We are very fortunate": letter from JP to his brothers, Oct. 22, 1929, *Catalogue Raisonné*, Vol. 4, p. 208.
38. "a style associated": telephone interview with Reuben Kadish, 1984.
38. "my letters are undoubtedly": letter from JP to Charles Pollock, Jan. 31, 1930.
38. "an immature person": interview with Harold Lehman, 1984.
38. "That fellow thought": Tolegian interview.
39. "doubtful of any ability": letter from JP to Charles Pollock, Jan. 31, 1930.
39. "If you had seen his early work": unpublished interview with Sanford (Sande) McCoy by Kathleen Shorthall, of *Life* magazine, Nov. 2, 1959.
40. "You think that's original?": Tolegian interview.
41. "more at ease with a rock": ibid.
41. "I think your philosophy": letter from LeRoy Pollock to JP, Sept. 19, 1928, *Catalogue Raisonné*, Vol. 4, p. 206.
41. "I have dropped religion": letter from JP to his brothers, Oct. 22, 1929.
42. One morning, a few hours before school began: Tolegian interview.
43. "I certainly admire": letter from JP to his brothers, Oct. 22, 1929.
43. "I have thought of going": ibid.
43. "ousted" from school: ibid.
43. "although i feel i will make": letter from JP to Charles Pollock, Jan. 31, 1930.
44. "He was extremely shy": Tolegian interview.
44. "happy as a little kid": interview with Berthe Pacifico Laxineta, Oct. 1983.
45. "I didn't even hear you": ibid.
47. "to sculpt like Michelangelo": Tony Smith to James Valliere, unpublished interview, Aug. 1965, Pollock Archive.

Chapter Three: Art Students League
PAGE

49. "immediate sympathy": Thomas Hart Benton, *An Artist in America* (Columbia, MO: Univ. of Missouri Press, 1968), p. 332.
49. "I'm damn grateful": "Unframed Space," *The New Yorker*, Aug. 5, 1950, p. 16.
49. "scented dudes": Benton interview, *Art Digest*, Dec. 1, 1930, p. 36.
49. "What the hell": unpublished interview with Paul Cummings, for the Archives of American Art, July 1973.
49. "It is absurd": quoted in his obituary in *The New York Times*, Jan. 21, 1975, p. 23.

50. "were mad . . . prophet": Benton, *An Artist in America,* p. 248.

51. "I improved my brand": ibid, p. 249.

51. "Benton is beginning to be recognized": letter from JP to his father, Feb. 3, 1933, *Catalogue Raisonné,* Vol. 4, p. 214.

52. "give you a quick look": telephone interview with Reginald Wilson, 1984.

52. "hurrying down the corridor": interview with Will Barnet, 1984.

52. "Why couldn't that nice young man": interview with Frances Avery, 1984.

52. "He couldn't draw": interview with Yvonne McKinney, 1984.

52. "jittery hands": interview with Joe Delaney, 1984.

52. "seemed . . . minimal order": Benton, *An Artist in America,* p. 332.

53. "He got things out of proportion": rough draft of a letter from Thomas Hart Benton to Francis V. O'Connor, 1964 (hereafter cited as "Benton notes").

53. "A good seventy years more": letter from JP to LeRoy Pollock, n.d., *Catalogue Raisonné,* Vol. 4, p. 212.

53. "I have much to learn": letter from JP to Stella Pollock, n.d., *Catalogue Raisonné,* Vol. 4, p. 213.

53. Charles tried his hardest: interviews with Charles and Frank Pollock, 1983–84.

54. "He was trying to impress": interview with Marie Leavitt Pollock, 1983.

54. "I'll go get them": interview with Nathaniel Kaz, 1984.

55. "As kids we ate chicken and pork": Frank Pollock interview.

55. Rita sent biscuits and cream: interview with Manuel Tolegian, 1983.

55. "a sense of ineptitude": Benton notes.

55. "I had a model there": unpublished interview with Paul Cummings, July 1973.

56. "Pollock volunteered": interview with Harry Holtzman, Dec. 1983.

58. "Run faster": Tolegian interview.

58. "The miners and prostitutes": letter from JP to Charles and Frank Pollock, n.d., *Catalogue Raisonné,* Vol. 4, p. 210.

59. "I would have been worried sick": letter from Stella Pollock to Charles and Frank Pollock, n.d., *Catalogue Raisonné,* Vol. 4, p. 210.

59. "sure hard work": letter from Stella Pollock to Frank Pollock, n.d.

59. "That's all I had to say": Tolegian interview.

59. "damned little left": letter from JP to Charles Pollock, n.d., *Catalogue Raisonné,* Vol. 4, p. 211.

60. "That lunchroom was crazy": interview with Philip Pavia, 1984.

61. "What do we need those Europeans for?": Tolegian interview.

61. "Pollock was posing": interview with Whitney Darrow, Jr., 1984.

61. "heard Thomas Craven lecture": *Catalogue Raisonné*, Vol. 4, p. 213.
61. "All Pollock does": quoted in Polly Burroughs, *Thomas Hart Benton: A Portrait* (Garden City, NY: Doubleday, 1981), p. 118.
62. "And when I say artist": letter from JP to his father, n.d., *Catalogue Raisonné*, Vol. 4, p. 212.
62. "What the hell": Tolegian interview.
62. "You wait": interview with Peter Busa, July 1984.
63. "We have a substitute": *Catalogue Raisonné*, Vol. 4, p. 215.
64. "So far": ibid.
64. "I like it better": letter from JP to his mother, March 25, 1933, *Catalogue Raisonné*, Vol. 4, p. 217.
64. "Well Dad by god": letter from JP to his father, Feb. 3, 1933.
64. "I am so sorry": letter from Stella Pollock to JP and others, n.d., *Catalogue Raisonné*, Vol. 4, p. 216.
65. "I always feel": letter from JP to his mother, March 25, 1933.

Chapter Four: Life with the Bentons
PAGE

66. lit with blue bulbs: interview with Frances Avery, 1984.
66. "Jackson adored my mother": telephone interview with Jessie Benton Lyman, 1984.
67. "Jack must have told him": Benton notes; see also Benton, *An Artist in America* (Columbia, MO: Univ. of Missouri Press, 1968), p. 339.
68. "My mother talked": telephone interview with Thomas P. Benton, 1985.
68. With the first few sounds: Polly Burroughs, *Thomas Hart Benton: A Portrait* (New York: Doubleday, 1981), p. 119.
68. "Jack tried to play": Benton notes.
69. "Clean up": telephone interview with Elizabeth Pollock, 1984.
70. "I am inclined to believe": Benton notes.
71. "Overnight the Helen Marot I had known": *Sketches from Life: The Autobiography of Lewis Mumford* (New York: Dial Press, 1982), p. 247.
72. "I felt so sorry": letter from Stella Pollock to JP and his brothers, Aug. 30, 1934.
72. "34 cents in my pocket": unpublished interview with Sanford (Sande) McCoy by Kathleen Shorthall, of *Life* magazine, Nov. 2, 1959.
73. "Much as Jackson": ibid.
73. "Jack was a very proud . . . young man": letter from Rita Benton to Francis V. O'Connor, 1964. Quoted in O'Connor's unpublished dissertation, *The Genesis of Jackson Pollock: 1912 to 1943*. Submitted to Johns Hopkins in 1965.
74. "most beautiful": ibid.

74. "Mrs. T. H. Benton Collection": *The New York Times,* Dec. 1, 1934, p. 11.

75. "an enraged Commie": Benton, *An Artist in America,* p. 171.

75. "petty opportunist": *Art Front,* April 1, 1935.

76. "take the Marxist slant": quoted in *Art Digest,* April 15, 1935, p. 13.

77. "He was truly a lost soul": letter from Manuel Tolegian to Thomas Hart Benton, Aug. 21, 1964.

Chapter Five: The Project
PAGE

78. "Bums are the well-to-do": letter from JP to his father, Feb. 3, 1933, *Catalogue Raisonné,* Vol. 4, p. 214.

78. "grateful to the WPA": "Unframed Space," *The New Yorker,* Aug. 5, 1950, p. 16.

79. "plumbers' wages": quoted in Francis V. O'Connor, *Federal Art Patronage, 1933 to 1943* (College Park, MD: Univ. of Maryland Art Gallery, 1966), p. 7

79. "Lenin's head": ibid., p. 8.

79. "poor art for poor people": quoted in Harold Rosenberg, *The De-definition of Art* (New York: Horizon Press, 1937), p. 35.

80. "I paid a severe price": quoted in Thomas B. Hess, *Barnett Newman* (New York: Museum of Modern Art, 1971), p. 88.

80. dressed in pajamas: telephone interview with Jacob Kainen, 1984.

81. Twelve of Pollock's watercolors were destroyed: these are listed in a WPA document dated March 7, 1941, as follows: #463 *White Horse Grazing,* #1322 *The Drought,* #4002 *The Twister,* #4004 *Shore Landscape,* #4753 *Sunny Landscape,* #5430 *Baytime,* #5431 *Martha's Vineyard,* #9100 *Landscape,* #9191 *Landscape #4,* #9540 *Landscape,* #9721 *Landscape,* #9903 *Landscape.*

81. Flushing warehouse: see *Art Digest,* Feb. 15, 1944, p. 7.

82. "disaffected": unpublished interview with Carl Holty by William Agee, for the Archives of American Art, 1964.

83. "The Project can't use this work": unpublished interview with Dorothy C. Miller by Paul Cummings, for the Archives of American Art, 1970.

83. "There's no news here": letter from JP to Charles Pollock, n.d., *Catalogue Raisonné,* Vol. 4, p. 221.

83. helped out at the Siqueiros workshop: Laurance P. Hurlburt, "The Siqueiros Experimental Workshop," *Art Journal* (Spring 1976), pp. 237 et passim.

84. he didn't vote once: The records of the Board of Elections in New York City indicate that Pollock registered to vote for the first time in October 1944. The 1944 presidential election was the only election he ever voted in. (The records of the Board of Elections in

Suffolk County, where Pollock lived in later life, indicate that he never voted in that county.)

84. "He couldn't draw": interview with Axel Horn, Nov. 1983.
84. "He had no ideas": interview with Harold Lehman, 1984.
85. "private, lonely person": interview with Reginald Wilson, 1984.
85. "Jack had the misfortune": letter from Sande Pollock to Charles Pollock, Oct. 29, 1936, *Catalogue Raisonné*, Vol. 4, p. 220.
86. "He was really in love": interview with Arloie McCoy, Nov. 1983.
86. "walk me home": interview with Rebecca Tarwater Hicks, May 1984.
87. "It's almost embarrassing": ibid.
87. "I will do what you wish": letter from JP to Becky Tarwater, n.d.
88. "having a very difficult time": letter from Sande Pollock to Charles Pollock, July 21, 1937, *Catalogue Raisonné*, Vol. 4, p. 222.
89. "I found I loved": letter from JP to Becky Tarwater, n.d.
89. "out here for a week or so": postcard from JP to Charles Pollock, n.d., *Catalogue Raisonné*, Vol. 4, p. 223.
90. "he began escaping": Benton notes.
91. "very gentle young man": telephone interview with Dr. James Wall, 1984.
91. "There was a lot of calming down": quoted in Jeffrey Potter, *To a Violent Grave: An Oral Biography of Jackson Pollock* (New York: Putnam, 1985), p. 57.
91. "strong creative urge": letter from Dr. Edward Allen to Lee Krasner, Sept. 2, 1963, Pollock Archive.

Chapter Six: Still Struggling
PAGE

93. "extremely unverbal": Joseph L. Henderson, "Jackson Pollock: A Psychological Commentary," unpublished paper, 1966, quoted in B. H. Friedman, *Jackson Pollock: Energy Made Visible* (New York: McGraw-Hill, 1974), p. 41.
94. "give and receive feeling": quoted in C. L. Wysuph, *Jackson Pollock: Psychoanalytic Drawings* (New York: Horizon Press, 1971), p. 17.
95. "Christ, what a brutal . . . painting": letter from Sanford Pollock to Charles Pollock, n.d.
96. "heavy-handed and banal": Lawrence Alloway, "Art," *The Nation*, Nov. 2, 1970, p. 444.
97. "Jack is going very good work": letter from Sanford Pollock to Charles Pollock, n.d., *Catalogue Raisonné*, Vol. 4, p. 224.
98. "A winter of ups and downs": letter from Sanford Pollock to Charles Pollock, May 1940.
98. "The effect of this loss": Henderson, "Jackson Pollock: A Psychological Commentary," n.p.
98. detoxification room at Bellevue Hospital: unpublished interview

with Sanford (Sande) McCoy by Kathleen Shorthall, of *Life* magazine, Nov. 2, 1959.

99. "He broke a window": interview with Manuel Tolegian, 1983.

99. "haven't much to say": letter from JP to Charles Pollock, n.d., *Catalogue Raisonné*, Vol. 4, p. 225.

99. fall of 1940: The date of Pollock's meeting with Graham remains disputed among art historians. It has been stated elsewhere that the two men first met in 1937, but Graham was in Mexico that year. The date offered here is based on the recollections of Graham's widow.

100. "Of course he did": quoted in James T. Valliere, "De Kooning on Pollock," *Partisan Review* (Fall 1967), p. 603.

101. "I brought culture": John Graham, *Systems and Dialectics of Art*, with introd. by Marcia Epstein Allentuck (Baltimore: Johns Hopkins Press, 1971), p. 30.

101. "walk into any junk shop": Thomas Hess, Graham obituary, *Art News* (Sept. 1961), p. 51.

101. "We want bread!": quoted in Hayden Herrera, "John Graham: Modernist Turns Magus," *Arts* (Oct. 1976), p. 105.

101. "couldn't stop talking": inteview with Constance Graham Garner, July 1984.

101. "Let Paris come see me": ibid.

102. "Artists shouldn't look": ibid.

102. "always an Indian around": Sandy McCoy to Shorthall.

102. "plastic qualities of American Indian": interview with JP, *Arts and Architecture* (Feb. 1944), p. 14.

103. Alaskan Eskimo mask: Irving Sandler was the first to point out the connection between the Eskimo mask and the painting *Birth*. See "From Irving Sandler," *Art in America* (Oct. 1980), pp. 57–58. William Rubin has also commented on the role of the Eskimo mask in Pollock's development, though not in writing; his comments were made to a colleague. See Kirk Varnedoe, "Abstract Expressionism," in *"Primitivism" in 20th Century Art*, ed. William Rubin (New York: Museum of Modern Art, 1984), p. 641.

104. "The irony is": Sanford Pollock to Charles Pollock, Oct. 22, 1940, *Catalogue Raisonné*, Vol. 4, p. 225.

104. "great doubt about himself": quoted in Jeffrey Potter, *To a Violent Grave: An Oral Biography of Jackson Pollock* (New York: Putnam, 1985).

104. "I have found Pollock": letter from Dr. De Laszlo to the Examining Medical Office, Selective Service Systems, May 3, 1941. A copy of this letter is in the Pollock Archive.

105. "this god damned war": letter from JP to Charles Pollock, postmarked April 14, 1944, *Catalogue Raisonné*, Vol. 4, p. 233.

105. "all thru the war": letter from JP to Louis Bunce (who was a friend from the Art Students League) postmarked June 2, 1946, Bunce papers, Archives of American Art, Washington, DC.

105. "extremely trying": letter from Sande Pollock to Charles Pollock, July 1941, *Catalogue Raisonné*, Vol. 4, p. 226.
106. "hate like hell": Sande Pollock to Charles Pollock, Aug. 22, 1941.
106. "a damn good woman painter": Arloie McCoy interview.

Chapter Seven: Enter L.K.
PAGE

107. "I prided myself": John Gruen, *The Party's Over Now* (New York: Viking, 1967), p. 229.
108. "I'm Lee Krasner": interviews by Francine du Plessix and Cleve Gray, "Who Was Jackson Pollock?" *Art in America* (May 1967), p. 49.
108. "He stepped all over my feet": Barbara Rose movie, *Lee Krasner: The Long View*, 1978, distributed by the American Federation of Arts.
108. "I flipped my lid": Gruen, *The Party's Over Now*, p. 230.
108. "Let's go": Amei Wallach, "Lee Krasner: Out of Jackson Pollock's Shadow," *Newsday's Magazine for Long Island*, Aug. 23, 1981, p. 14.
108. "reading Jung": unpublished interview with LK by Dorothy Seckler, for the Archives of American Art, Nov. 1964.
109. "like tree trunks": William Phillips, *A Partisan View: Five Decades of the Literary Life* (New York: Stein & Day, 1983), p. 88.
109. "terribly drawn to Jackson": Gruen, *The Party's Over Now*, p. 230.
110. working as a customs clerk: interview with Clement Greenberg, Dec. 1983.
110. "born on a cold day": interview with Ruth Stein (the artist's sister), March 1984.
111. "to draw clothed women figures": ibid.
112. "I'd sit close to him": Eleanor Munro, *Originals: American Women Artists* (New York: Simon & Schuster, 1979; paperback edition by the same publisher, 1982), p. 104.
112. "always a brother": records of the National Academy of Design, New York City.
113. "This is so good": Barbara Rose, *Lee Krasner: A Retrospective* (New York: Museum of Modern Art, 1983), p. 13.
113. "Who is this?" LK to Seckler.
114. "I'm Igor Pantuhoff": interview with May Natalie Tabak Rosenberg, the critic's wife, Dec. 1983.
114. "Dear Lenore": John Graham to LK, Nov. 12, 1941.
115. "general whirling figures": J.W.L., "Mélange," *Art News*, Jan. 15, 1942, p. 29.
115. "strange": *Art Digest*, Jan. 15, 1942, p. 18.
115. "the Americans looked very good": quoted in James T. Valliere, "De Kooning on Pollock," *Partisan Review* (Fall 1967), p. 603.

115. "have to sign your paintings": Barbara Rose, "Lee Krasner," a lecture given at the Museum of Modern Art, New York City, Jan. 22, 1985.
116. "a human being in anguish": interview with Fritz Bultman, 1984.
116. "a guy in overalls": Rosenberg interview.
116. "They're all so dense": LK to Du Plessix and Gray, p. 51.
116. "You are very talented": Ellen G. Landau, "Lee Krasner's Early Career, Part Two: The 1940s," *Arts* (Nov. 1981), p. 81.
116. "I *am* nature": LK to Seckler.
117. "highly protective": interview with Peter Busa, 1984.
117. "Tuesday night": letter from Stella Pollock to Charles Pollock and others, May 5, 1942, *Catalogue Raisonné*, p. 226.
118. she felt disenchanted: LK to Seckler, and Landau, "Lee Krasner's Early Career," *ARTS* (Nov. 1981), p. 81.

Chapter Eight: Surrealists in New York
PAGE
121. *"le petit philosophe"*: interview with David Hare, 1984.
121. "deeply depressed man": "Jackson Pollock: An Artists' Symposium, Part I," *Art News* (April 1967), p. 30.
121. "uncontrollable neuroses": Jeffrey Potter, *To a Violent Grave: An Oral Biography of Jackson Pollock* (New York: Putnam, 1985), p. 70.
122. the movement was essentially defunct: see Lionel Abel, *The Intellectual Follies* (New York: Norton, 1984), p. 47.
122. lonely and depressing: Anna Balakian, *Surrealism* (New York: Dutton, 1970), n.p.
123. "they were absolutely ignorant": Calvin Tompkins, with the editors of Time-Life Books, *The World of Marcel Duchamp: 1887–* (New York: Time-Life Books, 1966), p. 156.
123. *"fermé"*: Sidney Simon, "Concerning the Beginnings of the New York School: 1939–43," an interview with Peter Busa and Matta, *Art International* (Summer 1967), p. 18.
123. "a fox in a hole": interview with Peter Busa, July 1984.
124. "The reason": ibid.
124. "sort of nonsense": Potter, *To a Violent Grave*, p. 70.
126. pigment is splashed freely: Robert Hobbs pointed out that there are drips in *Male and Female* in his catalogue for the show *Abstract Expressionism: The Formative Years* (Ithaca: Herbert F. Johnson Museum of Art, 1978), p. 8.
126. "bisexuality or sexual unsureness": William Rubin, "Pollock as Jungian Illustrator: The Limits of Psychological Criticism," *Art in America* (Dec. 1979), p. 79.
127. "Well, the WPA folded up": letter from Stella Pollock to Charles Pollock, Feb. 10, 1943.

128. truly inventive résumé: Joan M. Lukach, *Hilla Rebay* (New York: Braziller, 1983), photo insert.

129. "I could do an Arp easy": Potter, *To a Violent Grave*, p. 72.

129. "tiresome rush": quoted in Dore Ashton, *The New York School: A Cultural Reckoning* (New York: Viking, 1973), p. 110.

129. "This ... NO!": interview with the artist's friend and patron Alfonso Ossorio, Feb. 1984.

129. "mediocrity, if not trash": Jimmy Ernst, *A Not-So-Still Life* (New York: St. Martin's Press, 1984), p. 224.

130. "a picture a day": Jacqueline Bograd Weld, *Peggy: The Wayward Guggenheim* (New York: Dutton, 1986), p. 193.

131. "something of a miracle": "Jackson Pollock: An Artists' Symposium, Part I," p. 30.

132. "nice": Jean Connolly, "Art," *The Nation*, May 1, 1943, p. 643.

132. "Pretty awful, isn't it?": Ernst, *A Not-So-Still Life*, p. 241.

133. "starry-eyed": Jean Connolly, "Art," *The Nation*, p. 786.

133. "a real discovery": Robert Coates, "The Art Galleries," *The New Yorker*, May 29, 1943, p. 49.

133. attended the wedding: Busa interview.

134. "Who's L.K.?": Cindy Nemser, *Art Talk* (New York: Scribner's, 1975), p. 88.

134. "trapped animal": Peggy Guggenheim, *Out of This Century: Confessions of an Art Addict* (New York: Universe Books, 1979), p. 315.

134. "Pollock himself": ibid.

135. "Dear Baroness": Lukach, *Hilla Rebay*, p. 155.

Chapter Nine: *Mural*
PAGE

136. "to have the painting finished": letter from JP to Charles Pollock, July 29, 1943, *Catalogue Raisonné*, Vol. 4, p. 228.

137. "And where am I?": interview with Reuben Kadish, 1984.

137. "I have it stretched": ibid.

137. "An American is an American": "Jackson Pollock," *Arts and Architecture* (Feb. 1944), p. 14.

138. "*She-Wolf* came into existence": Sidney Janis, *Abstract and Surrealist Art in America* (New York: Reynal & Hitchcock, 1944), n.p.

139. named the painting *Pasiphaë*: interview with James Johnson Sweeney, March 1984. See also William Rubin, "Pollock as Jungian Illustrator: The Limits of Psychological Criticism," *Art in America*, Dec. 1979, p. 74.

140. "I don't know how I can face another day": Jacqueline Bograd Weld, *Peggy: The Wayward Guggenheim* (New York: Dutton, 1986), p. 332.

140. "Soby dropped in": letter from Howard Putzel to JP, n.d., *Catalogue Raisonné*, Vol. 4, p. 229.

141. "a really disciplined painting": interviews by Francine du Plessix and Cleve Gray, "Who Was Jackson Pollock?" *Art in America* (May 1967), p. 51.

141. "wet with new birth": Maude Riley, "Fifty-seventh Street in Review," *Art Digest,* Nov. 15, 1943, p. 18.

141. "an authentic discovery": Robert Coates, "The Art Galleries," *The New Yorker,* Nov. 20, 1943, p. 97.

141. "surprise and fulfillment": Clement Greenberg, "Art," *The Nation,* Nov. 27, 1943, p. 621.

143. "Jackson's supposed to deliver": interview with the artist's close friend John Little, Jan. 1984.

144. took off his clothes: Peggy Guggenheim, *Out of This Century: Confessions of an Art Addict* (New York: Universe Books, 1979), p. 296.

144. "I hate my easel": interview with Janet Chase, 1984.

145. "Lee was very possessive": Jeffrey Potter, *To a Violent Grave: An Oral Biography of Jackson Pollock* (New York: Putnam, 1985), p. 75.

145. "Certain individuals": Robert Motherwell, "Art Chronicle," *Partisan Review* (Winter 1944), p. 97.

146. "obviously wanted to accept": "Jackson Pollock; An Artists' Symposium, Part I," *Art News* (April 1967), p. 64.

146. Alfred Barr . . . felt the price was too high: Sweeney interview.

146. "VERY HAPPY TO ANNOUNCE": This telegram is in the Pollock Archive.

146. "I am getting $150 a month": letter from JP to Charles Pollock, n.d., *Catalogue Raisonné,* p. 233.

147. "talked not about art but about money": Potter, p. 152.

147. Pollock was visited by Benton: Cindy Nemser, *Art Talk* (Scribner's, 1975), p. 87.

147. "Said he liked my stuff": JP to Louis Bunce, n.d., Bunce papers, Archives of American Art.

148. "Hofmann's art colony": Little interview.

148. "I have a definite feeling": "Jackson Pollock," *Arts and Architecture,* p. 14.

148. "Pollock? He's strong!": interview with Peter Grippe, a friend of the artist, Jan. 1984.

148. "We get in for a dip": JP to his mother and others, n.d., *Catalogue Raisonné,* p. 234.

149. "Lee didn't think": interview with Nene Schardt, Aug. 1984.

149. "So let us hear from you": JP to Ed and Wally Strautin, Aug. 25, 1944, *Catalogue Raisonné,* p. 234.

149. "I inveigled Jackson": telephone conversation with Reuben Kadish, 1985.

150. "general whirling figures": J.W.L., "Passing Shows," *Art News,* Jan. 15, 1942, p. 29.

150. went in at night: Grippe interview.

150. "Jackson wasn't very serious": telephone interview with Theodore Wahl, 1984.

152. "veil the image": see Rubin, "Pollock as Jungian Illustrator," pp. 83–4.

153. "People said it just went on and on": interview with Clement Greenberg, Dec. 1983.

153. "match the French": ibid.

154. "the strongest painter of his generation": Clement Greenberg, "Art," *The Nation*, April 7, 1945.

154. "I really don't get": Maude Riley, *Art Digest*, April 1, 1945, p. 59.

154. "baked macaroni": Parker Tyler, *View* (May 1945).

Chapter Ten: The Springs

PAGE

155. "this lovely person": Jeffrey Potter, *To a Violent Grave: An Oral Biography of Jackson Pollock* (New York: Putnam, 1985), p. 81.

156. "Leave New York?": Joseph Liss, "Memories of Bonac Painters," *The East Hampton Star*, Aug. 18, 1983, Sec. II, p. 1.

156. "we have no money": ibid.

157. forty dollars: Barbara Rose, "American Great Lee Krasner," *Vogue*, June 1972, p. 154.

157. "Over my dead body": interviews by Francine du Plessix and Cleve Gray, "Who Was Jackson Pollock?" *Art in America* (May 1967), p. 50.

157. "it was the only way": Peggy Guggenheim, *Out of This Century: Confessions of an Art Addict* (New York: Universe Books, 1979), p. 316.

158. "a place to get a dog license": Cindy Nemser, *Art Talk* (New York: Scribner's, 1975), p. 87.

159. "I got out the phone book": interview with May Natalie Tabak Rosenberg, Dec. 1983.

159. the second witness: marriage certificate, city clerk's office, Borough of Manhattan.

160. "No coal as yet": card from JP to Ed and Wally Strautin, n.d., *Catalogue Raisonné*, Vol. 4, p. 236.

160. "I opened the door this morning": ibid.

160. "we really love it here": letter from JP to Louis Bunce, postmarked Jan. 5, 1946, Bunce papers, Archives of American Art.

161. "He used to drink a lot": interview with Mrs. Elywin Harris, Jan. 1984.

162. "What may at first sight": Clement Greenberg, "Art," *The Nation*, April 13, 1946, p. 445.

163. "Everyone is going or gone": letter from JP to Louis Bunce, postmarked June 2, 1946, Bunce papers, Archives of American Art.

164. "Jack would get pie-eyed": interview with Jay Pollock, July 1983.

164. "The work is endless": letter from JP to Louis Bunce, postmarked June 2, 1946, Bunce papers, Archives of American Art.
165. "pulled a ligament": card from JP to Ed and Wally Strautin, postmarked June 2, 1946, *Catalogue Raisonné*, Vol. 4, p. 237.
166. "one of the intellectual captains": Saul Bellow, "What Kind of Day Did you Have," (New York: Pocket Books, 1985); p. 88.
166. "You will wait until I pull over": Rosenberg interview.
167. "go upstairs and take a nap": ibid.
167. "The movement of knife into shell": John Bernard Myers, *Tracking the Marvelous: A Life in the New York Art World* (New York: Random House, 1983), p. 101.
169. "That's for Clem": interview with Clement Greenberg, Dec. 1983.
169. "Jackson Pollock's fourth one-man show": Clement Greenberg, "Art," *The Nation*, Feb. 1, 1947, p. 137.
170. Philip Rahv . . . felt Greenberg was overly dogmatic: William Barrett, *The Truants: Adventures Among the Intellectuals* (Garden City, NY: Anchor Press, Doubleday, 1982), p. 137.
170. Delmore Schwartz . . . was suspicious: ibid., p. 152.
170. "Give the winner an easel painting": ibid., p. 147.
171. "most powerful painter in America": "The Best?" *Time*, Dec. 1, 1947, p. 55.
171. "Very much an artist": letter from Benton to John Simon Guggenheim Memorial Foundation, Nov. 14, 1947, Foundation files.
171. "Creative painting": fellowship application form, John Simon Guggenheim Memorial Foundation, Oct. 14, 1947, Foundation files.

Chapter Eleven: "Grand Feeling When It Happens"
PAGE

172. offering the college a Braque: Jacqueline Bograd Weld, *Peggy: The Wayward Guggenheim* (New York: Dutton, 1986), p. 327.
173. "I'm better than all the fucking painters": telephone interview with Joyce Kootz, the art dealer's widow, 1985.
173. Steinberg once drew a portrait: Calvin Tompkins, "Profiles: A Keeper of the Treasure," *The New Yorker*, June 9, 1975, p. 46. See also, Calvin Tompkins, *Off the Wall: Robert Rauschenberg and the Art World of Our Time* (New York: Penguin, 1981), p. 57.
174. "dumped in my lap": Ken Kelley, "Betty Parsons Taught America to Appreciate What It Once Called 'Trash': Abstract Art," *People*, Feb. 27, 1978, p. 78.
174. "a place where art goes on": Clement Greenberg, *Ten Years*, exhibition catalogue (New York: Betty Parsons Gallery, 1956). Quoted in Tompkins, *Off the Wall*, p. 58.
175. "tragedy, ecstasy, doom, and so on": Selden Rodman, *Conversations with Artists* (New York: Devin-Adaro, 1957), p. 93.

175. "awful" or "terrible": interviews by Francine du Plessix and Cleve Gray, "Who Was Jackson Pollock?" *Art in America* (May 1967), p. 55.

175. "he wasn't the sort of artist": interview with Herbert Ferber, March 1984.

175. "I can't tell you that": ibid.

175. "risky and unfeeling act": "Personal Statement," *Tiger's Eye* (Dec. 1947), p. 44.

176. "self contained and sustained advertising concern": letter from Rothko to Newman, June 24, 1947, Newman papers, Archives of American Art.

176. "Jackson doesn't need": telephone conversation with Annalee Newman, the artist's widow, October 1984.

177. "sullen, intense, miserable": Du Plessix and Gray, p. 53.

177. "always telling me the local news": ibid., pp. 53–54.

177. "There was a desperation about him": ibid., p. 55.

178. "just now getting into painting again": letter from JP to Louis Bunce, postmarked Aug. 29, 1947, Bunce papers, Archives of American Art.

178. "Every so often": Rudi Blesh, *Modern Art U.S.A.: Men, Rebellion, Conquest, 1900–56* (New York: Knopf, 1956), p. 253.

178. The term was originated by William Rubin: see William Rubin, "Jackson Pollock and the Modern Tradition: Part One," *Artforum* (Feb. 1967), p. 19.

179. "poured, poured, not dripped": Jeffrey Schaire, "Was Jackson Pollock Any Good?" *Art & Antiques* (Oct. 1984), p. 85.

180. "I don't have any theories": JP to *Life*. A transcript of the interview is in the Time, Inc. archive.

182. "a lot of swell painting this year": letter from Stella Pollock to Frank Pollock, Dec. 11, 1947, *Catalogue Raisonné*, Vol. 4, p. 241.

182. only one sold: sales records of the Betty Parsons Gallery, Parsons papers, Archives of American Art.

182. "pick any one you want": Ferber interview.

182. "Since Mondrian": Clement Greenberg, "Art," *The Nation*, Jan. 24, 1948, p. 108.

183. "a good deal of poetic suggestion": Robert M. Coates, "The Art Galleries," *The New Yorker*, Jan. 17, 1948, p. 57.

183. "beautiful astronomical effects": unsigned review, *Art News* (Feb. 1948), p. 59.

183. "colorful and exciting": Alonso Lansford, "Automatic Pollock," *Art Digest*, Jan. 15, 1948.

183. "I am very worried": letter from Betty Parsons to Peggy Guggenheim, Feb. 26, 1947. A copy of this letter is in the Parsons papers, Archives of American Art.

183. "I am still very worried": letter from Betty Parsons to Peggy Guggenheim, April 5, 1948. A copy of this letter is in the Parsons papers, Archives of American Art.

185.	"A Maryland horse farm": Du Plessix and Gray, p. 52.
185.	"reckless with tools": Jeffrey Potter, *To a Violent Grave: An Oral Biography of Jackson Pollock* (New York: Putnam, 1985), p. 104.
186.	"Wilfredo doesn't speak any English": interview with Elisabeth Ross Zogbaum, Dec. 1983.
186.	"a new European country": Peggy Guggenheim, *Out of This Century: Confessions of an Art Addict* (New York: Universe Books, 1979), p. 329.
186.	"I am glad you took on Pollock": letter from Peggy Guggenheim to Betty Parsons, Oct. 8, 1949, Parsons papers, Archives of American Art.
186.	"experimental meanderings": Aline B. Louchheim, " 'Modern' or 'Contemporary'—Words or Meanings?" *The New York Times,* Feb. 22, 1948, Sec. II, p. 8.
187.	"strange art of today": "A Life Round Table on Modern Art," *Life,* Oct. 11, 1948, p. 56.
187.	"Have had fairly good response": letter from JP to Louis Bunce, postmarked June 2, 1946, Bunce papers, Archives of American Art.
189.	"adding to the confusion": "Unframed Space," *The New Yorker,* Aug. 5, 1950, p. 16.
189.	"there was no drinking": letter from Stella Pollock to Charles Pollock, Jan. 10, 1949, *Catalogue Raisonné,* Vol. 4, p. 243.
189.	"He is an honest man": Du Plessix and Gray, p. 48.
190.	"The Dr. doesn't give him anything": letter of Jan. 10, 1949.
190.	"My husband didn't believe": telephone interview with Mrs. Edwin Heller, the doctor's widow, Jan. 1984.
190.	"quieted any doubts": Clement Greenberg, "Art," *The Nation,* Feb. 19, 1949, p. 221.
190.	"tangled hair": Emily Genauer, *New York World-Telegram,* Feb. 7, 1949.
191.	"advanced stage of disintegration": Sam Hunter, "Among the Shows," *The New York Times,* Jan. 30, 1949.
191.	"the museum never knew": Grace Glueck, "Scenes from a Marriage: Krasner and Pollock," *Art News,* Dec. 1981, p. 60.

Chapter Twelve: "The Greatest Living Painter"
PAGE

192.	Pollock offered to demonstrate: interview with Arnold Newman, Dec. 1984.
193.	"little bit short of cash": ibid.
193.	"He talked": interview with Dorothy Seiberling, Jan. 1984.
193.	"If you want to see a face": JP to *Life.* The interview transcript is in the Time, Inc. archive.
193.	"Jackson Pollock—Is he the greatest ...?": *Life,* Aug. 8, 1949.
194.	"adjustment you have made": letter from Dr. James Wall to JP, Aug. 23, 1949, Pollock Archive.

194. "maybe it would seem exploitative": interview with Rebecca Tarwater Hicks, May 1984.

194. "completely understand": *The New Era* (Deep River, Connecticut), Aug. 25, 1949.

194. "movie cowboy Roy Rogers": *The Cody* (Wyoming) *Enterprise*, Aug. 12, 1949.

194. "made peace with themselves": James Valliere, interview with Daniel T. Miller, *Provincetown Review* (Fall 1968), p. 36.

195. "He couldn't read the article while we were there": James Brooks to James Valliere, Nov. 1965, Pollock Archive.

195. "The Model A's a good car": Du Plessix and Gray, p. 53.

195. "straight American boy": ibid.

197. "Don't let an artist": interview with Alfonso Ossorio, Jan. 1984.

197. "very silent": ibid.

198. "more than ever repetitious": Carlyle Burrows, New York *Herald Tribune*, Nov. 27, 1949.

198. "Late Work by Kandinsky": Stuart Preston, "Late Work by Kandinsky Pollock, and Others," *The New York Times*, Nov. 27, 1949, Sec. II, p. 12.

198. "the best show he has ever had": card from Stella Pollock to Frank Pollock, postmarked Dec. 22, 1949, *Catalogue Raisonné*, p. 246.

199. "an insane dinner party": letter from LK to Ossorio, n.d., *Catalogue Raisonné*, p. 247.

199. "Terrific, terrific": interview with Esteban Vicente, a friend and colleague of Pollock's, April 1984.

200. "What did you think": interview with Milton Resnick, April 1984.

200. "Pollock broke the ice": de Kooning made the comment at a memorial service for Pollock sponsored by The Club on Nov. 30, 1956.

201. left before the lecture was over: letter from LK to Ossorio, n.d., *Catalogue Raisonné*, p. 247.

201. "Jackson didn't like doing things with coffee": John Gruen, *The Party's Over Now* (New York: Viking, 1967).

202. "notoriously hostile to advanced art": "18 Painters Boycott Metropolitan; Charge 'Hostility to Advanced Art,'" *The New York Times*, May 22, 1950, p. 1.

202. "The Irascible Eighteen": editorial, "The Irascible Eighteen," New York *Herald Tribune*, May 23, 1950.

202. "like bankers": B. H. Friedman. "The Irascibles: A Split Second in Art History," *Arts* (Sept. 1978), p. 102.

202. "neutral territory": ibid.

204. "Piccolo discorso sui quandri di Jackson Pollock": undated magazine clipping from *L'Arte Moderna*, Pollock Archive.

204. "Do you know any Italian": interview with Marie Levitt Pollock, July 1983.

205. "shrug off": "Chaos, Damn It!" *Time*, Nov. 20, 1950, p. 71.

205. "at least for artist Pollock": letters, *Time*, Dec. 11, 1950, p. 10.

206. "I can't decide whether this painting is finished": telephone interview with Rudy Burckhardt, Sept. 1985.
208. "The painting is finished": Hans Namuth, "Photographing Pollock," in Barbara Rose, ed., *Pollock Painting* (New York: Agrinde Publications, 1978), n.p.
208. "Do you have any more?": interview with Hans Namuth, Dec. 1983.
210. drew attention to Pollock's technique: see Barbara Rose, "Namuth's Photographs and the Pollock Myth," in *Pollock Painting*.
210. "At a certain moment": Harold Rosenberg, "The American Action Painters," *Art News* (Dec. 1952), p. 22.
211. "I lost contact with my first painting on glass": Jackson Pollock movie, produced by Hans Namuth and Paul Falkenberg, 1951.

Chapter Thirteen: The "Black" Paintings
PAGE

214. "The big thing right now": letter from Jay Pollock to Frank Pollock, postmarked Dec. 3, 1950, *Catalogue Raisonné*, Vol. 4, p. 255.
215. "meaningless embellishment": Robert M. Coates, "Extremists," *The New Yorker*, Dec. 9, 1950, p. 110.
215. "personal comment": Howard Devree, *The New York Times*, Dec. 3, 1950, Sec. II, p. 9.
215. "richest and most exciting": B.K. [Belle Krasne], "Fifty-seventh Street in Review," *Art Digest*, Dec. 1, 1950, p. 16.
215. didn't know where his paintings came from: letter from Clement Greenberg to the author, April 1, 1984.
215. "I found New York terribly depressing": letter from JP to Ossorio and Dragon, Jan. 6, 1951, *Catalogue Raisonné*, Vol. 4, p. 257.
215. "I really hit an all time low": letter from JP to Ossorio, n.d., *Catalogue Raisonné*, Vol. 4, p. 257.
216. "Who, exactly, has he hit": interview with Clement Greenberg, Dec. 1983.
216. "like a movie star": Jeffrey Potter, *To a Violent Grave: An Oral Biography of Jackson Pollock* (New York: Putnam, 1985), p. 210.
217. "while I was in there": ibid., pp. 195–96.
217. "One couldn't entertain a dialogue": Deborah Solomon, "An Interview with Helen Frankenthaler," *Partisan Review*, 50th Anniversary Issue (1984), p. 795.
217. "Dali once told me": Selden Rodman, *Conversations with Artists* (New York: Devin-Adaro, 1957), pp. 107–08.
218. "I heard you were talking yesterday": Fielding Dawson, *An Emotional Memoir of Franz Kline* (New York: Pantheon, 1967), p. 84.
218. "I loathed the place": Barbara Rose movie, *Lee Krasner: The Long View*, 1978, distributed by the American Federation of Arts.
218. "Don't bother bringing him up": interview with Dan Rice, 1983.
218. "above water": letter from JP to Ossorio, n.d., *Catalogue Raisonné*, Vol. 4, p. 257.

219. "jurying was something I swore I'd never do": letter from JP to Ossorio, n.d., in *Catalogue Raisonné*, Vol. 4, p. 258.
219. "That's awful": telephone interview with the painter Leon Golub, a member of the Momentum group, Dec. 1983.
219. "The jurying was disappointing": letter from JP to Ossorio and Dragon, n.d., *Catalogue Raisonné*, Vol. 4, p. 258.
219. "not too happy": letter from JP to Ossorio and Dragon, June 7, 1951, *Catalogue Raisonné*, Vol. 4, p. 262.
219. "My home is in Springs": Jackson Pollock movie, produced by Hans Namuth and Paul Falkenberg, 1951.
220. "this is exotic music": telephone conversation with Paul Falkenberg, Sept. 1985.
220. "feel good about them": letter from JP to Ossorio, n.d., *Catalogue Raisonné*, Vol. 4, p. 258.
220. "stops the show": B.H. [Betty Holliday], *Art News* (April 1951), p. 47.
221. "the chef-d'école": Henry McBride, *Art News* (Dec. 1951), p. 20.
221. "Mr. and Mrs. Jackson Pollack": *The East Hampton Star*, May 10, 1951, p. 6.
222. "How did it go?": Barbara Rose, "Pollock's Studio: Interview with Lee Krasner," in Barbara Rose, ed., *Pollock Painting* (New York: Agrinde Publications, 1978), n.p.
222. "some of her best painting": letter from JP to Ossorio and Dragon, June 7, 1951, *Catalogue Raisonné*, Vol. 4, p. 261.
223. "a very quiet summer": letter from JP to Ossorio and Dragon, n.d., *Catalogue Raisonné*, Vol. 4, p. 263.
224. "Should I cut it here?": B. H. Friedman, "Interview with Lee Krasner," *Jackson Pollock: Black and White*, exhibition catalogue (New York: Marlborough-Gerson Gallery, 1969), n.p.
224. "the non-objectivists will find them disturbing": letter from JP to Ossorio and Dragon, June 7, 1951, *Catalogue Raisonné*, Vol. 4, p. 61.
225. "This is *Lee's* show": telephone interview with Jacob Kainen, Dec. 1983.
225. "could you do it in color?": Friedman, "An Interview with Lee Krasner," *Jackson Pollock: Black and White*, n.p.
225. "My paintings aren't selling": Greenberg interview.
226. "If Pollock were a Frenchman": Clement Greenberg, "Feeling Is All," *Partisan Review* (Jan.–Feb. 1952), p. 97.
226. "All I want is five hundred dollars": interview with Arloie McCoy, Dec. 1983.
226. "Where's the emulsion?": interview with Alfonso Ossorio, Feb. 1984.
227. "I have been skinned alive": letter from JP to Ossorio, March 30, 1952, *Catalogue Raisonné*, Vol. 4, p. 267.
227. standing on a high structure: B. H. Friedman, *Jackson Pollock: Energy Made Visible* (McGraw-Hill, 1974), p. 172.
227. a vacuum cleaner: William Lieberman, *Jackson Pollock: The Last*

Sketchbook (New York: Johnson Reprint and Harcourt, Brace, Jovanovich, 1982), p. 13.

227. "Two cars": ibid.
227. "Weather clear": This report is in the files of the Town of East Hampton police department.
227. Jackson Pollock, Artist: *The East Hampton Star,* Jan. 3, 1952, p. 1.

Chapter Fourteen: *Blue Poles*
PAGE

228. "I never pushed sales": Ken Kelley, "Betty Parsons Taught America to Appreciate What It Once Called 'Trash': Abstract Art," *People,* Feb. 27, 1978, p. 83.
228. "my financial mess": letter from JP to Betty Parsons, n.d., *Catalogue Raisonné,* Vol. 4, p. 245.
228. "If you cannot give me 15%": letter from Betty Parsons to JP, June 25, 1951, Pollock Archive.
228. "Betty sailed last Sat": letter, from JP to Ossorio, n.d., *Catalogue Raisonné,* Vol. 4, p. 262.
229. "very anxious": letter from Betty Parsons to JP, Jan. 31, 1952, Pollock Archive.
229. "Since Manet": interview with Clement Greenberg, Dec. 1983.
230. "Do you think the market": interview with Sidney Janis, Jan. 1984.
230. "The edge is gone": Thomas B. Hess, *Art News* (April 1952), p. 17.
231. "Here, get out of here": interview with Jane Smith, the widow of Tony Smith, Dec. 1984.
231. "a bicycle, an automobile tire": *The East Hampton Star,* Aug. 28, 1952, p. 6.
231. "I still respect you as an artist": Cindy Nemser, *Art Talk* (New York: Scribner's, 1975), p. 94.
231. "very severe shock": ibid.
232. "For crissakes, Jackson": Stanley P. Friedman, "Loopholes in 'Blue Poles,'" *New York,* Oct. 29, 1973, p. 48.
233. "looked like vomit": ibid.
233. Newman regretted the request: telephone conversation with Annalee Newman, 1985.
233. "This won't come through": Barbara Rose, "Pollock's Studio: An Interview with Lee Krasner," in *Pollock Painting,* ed. Barbara Rose (New York: Agrinde Publications, 1978), n.p.
235. "This is Jackson Pollock": Janis interview.
236. the highest price: Israel Shenker, "A Pollock Sold for $2 Million, Record for American Painting," *The New York Times,* Sept. 22, 1973, p. 1.
236. "not bad paintings": Clement Greenberg to James Valliere, unpublished interview, March 1968, Pollock Archive.

236. "The last thing I want": Greenberg interview.

237. "You're a fool": ibid.

237. "At a certain moment": Harold Rosenberg, "The American Action Painters," *Art News* (Dec. 1952), p. 22.

237. Pollock was appalled: William Rubin, "Pollock as Jungian Illustrator: The Limits of Psychological Criticism," *Art in America* (Dec. 1979), p. 91; see also letter from Parker Tyler, *Art News* (March 1961), p. 6.

Chapter Fifteen: Final Years
PAGE

238. "Is this a painting?": B. H. Friedman, "Interview with Lee Krasner," *Jackson Pollock: Black and White*, exhibition catalogue (New York: Marlborough-Gerson Gallery, 1969), n.p.

238. "pulling up in his coupe": interview with Al Cavagnaro, Jan. 1984.

239. "Found Jackson Pollock": Town of East Hampton Police Department, daily log, Dec. 23, 1953.

239. "they're really painted": Emily Genauer, New York *Herald Tribune*, Feb. 7, 1954.

239. recognized his 1953 paintings for what they were: interview with Clement Greenberg.

240. "I don't agree that he had shot his bolt": letter from David Smith to Adolph Gottlieb, Aug. 23, 1956, Gottlieb Foundation.

240. "I'm an old man": interview with Cile Lord, Feb. 1984.

240. "Do you think I would have painted this crap . . . ?": letter from Rodman's wife Maia Wojciechowska to author, Aug. 8, 1984.

240. "I can paint better than this guy": Clement Greenberg to James Valliere, unpublished interview, March 1968, Pollock Archive.

241. "It's full of holes": interview with Herbert Ferber, March 1985.

241. "I'm the best fucking painter": interview with May Natalie Tabak Rosenberg, Dec. 1983.

241. "Jackson, you're the greatest painter": interview with Sidney Geist, March 1984.

241. "What, me hit an artist?" John Gruen, *The Party's Over Now* (New York: Viking, 1967), p. 229.

241. "The reconciliation isn't real": letter from Clement Greenberg to Sue Mitchell, June 20, 1956.

242. ordered new art materials: interview with Lou Rosenthal, Sept. 1984.

242. "Remember how good?": Lord interview.

243. "You can't do that kind of painting anymore": ibid.

243. "All my sympathy": letter from James Johnson Sweeney to JP, July 15, 1954, Pollock Archive.

243. "knitted by now": card from Clement Greenberg to JP, Aug. 19, 1954, Pollock Archive.

Notes

243. "I hear you have broken your leg again": letter from Martha Jackson to JP, Feb. 14, 1955, Pollock Archive.

243. "I'm going to Europe": interview with Milton Resnick, April 1984.

244. "more deserving": letter from Clement Greenberg to David Smith, Aug. 16, 1956. Smith papers, Archives of American Art.

244. send him a polite apology: A copy of Baur's letter can be found in the Pollock Archive.

245. "Can you imagine being married . . . ?": Jeffrey Potter, *To a Violent Grave: An Oral Biography of Jackson Pollock* (New York: Putnam, 1985), p. 174.

245. "I don't want food": Lord interview.

246. "You have such warm eyes": Ruth Kligman, *Love Affair: A Memoir of Jackson Pollock* (New York: Morrow, 1974), p. 31.

246. "would always love him": ibid., p. 43.

246. "Get that woman off my property": ibid., p. 95.

247. On July 12 Lee sailed: letter from Stella Pollock to Frank Pollock, July 23, 1956.

247. "I can't go": interview with Carol Braider, Jan. 1984.

247. "You know I'm a painter . . . ?": Kligman, *Love Affair*, p. 163.

247. "I miss you": letter from LK to JP, July 21, 1956, *Catalogue Raisonné*, Vol. 4, p. 276.

247. "last painting place": card from LK to JP, n.d., Pollock Archive.

247. "minimized what I had done for him": letter from Peggy Guggenheim to Clement Greenberg, Feb. 12, 1958, Greenberg papers, Archives of American Art.

249. "I feel pretty sick": interview with Roger Wilcox, Jan. 1984.

249. "Let me out": Kligman, *Love Affair*, p. 201.

249. "Two dead at scene of accident": Town of East Hampton Police Department, daily log, Aug. 11, 1956.

249. "Jackson is dead": interview with Paul Jenkins, Jan. 1984.

Chapter Sixteen: Lee by Herself
PAGE

251. "He is gone": letter from Stella Pollock to Irene Crippen, Jan. 6, 1967.

252. "I had to realize": Barbara Rose, *Lee Krasner: A Retrospective* (New York: The Museum of Modern Art, 1983), p. 95.

252. seventeen new canvases: Eleanor Munro, *Originals:* American Women Artists (New York: Simon & Schuster, 1979 [paperback, S&S, 1982], p. 116.

252. "The second attempt": ibid.

253. "we had a little less trouble": Les Levine, "A Portrait of Sidney Janis Taken on the Occasion of his 25th Anniversary as an Art Dealer," *Arts* (Nov. 1973), p. 53. See also Calvin Tompkins, *Off the Wall: Robert Rauschenberg and the Art World of Our Time* (New York: Penguin, 1981), p. 122.

254. "I wish I had as much money": Jeffrey Schaire, "Was Jackson Pollock Any Good?" *Art & Antiques* (Oct. 1984), p. 85.
254. "There were many happy moments": John Gruen, *The Party's Over Now* (New York: Viking, 1967), p. 233.
255. Lee had admired: interview with Ruth Stein, June 1986.

INDEX

Index

B Solomon, Deborah
P771j Jackson Pollack

B Solomon, Deborah
P771j Jackson Pollack